NEIL KENT

The Triumph of Light and Nature

Nordic Art 1740-1940

With 224 illustrations, 39 in colour

THAMES AND HUDSON

Acknowledgments

I am grateful for the considerable assistance given me by innumerable people throughout the Nordic countries, Great Britain and the United States of America. In particular, I should like to express my great debt to Professor Allan Ellenius of Uppsala University; also to Professor Malme Malmanger of Oslo University and Professor Teddy Brunius of Copenhagen University. At the School of Slavonic and Eastern European Studies, London, special thanks go to Mrs Hannele Branch who patiently bore with me through all the months required to learn Finnish.

I am also greatly indebted to Pontus Grate of the National-museum, Stockholm; Björn Fredlund and Anne Pettersson from Göteborgs Konstmuseum; Heikki Malme of the Ateneum, Helsinki; Tone Skredsmo of the Nasjonalgalleriet, Oslo; and Kasper Monrad of the Statens Museum for Kunst, Copenhagen, for their help. Thanks go also to Aivi Gallen-Kallela; Marita Ahlström of the Gyllenberg Museum, Helsinki; Jakob Ågotnes of Aulestad; and Karla Kristjánsdóttir of the Listasafn Islands, Reykjavik.

Special thanks must go to Søren Wichmann and Peter Donner, of Copenhagen, who respectively inspired and estab-lished my interest in Nordic culture, and to the rest of the Donner family at whose house my interest in Nordic art was first nurtured. Gratitude is owed to my family and friends, who provided much help: above all, my mother Mrs Arline Kent Stewart, and Rolf Kjellström of Uppsala. Finally, and with special gratitude, I am grateful for the enormous help given by the Thames and Hudson staff.

CONTENTS

Introduction

Until the recent exhibitions 'Northern Light' (1982–3, in the United States), 'The Golden Age of Danish Painting' (1984–5, in England and France), and 'Dreams of a Summer Night' (1986–7, in England, France and Germany), few people, at least outside Scandinavia, had been aware not only of Nordic art as a whole but also of its distinctness of vision, its emotional power, its unique quality of spiritual depth, and its rich thematic and stylistic range, while it yet remained firmly rooted in the Western European tradition. Even in Scandinavia, before the exhibition 'The 1880s in Nordic Painting' (1985–6, in Oslo, Stockholm, Copenhagen and Helsinki), only a small number of connoisseurs was aware of the art produced in the countries of their Scandinavian neighbours. This lack of an overall perspective on Nordic art, in Scandinavia and in the rest of the world, is probably the reason for the absence of any book which gives an overview of painting and sculpture in the Nordic countries from about 1740, when some of the first native artists began to work, until about 1940, when modernism finally came to dominate the arts in the West. This is, therefore, the first general survey of Nordic art – the art, that is, of Sweden, Denmark, Norway, Finland and Iceland. The underlying argument is that there are sufficient shared characteristics in the painting and sculpture of these countries to justify treating them in one volume, particularly for the period under review.

At first glance, the five countries seem to share more differences than they do common features. Each is independent, in each a different language is spoken. (In Finland, the majority speak Finnish, which is related to Hungarian and Samoyed, spoken on the borders of western Siberia!) Furthermore, relations between the Nordic countries have not always been amicable. The wars and political struggles between Denmark and Sweden in the seventeenth century (Scania was lost by Denmark to Sweden in 1660), left considerable antagonism against each other. In Finland, internal difficulties with a generally, though by no means always, more privileged Swedish-speaking minority continue today. Norway did not gain political independence from the Swedish crown until 1905, while Iceland remained a Danish dominion until 1944. The modern political balance of power in Scandinavia is also one which suggests disunity. Iceland, Norway and Denmark are committed members of NATO, while Sweden is firmly neutral, and Finland is bound by a defence treaty with the Soviet Union.

The ties binding these nations together, however, are deeper and more powerful than this historical disunity. For one thing, most educated people in the region are able with little difficulty to communicate with and understand fellow Scandinavians. In Finland, Swedish remains one of the two official languages. Along with English, Swedish is in fact the Nordic countries' lingua franca. Most importantly, a common Scandinavian cultural identity united the Nordic region throughout historical times. This identity has been reinforced by the Lutheran church, established in all the Scandinavian countries since the sixteenth century. Finally, given their geographical position, the five countries face similar climatic conditions which have a pervading influence on the outlook of their inhabitants: the rigours of wintry cold and darkness, and a tough and not easily yielding landscape have united the Scandinavian peoples in their relative isolation, whether on the heathlands of Jutland, the mountainous fjords of Iceland and Norway, or the vast, forested plains of Sweden and Finland. Thus, for all the very real differences among the Nordic nations, there are deep common geographical, historical and cultural characteristics which unite them and find a resonance in their art.

The chronological framework of this book has meant that due credit could not be given to the illustrious seventeenth-century Swedish artist David Klöcker Ehrenstrahl (1628–98), famous for his imperious Baroque history paintings and portraits, such as Karl XI's Coronation in Uppsala Cathedral *(1675). Ehrenstrahl was, in fact, a German from Hamburg and his highly accomplished art is superior to that of any of his contemporaries in Scandinavia, or indeed to*

6

that of any of the artists active there until the 1740s. Similarly, successful sculptors active in the Nordic countries before the eighteenth century were invariably of foreign background and training. At the other end of the period in this survey, painting and sculpture in the first three decades of the twentieth century in Scandinavia are more appropriately regarded, with few exceptions, as the tail-end of traditionalism rather than as part of the modernist movement, which exerted a strong influence only after the Second World War.

By including as wide a range as possible of artists, subjects and styles, I have tried to present a broad view which shows diversity and richness. Even so, a critical perspective had to be maintained in order to accommodate, within the limits of such a book, the artists who seemed to me to be most important from an art historical and social historical point of view; thus, although some of the paintings and sculptures most beloved by a Scandinavian public are included, I have also considered works which have not yet achieved the general recognition, even within the Nordic countries, which they deserve. The fact that the paintings of such artists as the Danes Vilhelm Hammershøi and Carl Holsøe have recently attracted the commercial art dealers of New York and London does not mean that their work should receive greater emphasis than, say, that of the Finnish painter Magnus von Wright and the Swedish artist Sophie Ribbing, who are, in my opinion, equally talented but virtually unknown outside Scandinavia. I do not intend, in this way, to belittle the works of Hammershøi or Holsøe but, rather, to bring to wider attention lesser known, but perhaps just as important works by other painters and sculptors. It is for this reason that Edvard Munch receives here no greater consideration than certain other artists, such as the Finn Akseli Gallen-Kallela. This approach has also been applied to subject-matter. That history painting and mythological subjects have not been as popular, until very recently, as they were in the middle of the nineteenth century does not invalidate them. Moreover, it seems to me that a painting which is loved by the public but disdained by art historians does deserve at least some mention along with those generally rejected by the average viewer but admired by the specialist.

To obtain an adequate survey of Nordic art, it is, of course, necessary to place it in its historical and cultural context. I have thus related artistic developments to the political, social and economic circumstances of each period, including the philosophical and literary views held at the time. This contextual information is presented with a minimum of interpretation. The book does not draw conclusions about Nordic art but, instead, seeks to raise questions by introducing it to a wide public and to stimulate further research.

During the eighteenth century in Denmark and Sweden, artistic patronage was exercised by the royal families and the aristocracy. The nineteenth century, however, witnessed the increasing buying power of a prosperous middle class, often of foreign background. By the end of the century, religious patronage too was influential. Heinrich Hirschsprung in Denmark, and Ernst Thiel and Pontus Furstenberg in Sweden, all of Jewish-German families, are three examples of the new type of art patron. It is possible that the patronage of these rich industrialists, for a type of Nordic art which was acutely conscious of its Scandinavian identity, was a product of their desire to be part of their adopted countries. Why did middle-class patrons in the late nineteenth century, like the Finn Gösta Serlachius, a saw-mill magnate, buy paintings of Finnish nature just as their factories were exploiting Finnish natural resources in an unprecedented manner? Why were ship-owners, especially in Norway, avid collectors of paintings of their homeland, when their ships were carrying off hundreds of thousands of their countrymen to America, often unable to remain at home because of hopeless economic circumstances?

The shift in patronage from the courts to the rich, emerging bourgeoisie, however, was not only a shift in control over the artist's work from one élite to another. In certain respects, there was a positive side to it: the artists acquired greater freedom to choose their subject-matter and style, within new, prescribed limits, whereas until the nineteenth century the artist had had

little choice, because convention and his patrons' demands dictated the content and the style. Some artists made use of this artistic liberty, while others did not. The Swedes Johan Fredrik Höckert and Anders Zorn were willing to provide their patrons with exactly the kind of paintings expected by them, in order to achieve sales and large profits. Others, such as the Swede Ernst Josephson, thrived on antagonizing prospective patrons (though this did not prevent him from continuing to seek their financial support). Most artists, however, sought a compromise between their own choices and those of their patrons. For example, Vilhelm Hammershøi painted numerous domestic interiors, because they were popular, as well as landscapes, despite his own preference for the latter.

The chapters in this book have been built, more or less chronologically, round themes which provide a loose skeleton on which to flesh out the diverse art of the period from 1740 to 1940. Not all art in the second half of the eighteenth century was commissioned by the royal courts; the church, professional classes, academies and other bodies were also patrons. Equally, by the second quarter of the twentieth century, not all patrons were rich industrialists; some were royal, such as Prince Eugen of Sweden, himself an artist, and churches too continued to commission works of art.

During the late eighteenth century, Neo-classical style and subject-matter came to dominate the arts in Scandinavia, as elsewhere in Europe, reaching their apogee in the first quarter of the nineteenth century. None the less, it should be remembered that the classical conventions of painting were more deeply perceived by some artists than by others. The Danish painter Nikolai A. Abildgaard possessed a profound knowledge of Roman and Greek art and literature, but the Swede Pehr Hörberg had no knowledge of the latter and only a smattering of the former. For some painters and sculptors, especially in the outlying regions of Norway and Finland, illustrated works served as second-hand sources of current styles and conventions on the Continent. It is debatable whether these provincial artists understood much of the concepts behind what they saw only in reproduction, and whether what inspired them was not merely the product of their own misinterpretations!

In the first half of the nineteenth century, most Nordic artists went to Paris and Rome; it was necessary to study the art in the collections of these countries, and also to gain first-hand experience at the famous studios, such as that of Jacques-Louis David. Later in the century, it was virtually a duty for artists to visit and study in the dominant schools and studios, whether in Paris, Düsseldorf or Berlin. Other considerations may also have played their part: some artists must certainly have been driven to these places because it was a social convention that artists from the European periphery had to spend time at the mainsprings of European culture.

That an artist did or did not visit Paris, Rome, or Düsseldorf, when many of his noted colleagues did so, does not reflect on his skill or vision but, rather, on the demand for his work and on his reputation. Indeed, a surprising number of Scandinavian artists were financially unable to travel abroad, and some of them had no desire to do so. Dankvart Dreyer, for instance, remained in Denmark all his life, painting to a considerable degree in isolation from other artists, yet his work was among the best of the Golden Age of Danish painting. By contrast, the Norwegian Johan Christian Dahl, who lived in Dresden, was acclaimed by his highly educated patrons because his paintings no doubt evoked the sublime and symbolic allusions to nature, man and their interaction which his patrons had also found in the contemporary literary works of Goethe and other continental thinkers. One may question, however, whether Dahl, had he remained in Norway, or even in the more continental Denmark, would have enjoyed the opportunities presented by Dresden, one of Europe's greatest cultural cities. Not only might he not have come in contact with those who exerted a profound influence on him, he also might not have found the response and the necessary patronage in bankrupt Norway that he achieved in Germany.

Edvard Munch's post-Nietzschean, proto-existential perceptions, in a world in which conventional religion and a well-established social structure of society no longer existed to provide security or metaphysical answers, might have found only a limited response had he continued to live in Norway. Instead, he lived for considerable periods in Paris and, more importantly, in Berlin. The Norwegian painter Lars Hertervig, on the other hand, produced works of haunting beauty and deep emotional power but remained largely unknown outside Norway, where he spent most of his life suffering from insanity. He was forgotten by an age that preferred to award its accolades to more robust and fashionable artists.

One must be wary of oversimplifying the artists' intentions to express themselves directly in their works. That Eugène Jansson produced a self-portrait which is interpreted by some viewers as a portrayal of his sense of gloom and alienation does not mean that he felt gloomy and alienated, or that he intended to depict himself as such. Again, the fact that Carl Larsson produced paintings of idyllic family life does not imply that his own family life was similar (it is known, on the contrary, that Larsson's domestic situation was fraught with difficulties and disharmony). There is a popular tendency to confuse the depiction of emotions such as loneliness, isolation and anxiety with the artist experiencing them. This may sometimes have been the case and, indeed, it is well documented that Edvard Munch was tortured by such feelings. Other artists, however, were equally tormented, such as Carl Frederick Hill, but left few traces of these emotions in their works. The interesting question is whether paintings that expressed anxiety, loneliness or alienation were making use of an especially Nordic thematic convention.

Nature, particularly landscape, is the most recurring theme in much Scandinavian painting of the nineteenth and early twentieth centuries. Often, these depictions invited the viewer to respond emotionally to the landscape or other non-human subject. Some of the most characteristic works usually read in this way are those of Johan Christian Dahl and Caspar David Friedrich, from Swedish Pomerania, in the early nineteenth century; and of the Norwegian Harald Sohlberg and the Swede Prince Eugen, at the end of the nineteenth century and beginning of the twentieth. These artists used the northern landscape to allude to metaphysical moods and to the existential predicament of being both a part of the natural world and at the same time alienated from it.

By the 1880s and 1890s many Nordic artists saw nature as pantheistic and anthropomorphic. Sometimes, as in Prince Eugen's The Cloud, *nature is presented in ominous opposition to man. The pantheistic theme is most famously predominant in the Norwegian author Knut Hamsun's novel* Pan, *as well as in many other books, journals and paintings of the time. It was not an isolated Nordic phenomenon but reflected a trend among artists and writers on the Continent. The Nordic works, however, are characterized by a degree of emotional power and lack of sentimentality not often present in those of their continental counterparts.*

Two particular qualities of the Nordic environment contribute to the individuality of its painting: the light and nature's proximity. The cities, and especially the capitals Stockholm, Helsinki and Christiania (now Oslo), despite urban growth and increased industrialization, are even today only a short distance from the shores of rugged and largely unpopulated archipelagos. Thus, the Swedish late nineteenth-century artist Bruno Liljefors painted acute observations of the wildlife and landscape in his native province of Uppland not far from the city of Uppsala; similarly, Prince Eugen's works are mainly of the countryside just outside Stockholm.

Atmospheric conditions in the Nordic countries and their geographical position in very high latitudes produce unique effects of light. The 'blue hour' at twilight on a midsummer evening, when the sun barely sets below the horizon, pervades the Nordic sky like a gentle mist. In the winter, the pale and weak rays of the sun fall on the snow-covered landscape of Scandinavia in a way that seems evocative. Light does evoke mood and atmosphere in these

countries. If one wonders why the French nineteenth-century plein air *painter Jules Bastien-Lepage was so influential on Nordic artists of the last quarter of the nineteenth century, it is because he taught them the pictorial skills necessary to use such natural phenomena. Had it not been for Bastien-Lepage and the French* plein air *movement, Scandinavian artists might have continued to produce studio paintings rather than open-air works taken directly from nature. The peculiarly Nordic nature and its characteristics of light might not have been painted with such accuracy and power. Moreover, the realistic depiction of nature in the works of Bastien-Lepage helped Scandinavian artists to reject the classical and Italianate tradition of landscape painting that had been derived from such artists as the seventeenth-century French painter Claude Lorraine. Thus, during the nineteenth century, Nordic artists were able to turn their attention to their own landscape and people. This coincided with the development of nationalism and a greater awareness of the meaning of national identity.*

The use of light to suggest mood and atmosphere was not restricted to outdoor scenes but was also applied to domestic interiors. In the early nineteenth century, the Dane Wilhelm Bendz had painted the play of light in an interior so that it evoked mood and alluded to a spiritual dimension. Artists such as Vilhelm Hammershøi and the Finn Maria Wiik had fully exploited this technique by the end of the century. In view of the rich symbolism of their work, one must consider how important literary inspiration was for their pictorial style. Hammershøi, for instance, is quite likely to have read the Danish writer J. P. Jacobsen's novel Niels Lyhne, *where, by using words that conjure up subtle images of light in domestic interiors, different moods are evoked in correlation with the action of the novel. Such descriptions influenced many Nordic artists in the last quarter of the nineteenth century. Conversely, Nordic literature of this period often has a distinctly painterly quality.*

While Nordic painting was being released from the constraints and conventions of a classical tradition, sculpture continued to be bound by them. Since the emergence of Nordic sculptors in the mid-eighteenth century (excluding anonymous wood-carvers, who had always been active), a classical style had dominated sculpture. Though strongly Neo-classical in the second half of the eighteenth century, it had gradually assumed a more Gothic look by the 1830s and '40s. Later, in the early 1900s, Scandinavian sculpture began to reflect superficially modernist notions, but it was the work of Rodin that was the most radical source of inspiration for Scandinavian sculptors until the Second World War. And subsequently, growing nationalism and an increasingly bureaucratic, socialistic structure of society resulted in the domination of a Rodinesque kind of social realism, not unlike that which prevailed in the rest of Europe outside the modernist movements.

Art of the Royal Courts
1740-1800

By the 1750s a state of tranquillity and reasonable prosperity had established itself in the Nordic countries. Sweden, under its German-born king Adolph Frederick, had recovered from its unsuccessful war with Russia in the early 1740s. Denmark, though feebly ruled by Frederick V, strengthened the political parity with Sweden which it had gained during the Northern War (1700–21), when Denmark, with her allies Russia and Poland, had fought Sweden. These peaceful circumstances and an increase in trade with concomitant profits enabled the courts of Sweden and Denmark to encourage greater expenditure on the arts than had been conceivable for over half a century. It also permitted a co-operation in the arts between these two Scandinavian powers, which had been impossible since the late seventeenth century when the great architect Nicodemus Tessin the Younger (1654–1728), the architect of the Royal Palace in Stockholm, worked for both the Swedish and Danish courts. In this happy union the Swedish artist Carl Gustaf Pilo (1711–93) was the principal bond.

In Stockholm, Pilo trained under the painter Olof Arenius (1700–66), who is best known for his *Portrait of Augustin Ehrensvärd* (1756), an aristocratic Swedish military architect (1710–72). Pilo then moved to Copenhagen, the Danish capital, in the early days of 1741, eager to avoid an unwelcome marriage in Sweden and in pursuit of another attachment, the young daughter of a French actor, Charlotte Desmarées, whom he married in 1750. There he found a milieu not only more liberal and tolerant of his amorous relations, but a cultural ambience permeated with the wit and enlightened views propagated by the Danish poet and playwright of Norwegian birth, Ludwig Holberg (1684–1754). Sometimes called Denmark's Molière, Holberg wrote a brilliant satire, *Niels Klim's Subterranean Journey* (1741), mocking the austere and pietistic religious values prevailing in some Scandinavian circles at this time.

In Copenhagen, the gateway to the Nordic countries from the Continent, Pilo thrived, becoming not only Court Painter but also Director of the Kongelige Kunstakadamiet (Royal Academy of Art) in 1771. He succeeded the French sculptor Jacques-François-Joseph Saly (1717–76), whose monumental work, a mounted *Frederick V* (1757–71), is in the centre of Amalienborg Square, surrounded on four sides by the Royal Palace. The academy, newly organized in 1754 after the French system, provided the necessary channel for aspiring artists to acquire the skill and financial means to practise their career.

One work, Pilo's *Portrait of Frederick V in Coronation Robes* (c. 1751), exemplifies his painting at its finest: a luxuriant Rococo display of ermine and lace, silk and satin, is set against a gauzy background of browns and blues, from which the king's head protrudes doll-like and dainty, as in a porcelain figure by the Meissen painter Kändler. It is surprising that, for all his virtuosity and stylistic similarities to the type of painting produced in Paris and Dresden, Pilo never visited those cities and, except possibly for a brief journey to Vienna, spent his whole life in Sweden and Denmark.

By contrast, the older Gustaf Lundberg (1695–1786), also from Stockholm, where he studied under the Hamburg-born court painter David von Krafft (1655–1724), spent most of his life in Paris, studying under three of the most eminent French artists of the time, Hyacinthe Rigaud, Nicolas de Largillière and J. F. de Troy. However, his contact there during 1720 and 1721 with the Venetian portrait painter Rosalba Carriera was more important for his artistic development. Through this artist, whose use of pastels was greatly admired in Paris, Lundberg acquired considerable skill in this new medium, enabling him to achieve a phenomenal success. His patrons included the young king Louis XV, his queen Maria Leszczynska and her father Stanislas, the former king of Poland, who was a keen dilettante in pastels.

I

However, some of Lundberg's most successful works were not commissioned by royal patrons, but were produced as presents to other artists. A portrait (1741) of the renowned painter François Boucher is an example of this type; it is a work full of wit and colouristic delicacy and, though Boucher's head is portrayed in a pose similar to Pilo's head of Frederick V, it possesses an anatomical and psychological realism unmatched in the latter. Along with his companion portrait of the French artist and director of the French Academy in Rome, Charles Natoire, it was exhibited on the occasion of Lundberg's election to the French Royal Academy that same year. Four years later, in 1745, he returned to Stockholm to great acclaim by the Royal Court. Finally, in 1772 Gustaf III rewarded him with the newly created Order of Vasa. Meanwhile, in Paris, his enviable position was gradually assumed by a fellow Swede, Niclas Lafrensen the Younger, who painted charming *fêtes galantes* in the manner of Pater and Fragonard. However, he belongs to a later epoch, the revolutionary 1790s, far removed from the tastes and values of the Rococo.

Yet even the 1770s were years of growing political unrest and indeed the first upheavals of revolution were occurring, not only in France but in Scandinavia as well. In Denmark a romantic scandal implicating the English-born Queen Caroline Mathilde, the sister of George III, with the German doctor, Johan Frederick Struensee, caused political turmoil when Struensee used his position near the throne to crush aristocratic power in the interest of royal absolutism, in order to instigate reforms. His political ambitions, however, were brutally cut short when antagonized nobles, under their leader Guldberg, took advantage of the weakness of the mentally unbalanced King Christian VII. They exposed the liaison in 1772, which led to a summary execution of this failed reformer. Publicly, this affair provoked a xenophobic reaction because of the culprits' foreign backgrounds and this attitude spilt over into the artistic sphere. Foreign artists were expelled and Pilo was obliged to return to Sweden.

It was with great sadness that Pilo fled Denmark, but he was soon aware of the favourable political and artistic climate which now reigned in Sweden under its new monarch Gustaf III (1746–92), whom the sculptor Johan Tobias Sergel called a 'ray of eternal light'. Gustaf was a passionate aesthete who saw himself cast in the role of the Sun King Louis XIV of France. With the knowledge gained during extensive artistic explorations of Italy and France, he imported some of the artists and architects he encountered there to fulfil his dream of making Haga, near Stockholm, a Swedish Versailles, and the capital itself a stately Neo-classical city. Louis Jean Desprez (1743–1804), a Frenchman, supervised these various plans. Few of the architectural works, however, had been carried out, when a disaffected aristocrat, Jacob Johan Ankarström, assassinated Gustaf at the Royal Opera House in Stockholm in 1792. In spite of his untimely end, his reign had provided fertile soil for the development of the visual and plastic arts. For Pilo especially, Gustaf supplied considerable financial assistance and in 1777 he was made Director of the Swedish Konstakadamien (Royal Academy of Art), the first Swede to assume this post after the Frenchman Pierre Hubert L'Archevêque (1721–78), who had been coaxed to Stockholm in 1755, retired and returned to die in France.

At about the same time as Pilo was given his prestigious appointment, he was also commissioned to paint the king's coronation of 1771. This painting, unusual in its epic scope, was begun in 1782 and, although it is set in Stockholm's Great Church where the coronation occurred, it is composed from the imagination as Pilo had not been present on the occasion. It successfully glorifies the royal absolutism which Gustaf III attempted to re-establish.

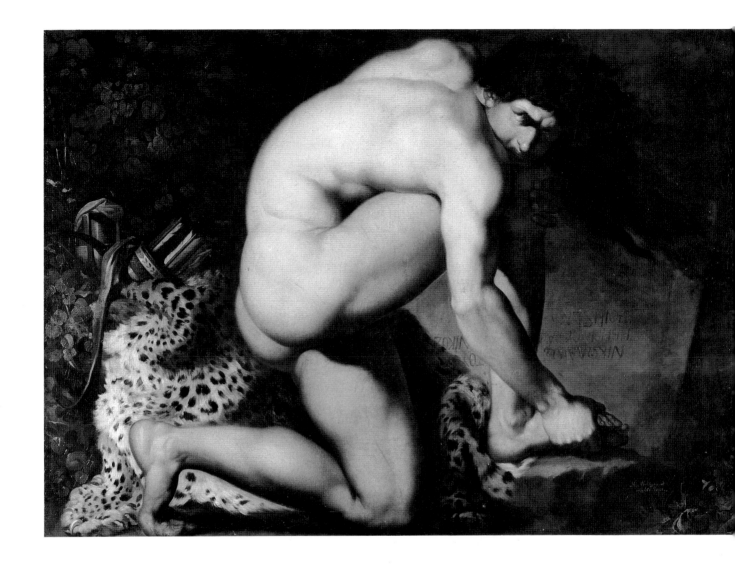

1 **Nikolai A. Abildgaard** *The Wounded Philoctetes* 1774–75

Sweden had regained its greatest painter, but this did not mean that Denmark suffered from the loss. On the contrary, it enabled the Danish Kunstakadamiet to cleanse itself of the old Rococo style to which the foreign artists had adhered and to bring to the fore new Danish painters and sculptors. They had been inculcated with Neo-classical values which were inspired by the writings of the German archaeologist and art historian Johann Joachim Winckelmann and others in Rome. If Christoffer Wilhelm Eckersberg (1783–1853) is regarded as the father of Danish painting, then Nikolai A. Abildgaard (1743–1809) and Jens Juel (1745–1802) must be considered its two grandfathers, for it is from them that Danish artists trace their artistic ancestry.

Abildgaard won the Academy's gold medal in 1767, which provided the most gifted young artists with the means to study abroad. This enabled him to travel to Rome, where he immersed himself in the study of the Antique. He shared the company of artists such as Jacques-Louis David, who was also infatuated with the ruins of Rome and the splendid collections of antiquities such as that of Cardinal Albani, a friend of Winckelmann, then Vatican Librarian and Superintendent of Roman Antiquities. It was on the basis of this deeply classical background that Abildgaard produced his famous work *The Wounded Philoctetes* (1774–5) on a mythological theme. He chose to portray the moment when the

1

13

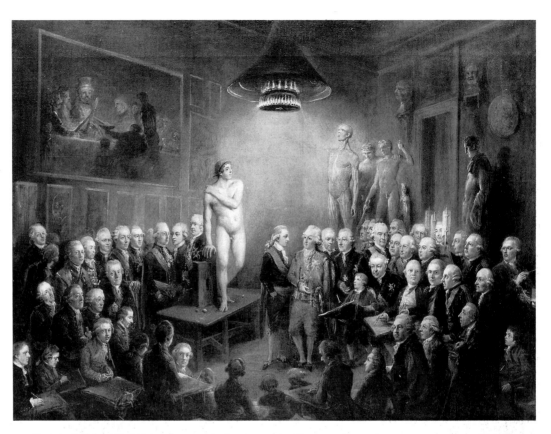

2 **Elias Martin** *Gustaf III's Visit to the Konstakadamien 1780* 1782

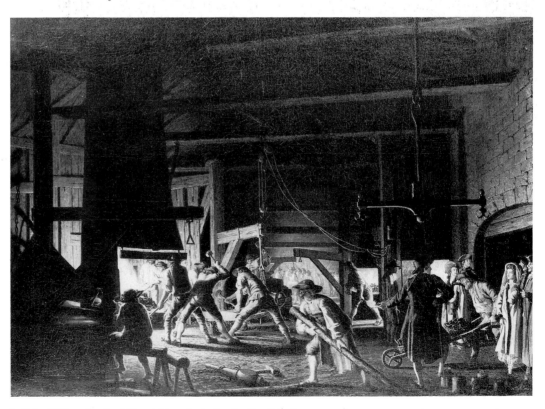

3 **Pehr Hilleström the Elder** *Visit to the Anchor Smithy, Söderfors Estate* 1782

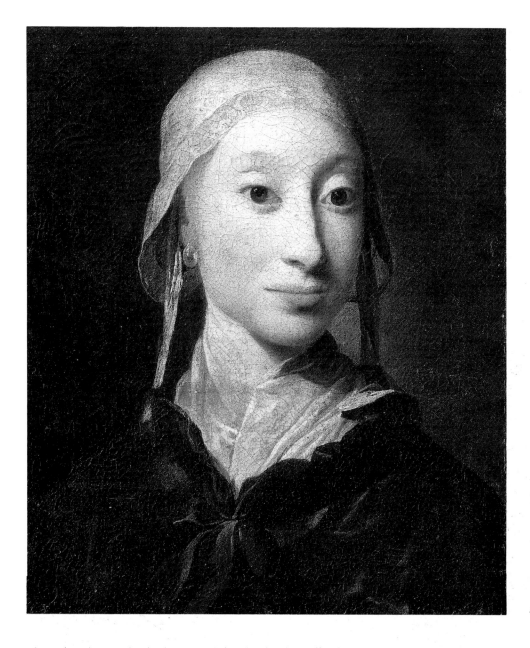

4 **Jens Juel** *A Holstein Girl* 1766–67

Thessalian king, who had avenged the death of Achilles by attacking Paris, grasps at his own wound inflicted by an arrow soaked in viper's venom. The depiction of this grim story from the *Iliad* is a prime example of the new austere style. The muscular figure of Philoctetes has been strongly influenced by the works of Michelangelo and the contrast of the figure against the sombre dark background gives it the frieze-like quality sought by Neo-classical artists. It is further accentuated by a strong sense of rhythm.

Jens Juel followed Abildgaard to Rome in 1774. His style was influenced by the years of training he had spent in Hamburg and Dresden, and later by his extended stays in Switzerland where he illustrated, with the etcher Johann Friderich Clemens (1748–1831), the collected work of the great naturalist Charles Bonnet. He then moved to Paris. There is a striking similarity in style between his hypnotic painting *A Holstein Girl* (1766–67) and the work of Jean-Baptiste Siméon Chardin, and it is possible that Juel was familiar with Chardin's work even before his visit to Paris. The dark undifferentiated background,

4

15

the curious facial features of the girl and the gaze of her penetrating, almond-shaped eyes have an alluring sphinx-like quality that makes this painting one of the finest portraits in Nordic art. Juel painted many leading members of Danish society, his principal patrons, often in the manner of Gainsborough, set against a landscape background. In these landscapes-cum-portraits too Juel is unexcelled in Scandinavian painting.

II One of Juel's finest landscape paintings, *The Ryberg Family Portrait* (1796–97), is a work in the grand English manner, depicting the family in the park of their country house. As such the painting is a portrait of the landscape too, tamed and dominated by the family, like the spaniel at their side. Colours are muted and the work has a lyrical simplicity far removed from the bombastic bravura of Abildgaard in his allegorical works, or the naïve rustic quality often to be found in Swedish landscape painting. Elias Martin (1739–1818) and Pehr Hilleström the Elder (1732–1816) were the leading landscape artists of the period. Though each had spent a considerable time in Paris, Martin lived for twelve years in England, becoming an Associate member of the Royal Academy, and married an Englishwoman. Hilleström, however, visited Holland and was most impressed by the paintings he saw there. He returned to Sweden in 1776 and became Court Painter. Whereas Martin devoted himself primarily to lyrical, Italianate landscapes of pastoral tranquillity, Hilleström was preoccupied with anecdotal scenes full of jovial peasants.

Their most interesting works today are not so much these idylls but rather those paintings of working men at their labours in candle-lit interiors or dazzling sunlight. Martin's *Sveaborg: Ship-building* (mid-1760s) is a sunny dock-side scene on Finland's fortress island, outside Helsinki, in which a ship is being constructed, while Hilleström's

3 *Visit to the Anchor Smithy, Söderfors Estate* (1782) portrays toiling eighteenth-century Vulcans, their faces illuminated by the brilliant flames of the furnace fires. These are Scandinavian descendants of seventeenth-century Dutch genre paintings in that they attempt to show realistic work-a-day scenes and the effects of light. They remain picturesque and idyllic, despite the fact that two of Hilleström's brothers were smiths and that Martin was well acquainted with peasant life. The viewer shares in them as Marie Antoinette and her court shared in the life of dairy maids at the mock dairy of Versailles, for they were painted to provide amusement and light entertainment.

Martin and Hilleström scorned such thematic devices in other works and more directly fulfilled their Court function of glorifying the monarchy. Martin's *Gustaf III's Visit to the Konstakadamien* (1780) and Hilleström's *The Royal Museum with Endymion in the Foreground* (1796) both show the king as a defender of the arts. In the former, a style of group portraiture derived from the Dutch masters is married to Neo-classical sculptural elements to create a highly theatrical effect. In this way, Martin's ability to convey the anecdotal has compensated for his failings as a draughtsman. Hilleström's work is more purely classical in its spatial and architectural dimension than Martin's, but it is the associations of the sculptures depicted that give it allegorical significance.

It was in portraiture that Swedish painters achieved their greatest success in the second half of the eighteenth century. The Malmö-born artist Alexander Roslin (1718–93) received such enormous acclaim in Paris, where many aspiring Nordic artists travelled at this time, for his intimate and charming portraits that he remained there for the rest of his life, receiving the honour of an apartment in the Louvre for his achievements. His fame in St Petersburg, at the Court of Catherine the Great, was such that he journeyed there to carry out several commissions. In doing so, he followed Virgilius Erichsen (1722–82), the Danish artist who had painted a magnificent portrait of the Russian Empress, *Catherine II in Front of her Looking Glass* (1764).

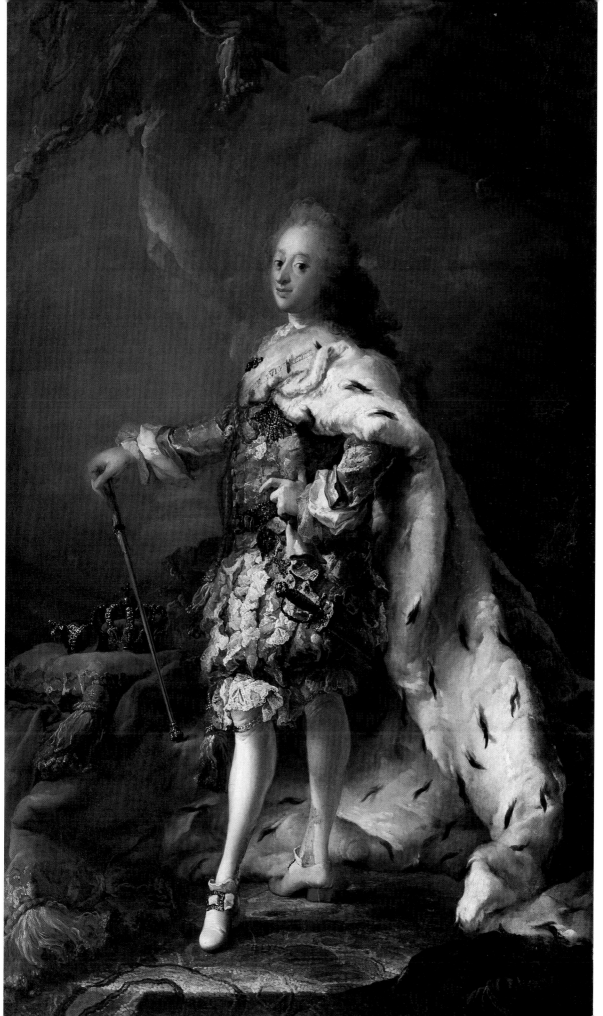

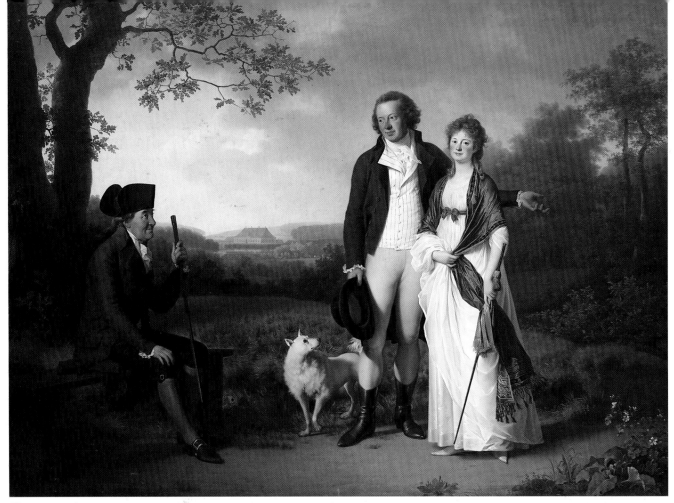

II

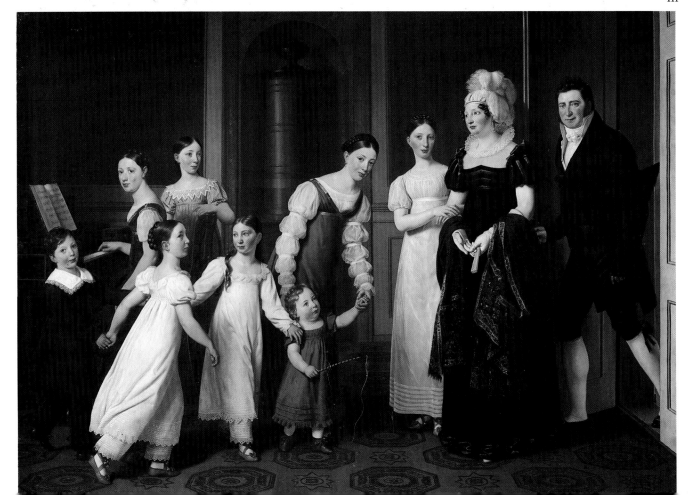

III

IV

V

VI

Roslin went to Copenhagen in 1772 when he was appointed Court Painter after Pilo's departure. Frequently, Swedish travellers passing through Paris employed him to paint their portraits. For these commissions Roslin used the studies he had made of other artists' works during his extended travels in Germany, Austria and Italy, as well as in France. These travels were important not only for his artistic development, but also for the social contacts with future patrons. One of these was Carl Fredrik Adelcrantz (1716–96) who was the Director of Royal Buildings in Stockholm and in charge of their artistic treasures. Roslin showed him in *Portrait of Adelcrantz* (1754) as a sophisticated and witty connoisseur, holding an architect's compass as a symbol of his influential office, gentle and approachable despite his power.

9

Roslin continued to produce this elegant and playful kind of portraiture for almost forty years, painting many members of the French royal family and earning the admiration of Boucher and Nattier, until the guillotine did away with many of his patrons during the early years of the French Revolution. He refused to leave Paris and died there, while other Swedish portrait artists who had been living in France returned to their homeland or otherwise fled abroad.

One such Swedish painter was Niclas Lafrensen the Younger (1737–1807). On returning to Sweden his reputation grew and, among other portraits, he was commissioned to paint the dashing and self-possessed aristocrat Hans Axel von Fersen (1799). Von Fersen had been the paramour of Queen Marie Antoinette and had endeavoured to assist the French royal family on their futile flight from Versailles. He was later killed by a mob during the revolutionary upheavals in Sweden.

7

Lafrensen the Younger produced many *fêtes galantes*, full of amorous anecdote, in blues and golds of delicate hue, and for these he benefited not only from the lessons of Rosalba Carriera, Boucher and Fragonard, whom he encountered in Paris, but also from the miniature painting of his father Niclas Lafrensen the Elder (1698–1756), and from the portraits by Cornelius Høyer (1741–1804), a student of Pilo. Their miniature paintings influenced the younger Lafrensen's works towards the end of his career, when miniature painting had become fashionable throughout Europe after the French Revolution.

Peter Adolph Hall (1739–93), another court painter, died among emigrés in Belgium after a successful career in Paris as a portraitist. Some of his most telling portraits are of his own family, such as the miniature of his daughter Adélaïde Hall (c. 1785). He also painted the sculptor Johan Tobias Sergel (1778–79). All bear witness to Hall's keen powers of observation, developed while he was a student of medicine and the natural sciences under the great botanist Carl Linnaeus (1707–78), who had produced richly illustrated works on Swedish flora at Uppsala University.

Roslin, Lafrensen the Younger and Hall had succeeded in charming the royal courts of France and Sweden with lyrical works that captured the imagination of their patrons, enabling them to see a loftier image of themselves than reality provided. Adolph Ulric Wertmüller (1751–1811) possessed the ability to elevate the patrons he portrayed into historical personages, who could be identified with classical heroes and heroines. Wertmüller had been a student with Hall of L'Archevêque, and for several decades painted members of the French court, one of his most elegant and delightful works being *Portrait of Queen Marie Antoinette with Two of Her Children Promenading in Trianon's Park* (1785), which was commissioned by Gustaf III on a state visit to Paris.

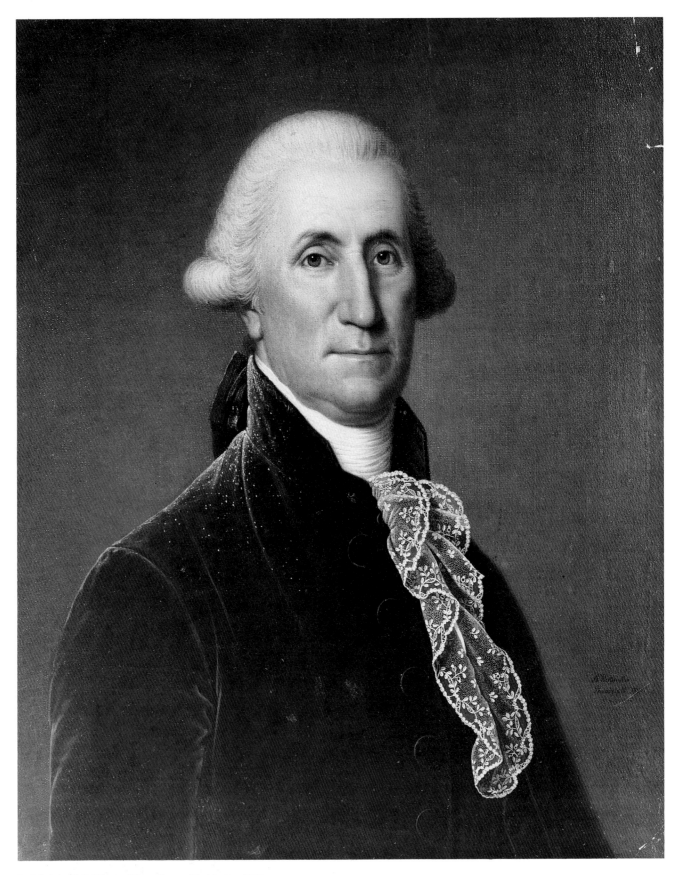

5 **Adolph Ulric Wertmüller** *George Washington* 1795

8 **Carl Fredric von Breda**
Portrait of James Watt 1792

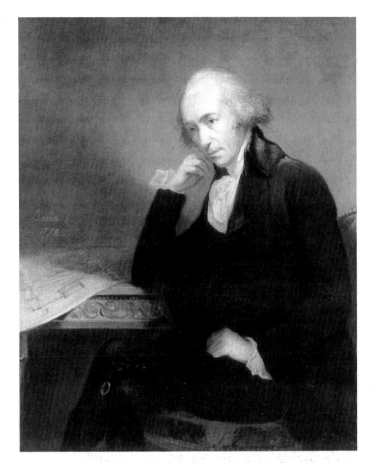

6 **Peter Adolph Hall** *Girl in a Rustic Dress* 1785

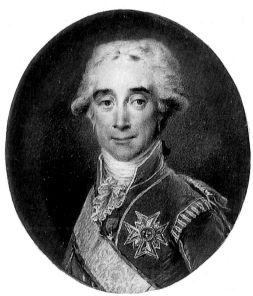

7 **Niclas Lafrensen the Younger** *Hans Axel von Fersen* 1799

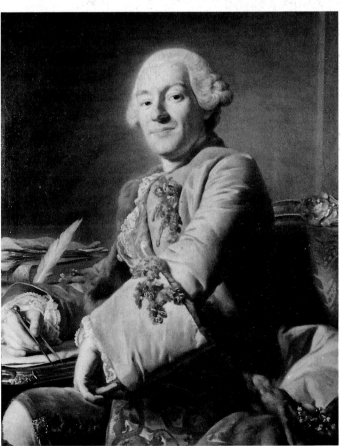

9 **Alexander Roslin**
Portrait of Adelcrantz 1754

He journeyed from country to country, arriving in America in 1794 where he was commissioned to paint the renowned portrait of the first American president, *George Washington* (1795). This portrait, of which there are several contemporary replicas, earned him great fame at the time. It succeeds in evoking the courage, fortitude and wisdom of Washington which the new American government wished to emphasise in order to associate his virtues with the new nation itself. Gone are the sugary colours of Wertmüller's early work in favour of more subdued ones. By stressing particular details, an impression of realistic portrayal has been achieved, though it is known that Wertmüller tactfully omitted the smallpox scars which marked Washington's face. For Wertmüller this was not so much a compromise with reality but a pursuit of the more important 'real' value of the heroic. 'Real' for many late eighteenth-century European artists meant the portrayal of the ideal, the ultimate reality hiding within the outward form which imperfectly reflected it: since Washington's essential quality was supposed to be heroic, he had to be portrayed as such. In striving to portray Washington as an Apollonian figure, Wertmüller was harking back to classical traditions of beauty and reality derived from Plato.

A similarly Neo-classical approach to painting was also followed by the Swedish aristocratic portraitist Carl Fredric von Breda (1759–1818), possibly the most English-influenced Nordic painter of the period. The only notable artist born into court circles, von Breda used his position to acquire commissions and became the unrivalled painter of the royal family and nobility. During eight years in London, from 1787 to 1796, where he was a pupil of Sir Joshua Reynolds, he exhibited with considerable public acclaim at the Royal Academy, where Reynolds had been the first president. Von Breda's *Portrait of James Watt* (1792) bears witness to his master's influence in its sensitive use of colour, while its composition and painterly technique derive from Thomas Gainsborough. A prolific painter, von Breda produced more than 450 works, many of which bear a stylistic affinity to Danish portrait painting of the late eighteenth century, which led Sergel to label him 'Stockholm's Juel'.[1]

However, it was in late eighteenth-century sculpture that the Neo-classical pursuit of the 'real' reached its apogee. The lone star among Nordic sculptors was the Swede Johan Tobias Sergel (1740–1814). Before his return to Sweden in 1779, he spent many years in Paris and Rome where he had become a friend of the Swiss-born painter Henry Fuseli and of Abildgaard. Though he never achieved the erudition of the latter, Sergel became a considerable scholar of antiquity. There, he felt, was to be found the beauty of nature at its fullest and in this conviction he was supported by the philosopher of art and man of letters Carl August Ehrensvärd (1745–1800), son of Augustin Ehrensvärd, the architect of the Sveaborg Fortress. Ehrensvärd travelled to Italy in 1781, going as far as Sicily, where he visited the Greek temples at Segesta and Selinute, as well as those recently discovered at Paestum near Salerno. He soon came to think that it was Greek, rather than Roman, sculpture and architecture which embodied nature at its most beautiful and 'real'.

It was Carl August Ehrensvärd, a brilliant caricaturist, who had strengthened Sergel's commitment to the Neo-classical style. Sergel had gained great acclaim for his cool, classical work *Amor and Psyche* (c. 1770), commissioned by Louis XV of France in a terracotta model, but it is *Faun* (1774) which epitomizes Sergel's work at its best. A keen awareness of anatomy in conjunction with great skill in capturing the sensual tonal qualities of the marble enabled Sergel to portray a tense erotic moment in this mythological creature's revel. Nevertheless, shadows of the Baroque always remained in Sergel's work, an inheritance from his former tutor L'Archevêque, whose sculpture *Monument to Gustaf II Adolph* (1756–96, completed by Christian Adams) still adorns

10 **Carl August Ehrensvärd** *Caricature of Gustaf III's Attempt to Produce an Heir c.*1770s

24

Gustaf Adolph Square in Stockholm. Even Sergel's later work *Resurrection* (1785), for the Adolph Frederick Church, has a Baroque dynamic rhythm, despite the classical forms of the figures.

The Neo-classical style dominated the arts in late eighteenth-century Scandinavia, but folk art also flourished. In Sweden, Pehr Hörberg (1746–1816), the son of a poor 'soldier-farmer' from Östergötland, began his artistic career as a *bonadsmålerer* (an itinerant painter who went from church to church and house to house, painting naïve but strictly stylized illustrations of biblical texts). This was a form of folk art particularly popular in Dalecarlia and later inspired the Swedish poet Erik Axel Karlefelt (1864–1931) to glorify it in his poetry. It was also popular in the southern province of Småland where *bonadsmålerie* achieved similarly high levels of artistry. There, at Urshult, Abraham Clemetsson (1764–1841), with his father Clemet Håkonsson (1729–95), established a peasant school of art for this type of painting. *The Wise and Foolish Virgins and The Three Wise Men* (1792) is a consummate example of Clemetsson's work, charming and lyrical. Pehr Hörberg went to Clemetsson's local school, first as a student and then as a master painter. He achieved such proficiency there with *bonadsmålerie* and portraiture that he came to the attention of many notable artists, including Pilo and Sergel, as well as the Court. These people became his patrons, enabling him to study at the Konstakademien in Stockholm, and to develop his talent as a portrait painter. The portrait of his father, *Åke Hörberg* (1771), is unique in portrait painting of this time in Scandinavia, for it combines an intense study of the sitter's character with such acutely observed detail that it borders on caricature. At the same time, it is a work of emotional power which captures the individuality and strength of this rustic Swede of the late eighteenth century.

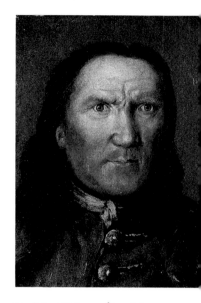

11 **Pehr Hörberg** *Åke Hörberg* 1771

* * *

12 **Abraham Clemetsson** *The Wise and Foolish Virgins and The Three Wise Men* 1796 (detail)

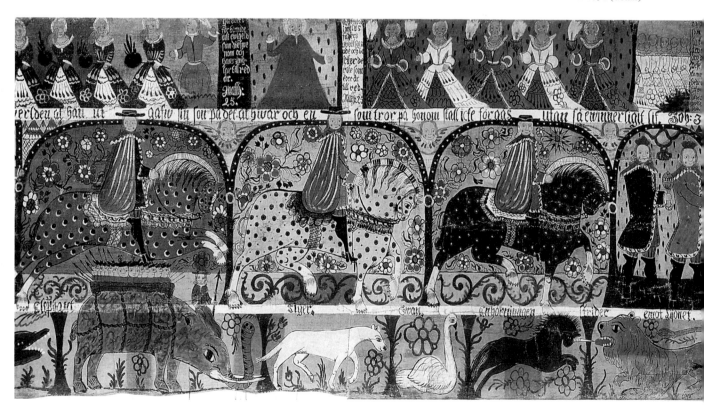

NEO-CLASSICISM

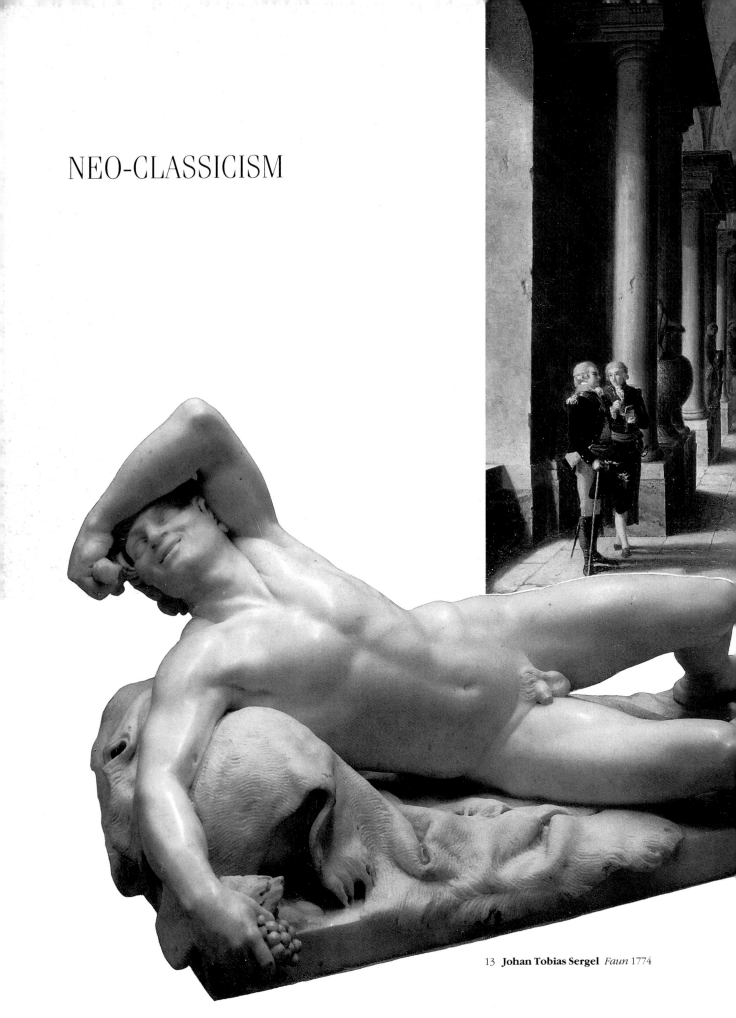

13 **Johan Tobias Sergel** *Faun* 1774

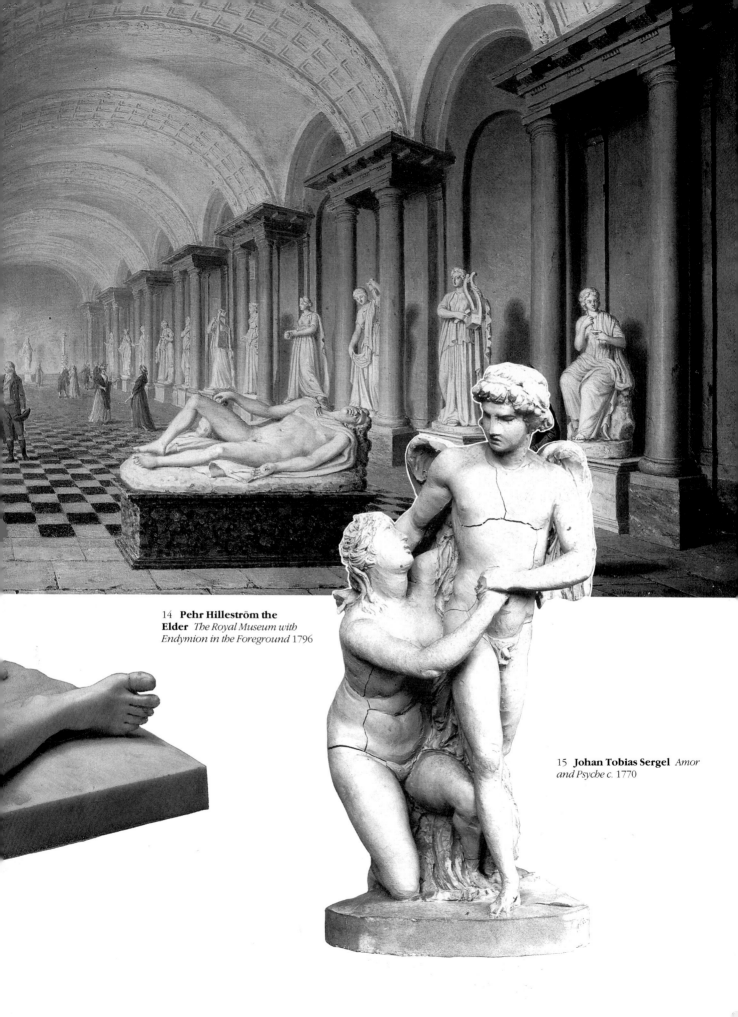

14 **Pehr Hilleström the Elder** *The Royal Museum with Endymion in the Foreground* 1796

15 **Johan Tobias Sergel** *Amor and Psyche c.* 1770

In Norway a tradition of naïve painting based on styles in church decoration of the seventeenth and early eighteenth centuries persisted until the end of the eighteenth century, for the country, then under Danish sovereignty, was remote from European cultural life and was economically impoverished. Christiania (now Olso) and Bergen were exceptions to this rule, being Norway's two main ports: shipping brought foreign wealth to its ship-owners and merchants, some of whom devoted considerable amounts of money to decorating their homes with paintings and other works of art. The scarcity of native Norwegian artists who could afford to acquire the necessary artistic training to carry out major commissions placed foreign artists in a favourable position to receive these. Mathias Blumental (*c.* 1719–63) was a Danish artist who prospered in Bergen. He decorated a room in 1756 for the new house of one of Bergen's leading burghers, Henrik Jansen Fasmer, with murals in a sophisticated, Rococo manner. One of these murals depicts the ruins of the city after its Great Fire in 1756.

One of the few native Norwegian artists active in Norway in the second half of the eighteenth century was Peder Aadnes (1739–92), who contented himself with a simple style. Aadnes had been an apprentice to the itinerant portrait and altarpiece painter Eggert Munch (*c.* 1685–1764), who had studied art in Copenhagen. This was necessary for Norwegian artists who aspired to any degree of higher training at this time, since there were no such schools in Norway. Munch's best-known painting, *Portrait of Karen Dorph* (*c.* 1760s), is painted with the pale blues and silvery tones which Aadnes admired, and has certain affinities to the style of Pilo in the use of colour. Aadnes travelled with Munch throughout the countryside, as was usual at this time for a Norwegian artist and apprentice, fulfilling commissions for prosperous merchants and farmers. He became self-employed by the early 1770s. His most charming work is his *Portrait of Christine Sophie Munch* (*c.* 1780s) which is also indebted to Pilo in its choice of colours and tonal variations. It was in landscape mural painting for drawing-rooms, however, that Aadnes excelled, and in 1774 he painted a mural on the Hesleberg estate, at Ringerike: Rococo-inspired figures pose in a verdant landscape which naïvely combines elements from both Italianate and Nordic designs, attempting to create a decorative harmony.

Ola Hansson (*c.* 1750–1820) looked further back for inspiration, to the Norwegian Gothic and Baroque. A painted room of 1782 in a log house at Rygi, in Telemark, is rustic in the extreme. The brightly coloured biblical scenes could have been taken from church murals of more than eighty years before, such as those of 1699 in Gol Stave Church. Such work contrasts sharply with that of the German-born H. C. F. Hosenfelder (*c.* 1719–1805), who was employed at the Herrebøe Fajance Factory until it was shut down. He produced portraits and murals for domestic interiors which strive to show modern continental fashions in dress and décor. His *Portrait of James Collett* (1792) has, nevertheless, a naïve charm which mocks any attempts to create a mundane atmosphere.

Even more remote than Norway from continental culture was Finland. The Finnish art of the late eighteenth century draws similarly on German Gothic and Baroque styles of painting no longer employed in the heart of Europe and generally abandoned in Sweden and Denmark, in art made for churches and the homes of rich landowners, who were mostly from Finnish-Swedish backgrounds. Thomas Kiempe (*c.* 1752–*c.* 1808) was an artist from the extreme north of Sweden, by the Finnish border, who had moved to Finland in the 1780s where he produced a considerable number of altar paintings. Simple and stylized, his figures are directly related to medieval Finnish and Swedish church painting, in which people didactically gesticulate to emphasise moral tales. Kiempe's *Communion* (*c.* 1796), for Virdois Church, is one of his most spiritually aspiring paintings and is based on an earlier work of 1794 in Soini Church.

17

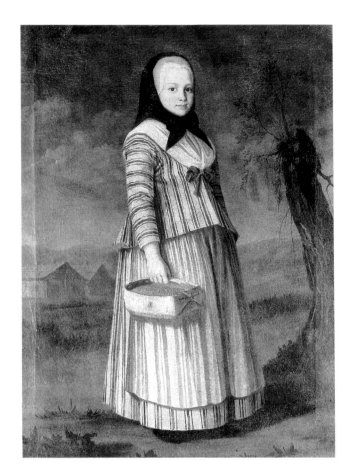

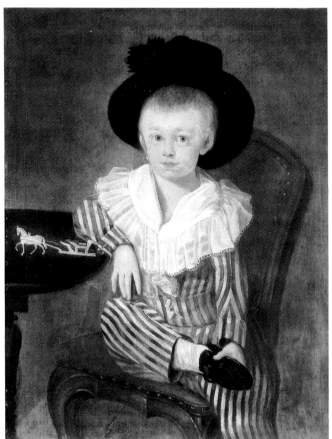

A little more modern are the works of two artists from Oulu on the north-west coast of Finland, Isak Wacklin (1720–58) and Mikael Toppelius (1734–1821). Both enjoyed a broader and more continental artistic training than most Finnish artists. Wacklin had studied under Pilo in Copenhagen and afterwards travelled to England where he produced his charming portrait of *Miss Heckford* (1757), while Toppelius had studied in Stockholm where he worked on the pulpit of the chapel at the Royal Palace (1751–52), under the Swedish artist Johan Pasch the Elder (1706–69). Whereas Wacklin devoted himself almost exclusively to portraiture, including his best work, the sombre *Self-portrait* (c. 1756), Toppelius painted many works with religious themes. His altar triptych in the Baroque style, *Christ Crucified* (1770), *Abraham's Sacrifice of Isaac* (1773) and *Gethsemane* (1773), in Lochteå Church, is his finest work.

Other Finnish artists of this period looked to early and mid-eighteenth century Swedish portrait painting for inspiration. One such painter was the Finnish-Swede Nils Schillmark (1745–1804), whose *Wild Strawberry Girl* (c. 1782) portrays a young artistocrat, Ulrika Charlotta Armfelt, in a stately pose. Schillmark emigrated from the north of Sweden to Finland and brought with him a typically late eighteenth-century Swedish taste for muted colours, as his subtle landscapes also demonstrate. His large œuvre bears witness to a considerable level of technical achievement and aesthetic appeal which was exceptional in Finland at this time and on a par with that produced in the other Nordic countries.

Individual artistic achievement in Norway and Finland was the exception rather than an aspect of a consistent and sustained flourishing of the arts. It was not until the following early decades of the nineteenth century that greater financial resources, a more widely educated public and improvements in travel led to a growth in the arts in these outlying countries of Scandinavia.

16 **Nils Schillmark** *Wild Strawberry Girl c.* 1782

17 **H. C. F. Hosenfelder** *Portrait of James Collett* 1792

16

Classicism
1800-1850

What came to be known as the Golden Age of Danish Art (1800–50) was a period in which Danish painting and sculpture achieved an apogee in the ability to portray light, landscape and the rising Danish middle classes. Many of the works produced at this time were successful in expressing aspects of Danish life and culture with a subtlety and emotional power that has made them interesting for later generations, who can find there also visions of a more peaceful, contemplative and simple life than is available to most people in the western world today. This art, however, was not nurtured in a cradle of prosperity or tranquillity. On the contrary, the early years of the nineteenth century were marked by a series of catastrophic events. In 1801 the Battle of Copenhagen, fought between Allied and Napoleonic forces, led to Denmark's political defeat and economic impoverishment. Six years later Copenhagen was bombarded by the English in retaliation for continued Danish support of Napoleon: hundreds died and about half the city, including parts of the ancient Cathedral of Our Lady, were consumed in the flames of the ensuing conflagration. The defeat of Napoleon in 1814 ensured the dismemberment of the Danish and Norwegian union, since the Allies rewarded Sweden for her support against Napoleon by transferring sovereignty over Norway from Denmark to Sweden. The Napoleonic Wars, however, contained the seeds of Denmark's resurrection. On the one hand, they focused thoughts and energies on the events, ideals, values and tastes propagated abroad. On the other, they encouraged a new appreciation of Denmark itself, shorn of its Augustan ambitions and yearning to explore the more domestic and private virtues and beauties which remained. Neo-platonic thought and classical forms were adapted to express the values of early nineteenth-century Scandinavian society. They provided the ideological and philosophical underpinning for visual expression in painting and sculpture. Rightly, Christoffer Wilhelm Eckersberg (1783–1853) has been called the father of Danish painting, for it was he who tied together the diverse strands of Danish and foreign artistic traditions and bequeathed this fusion to his students, enabling them to climb to high levels of artistic achievement.

Eckersberg, a native of southern Jutland, where his father was a carpenter and painter, had been first an apprentice painter in Åbenrå from 1797 to 1800, not far from his birthplace. In 1803 he moved to Flensborg and then to Copenhagen, where he became a student of Abildgaard at the Kunstakademiet from 1803 to 1809. Unfortunately, a mutual antipathy between Eckersberg and the professor caused many impediments to his early advancement, so that he was not awarded the gold medal until after Abildgaard's death in 1809. In 1810 Eckersberg went to Paris where he remained until 1813, apprenticing himself to the Neo-classical painter Jacques-Louis David and taking to heart his admonition to paint after Nature and the Antique in order to find Truth. Under the revolutionary painter's tutelage, Eckersberg produced some of his finest paintings in a variety of genres: portraits, landscapes and mythological scenes. In particular, his *View over the Pont Royal from the Quai Voltaire* (1812) and *Portrait of Emelie* (1813), which depicts his young French model, showed David that Eckersberg possessed considerable talent. In Paris he also became a life-long friend of Johann Friderich Clemens, Juel's collaborator, and assisted him on various projects. Of greater importance, however, were the years he spent in Rome from 1813 to 1816 and the effect the bright southern light had on him.

In Rome it was not only the graceful forms of antique sculpture and architecture but also the luminous blue sky and enveloping light given off by a sun higher in the heavens than he had seen before that provided him with a new artistic vision. Eckersberg produced many paintings and sketches of architectural subjects in Rome, beneath a warm and glowing sky, such as *A View through Three of the North-Western Arches of the Third*

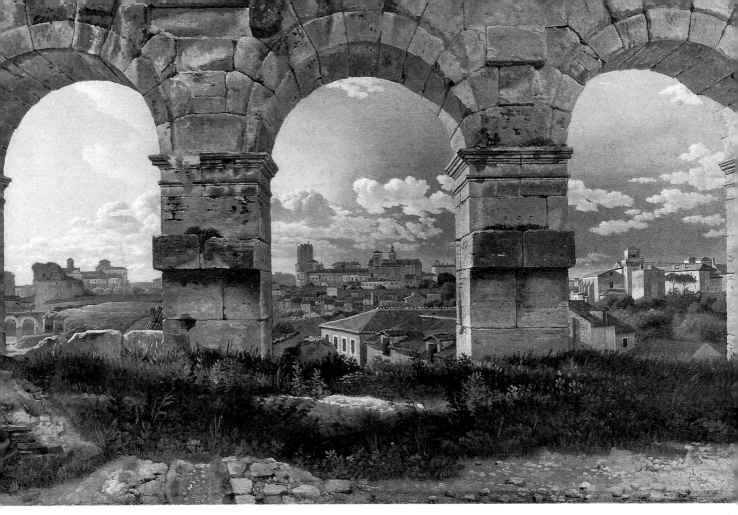

18 **Christoffer Wilhelm Eckersberg** *A View through Three of the North-Western Arches of the Third Storey of the Colosseum* 1813–16

Storey of the Colosseum (1813–16) and *The Steps and Façade of S. Maria in Aracoeli* (1813–16). The unusual angles of the perspectives, the rigidity of the forms, reminiscent of Jean-Auguste-Dominique Ingres (who had also been a student of David), and the portrayal of a sky acutely observed and depicted with all its momentary characteristics, give an almost mystical dimension to Eckersberg's works that also hints at the Nazarenes.

When Eckersberg returned to Copenhagen in 1816, he tried to transfer this approach, based on his experiences in France and Italy, to the Nordic environment. In *The Russian Ship 'Assow'* (1828) Eckersberg portrays the sea as precisely as he depicted Rome and its Campagna. Ships and frigates sail by one another, graceful and majestic, like the figures in an antique frieze, with an extraordinary architectural plasticity and total integration with the Danish sky and sea, whose sensitive depiction is unsurpassed in the art of Scandinavia. This work represents a supreme example of the successful fusion of classical and Nordic elements.

The fruitful combination of these two traditions is even evident in his portraits. Eckersberg was obliged to depend on these for his livelihood, since it was this genre which most appealed to the rich middle-classes who had superseded the court and aristocracy as the principal patrons of art at this time, much as industry and trade had surpassed agriculture as the nation's most important sources of wealth. These new pillars of the community were not interested in delicate and lyrical works of poetical allusions; they preferred portraits which emphasised their authority through wealth, their dignity and domestic security. In one of Eckersberg's most successful works of this kind, *The*

19

Nathanson Family Portrait (1818), painted the same year he was appointed professor at the Kunstakadamiet, the members of the family of the Jewish merchant, who provided much support for Eckersberg, are bathed in a bright light and are arranged as in a frieze, with a strong rhythm from left to right. Each character has his own formal individuality, not as a social statement of individual isolation, as has been suggested, but as a classical expression of balance and harmony in form and spacing. In this respect Eckersberg was enlarging a tradition in portraiture already employed by Juel. His bonds to this great painter were further strengthened, after the dissolution of his first unhappy marriage in 1816, by two subsequent ones to the artist's two daughters, first to Julie and then, after her death, to Suzanne.

Landscape and history painting continued to be important in Eckersberg's work, albeit less financially rewarding than portraiture, and he produced fine paintings in these genres after his return to Denmark. For twenty-four years, from 1817 to 1841, he worked on a series of paintings on the history of Denmark for Christiansborg Palace, of which *Christian I Inaugurates the Order of the Elephant in 1457* is possibly the most famous. Yet it is landscape and marine painting, rather than these or his academic altar paintings, which have been acclaimed by the public as more successful, because of his ability to capture the tonal variations of light in the Danish sky, coastal waters and landscape. In particular, his *The Brickworks at Renbjerg on Flensborg Fjord* (1830) has a delicacy and brilliance in its handling of light which has made it one of his most popular works.

Eckersberg continued to paint for many years until a cholera epidemic at the Academy killed him in 1853. His work inspired the next generation of young artists. A list of Eckersberg's students reads like a register of most Danish and many Swedish and Norwegian painters of the years 1820 to 1860. Of these, however, his closest and most significant heirs were Christen Købke (1810–48), Constantin Hansen (1804–80), Wilhelm Marstrand (1810–73) and Martinus Rørbye (1803–48). Through these artists, and their middle-class patrons, a new emphasis in art was placed on bright summer light, a plethora of figurative and architectural detail, and interiors possessing domestic intimacy.

Købke's *The Landscape Painter Frederik Sødring* (1832) has all these qualities. Parts of the sitter's face and hands reflect light like a full moon in summer, while the red case on the table and dabs of red paint on his palette twinkle like stars out of the otherwise pale Italian-inspired tonalities. Sødring (1809–62), a fellow artist of Købke's in Copenhagen, is best known for his *View of Marmorpladsen with Ruins of the Unfinished Frederik's Church* (1832), a scene from Copenhagen. He shared with Købke the atelier shown in his portrait. His smiling, playful face, gentle and thoughtful, is surrounded by an abundance of interior architectural detail which indicates Købke's keen sense of observation and skill in portraying what he saw. In his more purely architectural paintings Købke's ability to depict architectural details is equally apparent. For instance, his *View of Århus Cathedral* (1830) commemorates the medieval Danish edifice in the way artists were now accustomed to use to paint Roman ruins, with human figures added for local colour.

Particularly striking, and an inheritance from Eckersberg, is the emphasis on monumentality which can be seen in Købke's *View in Front of the North Castle Gate* (1834), a place not far from where Købke and his family lived and worked (his father had been a baker at the castle). In this work, the rigid compositional arrangement, similarly employed by Eckersberg to depict the ancient monuments of Rome, is used by Købke of a Danish monument. It is also full of incidental detail, and bathed in a warm summer light which is one of its most striking features. In *Frederiksborg Castle in the Light of*

OPPOSITE
19 **Christoffer Wilhelm Eckersberg** *The Russian Ship 'Assow'* 1828

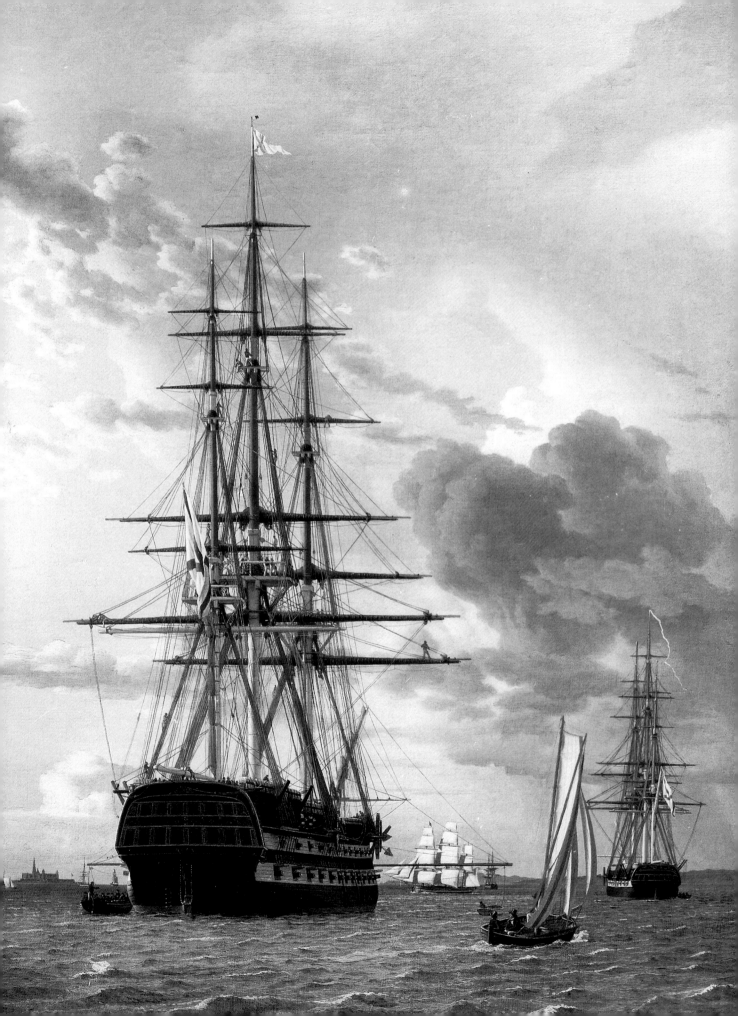

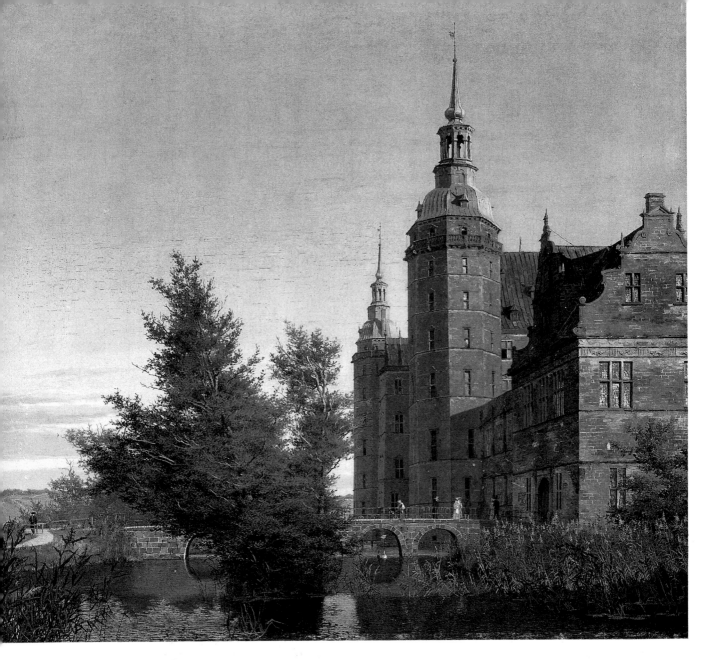

20 **Christen Købke** *Frederiksborg Castle in the Light of Evening Seen from Jaegerbakken* 1836

Evening Seen from Jaegerbakken (1836) a brilliant display of the luminous qualities of a Danish dusk is combined with the picturesque turrets and towers of the castle which together conjure up a fairy-tale mood and point the way to Nordic stylistic trends later in the century.

It is interesting that Købke did not go abroad until 1838, first to Dresden and then to Rome, but these travels exerted little influence on him, since Eckersberg had already given him what Italy had to offer artistically. He did produce, however, a series of sketches of Neapolitan and other Italian views which have a freshness and brilliant luminosity. His final years were not happy, partly because changing artistic tastes left him increasingly isolated from the rising generation of artists, such as Vilhelm Kyhn (1819–1903) and Christen Dalsgaard (1824–1907), who were less interested in the depiction of light as the principal feature in a painting.

In contrast to Købke, Constantin Hansen was in every way a direct product of Rome: he was born there in 1804, where his father, the portrait painter Hans Hansen (1769–1828), was studying. At his christening in Vienna, on the way home to Denmark, his

21 **Constantin Hansen** *A Group of Danish Artists in Rome* 1837

22 **Wilhelm Marstrand** *The Waagepetersen Family* 1836

godmother was Mozart's widow, then married to a Dane. While studying at the Kunst-akadamiet from 1816 to 1833, Hansen longed to return abroad, particularly to Rome; this was finally made possible by a stipend in 1837. It was while there, under commission from the Kunstforeningen (Artist's Society), that he painted *A Group of Danish Artists in Rome* (1837), which includes a self-portrait and portraits of Marstrand and four other Danish artists resident in Rome: Albert Küchler (1803–86), Ditlev Blunck (1798–1854), Jørgen Sonne (1801–90) and Niels Simonsen (1807–85). They are gathered in a room overlooking the city, on the Via Sistina, in the house of the architect M. G. B. Bindesbøll (1800–56), who later built the Neo-classical Thorvaldsen's Museum in Copenhagen in the early 1840s. Bindesbøll's fez and the oriental rug on which he reclines are two of the effects of Hansen's travels with his friend Rørbye in Greece and Turkey from 1834 to 1837. He had been inspired, like many others in northern Europe, by the writings and political involvement of Byron. Light streams into Bindesbøll's room, which is monumentally composed, like a temple sanctuary, but the downcast faces of the figures strike an enigmatic note. It has been suggested that a cholera epidemic in Rome at that time had provoked a general mood of depression, but this may well have nothing to do with the expressions of the sitters' faces and the mood of the picture. It has also been suggested that *A Group of Danish Artists in Rome* may be a variation of Raphael's *School of Athens*, in the Vatican. Hansen's work, by virtue of its interesting composition, realistic detail and evocative use of contrasting light and shadow, is the most memorable example of group portraiture produced by a Scandinavian artist in Rome at that time.

Marstrand and Rørbye were not as faithful followers of Eckersberg's teachings as were Købke and Hansen: the two former pursued a progressively divergent approach to painting from their old master's. Despite the fact that Marstrand was Eckersberg's favourite student and was given a stipend to visit Berlin, Dresden, Rome and Paris from 1836 to 1841, he rejected his mentor's great dependence on sketches and his preoccupation with architectural details. Instead, Marstrand's paintings are anecdotal in a way alien to Eckersberg and his other students. Marstrand's *The Waagepetersen Family* (1836) is characteristic: it is a rich, vividly coloured group portrait of the wife, children and family nurse of the Copenhagen merchant Christian Waagepetersen, happily play-ing with one another in their sitting-room, the folk dress of the nanny adding a strong note of local colour and genre interest. The sense of intimacy prized by Eckersberg is present, but taken much further. The door of a bedroom is slightly ajar and the viewer can glimpse the linen of a bed within, a private detail Eckersberg would never have allowed himself, but which here heightens the work's narrative content, the glorification of middle-class domesticity. Marstrand's paintings became the most popular paintings of the nineteenth century in Denmark and even at the turn of the twentieth century the art critic Karl Madsen could still call Marstrand 'the greatest genius in Danish painting'.[2]

The narrative element and genre interest in folk costume, however, received their fullest expression in the paintings of Martinus Rørbye. The son of a Danish official who had left Norway in 1814, on the dissolution of its union with Denmark, Rørbye had first studied law before he became a student of the landscape painter and portraitist Christian August Lorentzen (1746–1828). With this background, and private tuition from Eckers-berg, Rørbye developed an individual style of painting which devoted considerable attention to architectural features, strong light and shadow, and which depended on numerous sketches; he placed great value as well on the narrative and the anecdotal. These aspects of his works have led many art historians and critics to label him the 'Father of Reportage Painting'.

21

22

IX

Rørbye's most imposing work, *The Prison at the Town Hall and Palace of Justice* 27
(1831), depicts the newly erected, Roman-inspired building in Copenhagen (it remains today, outwardly unaltered) in the same dramatic and monumental composition that his master and colleagues would have admired, but instead of being the focus of the painting, it becomes a theatrical backdrop for the events taking place before it: begging figures plead and admonish. This subject led contemporary journalists to comment and speculate on the painting's possible allegorical message about crime and punishment. In this respect Rørbye can be described as a Danish nineteenth-century Hogarth. Unlike Hogarth, however, he drew not only on local, native scenes, but also on the lands and cultures to which his *wanderlust* carried him, for he travelled to Paris and Rome, in 1834, and also in Greece and Turkey, as mentioned before, where he painted *Greeks Fetching Water from a Well at the Tower of the Winds in Athens* (1836). Unlike previous paintings of this scene, such as that by Abildgaard, Rørbye concentrates on its incidental quality, rather as though he were presenting the viewer with a visual report.

Rørbye can be compared, in his attention to Orientalist subjects, with the Danish author Hans Christian Andersen (1805–75). Just as he re-created foreign places in his enchanting tales, so Rørbye painted scenes of oriental exoticism full of anecdote and local interest. The similarities to Andersen were not limited to this aspect: like the author, Rørbye travelled to little-known parts of Scandinavia, some more foreign to his contemporaries than even Rome. One such place was Skagen.

In 1833, Rørbye became the first painter to visit this remote fishing village on the northern-most tip of Denmark and, in 1847, he returned there to paint a work, *Fishermen Out To Rescue a Ship in Distress* (1847), which glorifies the sea and the tough life of men who depend on it. While Rørbye was the first to present Skagen through a painterly medium, Andersen did so through a literary one, and their efforts in bringing Skagen to the attention of other painters and writers was to reap enormous fruits, as will be seen in Chapter 5.

Rørbye was by no means the only artist to capture the expressive qualities of the Danish landscape at this time. Others such as Dankvart Dreyer (1816–52), Peter Christian Skovgaard (1817–75) and Jørgen Roed (1808–88) devoted their art to depicting the Danish landscape, not the wilder and more remote parts sought by Rørbye, but the more intimate, tame and familiar.

Dreyer had been taught perspective by Eckersberg, but his principal instructor at the Academy in Copenhagen was Johan Ludvig Lund (1777–1867), whose paintings glorified monuments from Denmark's past in the style of the Nazarenes. Under their influence Dreyer became a delicate colourist, using his skills to portray the countryside of his beloved Fünen, where he lived for many years, and later Jutland, which he visited extensively. By virtue of his poetic approach to painting, scenes which formerly would have been considered banal now became accepted as beautiful. His *View from Assens* 24
(1834) is of an unassuming settlement of houses nestled on the shore, opposite the coast of Schleswig, but what a symphony of light it is, with the glistening blue sea and sky counterposed to the rust-coloured roofs of the houses, and the trees and bushes which discreetly impair their view, hinting at the unfolding of events and emotions within the houses not perceptible to the viewer! As his friend the artist J. T. Lundbye (1818–48) wrote in 1844: 'It was as if he needed to express more than landscape is able to say.'[3] 23
The same could also be said of Peter Christian Skovgaard, another artist friend of Lundbye. However, rather than the coasts and open fields which Dreyer depicted, Skovgaard became the supreme painter of his native North Zealand's lush beech woods.

19TH-CENTURY DANISH LANDSCAPE PAINTING

23 **Johan Thomas Lundbye** *Autumn Landscape at Hankehøj near Vallekilde* 1847

24 **Dankvart Dreyer** *View from Assens* 1834

25 **Peter Christian Skovgaard** *Landscape near Kongens Møller* 1844

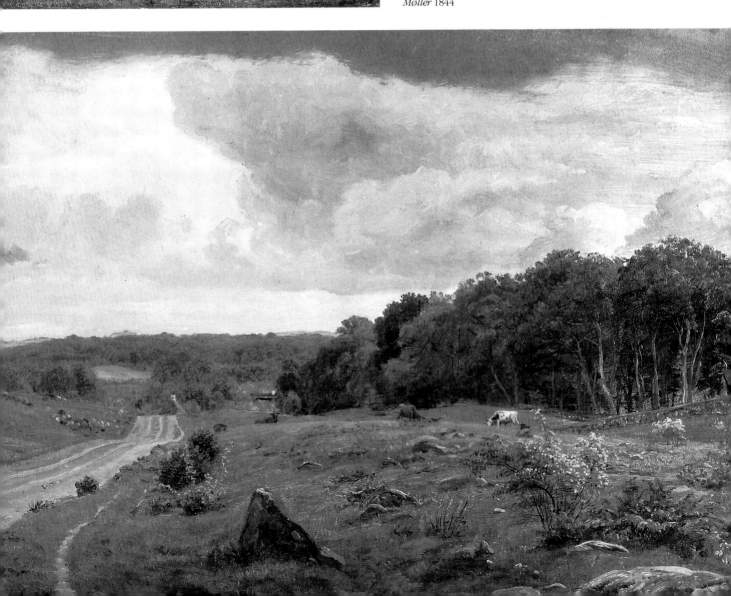

Skovgaard had been one of Lund's students and he concerned himself with the serene in nature, rather than the dramatic. For this reason his paintings are not infused with strong light and shadow, and strong perspectives are also absent. The serene characteristics are clearly shown in *Landscape near Kongens Møller* (1844). A sense of monumentality remains, which lends his predominantly summer landscapes a strong emotional quality, reminiscent of the Norwegian painter Johan Christian Dahl (1788–1857), and of Claude Lorraine, after Skovgaard's extensive travels to Italy in the 1850s.

Dreyer's and Skovgaard's colleague Jørgen Roed had a different approach: perspectives were crucial to his art, inherited from Eckersberg and based on countless sketches made during Roed's many visits to Paris, Rome and Munich. This characteristic gives his works an architectural emphasis which, while he too eschewed the depiction of strong light and shadow, none the less imparts to them a sense of monumentality. This quality can be seen in sketches made in Paestum and Naples which he visited with Constantin Hansen. It is Roed's masterpiece *A Street in Roskilde. In the Background the Cathedral* (1836) which best combines his style of landscape painting with a dominating interest in architectural motifs. The ancient Danish cathedral, in which many of Denmark's monarchs have been buried, is painted powerfully and realistically but with none of the dramatic romanticism found in much continental painting of Gothic monuments, like that of the north German artists Caspar David Friedrich (1774–1840) and Friedrich Schinkel in the first half of the nineteenth century. Unusually, too, *A Street in Roskilde* depicts a wintry scene in which the cloudy sky is sombre in contrast with the children at play in the foreground. As such this painting can be considered a forerunner of the wintry landscape scenes that so appealed to Nordic artists in the final decades of the nineteenth century.

* * *

While Danish artists achieved new artistic heights during the first half of the nineteenth century, Swedish artists found themselves immersed in a stagnant culture. Despite their close links with France, the newly imported royal family of Bernadotte, whose founder Karl Johan had been one of Napoleon's generals before his accession to the Swedish throne, failed to effect any changes in the cultural and, specifically, the artistic climate in Sweden, which had deteriorated after the assassination of Gustaf III in 1792. Landscape painting, in particular, languished in the early years of the nineteenth century.

Certain portrait artists did achieve a high level of proficiency in Sweden and their work shows close affinities to that of Danish portrait painters of the same period, such as Wilhelm Bendz (1804–32) and Christian Albrecht Jensen (1792–1870). The Swedes Johan Gustaf Sandberg (1782–1854), Olof Johan Södermark (1790–1848) and Per Krafft the Younger (1777–1863) formed a triumvirate which dominated the more progressive element in an otherwise conservative and dryly pedantic Swedish school of portraiture. They shared with Bendz and Jensen a common devotion to commissioned portrait painting of the new middle-classes which focused on realistic detail and attempted some psychological insight into their sitters.

Of these painters, Sandberg, though he never studied abroad and lived all his life in Stockholm, achieved the greatest success in both history painting and portraiture. He had begun his studies at the Konstakadamien in Stockholm at the early age of twelve, ultimately winning the gold medal in 1809 for a history painting on the subject of Karl XII in Stralsund, a north German city on the Baltic still under Swedish sovereignty at the beginning of the nineteenth century. While at the Konstakadamien, Sandberg also

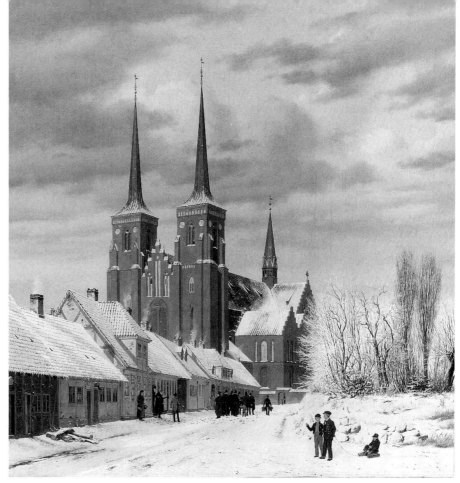

26 **Jørgen Roed** *A Street in Roskilde.
In the Background the Cathedral* 1836

27 **Martinus Rørbye** *The Prison at
the Town Hall and Palace of Justice*
1831

worked on decorations at the Royal Theatre in Stockholm, under the painter J. G. Brusell, which possibly added to the theatrical quality of some of his painting.

Then in 1814, Sandberg joined two of his friends, the sculptor Bengt Erland Fogelberg (1786–1854) and the painter Johan von Breda, son of the professor Carl Fredric von Breda, to found an artistic society, Sällskapet for konststudium (The Society for the Study of Art), which they hoped would be an alternative to what they considered was the staid and dryly academic Konstakadamien. Here students were able to draw from the nude, an option forbidden by the Konstakadamien. Sandberg commemorated the establishment of this society in his accomplished pastel work *Sandberg, Fogelberg and Johan von Breda* (1815), of himself and the two other founders. It is an intense and dramatic work in the spirit of Jacques-Louis David, which vividly portrays the emotional dynamism of these zealous artistic reformers united, like Greek warriors, to vanquish the tyrants of the moribund artistic world in which they were compelled to live.

Sandberg, Fogelberg and Johan von Breda were like modern Nordic heroes, successors to the imported classical ones of the preceding decades. This is an indication of the interest in native traditions of the heroic which began at this time in Scandinavia.

28 Johan Gustaf Sandberg
Midsummer Dance at Säfstaholm
1825

29 **Johan Gustaf Sandberg**
Portrait of Erik Gustaf Geijer 1828

In 1814, the Swedish Professor Per Henrik Ling had advocated the use of Nordic myths in the visual arts. In this he was responding to the call of the German thinkers Johann Gottfried Herder (1744–1803) and Johann Gottlieb Fichte (1762–1814). Herder's *Ideas on the History of Humanity* (1784–91) and Fichte's *Addresses to the German Nation* (1807–08) advocated a turning from foreign classical myths and cultural values towards native Germanic ones as a new source of spiritual rejuvenation and artistic inspiration. These views had been much taken to heart by Goethe and led to a reappraisal of Nordic myths and cultural values. Sandberg was fascinated by Nordic mythology and, taking the name of Widar, was elected into the Gothic Society in 1822, where lectures on this subject and exhibitions of art were held.

It is the deep emotionalism which is expressed in the faces of the characters Sandberg portrays that is the chief characteristic of his paintings, a quality which caused his contemporary the art critic Lorenzo Hammarskiold to write: 'Sandberg dips the brush in his own heart, which is why his paintings penetrate into the heart of everyone.'[4] Certainly, *The Walkyries* (1817), a work inspired by Nordic mythology, was greatly acclaimed, and the important early nineteenth-century patron of the arts, Count Gustaf Trolle Bonde, acquired it for his collection at Säfstaholm in 1820. This was but the first of many Sandberg paintings purchased by Trolle Bonde, which included one of Sandberg's most famous works on a folklore subject, *Midsummer Dance at Säfstaholm* (1825). This 28 painting endeavours to achieve a considerable degree of ethnological accuracy, unlike the works of Martin and Hilleström, with great attention paid to local costumes and their accoutrements.

After the elder Breda's death in 1818, Sandberg increasingly assumed his position as the leading Swedish portrait painter. Rather cynical about this role, he declared in a letter to Fogelberg: 'I divide my time between portraits and historical works, the former for the body, the latter for the soul. . . .'[5] The tradition of ranking history painting higher than portraits or landscapes was very old and generally accepted throughout the western art world at this time. Nevertheless, whatever the merits of Sandberg's history paintings (see Chapter 4), it is his portraits which today are more generally valued.

Certainly, his *Portrait of Erik Gustaf Geijer* (1828), at Gripsholm Castle, to the west of 29 Stockholm, is one of the finest of the period. Here Geijer (1783–1847), the eminent Swedish poet and musical composer from Värmland, is portrayed as a deeply spiritual

person, painted in muted tones of blues and browns. Geijer, indeed, became a keen proponent of the use of Nordic mythology as a subject for the visual arts, after an initial period of grave doubt, and, along with the poet Esias Tegnér (1782–1846), also from Värmland, was one of the leading literary figures in the Gothic Society. Both had been deeply impressed by the writings of the Danish poet and professor of aesthetics Adam Oehlenschläger (1779–1850), whose *Poems* (1803) and *Poetical Writings* (1805) glorified the Gothic and Nordic. The English novels of Sir Walter Scott and MacPherson's *Ossian* further confirmed them in their turn towards an appreciation of Nordic mythology. Neither, however, desired a complete rejection of the classical. Rather, it was a sort of Hegelian synthesis which they felt was required. Tegnér wrote, 'He who has read his Horace and his Eddas, shall immediately and joyously hear the tones of his homeland both from Rome and Iceland.'[6] These words resonated not only in Sweden but throughout Scandinavia as the century passed.

A cooler and more serene style of painting, which faithfully adhered to the Neo-classical tradition, is represented by the work of Per Krafft the Younger. Son of the portrait painter Per Krafft the Elder and brother of Wilhelmina Krafft (1778–1828), a miniature painter, Krafft the Younger had been a student at the Konstakadamien from 1783 to 1796, where, in particular, he was most impressed by the works of Carl Fredric von Breda. When he went to Paris in 1796, it was to Jacques-Louis David that he turned for instruction. The battle paintings of Gérard and Gros also influenced him, as can be seen in his painting *Duke Karl at the Battle of Högland in 1788* (*c.* 1810), perhaps the finest example of a Neo-classical battle painting in Sweden. He developed a style strongly based on a meticulous study of classical sculpture, as well as of the masters of the Italian Renaissance, and these influences can be seen in his portrait paintings. *The Misses Laurent* (1815), painted ten years after his return to Sweden, is even more self-consciously Neo-classical. The two sisters are portrayed in a sculptural manner, their intense expression focused on their father's bust, which commands their attention as though they were swearing an oath, giving a spiritual dimension to this triple portrait. Here, as in Sandberg's group portrait of the same year, the background is austerely depicted in sombre tones, a quality which serves to heighten the emotional drama we are witnessing.

In 1818 Krafft was made professor at the Konstakadamien and continued to paint in the spirit of David until the last years of his life, at his best infusing his portraits with a strong sense of each sitter's character, thereby integrating characteristics of both Neo-classical and Romantic styles.

An equally happy fusion of classical form and romantic intensity of expression is to be found in the work of Olof Johan Södermark, who gave up his commission as a lieutenant colonel in the Swedish army in 1834 to devote himself to painting. In 1808, the first year he exhibited at the Konstakadamien in Stockholm, he had been employed by the military in preparing topographical maps; the next year he was employed in Scania in the extreme south of the country in drawing and engraving maps of Sweden. These experiences had quickened his artistic inclinations and, in 1824, on the pretext of convalescence from war injuries received in Norway, he was granted leave to travel to Paris where he stayed until the following year. Thereafter, he moved to Rome, staying with Johan Niklas Byström (1783–1848), the Swedish sculptor. In Rome he studied independently, as he had done in Paris, until 1828, when he returned to Sweden. There, his membership of the Gothic Society brought him acquaintance with many of the leading intellectual and artistic people of the time, and assisted him to form contacts with prominent members of Swedish society who later commissioned portraits from him.

30

30 **Per Krafft the Younger** *The Misses Laurent* 1815

Though Södermark spent some time in Munich, from 1832 to 1834, where he concentrated on studying fresco techniques and history painting, portraiture remained his focus throughout his life. His *Portrait of Jöns Jacob Berzelius* (1843) is one of his most successful paintings. The classical references are less overt but the austere background and monumental composition strengthen the work's visual focus on the realistically portrayed face and hands of the famous Swedish man of science. The mechanical instruments point to the sitter's identity.

In Denmark, Wilhelm Bendz, one of Eckersberg's private pupils, and his close friend Christian Albrecht Jensen exclusively painted portraits, the latter producing over four hundred works, in which he synthesised classical form with romantic expression. On an art-political level, his paintings rebelled against what Bendz and Jensen considered to be

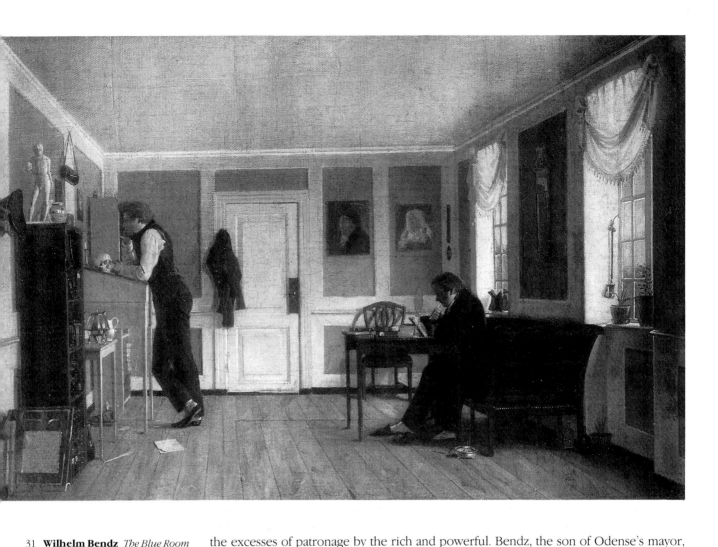

31 **Wilhelm Bendz** *The Blue Room or Interior in the Amaliegade* 1825

31

the excesses of patronage by the rich and powerful. Bendz, the son of Odense's mayor, particularly resented philistine influence. After an outburst of rage against the patronage of the Danish crown prince (who was, however, devoted to the arts), he went abroad in 1831, first to Dresden and Munich and then to Italy, where he died of a fever in Vicenza the following year. His sensitive works have a spiritual dimension that was of great importance for later Nordic art. *The Blue Room or Interior in the Amaliegade* (1825) is a portrait of his brother with a friend, but it is a portrait of a different order from the others which have been considered. It is as though the viewer is intruding on a private scene, in which the artist's brother seems to be pondering about existence. The architectural frame of the room acts as a gateway to the souls of the individuals within, a fragile but dignified world of order in an otherwise chaotic universe. By contrast, in Jensen's *Portrait of the Artist's Wife Catherine Jensen, née Lorenzen, with a Turban* (1842), a much more directly approachable image is presented, as though the viewer has been welcomed into the presence of a distinguished person eager to make them feel at ease. These divergent artistic approaches became the pillars on which later nineteenth-century portraiture was based.

*　*　*

Classical form and theories were clearly of major importance to painting in the first half of the nineteenth century in Scandinavia, but they were even more central to Nordic sculpture. The Danish sculptor Bertel Thorvaldsen (*c.* 1768–1844) was the Neo-classical style's leading exponent, not only in his native Denmark, or in Scandinavia as a whole, but also in France and Italy. He achieved an extraordinary renown in his own time, never matched by any other Nordic sculptor or artist. Indeed, he became the first Protestant sculptor, commissioned by Cardinal Consalvi, to build a monument in St Peter's Cathedral in Rome: the Neo-classical tomb of Pope Pius VII (1824–31), in which the female figures flanking the pope symbolize wisdom and fortitude.

32　**Christoffer Wilhelm Eckersberg** *Bertel Thorvaldsen* 1814

Thorvaldsen, the son of an Icelandic immigrant to Denmark, had begun his artistic career assisting his father with the carving of wooden galleon figures for sailing ships. In 1781 he went to the Kunstakadamiet in Copenhagen, where Abildgaard instilled in him a profound appreciation of classical sculpture. Through Abildgaard, Thorvaldsen won the gold medal from the Academy for his relief *The Apostles Peter and John Healing the Lame Man* (1793). He assisted his mentor on interior decorations for Crown Prince Frederik's residence, Levetzaus Palace, at Amalienborg in 1794. The next year, Thorvaldsen produced a bust of Count A. P. Bernstorff, the prime minister and patron of the arts, not as a commission but as an offering to enlist Bernstorff's assistance, which he indeed gave. Abildgaard also helped Thorvaldsen to win the Rome stipend which enabled him to go there in 1797. Thorvaldsen lived in Rome until his return to Denmark in 1838, gaining profound inspiration from classical sculpture and the Roman ruins. Furthermore, he developed an archaeological attitude towards classical sculpture, based on the Danish archaeologist Georg Zoega's views, which involved careful analysis of finds and strict attention to detail.

Under the patronage of the British architect and collector Thomas Hope, Thorvaldsen produced the sculpture *Jason* (1802–28), based on the *Apollo Belvedere* in the Vatican, which won him international fame. (In 1801, he had made a clay model of Jason but as he could not afford to have it cast in plaster it was destroyed. The sculpture for Hope was from a new clay model.) As a result of Hope's patronage, Thorvaldsen's renown grew, assisted also by his Danish friend Friederike Brün, the sister of Bishop Mynster, a theologian who incurred the ire of his fellow Danes Nikolai Frederik Severin Grundtvig, the theologian, poet and educationalist, and Søren Kierkegaard, the philosopher, because of his orthodox religious views and conservatism. Further support for Thorvaldsen was provided by Baroness Jacoba Elisabeth Schubart, of whom Thorvaldsen modelled an intimate and sensitive bust in 1804, at her house in Montenero, near Livorno, in Italy.

Commissions from various parts of Europe followed: the Duke of Bedford ordered a frieze on the subject of Achilles and Patroclus; most importantly, the French authorities in Rome commissioned Thorvaldsen to create a frieze at the Quirinal Palace intended to honour the emperor, Napoleon. It was to adorn the ballroom of the former papal residence and was to be on the theme of Alexander the Great's entry into Babylon in which the Macedonian king was supposed to have been received by the inhabitants as a saviour. This considerable achievement of Thorvaldsen, *The Alexander Frieze* (1812), was made in plaster and set into place at breakneck speed, but Napoleon never arrived in Rome. Instead, he ordered the frieze to be produced in marble for the Church of the Madeleine in Paris, but this too was prevented by his fall from power and, ultimately, the plaster frieze was purchased by the Italian Count Sommariva for his villa on Lake Como. A replica in marble (1829–31) was also made for Charlottenborg palace in Copenhagen, the state residence of the Danish royal family.

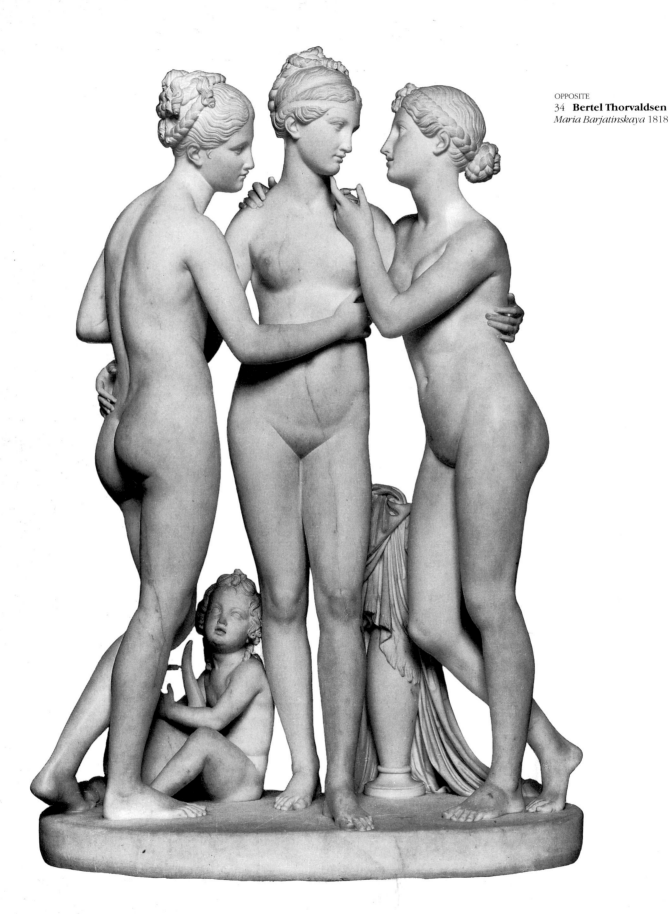

33 Bertel Thorvaldsen *The Three Graces* 1817–19

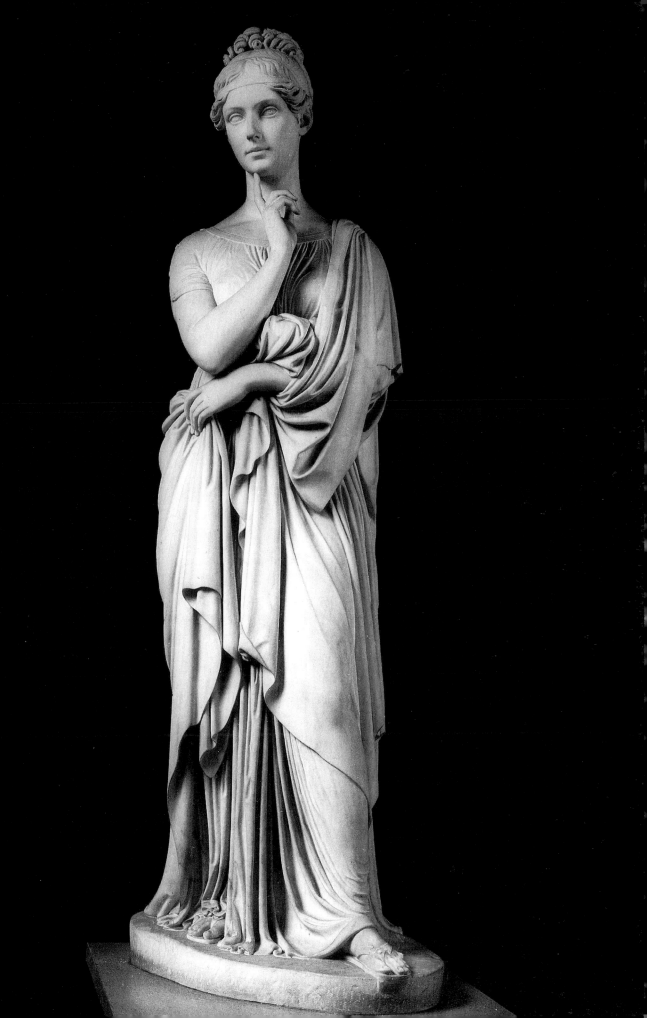

More important for Thorvaldsen's livelihood, however, were commissioned portrait busts. Among these were *Lord Byron* (1831) and *Friedrich Schiller* (1837 in marble, 1839 in bronze). Thorvaldsen's busts, static and serene, combine the Platonic and Neo-classical notions of the 'real' and the 'ideal', which in his finest works give a Platonically spiritual dimension to his subjects, thereby ennobling them.

In contrast to the works of the Italian Neo-classical sculptor Antonio Canova (1757–1822), his rival, those of Thorvaldsen have an Apollonian quality which sets them apart from the sensuality of the former's sculpture. Moreover, movement and the erotically provocative have no role in the Protestant sculptor's œuvre. Even such a subject as his famous *The Three Graces* (1817–19) is coldly elegant rather than enticingly erotic; the texture of the marble is very smooth and highly polished, giving a satin-like sheen. His *Maria Barjatinskaya* (1818) possesses a still colder beauty. He has portrayed the Russian princess, visiting Rome at the time, in an Augustan pose and antique garb, full of stern dignity beyond her twenty-five years. This sculpture looks back to the Hellenistic work *Pudicitia*, in the Vatican; the princess, however, has a restrained and muted quality which is unique to Thorvaldsen.

Two of his assistants in Rome, Herman Ernst Freund (1786–1840) and Herman Vilhelm Bissen (1798–1868) continued his Neo-classicism in sculpture. However, whereas the latter produced works on strictly classical themes, the former used his keen interest in Nordic mythology, an interest which increased during the 1820s, creating sculptures based on themes from it. Freund and Bissen were both commissioned to produce sculptural works for Charlottenborg Palace (Freund in 1825, Bissen in 1835) after long and intense training at home and abroad. Freund, from the German village of Uthlede near Bremen, went to Copenhagen (then an important cultural centre for north Germany as well as for Scandinavia) in 1803 to become an apprentice iron-smith. He then entered the Kunstakadamiet, where his training as a smith was a useful background to sculpture.[7] By the time he left the Academy in 1817, he had won the gold medal for his relief *Abraham Casting Out Hagar and Ismael* (1817). This enabled him to tour Germany and Austria on his way to Rome to work under Thorvaldsen. In Germany, the sculptures of Johann Gottfried Schadow (1764–1850), the leading German Neo-classical sculptor and theorist, exerted a considerable influence on him.

From 1818 until 1828 Freund lived in Rome, in close contact with Thorvaldsen and cementing both his friendship with Bissen and his rapport with his benefactor Prince Christian Frederik. He also absorbed the taste for Pompeian decoration which was fashionable at the time. In Christen Købke's *Portrait of Freund* (1838), he is shown in his room, decorated in the Pompeian style, with his statue of Odin, the Norse god. *Odin* (1822) and *Loke* (also 1822) are Freund's most famous and successful works that show the synthesis of classical and Nordic elements, which Freund had achieved by using classical forms to portray Nordic deities.

In part, Freund's preoccupation with Nordic subjects was inspired by the writings of Adam Gottlob Oehlenschläger, one of Denmark's leading early nineteenth-century poets, and the Norse epic *Eddas*; in part by a desire to master a style in which he had few rivals. Thorvaldsen's successful bid against Freund to acquire the commission for the sculptures of the Cathedral of Our Lady in Copenhagen had left Freund devastated when Thorvaldsen returned home to start the work in 1820.

Freund's increasing preoccupation with Nordic subjects rendered in classical form was warmly received by the public, despite losing the commission for the Cathedral. His masterpiece at Charlottenborg Palace, *The Ragnarok Frieze* (begun in 1825, but largely destroyed during the disastrous palace fire of 1884), was based on an ancient Nordic

fable. It integrated successfully the classical and Nordic elements more than any other Scandinavian sculpture of the period. Still incomplete at the time of Freund's death in 1849, it was completed by his close friend Bissen.

Bissen, from Schleswig, had entered the Kunstakadamiet in 1816, remaining there for only two years before returning dissatisfied to his home province. However, an unexpected meeting with Prince Christian Frederik, who was travelling through on his way to Italy, in conjunction with Thorvaldsen's visit to Copenhagen in 1819, strengthened his resolution at the moment when he had begun to doubt his vocation. On the advice of Johan Ludvig Lund, he changed from painting to sculpture, quickly earning a commission to carry out reliefs at the Royal Chapel in Copenhagen. In 1824 he arrived in Rome and further travels in Italy took him to the Greek and Roman ruins of the south, including Sicily, as well as to the Renaissance treasures of Florence. While in Italy he adhered to classical themes, in Thorvaldsen's tradition. One such sculpture, *Flower Girl* (1828–29), was commissioned by the future king Frederik VII. This work succeeds in being a warmer and more spirited classical interpretation than any of Thorvaldsen's sculptures by virtue of its freer and less academic handling.

Bissen returned to Copenhagen in 1834 to start decorative work at Charlottenborg Palace. There he produced *Ceres and Bacchus Bearing the Fruits of Civilization to Mankind* (1835–41, destroyed in 1884 in the palace fire), one of his most esteemed works in the Neo-classical vein. After the war between Denmark and Germany over control of the border region of the Duchy of Schleswig-Holstein (1848–50), Bissen produced sculptures on themes from Denmark's ancient and more recent history. In particular, his bust *Bishop Mynster* (1835–36) became very popular and was reproduced in plaster copies, not least because the sculptor was successful in capturing the character of this outspoken, conservative churchman. In contrast with Bissen's Romantic sculpture, Freund's work of the same subject *The Funerary Monument to Bishop Mynster* (1834), is one of his more purely classical. Its sharp adherence to a realistic portrayal of the deceased man's physiognomy emphasises, though, the stylistic similarities in the work of Bissen and Freund, who endeavoured to depict reality as accurately as possible.

In certain respects, Jens Adolf Jerichau (1816–83), a student of Freund, was of greater importance to the development of Danish sculpture than either his teacher or Bissen. Though he too continued the Neo-classical tradition of Thorvaldsen, visiting Rome in 1838, where he worked as assistant in the latter's atelier, he brought to his work a new and important addition to classical forms and themes: naturalism. His work *Panther Hunter* (1845–46), full of dynamic movement, successfully marries Neo-classical precepts with a new perception of the forces of nature. It was, exclaimed the art critic and historian Niels Lauritz Høyen (1798–1870), 'nature turned to stone', said in sharp criticism at the time, but which has now turned out to be praise.[8]

In Sweden Johan Niklas Byström (1783–1848) and Bengt Erland Fogelberg (1786–1854) also pursued a Neo-classical tradition of sculpture, but their work tends to be more academic than that of their Danish counterparts. Byström was keen on modelling after nature, but strove to idealize his perceptions, as classical principles dictated and his renowned tutor at the Konstakadamien, Johan Tobias Sergel, desired. In 1803 he had gone to Stockholm from the provincial town of Filipstad in the hope of entering the sculptor's atelier, but Sergel rejected him then. Instead, Byström studied under the Swedish artist Elias Martin and spent six years at the Konstakadamien until 1809, by which time Sergel had reconsidered the aspiring artist and accepted him as his student. In 1810 he won a stipend and went to Rome to study the antiquities. He produced sculptures on classical themes, faintly tinged with sensuality, as, for instance, in *Innocence* (1823).

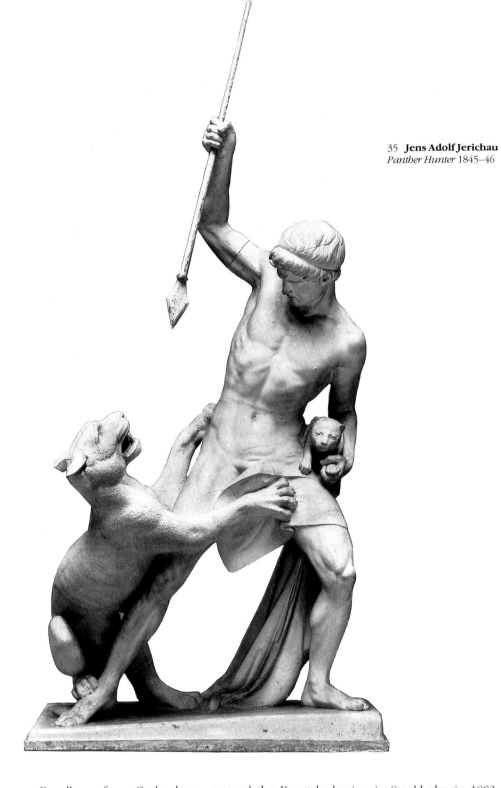

Fogelberg, from Gothenburg, entered the Konstakadamien in Stockholm in 1803. While there he earned the admiration of Sergel and entered artistic circles centred round the Gothic Society. In 1819, Fogelberg went to France and then Italy, where he arrived in 1821 in the company of a Swedish architect P. A. Nyström. Once in Rome, he studied the antiquities, frequenting Byström's Villa Malta, near the Spanish Steps, where Nordic artists often met. Instead of adhering strictly to classical themes, like Byström, Fogelberg used his formal classical language to create works on Nordic mythology, which were sometimes, as in the case of *Odin* (1828–31), commissioned by King Karl Johan, who was

attracted by the glory which the Nordic god embodied. Byström and Fogelberg are, thus, the Swedish equivalents of the Danish sculptors Bissen and Freund: Byström entirely steeped in the Neo-classical tradition, Fogelberg using classical forms but Nordic subjects. For example, Byström's *Sleeping Bacchante* (1811) and Fogelberg's *Tor*, *Balder* and *Frej* (1839–44) are all directly derived from classical prototypes, but in the latter's three sculptures it is the three gods' dress and, of course, the subjects which give them a Nordic identity. Such timid and half-hearted use of Nordic imagery did not satisfy the emerging national consciousness of an increasing number of artists who wished to bring to their work their native subject-matter. This desire later provoked a more thorough revolution against the classical tradition towards a much more fundamentally Nordic idiom.

<p style="text-align:center">* * *</p>

Sculpture in Norway and Finland, too, in the first half of the nineteenth century was inspired by Neo-classicism, and although of fairly restricted scope, it was the beginning of its development later in the century. In both countries limited financial resources made it virtually impossible for any sculptor to be trained or to expect to receive any major commissions. In Norway, one artist alone, Hans Michelsen (1789–1859), courageously asserted himself as a sculptor and received considerable success not only at home but also in Sweden. Michelsen was born at Hegstad, near Trondhjem in central Norway. At home, in the province of Trøndelag, he doubtless came into contact with the folk woodcarvings, a Norwegian craft which had attained extremely high levels of workmanship even in Viking times, and which had persisted into the nineteenth century. His fascination with sculpture and his resolution to pursue it were probably inspired by these carvings. As he was unable to receive any training in Norway, Michelsen went to Stockholm in 1815 to attend the Konstakademien. There he became a pupil of one of Sergel's favourite students, Eric Gustaf Göthe (1779–1838) who worked in the prevailing Neo-classical style, which naturally was passed on to him.

Michelsen pursued further studies at the Copenhagen Kunstakadamiet under Bissen and also lived in Paris and Rome from 1804 to 1810, when he returned to Norway. In 1819 he produced one of his most successful works, a bust in bronzed plaster, of the aristocrat Herman Wedel-Jarlsberg. Then, in 1820 he made a second journey to Rome to join Thorvaldsen as his student, remaining there for six years, on a state stipend from Norway. The *Herman Wedel-Jarlsberg* had won him considerable acclaim which resulted, while he was in Italy, in commissions of marble reliefs (1822) for Crown Prince Oscar of Sweden and Norway, on themes from the life of Christ.

Under Thorvaldsen's influence, Michelsen's works in Italy assumed an even more strictly classical form than his earlier ones. *Woman's Bust with a Classical Hair-Style* is a good example of his allegiance to Roman antiquities and the precepts of Neo-classicism. This style continued to meet with admiration in important circles, especially that of the royal court, one of the few possible sources for major commissions in Norway in the 1820s. Michelsen returned to Christiania in 1826, expecting to carry out work at the newly built royal palace for King Karl Johan. However, work on this residence of the Swedish monarch for his visits to Norway was curtailed by lack of funds and Michelsen found himself without employment.

In 1828 he returned disenchanted to Stockholm, assisting Byström for a short time before becoming financially independent and acquiring his own atelier. Patronage from the royal family revived him and he was commissioned to produce several busts, including those of Karl Johan himself and his heir, later Karl XIII.

When Michelsen returned to Trondhjem in the summer of 1833 he hoped to produce the sculptures for Nidaros Cathedral there. Through the good offices of the king, who provided the money to carry out the work, he made twelve plaster sculptures of the Apostles (1834–39), which his royal patron so admired that he ordered others to be made for the church in Skeppholmen and the Catholic Church of St Eugenia, both in Stockholm (the practice of Roman Catholicism was no longer a treasonable crime and so Catholic churches could be re-established), and at the chapel at Skokloster, a large house near Uppsala, all in the Neo-classical style. By 1839 Michelsen was Court Sculptor.

One of Michelsen's most appealing works is a bust of Professor Ling (c. 1840), which combines the Neo-classical style with sensitive attention to the individuality of the sitter. In 1842 Michelsen executed a monument in zinc, one of its very early uses in Nordic sculpture, to the now deceased Herman Wedel-Jarlsberg, commissioned by King Karl Johan. By this time, however, Michelsen was ill and he returned to Norway. He produced there, despite illness, a series of delightful plaster angels for the chapel at the royal palace in Christiania.

The Neo-classical style had persisted longer in Norway than in Sweden or Denmark, but by 1846 Michelsen too had become preoccupied with Nordic themes. In 1846 he produced statues of the god Odin and the ancient king Harald Harfagre, followed, in 1849, by a sculpture of King Olav Trygvason, which was made for the neo-Gothic royal residence, Oscarshall, just completed, near Christiania.

In Finland, there is one sculptor who stands out in the first half of the nineteenth century: Eric Cainberg (1771–1816). A Finn by birth, he was obliged to study in Stockholm, where he entered the Konstakadamien as a student of Sergel. A stipend which he received in 1802 enabled him to spend the next six years in Rome, where he became immersed in antiquities and the Neo-classical style. In 1809 he returned to Stockholm. After the peace concluded in Finland that year, at the end of the Swedish-Russian War which transferred sovereignty of Finland from Sweden to Russia, conditions became more stable in Finland and Cainberg went to Turku (Åbo in Swedish) in 1813, as a sculptor of portrait medallions.

Cainberg's training in Stockholm and Rome placed him in a unique position in Finland and in 1814 he received a commission to produce six reliefs in the Neo-classical style for the ceremonial hall of the Gamla Akademihuset (Old Academy) in Turku. He was thus the first Finn to produce a monumental Neo-classical work which was also a sculpture on a subject of national importance, *Väinämöinen Playing the Kantele* (1814), in which the mythological Finnish bard, who combines the characteristics of Mercury and Orpheus, plays his Finnish stringed instrument. Originally, this relief was to deal with Gustaf III, the Swedish king who had led Sweden and Finland in the war against Russia in the 1780s, but the Russian authorities not surprisingly preferred a less controversial subject, and so this one from the Finnish epic *Kalevala* was chosen. Such subjects reflected the contemporary interest of artists and writers in themes from Finnish folklore. In 1815, the Selmaförbundet (Selma Association), later called the Aurasällskapet (Aura Society), was founded in Turku by artists and writers to foster a national consciousness. Other reliefs in Cainberg's series included *Gustaf Vasa Receiving Agricola's Bible Translation*, a theme from the Reformation of the sixteenth century, and *Alexander I's Visit to Åbo Academy*, treating the subject of the arrival in Turku of the country's first Russian ruler, Tsar Alexander I (ultimately loved by the Finnish people for the degree of autonomy he gave Finland). Cainberg, however, died in the middle of his work and the series remained unfinished. It was not until the latter part of the century that a successor emerged to fill the gap in Finnish sculpture left by Cainberg's death.

Though Norway had been under Danish sovereignty since 1483, and though Finland had been ruled by Sweden since the early Middle Ages, both Norway and Finland have always been regarded as having separate identities from those of their rulers but as tied by traditions, family connections, trade and culture. The Swedish-Russian War of 1808 to 1809 and the Napoleonic Wars of 1805 to 1815 violently overturned these ties: Finland was ceded to Russia and Norway to Sweden. Furthermore, the wars left both Finland and Norway in great poverty and with national pride sorely wounded, as a result of which a century of considerable discontent ensued.

These circumstances were disastrous for the few artists of Norway and Finland, where no art academies existed to educate or sustain them. They now found themselves more isolated than before from their former cultural centres, Copenhagen and Stockholm, despite improvements in transport and communications. This predicament was aggravated because politically, economically and culturally Norwegians as a whole, and artists in particular, were now encouraged to orientate themselves to Stockholm, while Finns, even the upper classes of predominantly Swedish background, were the subjects of a mild but concerted attempt to oblige them to regard St Petersburg, just over the Gulf of Finland, as their new focus. The hopes of the new masters of Norway and Finland for a political and cultural re-orientation were disappointed: the unions were ultimately a failure. Norway declared independence from Sweden in 1905, and in 1918 the Finns fought a bitter war against the Russians. Surprisingly, it was this very strife and its concomitant upheavals that provided the leaven necessary to elevate the art of Norway and Finland above its previously modest level. By awakening a national consciousness, artists embarked on an exploration of spiritual values, which became of momentous importance for Nordic art as a whole.

The new developments in Norwegian art may be said to have had three precursors who paved the way for the more important and internationally acclaimed artists who followed, by making Scandinavians, as well as many continental Europeans, aware of the natural and cultural riches which the Nordic countries possessed. Though some were younger than their more acclaimed colleagues, they belong artistically to an older generation whose works have an endearing, naïve and provincial quality. These artists were Jacob Munch (1776–1839), Johannes Flintoe (1787–1870) and Matthias Stoltenberg (1799–1871), and they found their patrons among the prosperous merchants and farmers of Norway.

Munch had begun his professional life as an officer in the army where he had achieved the rank of captain. He began to teach drawing, for which he had earlier shown a facility, at the military academy in Christiania in 1801. Within the next few years, his artistic aspirations were developed and he succeeded in gaining admission to the Kunstakadamiet in Copenhagen, where he studied from 1804 to 1806, the only higher educational institution for a young artist from Norway at this time. It was not until 1812 that it became possible for a local artist to achieve a high standard of training in Norway, when the Tegne-Institut (Drawing Institute), re-named from 1822 the Kongelige Tegne- og Kunstskole (The Royal Drawing and Art School), opened its doors.

Further studies took Munch to Paris in 1807 for two years, and finally to Italy. There he befriended Herman Schubart, a rich merchant living at Montenero, whose wife's marble portrait by Thorvaldsen had been so successful. It was Thorvaldsen who was in fact painted in what is one of Munch's most accomplished portraits, *The Sculptor Thorvaldsen* (*c.* 1811), in which the Neo-classical master is depicted in a stately pose. The work thus seems closer to the eighteenth than the nineteenth century in style. *The Sculptor Thorvaldsen* proved to be the beginning of Munch's successful career in portrait

The Awakening of National Art
1830-1870

36 **Matthias Stoltenberg** *Portrait of Margrethe Bredahl Plahte* 1831

painting, and by 1815 he had even acquired the patronage of the new Swedish king, Karl Johan, who had seen Munch's work while on a visit to Norway in 1815.

In contrast with the portraits of Munch, those of Stoltenberg possess keen psychological insights. The son of a wealthy merchant from the town of Tønsberg, on the Oslo Fjord, Stoltenberg suffered from partial deafness which prevented him from joining the civil service. Instead, he went to Copenhagen in 1811 where, after a woodcarver's apprenticeship, he became a private pupil of the landscape painter Professor Christian August Lorentzen until about 1823. This formed the basis of an artistic career which took him to the north of Norway and earned him considerable popularity. Among his portraits

36 perhaps the most charming is *Portrait of Margrethe Bredahl Plahte* (1831), whose family, the Mønichens, became Stoltenberg's greatest patrons. In this work it is as though the attire and social position of the sitter are a burden to her; her eyes peer out at us in a mournful and weary manner, somewhat reminiscent of a portrait by Goya. For all the charm of such portraits and their new attention to realistic portrayal and psychological insight, however, it was landscape painting which was to prove important in the development of Norwegian nineteenth-century art.

Johannes Flintoe was a landscape artist who had combined a career as a theatre decorator with studies at the Kunstakadamiet in Copenhagen. His work was of even greater importance to Norwegian art than Munch's or Stoltenberg's, for it was he who first brought the beauties of Norway's wild landscape to the attention of many native artists. As the Norwegian art historian Magne Malmanger has put it, 'With Flintoe it had to do with a more conscious discovery. The views can be seen as a link in the overall task of discovering Norway.'[9] Certainly, his excellent gouaches of the Norwegian landscape are

37 evidence of his deliberate search for native subject-matter and form of expression. He travelled extensively in Norway, from 1819 to 1825 in particular, highlighting in his work the natural beauties of the Telemark and Gudbransdal regions. The paintings from this

37 **Johannes Flintoe** *Duel at Skiringsal* mid-1830s

period contrast sharply with his later style, an example of which is to be found in his neo-Rococo murals, abounding in aviary motives, produced for the Bird Room (1840–43) in the new royal palace in Christiana.

The two leading proponents of the artistic resurrection of the wild beauty of the Nordic countries, however, were two artists generally considered to be German, Johan Christian Dahl (1788–1857) and Caspar David Friedrich (1774–1840). The former came from the old Hanseatic town of Bergen, which was indeed strongly influence by German culture and enriched by German trade; the latter from the harbour town of Greifswald in Pomerania. It had been under Swedish hegemony since 1631, though a German-speaking province, and from 1815 came under Prussian rule. Both artists thus grew up in a world which was a mixture of Nordic and Germanic elements.

Dahl had been taught by the German artist Johan Georg Müller, and early in life developed a keen interest in landscape painting, reinforced by his great fascination with the natural sciences, in particular with botany. He soon adopted whole-heartedly the current fashion for studies after nature. Friedrich had taken painting lessons from an architect and drawing master at the local university, Johann Gottfried Quistorp, and he also learnt the art of woodcuts from his brother Christian, a carpenter.

Both Dahl and Friedrich studied the Old Masters. In Dahl's case it was primarily the seventeenth-century Dutch landscapists Jacob van Ruysdael and Allart van Everdingen who pointed the way with regard to subject-matter, while Nicolaes Berchem and Claude Lorraine were his models for composition. Dahl wrote: 'I chose Berchem's great masses for cliffs. Lorraine taught me disposition and harmony in the foreground and a gradually disappearing background.'[10] Dahl made numerous copies of these Old Masters' works, and also of paintings by Jan Both for whom he had considerable admiration. It was his training at the Copenhagen Kunstakadamiet, which he entered in 1811 under Lorentzen, that opened his eyes to Danish masters and their ability to depict the Danish landscape.

61

38 Caspar David Friedrich
The Arctic Sea c. 1823–24

Friedrich's experience was comparable. He spent four years at the Kunstakadamiet from 1794 to 1798, moving to Dresden in 1799. Dresden proved more satisfying to Friedrich than Copenhagen, and he was particularly drawn to the landscape tradition of German artists such as J. C. Klingel and Adrian Zingg. In 1799 he produced illustrations for Schiller's great work *The Robbers*.

While in Copenhagen Dahl was particularly impressed by the art of Jens Juel and especially by his tonal harmonies. Of even greater importance to him were the artists who were a generation younger than Juel, such as Eckersberg, whose pale and luminous colours he admired, and Christian Albrecht Jensen, who became a close friend. Dahl produced many works portraying the countryside of Zealand, as well as of the island of Møn and of Scania in the south of Sweden. His main inspiration, however, came from the towering peaks of his native western Norway and its deep, majestic fjords; these alone finally seemed to him to be worthy subjects to paint. For Dahl, as for Philip James de Loutherbourg (1740–1812) in England, it was the violent and unruly in nature that inspired the artist. Thus, it was 'the ability to depict Nature in her free and wild condition' that was his principal goal in painting.[11]

Similarly for Friedrich, it was the north and its peculiarly wild geography and climate that fascinated him. Indeed, Friedrich had for years entertained vain hopes of travelling 38 to Iceland and his great work, *The Arctic Sea* (*c.* 1823–24), is a vision of the Arctic which existed only in the artist's imagination. Perhaps the death of Friedrich's younger brother

Christoffer – who died while saving Caspar David, as a child, when he slipped through the ice in a skating accident – added another meaning for Caspar David Friedrich's fascination for ice and snow. Certainly, Friedrich painted many works with these subjects. Another aspect of the Nordic climate that interested him greatly was the light, and he produced a series of paintings with this theme, which were unfortunately destroyed at the end of the Second World War. Yet, what was most important to Friedrich was the ability of the Nordic atmosphere to express metaphysical states in himself. He wrote: 'The painter should not merely paint that which he sees before him, but also that which he sees within himself. If, however, he sees nothing within himself, he should then cease to paint that which he sees before him.'[12]

In 1818 Dahl left Copenhagen for Dresden, one of Europe's most civilized and cosmopolitan cities, the court of the Catholic King of Saxony, and at this time home of the German Romantic poet Ludwig Tieck (1773–1853) and the natural scientist, doctor and artistic dilettante Carl Gustav Carus (1789–1869). Dahl was to remain here for the rest of his life.

Dahl used the sketches he had painted in Norway for his many landscapes paintings. It was *Norwegian Mountain Landscape* (1819) which provided him with immediate acclaim in Dresden. Though still a very classically inspired and formally controlled work, it shows the influence Eckersberg had on his depiction of light, a quality which had many admirers. In 1820, Crown Prince Christian Frederik of Denmark invited him to stay at his villa on the Bay of Naples. Tiring soon, however, of the luxurious but formal life which surrounded the prince, Dahl departed as quickly as decorum would allow, to visit Rome and other places in Italy, returning in 1821 to Dresden. Here Friedrich once again gave him friendship and assistance. Two years later Dahl moved into Friedrich's house on the Elbe and they both lived there until Friedrich's death in 1840.

Despite Dahl's travels in Italy and a later visit, in 1847, to Paris, Norway remained the primary source of his artistic inspiration all his life. In 1824 Dahl was made a professor at the Academy of Art in Dresden, but he returned to Norway for the summer of 1826, visiting among other areas the regions around Hardangerfjord and Sognefjord. During this period he produced a large quantity of preparatory sketches of nature, using an increasingly free brushstroke.

Dahl shared with Friedrich an attitude to nature which derived in part from their admiration for Carl Gustaf Carus, who advocated the need of the artist to stand in awe before nature. Such feelings were very important in Dahl's and Friedrich's perception of the artist's role in painting and his relationship to landscape. Patriotism too was of importance, not only for Dahl but also for Friedrich, who violently hated Napoleon and the French and greatly admired Sweden, naming his son Gustaf Adolf after the great Swedish king. In *Riesengebirge* (c. 1835) he even depicted the little boy holding a Swedish flag.

Fichte's philosophical treatise *Natural Philosophy* played a considerable role in the orientation of these artists, especially what they saw as its emphasis on the emotions and their links to cultural and national identities. Fichte, originally a disciple of Immanuel Kant but later an absolute idealist, was made philosophy professor at the University of Jena in 1793. His views provided the philosophical basis for the Jena School of Mystics which fostered the conception, so important to the awakening of nationalism in art as well as in politics, of the Volksgeisst (Spirit of the People).

* * *

39 **Johan Christian Dahl** *Winter at Sognefjord* 1827

Friedrich and Dahl could use sketches of a summer landscape to create a winter scene and still remain true to nature by portraying her power and activity as an expression of the soul. Whereas Dahl preferred to depict nature full of energy and movement, Friedrich sought to achieve a frozen image, silent and immeasurable, but infused with a religious spirit not present in Dahl's works. This characteristic of Friedrich's painting reflects the views of the German theologian Ludwig Kosegarten (1758–1818), whom Friedrich admired. Although Dahl and Friedrich were committed Protestants in the Lutheran tradition, Dahl preferred an oblique approach, while Friedrich, as in *The Cross on the Mountains* (1807–08), overtly stated Christian beliefs. This deeply symbolic work was intended for the Protestant king of Sweden. In Dahl's paintings, a progression can be followed away from a prosaic view of landscape to one richer in emotional content. His *Norwegian Landscape* (1814) is a painting in the classical tradition, in composition and subject, not unlike works by Everdingen, but with keenly observed botanical details. The sharply perceived sky reminds us that Dahl was a contemporary of Constable.

39 *Winter at Sognefjord* (1827) is based on a summertime sketch made in Norway in 1826, depicting a *bautastein* (an ancient Norse stone monument), by the edge of an icy fjord. Though the mood of the work has a deeply frozen, static quality, the sharply delineated vertical stone juts upward, creating a surging movement that seems to embody the rise of the awakening Norwegian national identity, as if the featureless runestone were commemorating the country's long-suffering dignity. *Shipwreck on the*
40 *Coast of Norway* (1832) is a more turbulent scene, in which the vessel about to be dashed against the rocks contrasts with the frailty of the lifeboat full of desperate survivors, the violence of the waves mirroring the thundery cumulus clouds which envelop both land and sea. It could be a symbol of Norway itself precariously coping with upheaval and possible doom. At the same time it is a virtuoso depiction of nature by a

natural scientist who has zealously observed her forces at their most violent. It is not unlike, in spirit, a work by Turner exploring the atmospheric effects of land and sea.

The depiction of the raw forces of nature achieved its supreme expression in Dahl's *Birch Tree in a Storm* (1849). Dahl has here rid his painting of any human presence; we view nature as if uncorrupted by man, untamed and primeval, and yet emanating a pantheistic spirit. The towering birch tree pits itself against the rocky barren soil and howling winds. It is ultimately an optimistic theme, despite the destructive natural forces. By contrast, Friedrich's *The Arctic Sea*, in which the viewer witnesses the aftermath of struggle, presents the forces of nature as having vanquished that life which has dared to oppose her brutal forces. For all their apparent pessimism, however, such works by Friedrich have a sublimity and metaphysical content that point, in certain respects, to the later work of Peder Severin Krøyer (1851–1909), Edvard Munch (1863–1944) and Emil Nolde (1867–1956), who were to produce paintings that attempted to integrate the contours of light, sea and land with the human psyche.

Although he lived and worked in Dresden, Dahl had unwittingly initiated a great landscape tradition in Norway. Two of his Norwegian students in Dresden took up his example and concentrated on landscape painting: Thomas Fearnley (1802–42) and Peder Balke (1804–87). Fearnley, a native of Fredrikstad, in southern Norway, not far from the Swedish border, had first trained as a military officer, like many other early nineteenth-century Nordic artists. He left military school in 1819 and began his artistic studies at the Tegneskolen in Christiania. Two years later he moved to Copenhagen to study at the Kunstakadamiet, from 1821 to 1823. This was followed by study at the Konstakadamien in Stockholm from 1823 to 1827, under Carl Johan Fahlcrantz. During this time he also travelled in Norway, particularly in Telemark and Setesdal in 1824. Especially important for Fearnley was the summer of 1826 with Dahl in Norway, from whom he learnt to 'paint

40 **Johan Christian Dahl**
Shipwreck on the Coast of Norway
1832

38

from Nature'.[13] Thus, when Fearnley arrived in Dresden in 1829 to study under Dahl, he already had a wide Nordic education which emphasised naturalistic detail less than mood, a feature reinforced by his acquaintance with Friedrich. This emphasis on mood exerted an increasing influence on Nordic art during the nineteenth century.

Fearnley travelled extensively in the 1830s, visiting Munich, Paris, London and the English Lake District, but it is during his stay in Italy, from 1832 to 1835, that he painted one of his earliest works which concentrate on mood, *From Sorrento* (1834). In this painting naturalistic detail is suppressed, while a lyrical mood is created through the luminous pale yellow and blue tonalities which capture the atmosphere of an Italian coastal scene bathed in a warm southern light. Fearnley's paintings of Italy, however, were merely a period of training to refine his skill in capturing mood. When he applied this knowledge to a Norwegian subject, Fearnley produced his consummate masterpiece, *Labro Falls* (1837). In this painting, the raging rapids at Numedal are depicted in a way that suggests the mood of the surging water and rugged banks. The natural drama is heightened by a brilliant display of light and shadow (as in *From Sorrento*), while the sky, clearly influenced by Constable, strengthens the visual realism of the picture. Yet the viewer is not merely witnessing a scene of wild nature in Dahl's manner, for man's presence here is strongly intimated. The timber shorn of its bark and borne by the torrents has a human allusion, and the solitary eagle perched on timber in the foreground has a meaningful tone which adds to the dramatic mood.

Balke, like Fearnley, had attended the Tegneskolen in Christiania from 1827 to 1829, studying under Jacob Munch, and the Konstakadamien in Stockholm, with Johan Carl

41 **Thomas Fearnley** *From Sorrento* 1834

Fahlcrantz, from 1829 to 1832. Balke also studied under Dahl in Dresden (from 1835 to 1836, then again from 1843 to 1844) and in Norway for one summer. The three following years he lived in Paris where Dahl visited him in 1847, and, like his slightly older colleague Fearnley, he stayed in London from 1849 to 1850, where Constable and Turner impressed him.

Balke profited by a journey in 1832 to East Finnmark, a Lapp region in the extreme north of Norway, where he produced awesome studies of this bleak polar area, which Dahl himself used for his own paintings. These were executed by Balke using sponges, his fingers and indeed anything that came to hand which could heighten the painterly effect. His *Landscape Study from Nordland* (1860) is a typical example of the almost annihilating mood of weightiness which these methods produced. The soaring snowy peaks and downcast sky threaten to crush the viewer. 42

To an even greater degree this despairing, tumultuous mood is a theme of Balke's *Vardøhus Fortress* (*c.* 1860). This far north-eastern defence of Norway, near the Russian border, is depicted before the onslaught of a mighty storm. The dark cloud which dominates the background anticipates in mood the much later work of the Swedish painter Prince Eugen (1865–1947), by its symbolic content and what appears to be a thick, almost abstract, impasto of the foreground, but which actually is paint thinly applied by flat brushstrokes. It also points towards Strindberg's works of about 1900 and even to the American Abstract Expressionists in the late 1950s and 1960s. Perhaps not surprisingly, Balke's sombre paintings did not appeal to the Norwegian public; they preferred Fearnley's lyrical works with their discreet brushstrokes. Balke was obliged to seek recognition through Swedish and French patrons, who were less shocked by his innovative technique and dark tonalities. He found patronage from the French king Louis-Philippe, who had travelled to Norwegian Lapland as a young man and who had been greatly impressed by its wild landscape. 43

In contrast to Balke, the Norwegian Hans Gude (1825–1903) began his artistic career at the age of eleven, becoming a student of the naïve landscape painter Johannes Flintoe in Christiania and entering the Tegneskolen there in 1837. He won the Norwegian public's admiration for his gentle and graceful views of high mountain peaks and, in later years, of coastal scenes full of wistful melancholy. In 1841 he became the first Norwegian to settle in Düsseldorf, where the Academy of Art was one of the first in Europe to teach painting, as well as drawing. Düsseldorf, which had been a provincial town until Napoleon reorganized Germany, was then the capital city of the Prussian Rheinland and its Academy thus drew not only German but other European artists to study there. Gude studied under the German artists Johann Wilhelm Schirmer and Andreas Achenbach, whose works looked back to the landscapes of Everdingen and other seventeenth-century Dutch masters, as well as to the romantic landscapes of Carl Friedrich Lessing.

Like other Norwegian artists, Gude placed great importance on sketches, but he was as aware as they of the limitations of this approach if too strictly applied: it could lead to paintings devoid of fantasy, movement and drama. He wrote: 'to paint after Nature as the only healthy way will exclude all dramatic life, all momentary tones, storm and weather, changing light and shadow, sunset and everything indeed that has movement in it.'[14]

Gude's *A Mill Dam* (1850) skilfully combines a sharp and accurate depiction of boulders, enveloped in moss and lichen, that has few equals in Norwegian paintings of this period, with a dramatic portrayal of light and shadow playing on a waterfall and a stream, which we might think of as anticipating an Impressionist work. *Funeral Procession on Sognefjord* (1866) is a more meticulously finished painting that sacrifices 46

44

42 **Peder Balke** *Landscape Study
from Nordland* 1860

43 **Peder Balke** *Vardøhus Fortress*
c. 1860

44 **Hans Gude** *Funeral Procession on Sognefjord* 1866

the spontaneity of *A Mill Dam* in the interest of mood and atmosphere. Seventeen years before, Gude had anticipated the scene: 'From our window we can see out over the broad Sognefjord, but today it is no joyful sight, clouds hang heavy over the mountains, and the cold glaciers on high glisten, when the wind for a moment tears a hole in the fog, and the rain here and there blankets the mountains and hides them completely; just then several boats rowed by with many people; they were all quiet and the women were wrapped in white linen, and the first boat carried in its stern a mournful burden – a coffin. They were on the way to the cemetery, which lies there, just on the other side of the fjord.'[15] A melancholy scene, yet Gude has transformed it into something majestic and powerful. This is also apparent in the first version of the work (1852–53) which he had made in collaboration with another Norwegian artist, August Tidemand (1814–76). It is as though the country funeral had been elevated into the final act of some ancient tragedy in which the participants are the heart and soul of Norway. To such artists as Dahl, Fearnley, Balke and Gude, all urban dwellers, the countryside and its inhabitants were the true embodiment of the Norwegian people with their folk traditions and values.

The only Norwegian artist of this period who was a native of the countryside was August Cappelen (1827–52), a pupil of Gude's. He came from Telemark, in the middle of Norway, but spent his short life as an artist with his teacher in Düsseldorf, having arrived there in 1846. Cappelen's *Falls in Lower Telemark* (1852) has a freshness and sparkle that capture the dynamism of the dramatic woodland in which earth, sky and water are the principal actors. At the same time, the work has a melancholy mood imparted by the vortex of energy. This mood also pervades another powerful work by Cappelen, *Dying Wildwood* (1852). The sickly yellow sky and grey-green withered forest stand as portents of Cappelen's own untimely death that year. Unlike Dahl's towering birch tree braving wind and rain, Cappelen's huge, expiring tree, its trunk eclipsed by a boulder, seems to be on the verge of surrender to the hostile forces of nature.

47

45 **Werner Holmberg** *Kyrö Falls* 1854

46 **Hans Gude** *A Mill Dam* 1850

47 **August Cappelen** *Falls in Lower Telemark* 1852

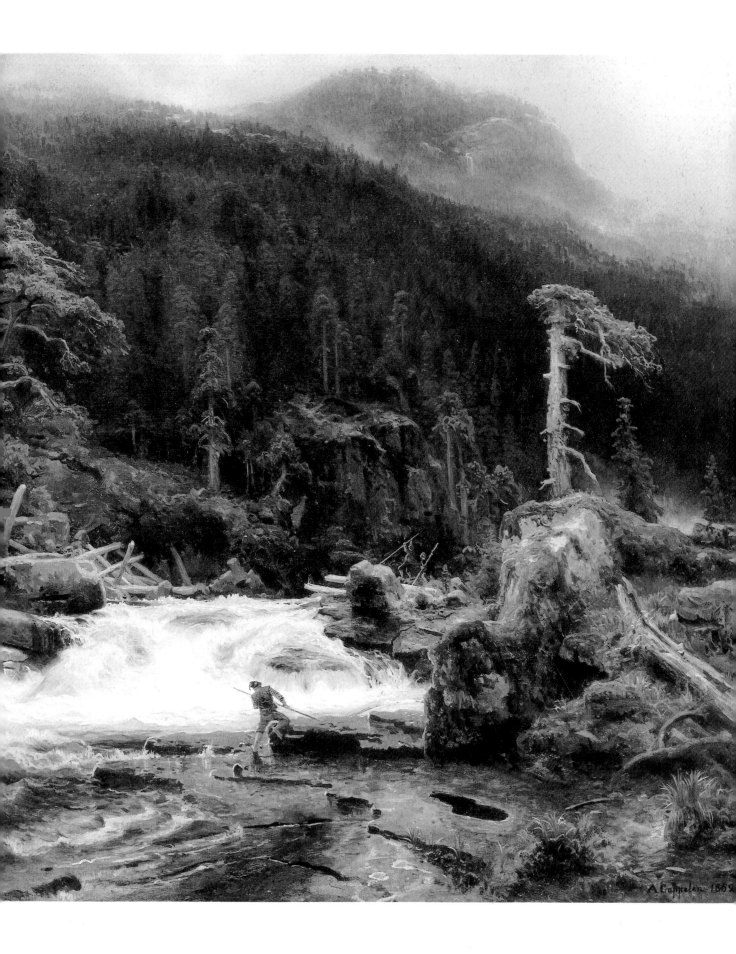

48 **Wilhelm Finnberg**
Portrait of Carl Edwin Lundgren 1828

OPPOSITE
49 **Alexander Lauréus**
Peasant Dance at Christmas in Finland 1815
(detail)

At an opposite pole to Cappelen was Johan Fredrik Eckersberg (1822–70), also a student of Gude's. As a young man he had been to the Low Countries to learn about trade (one of Norway's principal sources of wealth in the middle of the nineteenth century), but the Old Master paintings there interested him so much that in 1841 he returned to Norway to study at the Tegneskolen under Flintoe. In 1846, he too went to Düsseldorf, where Schirmer's classical style influenced him.

When Eckersberg returned to Norway he brought with him a cool, classical style, with forms meticulously delineated, as can be seen in one of his most appealing works, *From Valle in Setesdal* (1852). Eckersberg became increasingly keen to provide a substitute for the now flagging Tegneskolen, and in 1859 he founded his own school of painting to which many young artists came who were tired of the more restricted Tegneskolen.

Landscape and its use to depict mood and express national, as well as individual, consciousness became a primary subject for Norwegian painters in the nineteenth century. In Finland, however, early in the century, though landscape also played a significant role, it was mainly in portraiture that an unusually large number of skilful artists were at work doing commissions for the aristocracy and gentry, and producing illustrations of wildlife, especially birds, for scientific works. Willhelm Finnberg (1784–1833), a native of Pargas where his father was a seaman who also painted, was the most important artist in Finland in the first three decades of the nineteenth century. He had begun his career as a house-painter, but his considerable talents as an artist were quickly noticed and he was sent by well-off local people to Stockholm in 1806 to attend the Konstakadamien. There he won a Royal Medal in 1811 for a typically classical subject, *Daedalus and Icarus*, which was followed by another award-winning work, *Alexander and Diogenes* (1814).

Three years later, in 1817, after the upheavals of the Napoleonic Wars had subsided, Finnberg went to Turku, the old episcopal seat and university city of Finland, and devoted himself largely to portrait-painting, although he was obliged to take on more mundane painting tasks as well, such as the decoration of church pews. Often a brilliant colourist, whose works are full of shimmering tonalities, his *Portrait of Carl Edwin* 48 *Lundgren* (1828) is painted in a reserved, stately style which is inspired by the Neo-classical vogue. The disastrous Great Fire of Turku in 1827 had destroyed his masterly altarpiece there, along with most of his other paintings, and only his pulpit paintings of *Christ and the Apostles* (1822, in the church at Kimeto) survived as proof of his skills in religious painting. As a result, shortly after, Finnberg returned to Stockholm, a richer city than any in Finland, to earn a better income than the unsettled political and poor economic conditions of Finland could provide. There he illustrated a lithographic work depicting the ruins of Turku. However, a life of poverty and little success awaited him also in Sweden.

Though less technically skilled, the Finn Alexander Lauréus (1783–1823) achieved in his work a higher degree of psychological realism. Born in Turku, he began his artistic career in Stockholm in 1802, where he studied under Hillestrand ö m, acquiring a keen interest in genre painting. Though he returned to Finland for a brief visit in 1806, he continued to live in Stockholm, where he produced such brilliantly illuminated works as *Peasant Dance at Christmas in Finland* (1815), one of several variations on this theme, 49 which glorify his Finnish 'roots'. These works look back to the paintings of Teniers and Steen, as well as Hogarth, and were undoubtedly influenced by the writings of the Genevan philosopher Jean-Jacques Rousseau. Finnish and Swedish themes provided the subject-matter for the many illustrated works he produced, especially on Karl Michael

50 Alexander Lauréus
Self-portrait c. 1805

Bellman (1740–95), who had been a poet, musician and friend of Gustaf III. Lauréus received many honours in Sweden and in 1815 he was appointed professor at the Stockholm Konstakadamien.

It was in portraiture, however, that he achieved his greatest artistic expression, influenced by the English tradition of painting exemplified in the works of Gainsborough and Reynolds, as interpreted initially by Carl Fredric von Breda. Lauréus's extended travels to Germany, Holland and France, where he studied under the rather banal Neoclassical painter Pierre-Narcisse Guerin, broadened the scope of his portraits. His *Self-portrait* (*c.* 1805) is one of the most sensitive in Finnish art and beautifully expresses his reclusive nature and spirit. However, Lauréus died prematurely in Rome in 1823 at a moment that might have been the beginning of a new stage in his career.

Three brothers, who grew up in the isolated north of Finland, became the principal, most skilled and sensitive artists in Finland until the middle years of the nineteenth century: Magnus (1805–68), Wilhelm (1810–87) and Ferdinand von Wright (1822–1906). Their father was a strict and vitriolic officer, whose family had fled to Finland from Scotland in the middle of the seventeenth century during the Protectorate of Cromwell. They grew up in the seemingly idyllic country estate at Haminanlaks near Kuopio, in the north of Finland, but had a difficult childhood under their father's tyranny, and sought escape in painting. Virtually self-taught, their work shares certain common qualities, such as brilliant colour. They painted portraits and landscapes, often bathed in a cool and crisp light, and with a sharp attention to natural detail. The latter was the result of the brothers' love of nature and immersion in the scientific study of it. Magnus, who was also a cartographer, wrote scholarly articles on birds and was a member of the Society for Finnish Fauna and Flora. Wilhelm became attached to the Academy of Sciences in Sweden in 1835 and became an inspector of fisheries in the southern Swedish province of Bohuslän, while Ferdinand continued to live a largely isolated existence in Haminanlaks, surrounded by its lakes and forests, which he painted with devotion.

The formal artistic training the Wright brothers did acquire was limited, but Magnus had received some private instruction while in Stockholm from 1826 to 1829, from the Swedish painters Carl Johan Fahlcrantz, in landscape painting, and Johan Fredrik Julin (1798–1843), in the technique of watercolour. This enabled him to become an illustrator for studies in the natural sciences and when he returned to Finland in 1829 he produced illustrations for an ornithological compendium, *Swedish Birds* (1828–38), on which he was assisted by his brother Wilhelm. This was followed in the next decade by other zoological illustrations, including those for the magnificent *Finnish Birds* (1859), which was only published in its entirety, posthumously, in 1873. Wilhelm assumed Swedish nationality in 1834, and, availing himself of the knowledge his position at the fisheries afforded him, illustrated another Nordic work of natural science, *Scandinavian Fish* (1836–38), assisted by his younger brother Ferdinand. Wilhelm, who was plagued by illness, became a total invalid in 1856, and retired to his house, Marieberg, incapacitated and unable to paint or draw.

Ferdinand was the only one of the brothers to have had a full professional training as an artist. He attended the Konstakadamien in Stockholm, entering in 1837, and returned to Finland in 1844, painting first watercolours and then oils. Deeply influenced by Caspar David Friedrich, he went to Dresden in 1858, and studied under Johan Christian Dahl's son Siegwald, instead of making the pilgrimage to Düsseldorf, as had then become habitual for many young artists from the Nordic countries.

All three brothers succeeded in capturing in their work the charm and individuality of nature combined with acute observation. Magnus's *Hazelgrouse in the Wood* (1866) is a

52

splendid example of the eldest brother's ability in making what amounts to a portrait painting of three birds. As such it has no counterpart in Nordic art, although it shares a certain affinity with illustrations of birds by the American naturalist illustrator John James Audubon, in his *The Birds of America* (1827–38). Painted in brilliant colours, Magnus von Wright's birds have been depicted in anatomical detail without any trace of sentimentality. The birds are not portrayed like stuffed animals in a museum, but in their meticulously observed natural habitat. An appreciation of the dignity and beauty of animals had become fairly common in nineteenth-century Europe, at least among artists. It aroused a taste for a style of painting which alluded to the earlier prototype of aristocrats portrayed on their country estate, now applied to animal painting. Thus, the hazelgrouse in Magnus's painting dominate the wooded landscape in a similar manner as aristocrats dominate their parkland in a painting by Gainsborough, without, of course, the social implications of the latter.

Magnus von Wright's *Annegatan 15, a Cold Winter's Morning* (1868) is a very different sort of painting: it is more a depiction of a mood, than of animals, people, or even architecture, though these are all included in the painting. It is a picture that bears some comparison with a winter work by the elder Breugel and possesses an almost miniature-like fineness of execution, while the cool tones and filigree patterns of the branches of the trees emphasise the frostiness and bitter cold of a Finnish winter. V

In Wilhelm von Wright's *Hanging Wild Ducks, Still-Life* (1851) there is a static quality which strengthens the focus on the ducks, meticulously shown in their luxuriant plumage, but as lifeless and inert as the wooden spoon and carving board on either side. In Ferdinand von Wright's study *Doves* (1867), however, it is the dynamism and energy of the birds which is highlighted. A study in white against a brown background, the simplicity of form and colour accentuates the variegated and subtle texture of the white doves, positioned like panels in a medieval triptych. 53 51

Though landscape painting was not, in Finland, as major a genre in the early and middle years of the nineteenth century as it was in Norway, one artist who produced dramatic works rich in the mood of the Finnish forests was Werner Holmberg (1830–60). His paintings have a lyricism and monumentality unique in Finnish works of this time. Holmberg had studied drawing with Magnus von Wright and Per Adolf Kruskopf (1805–52), who had produced the first lithographic work on the topography of Finland, *Finnish Views Drawn after Nature* (1837–39). At the same time, Holmberg had continued to study law, but he gave up this career in 1850 to assist the painter Robert Wilhelm Ekman (1808–73), a popularizer of subjects full of nationalism (see Chapter 4), with his frescoes in Turku Cathedral. Holmberg then went to Düsseldorf in 1853, where he became a friend of Tidemand.

Kyrö Falls (1854), though painted in Düsseldorf, by its attention to naturalistic detail, dramatic mood and glorification of the forests and rivers of Scandinavia, is linked indubitably with Gude and his school. This work, together with his general artistic renown in Germany, earned Holmberg an offer of a professorship at Weimar, which bad health did not allow him to accept. In 1858, Holmberg returned home to Finland and produced some of the finest paintings of the heartland of his country near Kuru and Ruovesi, the latter a village north of Tampere which assumed great importance for Finnish artists later in the century. *Storm at Näsijärvi* (1860), exhibited at the Konstföreningen (Art Society, an organization which was a considerable source of support for many artists in Finland at this time), is characteristic of his best work from this period. Its subject seems to be a harbinger of the artist's own death from tuberculosis later in that year. 45

53 **Wilhelm von Wright** *Hanging Wild Ducks, Still-Life* 1851

OPPOSITE
51 **Ferdinand von Wright** *Doves* 1867

52 **Magnus von Wright** *Hazelgrouse in the Wood* 1866

Continentalism and Revolution
1830-1875

The period from 1830 to 1875 in Denmark and Sweden was a time of political upheaval. Happily, and in contrast to the rest of continental Europe, the change in the political structure was achieved without violence or bloodshed. None the less, the profound alteration of the political scene in the two major Scandinavian countries amounted to a revolution, for in single leaps both Denmark and Sweden ceased to be absolute monarchies and established parliamentary democratic systems which have continued to form the political bases of these countries to this day. In 1849 Denmark became a constitutional monarchy when its liberal king Frederick VII voluntarily relinquished much of his power and established a bicameral national assembly, guaranteeing civil liberties. In 1864 Sweden also became a constitutional monarchy and a parliamentary system of government was introduced with a new constitution, created by the Liberal prime minister and aristocrat Louis de Geer. A bicameral parliament was established here too and the vote given to large numbers of the peasants.

A leading figure who inspired many of these reforms was Nikolai Frederik Severin Grundtvig (1783–1872), a Danish theologian, poet and educationalist. Having travelled extensively in England, where the college system at Cambridge greatly impressed him, he created the Folk High School system of higher learning by convincing the Danish king and others of the need to educate the rural masses in Scandinavia, thereby assisting the development of democracy. By educating the small farmer or craftsman, Grundtvig felt that they would be able to make choices and assume the responsibilities that went with a parliamentary system of government. Another Dane, Søren Kierkegaard (1813–55), one of the greatest philosophers of the last two hundred years, laid even greater stress on the importance of choice, as in his book *Either-Or* (1843). One of the first philosophers to focus on the existential predicament, which is evocative of a sort of metaphysical anxiety, he placed enormous value on ethics and the exercise of choice in alleviating this anxiety, even when the choice made was ill-advised or immoral. Kierkegaard is thus rightly considered a forerunner of modern existentialism. On the political and social side Grundtvig and Kierkegaard helped smooth the road to democracy.

It was against this background that history painting became predominant, concentrating on important events in the process of democratization. Constantin Hansen, whose work was discussed in the last chapter, was its leading proponent. His best-known work of this type was *The Constitutional Assembly of 1848* (1860–64) which shows the meeting of the Danish government as a result of which royal absolutism eventually came to a voluntary end. War was raging in 1848 in Schleswig, where liberal Danish nationalist factions were seeking to incorporate the predominantly German Duchy of Schleswig-Holstein into the Kingdom of Denmark. The autocratic Prussia heavily supported the pro-German anti-democratic parties, who preferred autonomy from Denmark and an absolutist form of government. In Hansen's painting, the assembly room of the supreme court at Fredericksborg Palace is depicted with more than two hundred people, including the prime minister Count A. W. von Moltke, as well as ordinary farmers, who were now included in making government decisions. Work on the painting was begun some twelve years after the event. As an aid in re-creating the occasion accurately, photographs of the assembly's various members were used.

In Sweden no comparable artist emerged with Hansen's ability to record recent historical events. However, history painting glorifying Sweden's past did flourish from the mid-1830s. Pehr Hörberg's fresco at Finspång in Östergötland, of a few decades earlier, and Johan Gustaf Sandberg's frescoes (1833–38) in Uppsala Cathedral, painted for the burial chapel of King Gustaf Vasa, were among the earliest frescoes painted in Sweden since the end of the seventeenth century. They are based on themes from the life

54

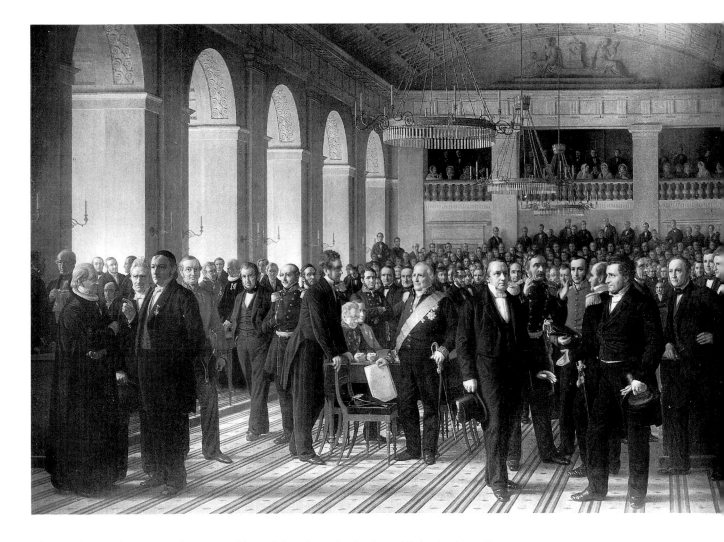

of Gustaf Vasa, the sixteenth-century king of Sweden who had established a hereditary monarchy, united the country and introduced the Reformation. Interest in this subject had originated with the poet Geijer, who had aroused the interest of Uppsala Cathedral's clergy. They urged that frescoes be commissioned and in 1831 Sandberg was finally chosen. Stylistically, these frescoes take their inspiration from the works of the Nazarenes, such as Friedrich Overbeck.

Seven scenes are included in the frescoes, of which two of the most noted are *Gustaf Vasa's Entry into Stockholm* and *The Battle of Brännkyrka*. Sandberg's friend Fogelberg provided assistance in the commission, which was executed in a technique for which Sandberg had previously had no training. The Finnish artist Robert Wilhelm Ekman helped him in the actual execution of the works. An isolated project at this time, these paintings were to provide an important basis for the development of fresco painting in Sweden in the final decades of the nineteenth century. Moreover, they exerted an influence on this type of painting in other Nordic countries.

Compositionally, these frescoes are typical of other Nordic history paintings of this time, in the theatrical arrangement of the figures, with meticulously depicted historical detail. The current secularization of society in Scandinavia is reflected here. What had previously been a religious subject, Christ entering Jerusalem, has been translated into a patriotic work in which Swedish nationalism is glorified.

54 **Constantin Hansen** *The Constitutional Assembly of 1848* 1860–64

55 **Carl Wahlbom** *Death of Gustaf II Adolph in the Battle of Lützen* 1855

This approach was also used by Carl Wahlbom (1810–58), whose *Death of Gustaf II Adolph in the Battle of Lützen* (1855), painted while the artist was in Rome, depicts the death of the Protestant Swedish warrior-king under the onslaught of the forces of the Catholic General Albrecht Wallenstein during the Thirty Years War. In this painting Wahlbom alludes to earlier religious works showing the burial of Christ. They inspired his composition in which the dead king is presented as a Christ-figure, the saviour of his people. Wahlbom was interested in Swedish historical themes, like so many of his contemporaries, a taste which was quickened by contact with Professor Per Henrik Ling. Wahlbom was also inspired by the poetry of the Swedish Romantic poet Erik Johan Stagnelius (1793–1823). His paintings have a sense of drama and dynamism which have led some to call him, particularly in regard to his skill in depicting animals, the 'Swedish Géricault'. Without doubt, his early training at the military academy in Karlsberg, and his work as a gymnastics instructor, assisted him to depict convincingly physical strain and movement.

In 1838 Wahlbom had been to Paris, and in 1843 he had settled in Rome, where Fogelberg exerted some influence on his style. Five years later, however, he returned to Sweden, where considerable professional honours awaited him. By 1856 he had been made professor at the Konstakadamien, but illness had begun to plague him and he died in London in 1858 on the way home from another sojourn in Rome.

* * *

It was in Finland, subjected to increasingly onerous Russian domination throughout the nineteenth century, that history painting assumed its greatest role as the embodiment of resistance and the assertion of Finnish national identity. Its leading exponent, though by no means the most artistically gifted, was Robert Wilhelm Ekman (1808–73). Called by some the father of Finnish painting, it was Ekman who first painted themes from his country's past. He was from Uusikaupunki in the south of Finland, where his father was mayor, and he had moved in 1823 to Turku, where he became a pupil of Gustaf Wilhelm Finnberg. Later, he moved to Stockholm, where he entered the Konstakadamien, achieving much success, particularly as a student and then assistant of Sandberg. In 1833 he had painted *Midsummer Dance on the Borders between Småland and Blekinge*, and the following year he assisted Sandberg on his frescoes at Uppsala Cathedral. Their influence is reflected in one of his own frescoes, *King Gustaf the First Receiving Bishop Mikael Agricola, the First Finnish Bible Translator* (1850–54), in Turku Cathedral. It is full of dramatic plays of light and shadow and rich in historical anecdote. Such static, theatrical tableaus were the products of experience gained in Paris. Ekman was especially influenced by the work of the French history painter Paul Delaroche. In Rome, where he went in 1840, he concentrated first on scenes of local interest, which were later to be of considerable use to him, transferred into a Finnish context, after his return in 1845.

Ekman's work stands in sharp contrast to that of another Finnish artist, Erik Johan Löfgren (1825–84). A painter with a delicate style, he had been a student in Paris where the works of Delaroche influenced him. This is evident in his best-known painting, *Erik XIV and Karin Månsdotter* (1864). It is a brilliantly coloured work depicting a poignant moment in the lives of the sixteenth-century Swedish-Finnish king and queen, who are portrayed in a pose taken from a *pieta*. This painting, however, is exceptional in that it has an emotional intensity not usually present in Löfgren's work.

IX

Mythological themes also provided equally suitable subjects on which to focus nationalistic feelings and, particularly in Sweden, fables of the Nordic gods were popular. The most acclaimed exponent in Sweden of this kind of painting was Nils Jakob Blommér (1816–53), who actively campaigned for a purely Nordic art, having become deeply impressed by the romantic and lyrical works of the German painter Moritz von Schind. He had seen this artist's paintings, of dancing Nordic nymphs, while travelling in Germany in 1847 on his way to Paris to become a pupil of the French history painter Léon Cogniet. His charming and graceful *Freja Seeking her Husband* (1852) was painted in Rome, shortly before he died there of a lung infection. In the painting, the Nordic goddess of love and fertility is borne through the clouds by her cavalcade of cats, vainly seeking her long-lost husband Od. Great pains have been taken by Blommér to give the goddess and her chariot a Scandinavian appearance, yet the figures of the cherubs are reminiscent of those by Andrea della Robbia in terracotta, and the compositional arrangement links it unequivocally with a classical Renaissance tradition.

56

This trait is also a characteristic of the rather fey work of a member of the Gothic Society, August Malmström (1829–1901). His bright, mythological painting *King Helmer and Aslög* (1856) shows a scene from the Icelandic sagas in which the young girl's guardian plays the harp which has enabled him to smuggle the noble maiden into Norway. Rich in Scandinavian antiquarian detail, the work's compositional arrangement is none the less also firmly rooted in Neo-classical paintings.

58

The Norwegian Frits Jensen (1818–70) attempted to be as realistic as possible in his works, painting the poses of the figures from life. Gude wrote, in regard to Jensen's *Viking Raping a Southern Woman* (1845), 'when he painted his Viking who is raping a

57

56 **Nils Jakob Blommér** *Freja Seeking her Husband*
1852

57 **Frits Jensen** *Viking Raping a Southern Woman*
1845

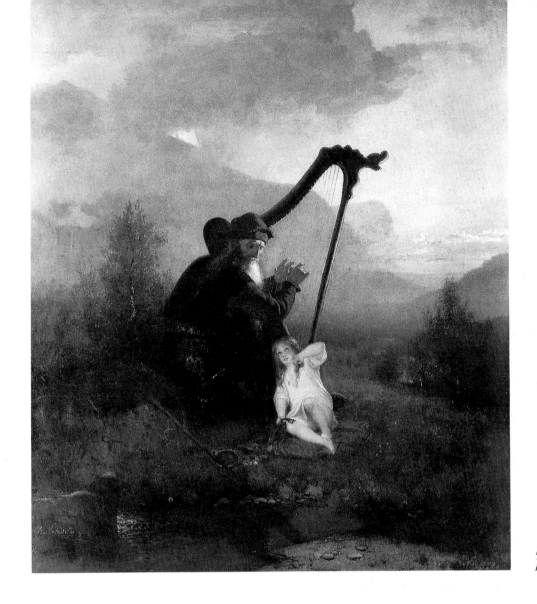

58 **August Malmström** *King Helmer and Aslög* 1856

southern woman, I was obliged to serve as his model, to hold the draped woman in that difficult position – a hard test for my friendship.'[16] That this picture looks like a scene from a play is hardly surprising: Jensen worked as a director in the leading theatre in Christiania, the National Scene, which was set up by him and his Norwegian colleague Ole Bull in 1849–50.

Another Norwegian, Peter Nicolai Arbo (1831–92), also painted works based on Nordic mythology. He had been first to Copenhagen in 1851, and had then lived in Düsseldorf for nine years until 1861. He moved to Paris in 1863 and did not return to Christiania until 1874. His painting, *King Sverre's Flight* (1862), a theme from Norway's Viking history, is reminiscent of works by Wahlbom, such as *Loke and Sigyn*; both shared a fascination with horses, devoting a considerable number of paintings to depicting them in battle or other situations, in which their movements and anatomy could best be illustrated. However, Arbo's melodramatic and theatrical works, like *Åsgårdsreien* (1868), were compositionally untypical of other mythological paintings of this period, and stylistically are related to *fin-de-siècle* Symbolist art by virtue of their crowded and turbulent composition and portrayal of androgynous figures.

* * *

In Finland a stronger national identity was firmly established through the works of one of Finland's greatest poets, Johan Ludvig Runeberg (1804–77). He, in turn, had been influenced by writings such as *Serbian Folksongs* (1828), by the German P. von Goetze, which had contributed to nationalism in central Europe. It has even been said that Finland might not have become an independent state had it not been for Runeberg's *The Tales of Ensign Stål* (1848), which glorifies the life of a soldier in the Swedish-Finnish war against Russia of 1808–09, though the writings of the Swedish-born Professor Johan Vilhelm Snellman (1806–81) also played an important part. The Finnish writer Aleksis Kivi (1834–73) followed in his footsteps. In particular, Kivi's novel *The Seven Brothers* (1870) consolidated the nationalist Finnish literary orientation. Such writings strengthened the nascent nationalism of many artists in Finland at this time, who concentrated on themes from Finland's folk tradition, especially its mythology.

The Finn Elias Lönnrot (1802–84) had begun in 1828 to collect the orally transmitted Finnish epic *Kalevala* during his visits to the eastern Finnish province of Karelia. His compilation of the *Kalevala* into a coherent literary work also encouraged the new taste for Finnish national themes. Ekman's painting, *Lemminkäinen's Mother Gathering Together her Son's Body in Tuonela's River* (1862), depicts a macabre episode from the *Kalevala* in which the adventurer Lemminkäinen, destroyed through his failure to heed his mother's admonitions, is brought back to life by her. This painting was commissioned as a gift to Elias Lönnrot. Other works on this subject followed in the succeeding decades, including Ekman's *Väinämöinen* (1886), ordered for the Gamla Studenthuset (Old Student House) in Helsinki. In this painting, Väinämöinen, the mythological bard of Finnish folklore, plays his instrument, the kantele, for the nymphs and deities of the woods and waters.

For all the grandiloquence of such highly theatrical works and the Nordic cultural identity which they sought to foster, the social and economic realities of Scandinavian society were grim in the middle decades of the nineteenth century. The wars between Denmark and Germany (1848–49 and 1864) wrought increasing havoc on the Danish economy, and poor harvests and famine in Sweden in the late 1860s caused great poverty, resulting in vast waves of emigration, especially to America, which seriously depopulated the country. Conditions were the same in Finland where a great famine in 1867 wiped out more than 20,000 people. This disastrous situation was compounded by a deepening rift between the Finnish people as a whole and their Russian rulers. Furthermore, monopolistic trends in the timber industry encouraged small landholders to sell their property to giant companies, thus accentuating the tendency towards the creation of a class of landless people who had little prospect of other employment in an agrarian society. Social discontent ensued. As an escape, a number of Scandinavian artists turned to the countryside and its people: Nordic painting thus reflected, on the one hand, native discontent and, on the other, artistic trends abroad, especially those, set by Gude and his school in Düsseldorf, of sentimental genre painting and lyrical landscapes.

In the middle of the nineteenth century, the art critic and historian Niels Lauritz Høyen (1798–1870) advocated a national art for Denmark, and the genre painter Christen Dalsgaard (1824–1907) answered his call. Having studied at the Academy in Copenhagen under Rørbye, Dalsgaard was also considerably influenced by Hansen's work, in particular the strong light and shadow, and his attention to architectural detail. Dalsgaard painted themes from Danish folk traditions. Farmers and fishermen in dramatic situations appealed to him most and he used them in his anecdotal paintings. Some works, like *Garden Door in Hellested Vicarage* (1852), could be scenes taken from short stories by the contemporary Danish writer Steen Steensen Blicher (1782–1848),

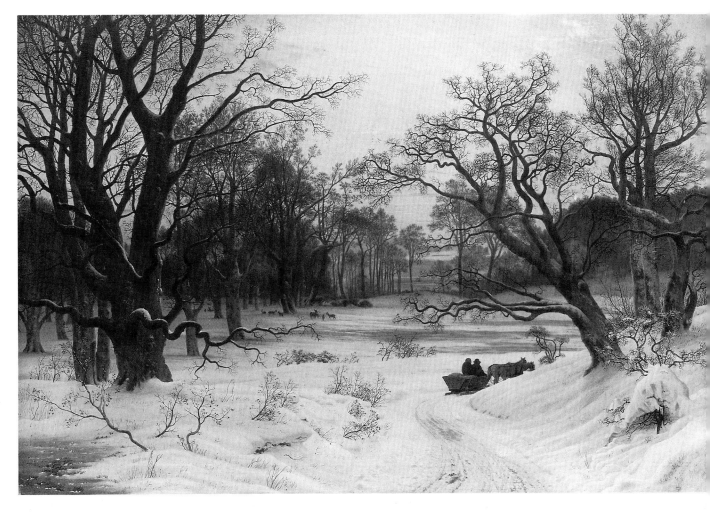

such as 'Excerpts from a Parish Clerk's Diary'. Others, such as *Country Carpenter Bringing a Coffin for the Dead Child* (1857), may imply biblical references.

59 **Vilhelm Kyhn** *Winter Evening in a Forest* 1853

A similar style of genre painting thrived in Norway in the paintings of two Norwegian artists, Olaf Isaachsen (1835–93) and Carl Sundt-Hansen (1841–1907), though their works do not have religious overtones. Isaachsen had been a student in Düsseldorf before moving in 1859 to Paris to study under Thomas Couture. He also toured Italy in 1863, before he returned to Paris and Norway. There he settled at Christiansand and devoted himself with great success to paintings of interiors of country dwellings. In *Bedroom from Kveste in Setesdal* (1866), the wooden furniture and walls seem to breathe with life; in this sense they anticipate the interiors of the Danish painter Vilhelm Hammershøi (1864–1916), although Isaachsen's world is rural and peasant, rather than urban and elegant.

62

While Isaachsen succeeded in capturing the feel and mood of a Norwegian country cottage, Sundt-Hansen concentrated on the wealth of detail of such buildings, giving them a strong photographic quality, thus documenting the period and place. This can be seen in his most famous work, *In the Sergeant's Detention* (1875).

Born in Stavanger of a Danish father, Sundt-Hansen had also studied in Copenhagen, Düsseldorf, Paris and Christiania, but it was Setesdal which inspired him, as it did Isaachsen. Although he lived for many years in Stockholm and settled later in Denmark, he returned permanently to Setesdal in the late 1890s.

GENRE PAINTING

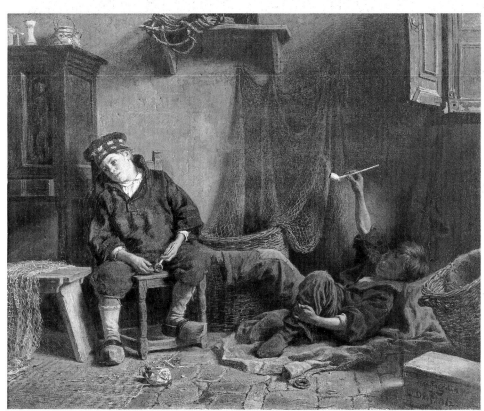

60 **Ferdinand Julius Fagerlin**
Young Fishermen Smoking 1862

61 **Bengt Nordenberg** *A Tithe
Meeting in Scania* 1865

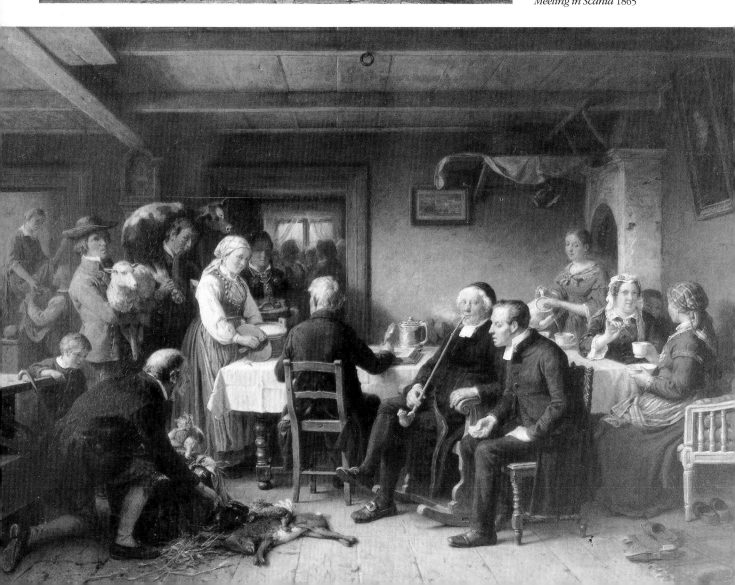

62 **Olaf Isaachsen** *Bedroom from Kveste in Setesdal* 1866

63 **Christen Dalsgaard** *Country Carpenter Bringing a Coffin for the Dead Child* 1857

64 **Karl Emanuel Jansson** *Sailor Boy* 1866

In Finland, genre painting of the Düsseldorf School achieved its greatest expression in the work of a young artist, Karl Emanuel Jansson (1846–74), from the Swedish-speaking islands of Åland, at the entrance to the Gulf of Bothnia. The son of a peasant farmer, his artistic talents had been discovered and encouraged by the local vicar who had sent Jansson's drawings to the Finska Konstföreningen (Finnish Artists' Society). This resulted in Jansson being granted a stipend to study first at the drawing school in Turku under Ekman and then at the Konstakademien in Stockholm. He too studied in Düsseldorf. When he returned to Åland in 1871, enjoying the largesse of the province's governor C. G. Lönnblad, with whom he resided, Jannson devoted himself to depicting the peasant life and customs there. *Åland Seamen Playing Cards in a Cabin* (1871) has certain stylistic affinities with works by the Danish Skagen painter Michael Ancher (see Chapter 5). *Åland Seamen* combines a realistic depiction of a room full of men with a picturesqueness that manages to avoid sentimentality. His genre portrait, *Sailor Boy* (1866), is a high point in Finnish art of the mid-nineteenth century. The keen observation in the portrayal of the sitter's face is poignant and remarkable for its psychological insight.

In Sweden, genre painting reached its height in the work of Johan Fredrik Höckert (1826–66), called by some the 'Swedish Delacroix'. His paintings are rich in a 'correspondence' of colour, in which similar tones and colours, spread throughout a work, unify the painting. In this he followed the example of Eugène Delacroix's *The Death of Sardanapalus*, where the use of 'correspondence' was lauded by the French critic Charles Baudelaire.

Höckert's paintings are also stylistically related to those of Tidemand and Gude in Norway, in their fascination with nature in its wilder, dramatic forms. Höckert entered Hill's School in Stockholm in 1840, and the Konstakademien in 1844, where the painter Johan Christoffer Boklund (1817–80), whom he had known since childhood, taught him history painting. It was in Bolklund's company that Höckert went to Munich where he spent three years studying at the academy, from 1846 to 1849. He became a frequent visitor at the Stubenvoll Club, a drinking society for artists, musicians and literary figures, including Thorvaldsen and Franz Liszt. Höckert also went to Paris, in 1851, where he studied history painting, producing one of his most successful works of this type, *Queen Christina Commands her Servants to Kill Monaldeschi in the Palace of Fontainebleau in 1657* (*c.* 1853). This painting depicts a melodrama in the life of the seventeenth-century queen who had involved herself in murderous intrigues in Europe after her abdication.

However, it was in Lapland, in the extreme north of Scandinavia, that Höckert found his greatest inspiration after his return to Sweden in 1850. He was commissioned to go there by the natural scientist N. G. Anderson and travelled extensively, making a series of sketches of the landscape and local inhabitants. Some of these sketches were used in one of his most popular paintings, *Service in a Lapp Chapel* (*c.* 1855). It was shown at the Paris Salon of 1853 and achieved considerable acclaim there (where Höckert was living at the time) because of the exoticism of its subject and its lyrical mood. Though it was purchased by Emperor Napoleon III, the painting earned Höckert less fame and success in Sweden. He therefore remained in Paris until 1857, painting more scenes from Lapland for a fascinated public, including *Funeral in Lapland* (1855) and *Interior of a Lapp Fisherman's Cabin* (1855–57). The use of colour in these works demonstrates the influence of Thomas Couture, whose paintings Höckert admired while in Paris. After he returned to Sweden, he turned his attention to another region, Dalecarlia, where he painted the colourful inhabitants of this prosperous heartland of Sweden.

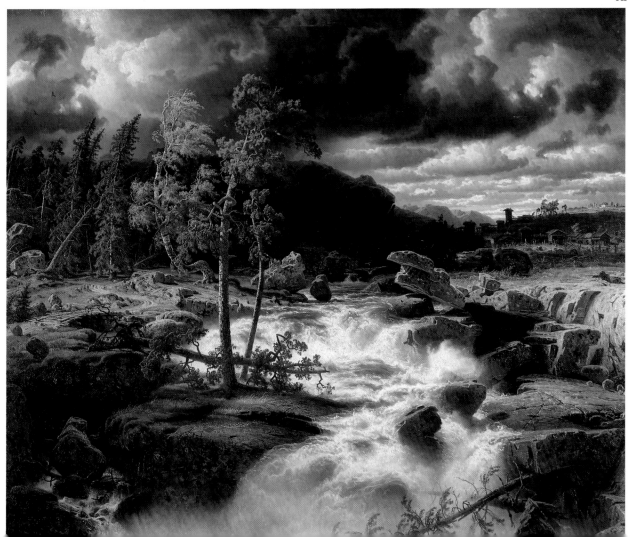

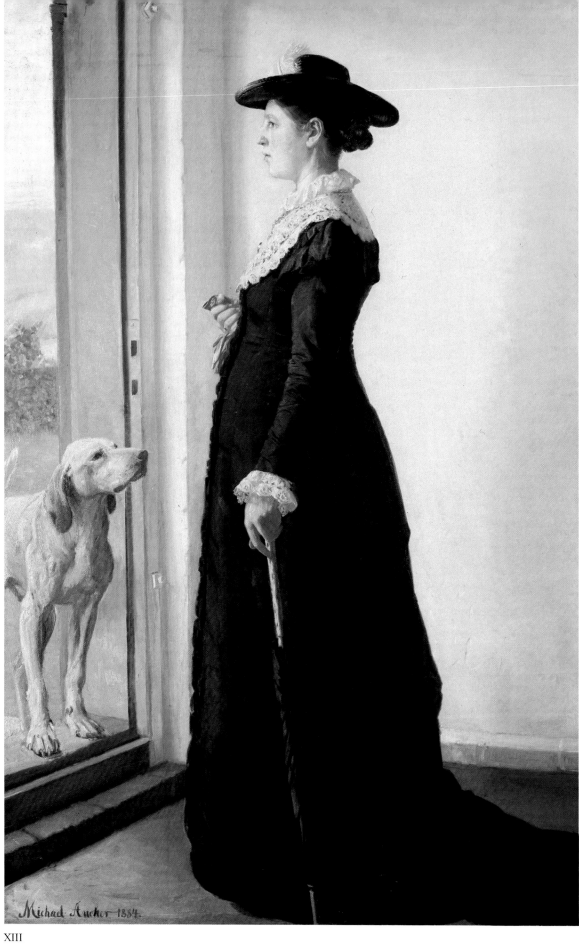

XIII

More admired at home was the work of Kilian Zoll (1818–60), an artist from the extreme south of Sweden. In 1836 he entered the Konstakadamien in Stockholm to which he remained attached for thirteen years, a period interspersed with visits to Copenhagen, where he also trained at the Kunstakadamiet. It was there that he became especially interested in Nordic themes.

When Zoll went to Düsseldorf in 1852, Tidemand's genre pictures attracted him and he became an ardent follower. On his return to Sweden for the summer, he applied this approach to a subject of Nordic interest, which was also encouraged by his contact with the genre painting of the Finnish artist Alexander Lauréus. *Midsummer Dance at Rättvik* (1851, of which there are two versions) captures the festive atmosphere of the Nordic celebration of life and light. It also demonstrates Zoll's acute eye for the details of costumes. Zoll learnt to paint the anecdotal and the picturesque in Stockholm, Copenhagen, and especially Düsseldorf. This painting is a classic example of what the Düsseldorf school painted and what its public appreciated. As the Swedish art historian Sixten Strömbom put it: 'One loved to see happy people in gay folk costumes – Norwegian or Tyrolian, equally charming – summer landscapes with stately masses of trees and smiling faces … from places of idyllic or pathetic character: nature in impressive expressions of power or harmonious ease, nature as scenery, not as an expression of a spiritual state.'[17]

Zoll returned to Düsseldorf frequently until 1859, the year before he died, while in Sweden he wandered in pursuit of local motifs. After his early death, many of his unfinished paintings were completed by Bengt Nordenberg (1822–1902), another Swedish genre painter, whom Zoll had met at Gåvetorp, the home of his friend and patron, Uno Angerstein.

Ferdinand Julius Fagerlin (1825–1907) was inspired by seventeenth-century Dutch genre painters and made use of subtle and lyrical colour and tone, depicting slightly humorous moments in the lives of shepherds and fishermen. Fagerlin had had an academic education, which was rare for most artists at that time, before he studied at the Konstakadamien in Stockholm. Most important in shaping Fagerlin's individual style were the lessons he learnt in Düsseldorf, where he went in 1853. He lived there for the rest of his life, excluding such years as those from 1856 to 1858 which he spent at Thomas Couture's atelier in Paris. Couture's influence can be detected from the brighter colours in Fagerlin's work after his stay in Paris. In Düsseldorf, influenced by F. W. Shadow, director of the Academy, and others, he developed a strong attraction for anecdotal painting. One such work, *Young Fishermen Smoking* (1862), combines realism of detail and psychological awareness, which, to some extent, obviate the sentimentality of the work and give it a reserved and dignified charm.

In 1865 Fagerlin received a gold medal at the International Exhibition of Art in Dublin for a genre work, *The Proposal*. This success increased his fame and earned him several commissions, such as that from the English Winch family, whose group portrait he painted in 1875. By 1877 Fagerlin had become one of the Swedish public's most admired genre painters, producing many variations on the theme of fishermen at home, though not, as they were depicted later in the century, at work on the open seas.

Sophie Ribbing (1835–94), from Småland in Sweden, employed a similarly realistic style in an attempt to achieve a psychological insight into her subjects. *Boys Drawing* (1864), for example, might easily have been merely sentimental in less able hands. This painting is an example of the high level of artistic achievement by one of the few female Nordic artists. She studied in Düsseldorf under C. Sohn during the 1850s. Ribbing was also a good portrait painter, as her *Portrait of Baroness Hochschild* demonstrates. Her

66

60

65

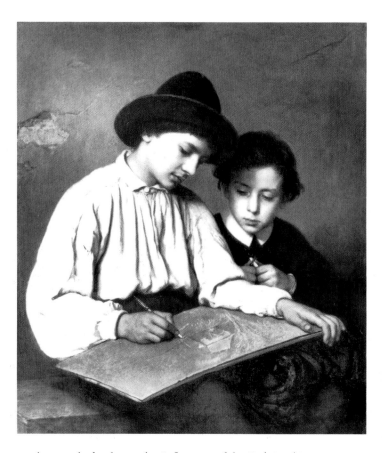

65 **Sophie Ribbing** *Boys Drawing*
1864

work as a whole shows the influence of the Belgian history painter Louis Gallait, who was her teacher in Brussels, where she studied after she left Düsseldorf. August Strindberg, an art critic in his early years, praised Ribbing's work for its freshness.

The psychological realism to be found in the works of Fagerlin and Ribbing contrasts strongly with the less subtle, highly staged and theatrical folk pageantry of Bengt Nordenberg's genre paintings. These depict the social customs and costumes of villagers, rather than attempting to show character or serious social commentary. *A Tithe Meeting in Scania* (1865) exemplifies his painting at its best. It looks back to Dutch seventeenth-century genre painting, but with little of the humour and levity of the latter. Rather it is a *tableau vivant* of Swedish life and customs in the middle of the nineteenth century. This was a period of religious revival and even fanaticism, when many different types of dissenting Protestant sects appeared, which stressed the personal revelation of the Holy Ghost to the individual. Since these sects provided a close-knit community, within the recently loosened social structure of Scandinavia, which had been unsettled by urban growth, poverty and emigration, many people were drawn to them, especially in Sweden. In *A Tithe Meeting in Scania*, peasants are arriving with the animals or other offerings which were required to support the clergy.

Nordenberg too had studied at the Konstakadamien in Stockholm, but his earlier work decorating furniture in farmhouses had perhaps strengthened his sense of colour and form. Furthermore, his training with Thomas Couture in Paris, where he went in 1856, remaining for one and a half years, and then his studies in Düsseldorf during 1858, encouraged him to use brilliant colours in his paintings of architecture and other inanimate objects. It was Rome, however, with its vibrant life and gaiety of its streets that inspired Nordenberg with a profound interest in genre painting.

94

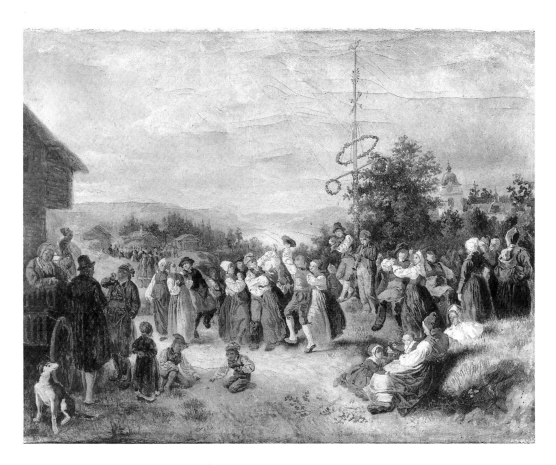

66 **Kilian Zoll**
*Midsummer Dance at
Rättvik* 1852

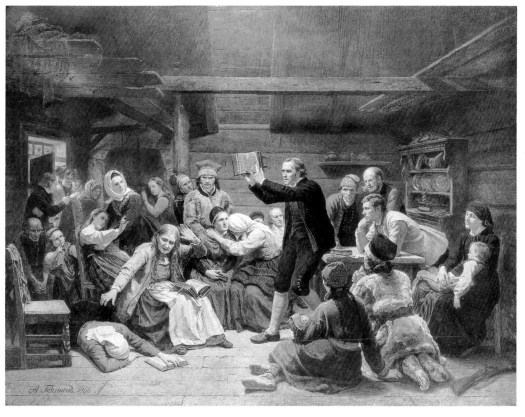

67 **August Tidemand**
Fanatics 1866

His genre themes, sometimes on the new dissenting Protestant sects, had their corresponding adherent in Norway. August Tidemand devoted himself in a number of paintings to such scenes, which he himself had witnessed. He studied first at the Kunstakadamiet in Copenhagen, from 1832 to 1837, and then at the Academy in Düsseldorf from 1837 to 1841. Tidemand also visited Munich in 1841 and Rome, where he stayed for three years, before returning to Christiania. Each summer, he returned to Norway, especially to the regions of Gudbrandsdal and Sogn, and acquired a wealth of images and impressions which he worked into his genre painting. Some of this material he used in the folk scenes painted for the Norwegian royal residence, Oscarshall, in 1849 and 1850. Most interesting for their reflection of the religious events of this period are two works, *Haugianians* (1847–48) and *Fanatics* (1866). In both, the figures are positioned in a theatrical way, gesticulating as though on a stage. This dramatic quality is somewhat reminiscent of dioramas, which had become popular at this time. *Haugianians* was a great success when exhibited at the Berlin Academy in 1848 because of its ethnographic interest. *Fanatics*, however, is the more penetrating work, attempting to analyse visually the group psychology of a meeting of religious zealots.

One of the most poignant Nordic genre and landscape paintings, which pointed the way towards the mood painting of the late 1880s and 1890s in Scandinavia, was one of the earliest Norwegian works made out of doors, by the Norwegian artist Amaldus Clarin Nielsen (1838–1932), *From Sognefjord* (1865). The ruined peasant cottage stands like a monument to a way of life that was drawing to an end, hallowed by time and weathered by the wind, rain and snow, as much a part of the landscape as the trees and grass.

Nielsen, after first studying in Copenhagen in 1856, had been trained by Gude in Düsseldorf from 1857 to 1859. He spent the following year in Cadiz in Spain, before moving on to Karlsruhe with Gude in 1867, and finally back to Norway. He was hostile to the academic approach of many other Nordic artists and placed considerable importance on the relationship of the artist with nature. In this respect he was to exert a considerable influence on the Norwegian artists of the next generation, especially on Werenskiold, who acknowledged this debt and who was to say of Nielsen's work, which had been exhibited in Christiania in 1883: 'Just see what finesse there is in all these things, how clear, true and controlled it is in colour and how self-confidently and securely drawn; Amaldus Nielsen is indeed one of our most popular artists; in fact I would even say he is one of our greatest.'[18] It is *Summer Night, Setesdal* (1864) which is perhaps his most accomplished painting, capturing the luminous quality of a bright summer night. Nielsen painted such themes for many years and *Morning at Ny-Hellesund* (1885), one of his later works, clearly shows the freshness of morning light on the placid waters of a Norwegian fjord.

Nielsen's coastal scenes are different from those of Anders Monsen Askevold (1834–1900). He studied with Nielsen in Düsseldorf from 1855 to 1858 and then went to Paris in 1861, where he stayed for the next five years. There, the animal painters Rosa Bonheur and Constant Troyon made the greatest impression on him. Askevold's *Rowboats on the Shore* (1869) and *Aenes at Hardanger Fjord* (1886) are freely handled and eschew photographic realism, often present in Nielsen's work, in favour of a more impressionistic style. This characteristic is also apparent in some of Askevold's popular works portraying cattle in pastoral landscapes, as, for example, in *Summer Day at the Mountain Farm* (1876), which conveys the lyrical beauty of the Norwegian countryside.

Whereas the works of Nielsen and Askevold illustrate two contrasting styles, both emanating from the Düsseldorf school, the œuvre of Lars Hertervig (1830–1902) is not typical of the work produced at this time in Norway. In 1838, Hertervig became an

68 **Johan Frederik Vermehren** *Study of the Heathland* 1854

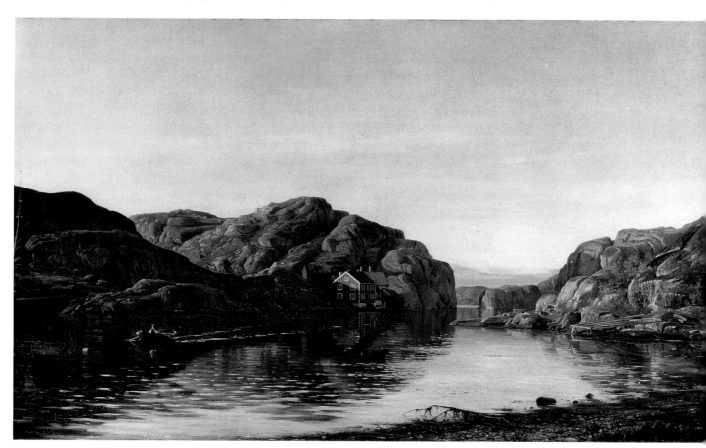

69 **Amaldus Clarin Nielsen** *Morning at Ny-Hellesund* 1885

apprentice to the painter Endre Dahl in Stavanger but did not take drawing lessons with Bernhard Fredrik Hansson until 1849. His talent was soon recognized and he was supported by the ship-owner and merchant H. G. B. Sundt, among others. Thus, he was able to enter the Tegneskolen in Christiania in 1850, where Flintoe and Eckersberg instructed him. In 1852 he, too, went to Düsseldorf to continue his studies, like so many of his compatriots, under Gude and Schirmer.

In the autumn of 1853 Hertervig had a schizophrenic breakdown and returned to Norway where all attempts to cure him failed. After he was released he spent six years with relations at Borgøya, near Stavanger, and he eventually settled in Stavanger. There he painted one of his most accomplished works, *Forest Lake* (1865), whose blues and browns are hallmarks of his painting. It is a dreamy vision of a primeval paradise, but one in which man has no part. The implied spiritual quality is somewhat akin to that in the work of the English artist Samuel Palmer, a contemporary of Hertervig. These characteristics set it apart from other Nordic painting of this time.

Far more typical of continental landscape painting were the works of the Norwegian Ludvig Munthe (1841–96), a student of the Düsseldorf landscape painter Sophus Jacobsen (1833–1919). Munthe had first studied art in Bergen with F. W. Scheirtz, before he went to Düsseldorf in 1861. Then, after visits to Paris in 1878 and 1880, he came increasingly under the influence of Corot and the Barbizon school, as can be seen in *Autumn in the Woods* (1882). This quality links him to the next generation of Norwegian artists, who rejected many of the values of the Düsseldorf school, rather than to his own.

The art produced by the Düsseldorf school is often considered to be excessively sentimental and contrived, though it enjoyed great popularity at the time. More acceptable today are the less saccharine landscape paintings produced by other Nordic artists associated with Düsseldorf. In Denmark, Johan Frederik Vermehren (1823–1910) was a childhood friend of the Danish artist Jørgen Roed (see Chapter 2), who taught Vermehren to paint in Jutland when he was only six years old. He painted the flat, bleak heaths of his native province, a subject formerly considered unworthy of attention. In *Study of the Heathland* (1854), the rust-coloured plains spread out like the sea in works by Casper David Friedrich: both their œuvres evoke a metaphysical infinity. Vermehren's paintings document, by their realistic detail, a natural feature of Denmark now almost entirely obliterated by cultivation and industry. The work for which the study had been made, *A Jutland Shepherd on the Heath* (1855), contains the figure of a shepherd whom Vermehren had met, but he seems out of place, despite the realistic detail. Indeed, it is as if Vermehren is attempting here to suggest a link with the kind of painting of the Roman Campagna which he might have seen as a student in Rome in 1856.

The Swedish artists Marcus Larson (1825–64) and August Jernberg (1826–96) painted works which typify Nordic painting of this period, though each painted different subject-matter. Whereas Larson worked on marine and landscape paintings, Jernberg is best known for his lyrical city scenes. Larson went to the Konstakadamien in Stockholm in 1843 and by 1844 had produced a very able self-portrait. In 1848 he won an award for the best depiction of an oak tree. He developed an interest in seascapes through his contact with the Danish marine artist Vilhelm Melbye (1824–82), whom he met on visits to Copenhagen. *The Frigate Josephine and the Corvette Lagerbjelke in Norway* (1852), which derives from his experience while on a cruise to the North Sea, is one of his best marine paintings; the great ships sail by in a magical Swedish landscape, luridly illuminated by an orange and red sky.

Larson went to Düsseldorf in 1852, where he trained under the Swede Andreas Achenbach. In 1853 he painted a work in collaboration with Kilian Zoll (a friend from his

70 **August Jernberg** *View Over Düsseldorf c.* 1865

Konstakadamien days), *Shipwreck on the Swedish Coast*. This was one of a number of paintings on which the two artists had collaborated: both had painted *View of Öresund* (1850), after taking the advice of a marine officer on technical matters relating to ships and conditions at sea.

Though a skilled portraitist, as his sensitive and richly coloured painting of Zoll confirms, he was most noted for his ability to paint the vital and rugged quality of Swedish nature. His extremely popular *Waterfall in Småland* (1856), though painted in Paris, is an example of his work at its most dramatic. The movement of the roaring cascades, on which sharp contrasts of light and shadow fall, gives a theatrical dimension to the Swedish countryside which appealed to his contemporaries. This painting was greatly admired not so much by the members of the Swedish parliament, who Larson had expected would purchase it, but by the famous Finnish poet Johan Ludvig Runeberg, who became his friend and patron. A well-travelled man, Larson visited Runeberg at Porvoo in Finland, and also went to London in 1862, where he hoped to exhibit at the World Exhibition. He died there, in 1864, after a prolonged illness.

XI

Jernberg, from Gävle on the Baltic coast north of Stockholm, had moved to the capital as a youth to attend Hill's school. He then studied at the Konstakadamien from 1843 to 1846, and subsequently went to Paris, where he spent the next eight years. More important, however, for Jernberg's artistic inspiration was his time in Düsseldorf, where he went in 1854 and remained, except for short travels, for the rest of his life. A skilful portraitist, he also produced a number of works based on Nordic mythology. Most admired, though, are the numerous paintings of local scenes in and around Düsseldorf. His *View Over Düsseldorf* (*c.* 1865), full of brilliant colours, depicts a view of the trees and rooftops of the city with a delicacy and poignancy that inspired other Nordic artists to paint views of their own Scandinavian towns and villages.

70

* * *

71 **Carl Eneas Sjöstrand**
Henrik Gabriel Porthan 1864

Sculpture in Finland and Norway began to develop considerably in the 1850s. No longer were the plastic arts restricted to isolated and solitary figures. In Finland, Carl Eneas Sjöstrand (1828–1906), though born in Sweden, has been called the father of Finnish sculpture because of the many young sculptors he trained at the Finska Konstföreningens Ritskolan (Finnish Art Society's Drawing School).

71

Sjöstrand had attended the Konstakadamien in Stockholm from 1843 to 1855, before he moved to Copenhagen to study under Bissen. Then in 1856 he went to Finland in the hope of receiving the commission to produce a monumental sculpture of the historian Henrik Gabriel Porthan, whose chief work, *On Finnish Poetry*, introduced Finnish folk poetry to a wide European public. The Finnish Literary Society finally gave Sjöstrand the commission, and the bronze monument was completed in 1864. It is Neo-classical in style, which shows the influence of Bissen. This was the first public monument to be unveiled in Turku, and it earned Sjöstrand great renown in Finland, which now became his adopted country.

Walter Runeberg (1838–1920) also worked in the Neo-classical tradition. The third son of Finland's famous poet Johan Ludvig Runeberg, he lived in Porvoo, on the Gulf of Finland east of Helsinki. He was a student of Sjöstrand's in Helsinki and exhibited at the Drawing School's exhibition in 1857, the first one of its kind to include sculpture. His work there earned him considerable acclaim. In the same year he became a pupil of Ekman's in Turku, and then went to study under Bissen in Copenhagen until 1862. He lived in Rome for fourteen years, and then in Paris from 1876 to 1893. His and Sjöstrand's work are the best examples of Neo-classical sculpture in Finland.

Runeberg's *Apollo and Marsyas* (1874), the first major Finnish sculpture executed in marble, was commissioned in 1867 by a ladies' society from Helsinki. (They contributed to lotteries in 1870 and again 1874, which was a common way of accumulating money to produce such works in Finland and Norway.) *Apollo and Marsyas* was only one of many works which Runeberg produced on classical themes. Other sculptures were often of Finnish cultural figures. His best-known work (though the subject is now unknown to

74

73 **Julius Middlethun**
J. S. Welhaven 1863

many of its admirers) is a bronze monument (1878–83) to his father, Johan Ludvig Runeberg. It is situated in the Esplanaden, at the centre of Helsinki, and on its base is engraved Finland's national poem, 'Our Country', written by Runeberg.

Classical and historical figures were not the only subjects which had come to occupy Finnish sculptors by the late 1860s. Johannes Takanen (1849–85), the Finnish-speaking son of a peasant farmer from Urpala near Viipuri (now a part of Russia), had also become a student of Sjöstrand. From 1867 to 1873 he pursued further training under Bissen in Copenhagen and then proceeded to Rome. Nevertheless, in spite of this continental training, it is his Finnish themes which are of greatest interest. *Aino* (1876), produced in plaster, though posthumously carved in marble, is of the beautiful maiden from the epic *Kalevala*. She was one of his favourite subjects, and is here sensual and alluring, for all the restrained Neo-classical form. Such works proved extremely popular and another, *Rebecca* (1876–77 in plaster, 1878 in marble) won him First Prize in the 1876 State Sculpture Competition.

In Norway two leading sculptors stand out from the second half of the nineteenth century, Julius Middlethun (1820–86) and Brynjulf Bergslien (1830–98). Middelthun was born at Kongsberg, where his father made medals and moulded the presses for the production of coins at the Mint. This background facilitated his endeavours to learn engraving and in 1836 he went to Christiania where he took work at a goldsmith's. He was also an accomplished draughtsman and in 1839 he entered the Tegneskolen; in the following year he transferred to Copenhagen to study under Bissen at the Kunst-akadamiet.

In the 1840s Middlethun became greatly attracted to poetry, especially that by Grundtvig and Oehlenschläger. This probably accounts for the lyrical quality of such sculptures as *Eros with a Dove* (1847). He left Denmark in 1851 for Rome, visiting Belgium and France on the way. In Rome, the Danish sculptor Jens Adolf Jerichau and the Swede Bengt Erland Fogelberg exerted the greatest influence on him. In 1860 Middelthun returned to Norway where he produced a number of able busts: *J. S. Welhaven* (1863, marble; 1867, terracotta) was commissioned by the Studentsamfundet (Student Society) and shows Welhaven with considerable sensitivity, avoiding a certain gravity which pervaded many inferior works of this period. The eclecticism of Middelthun's style, however, is best exemplified by a later work, his bronze bust of the composer Halfdan Kjerulf (1871–74), which achieves a Byzantine expression through its icon-like form and the far-away focus of the eyes.

73

The sculptor Brynjulf Bergslien, from Voss in Norway, had come from an artistically gifted family. He studied first in Christiania and then for a brief period in Berlin, before going to Copenhagen, in 1852, where he learnt engraving and medal-making. This training was succeeded by studies at the Kunstakadamiet with first Jerichau and then Bissen. In 1864 he went to Rome. When he finally returned to Norway, his lessons abroad and the careful anatomical studies he had made placed him in a very advantageous position. Thus, when a national fund was opened for a monument of King Karl Johan to celebrate fifty years of Norwegian-Swedish union, Bergslien received the commission: his *Karl Johan* (1868–74) looks back to the seventeenth-century Baroque sculptures which Bergslien had seen in Rome, as well as to the famous equestrian monument of Marcus Aurelius. Its style is in great contrast to that of a much later work by Bergslien, the charming and intimate, unfinished plaster model, *The Shepherd Boy's Dream* (1898).

74 (OPPOSITE) **Walter Runeberg** *Apollo and Marsyas* 1874

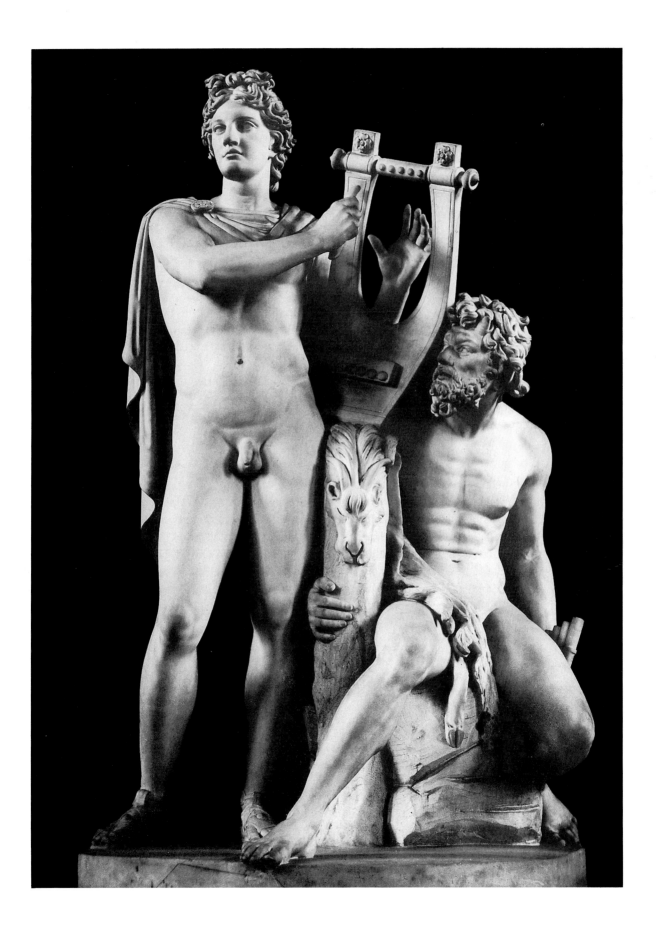

Skagen

1830-1910

Many innovative painters in the 1860s began to seek release from what they had come to consider was the rigid and academic instruction of the Düsseldorf school. Moreover, Denmark's defeat by Prussia in 1864 over the Duchy of Schleswig-Holstein strengthened the Nordic reaction against continental domination of the arts. Danish artists thus turned their attention away from political and historical subject-matter, as well as from landscape works with sweeping and majestic panoramas. Instead, they began to paint less dramatic landscapes, and portraits of people especially chosen to represent dignity, reserve and traditional rural virtues.

A precursor in this trend was the internationally acclaimed author of many of Europe's most beloved fairy tales, Hans Christian Andersen (1805–75). The son of a shoemaker from the city of Odense on the Danish island of Fünen, Andersen had tried his hand at music, ballet and the theatre. His career in these pursuits in Copenhagen, where he had moved when he was sixteen, proved both brief and unsatisfactory, but his literary and artistic talents soon made themselves obvious and rapidly earned him success. Since early childhood Andersen had loved to sketch and draw. In 1830 he visited Viborg in Jutland to see the cathedral, with the painter Martinus Rørbye, and Andersen was inspired to sketch a number of landscapes and views. The experience of doing such drawings served him in good stead during his travels in Germany and Italy in the early 1830s. Other than Rørbye, Andersen knew several artists, but their influence on his work was not as great as Rørbye's. Many of his drawings from this period have a naïve charm that captures the local Jutland atmosphere, much as do the short stories of the author Steen Steensen Blicher, whose works Andersen admired.

When Andersen was passing through Dresden on his way to Italy, he visited Johan Christian Dahl whose personality greatly impressed him, though his landscapes had little effect on Andersen's work. Rather, it was the paintings of the Dutch artist Hieronymus Bosch, which he saw in Berlin, that had the greatest influence on his drawings, particularly Bosch's *The Day of Judgment*, despite all the abuse Andersen cast on it in his writings. One such drawing, filled with spectral, grotesque figures, is *Walpurgis Night* (1831), made while Andersen was travelling in the Harz Mountains. It was possibly intended to illustrate Goethe's *Faust*, which he greatly admired. *Walpurgis Night* also commemorates the eve of the First of May when the end of winter is celebrated in much of Scandinavia. On his travels through Italy in 1833 and 1834 it was naturally the art and the landscape that provided Andersen with many of the images in these pen and ink drawings.

That Andersen found inspiration in Italy at this time was something shared by many other Nordic artists. However, Andersen's works of the 1840s and 1850s, including the sketches and drawings he did on his extended travels in the Balkans, Turkey, North Africa and the Iberian Peninsula, are quite distinct from similar work by his contemporaries in their simplicity of line and decorative manner.

Andersen's papercuts and collages are perhaps his most interesting and original work. These were made in the 1850s and 1860s to entertain the aristocratic families with whom Andersen stayed on his many travels in Scandinavia and Germany. They display a remarkably subtle and intimate sense of line and form. A papercut of 1865, produced at Frisenborg Manor in Denmark, is rich in anecdotal detail, with dancing ballerinas, clowns and angels filling the many stages. By contrast, *Collage with Clippings Related to the Danish Playwright Ludwig Holberg and Weber's Opera, Der Freischütz* has a compositional unity and simplicity, heightened by the gold, yellow, pink and blue cut-outs, which seem to predict the art of the 1930s.

For all the interest of these idiosyncratic works, Andersen's importance lies in the fact that he first brought the northern-most Danish peninsula of Skagen to the attention of

75

Nordic artists. In 1839 Steen Steensen Blicher had written the poem 'Grenen' which is a eulogy of Denmark's most northerly point, but few people took much notice of Skagen or considered it worth the journey. Andersen changed this attitude. In glowing terms, he exclaimed in 1859: 'We will visit this far-flung corner of Denmark, a desert between two roaring seas, the town which has neither streets nor alley-ways, where seagulls and wild geese fill the air over the undulating sand dunes and the church buried beneath the encroaching sand. Are you a painter? Then make your way up here, for there are motifs enough for you, here is scenery for poetry; here in the Danish landscape you will find an aspect of nature which will give you a picture of Africa's desert, of the ash heaps of Pompeii and of sandbanks in the great ocean above which birds soar. Skagen is worthy of a visit.'[19]

As mentioned in Chapter 2, Rørbye too had visited Skagen in 1833, and he returned there again in 1847 to paint, among other works, a rescue boat on its way to aid a foundering vessel. It is a richly colored painting whose heavy impastos vividly represent the raging foam of the sea. Vilhelm Melbye (1824–82), a noted marine painter, as were his brothers Anton (1818–75) and Fritz (1826–69), had also paid a visit to Skagen in 1848 and had painted a view of its town. Later, the able Danish marine artist Carl Frederik Sørensen (1818–79) visited Skagen in the 1850s and painted seascapes. Yet none of these painters can be said to have laid the ground work for the most important Nordic artistic colony which was soon to establish itself there: that was the result of Andersen's enthusiasm and that of a young student from the Kunstakadamiet in Copenhagen, Michael Ancher (1849–1927).

Ancher, a native of the Danish island of Bornholm off the south-eastern coast of Sweden, went to Skagen for the first time in 1874 in the company of the painter Karl Madsen (1855–1938), who was the leading Danish art critic of the late nineteenth century. Ancher found the unspoilt fishing community so artistically stimulating that he settled at the tiny Brøndum's Inn there, owned by the local merchant, Degn Brøndum. Ancher soon became infatuated with his host's step-sister Anna Brøndum (1859–1935), who became his wife in 1880 and who was also a remarkable painter (see below). From a simple studio in Brøndum's garden, Ancher worked in the tradition that had been established by Dalsgaard, Marstrand and Vermehren earlier in the century, that of painting the character of working people. Ancher, a skilful portraitist, often employed as models rustic locals, and one of them, Lars Gaihede, a fisherman, was his principal model until he died in 1887. Gaihede was also the favourite model of the Norwegian artist Christian Krohg, and of Ancher's wife Anna Ancher. Michael Ancher's *Portrait of Lars Gaihede* (1880) is painted in a style that has clear affinities with that of Frans Hals. Gaihede is portrayed in a monumental manner with a free brushstroke, in a way that emphasises the sitter's enigmatic personality. His eyes peer out at the viewer from beneath heavy eyelids, with a suspicious, quizzical look that hints at disapproval. Indeed, social intercourse between the poor fishermen of Skagen and its prosperous merchants was often less than happy and the sudden arrival of middle-class artists further strained the established texture of Skagen society.

Michael Ancher's work was not restricted to subjects from Skagen. While on a visit to his native Bornholm in 1879, he had painted a work which is stylistically very different, *By the Sickbed. A Young Girl Reads the Bible for the Old Lady in the Alcove* (1879). Here too the face of the old lady is portrayed with insight, with a far-away look in her eyes. However, whereas the painting of Gaihede shows the influence of Impressionism, this earlier work is painted with less broad brushstrokes which enabled Ancher to show many realistic details, and an almost photographic depiction of tones and textures. The

75 **Hans Christian Andersen**
Collage with Clippings Related to the Danish Playwright Ludwig Holberg and Weber's Opera 'Der Freischutz'
1865

76 **Michael Ancher** *Young Woman Ill in Bed* 1883

wooden cabinet reflecting light and the various textures of cloth and wallpaper have been painted with a virtuosity that is rare in Nordic art and only Ancher's later group portrait, *The Brøndum Family Picture, Christmas Day 1900* (1903), possesses a higher level of psychological penetration in the portrayal of Anna Ancher's mother, Ane Hedvig Brøndum: she is the focus of the picture and yet remains isolated in her own sad inner world. (She herself stated that she was weighed down by the death of loved ones, an unhappy marriage and the trials of life.)

Ancher had been able to maintain Skagen as his more or less private artistic domain. Other artists, who also lived there, or merely passed through, did not seriously challenge his position as the most celebrated artist in Skagen. The arrival, in July 1882, of the Norwegian-born Peder Severin Krøyer (1851–1909), intrigued by Skagen's fame as an artistic colony, changed this state of affairs. Krøyer appeared on this provincial scene as a worldly man, newly returned from Paris and other European travels, and Ancher felt threatened by him. In November 1882, only four months after Krøyer's arrival, he felt compelled to write to him: 'You are painting the shop at my parents-in-law, you couldn't come any closer than that … it was truly an attack on one's firm ground; it makes one think about the rich man, who had many sheep, but who butchered the poor one's only lamb.'[20]

79 Krøyer's *At the Grocer's When There Is No Fishing* (1882) demonstrates the great facility which so disturbed Ancher and aroused his jealousy. The interior of Brøndum's shop is depicted in soberly realistic detail, with great emphasis laid on the rugged characters of the people, testifying to Krøyer's respect for these fishermen. He and Ancher later became friends, even though Krøyer's works enjoyed a popularity which Ancher's painting never achieved. Krøyer used Impressionist techniques which he had learnt while in Paris as a student of Léon Bonnat. Whereas Ancher had come to be

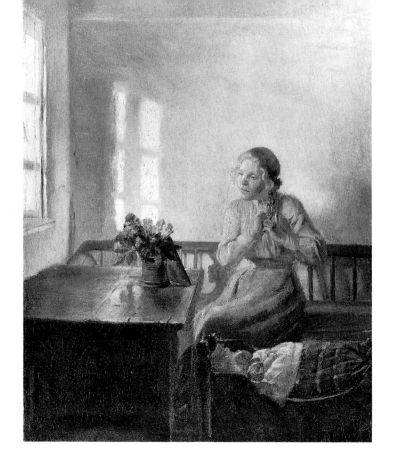

77 **Anna Ancher** *Interior with a Young Girl Plaiting her Hair* 1901

interested in painting in early manhood, Krøyer, at a younger age, had assisted his foster-father, a zoologist, in illustrating zoological works.

When he was only twenty-two Krøyer won the gold medal of the Kunstakadamiet in Copenhagen, where he had studied under Vermehren. This had enabled him to travel extensively on the Continent. In 1875 he visited Germany and Austria and while in Munich met another Norwegian artist, Eilif Peterssen (1852–1928), who also visited Skagen and who became a life-long friend of Krøyer's. In 1877 he travelled to the Low Countries and France, financially supported by Denmark's leading patron of the arts, the Jewish industrialist Heinrich Hirschsprung (who amassed the finest collection of Danish late nineteenth-century paintings, which he presented to the Danish nation in 1902).

In 1879 Krøyer travelled in Italy, Spain and France, where he joined the artists' colony of Cernay-la-Ville, near Barbizon. From there, on a foray to Paris, Krøyer met the most important cultural personality of late nineteenth-century Scandinavia, the Danish-Jewish intellectual Georg Brandes (1842–1927), a polemicist and aesthetician who influenced Nordic art and literature to a degree never equalled before or afterwards by another Dane. His fiery personality is brilliantly conveyed in a painting by the Dane Harald Slott-Møller (1864–1937), *Georg Brandes at the University of Copenhagen* (1889), which 80 emphasises both the frustration and the power in Brandes. The Skagen painters, including the playwrights Henrik Ibsen (see below) and August Strindberg (see Chapter 6), were but some of those who took Brandes' teachings to heart and propagated them.

Brandes was influenced in particular by Hippolyte Taine's *Histoire de la littérature anglaise* (1864–65), which impressed him by its claim that a work of literature expresses the psychology of a whole nation as well as reflecting the values of its middle-class writers; such ideas were prevalent in Danish literature also during this period. Brandes thought that Denmark needed a cultural rejuvenation to put an end to what he felt was its

mediocre culture. He wrote: 'Our literature is like a little chapel in a great church: it has its altar, but the great altar is not here.'[21] This 'great altar' was in Paris and it was there that he looked with admiration for literary and artistic inspiration. Gustave Flaubert's *Madame Bovary* seemed to Brandes to embody his own notion of realism. When Brandes published his influential work *The Modern Breakthrough Men* (1883), the breakthrough from Romanticism to Realism was nearing its completion: Realism was triumphant in the arts as well as in literature. Skagen seemed to Brandes to offer a new focus for the realization of Realist precepts. As he wrote in *The Air* (1910), 'Skagen does not lend itself to thoughts of death. The area's guardian angel possesses a fresher vitality than any other local deity in Denmark. I have seen it before me, powerful and fine and fair, with thick golden hair blown by a fresh wind and a pure, noble profile, clothed in a long white cape with a border of foam at the bottom.'[22]

Such an exalted view of Skagen is to be found in a work by the Skagen poet-painter Holger Drachmann (1846–1908). *Grenen, Skagen* (1907), though painted in winter, is a symphony of blue and yellow tonalities which embody the vitality of sand, sea, wind and sky. Brandes must have seen this painting when he wrote: 'The leading figures in Skagen are the air and the sea, a dissimilar and yet harmonious pair, which is changeable and at the same time a still image, reddens and at the same times darkens, becomes angry and storms.'[23] This work, though late in the history of Skagen as an artists' colony, must be seen as the culmination of a life-long relationship with the area, for Drachmann was a frequent visitor to Skagen from 1871 onwards, not long after he had completed his studies under the Danish marine painter Carl Frederik Sørensen.

Drachmann had written a short story about Skagen in 1874, 'From the Region of the Sand', included in his collection *In Storm and Stillness*. In it, a man from Copenhagen joins the fishing community and makes great efforts to become part of its society and share its identity, but he fails to do so because his roots are in the sophisticated surroundings of the city and he cannot ever be really at home in a simple country environment among working people. Drachmann here touched on the predicament of the newly arrived artists at Skagen: that of sophisticated people who had fled Copenhagen and other cities and attempted, usually during the summer months, to integrate themselves into a provincial and impoverished society which viewed them as intruders. Ultimately they were obliged to acknowledge defeat.

The inability to integrate fully in Skagen's local life and its picturesque simplicity was not only because, for these metropolitan artists, it was little more than a utopian fantasy. The changes taking place in Skagen itself were beyond their control: rail, steamboats, improved roads and an increase in tourism had the same effect on the daily life in Skagen as at any contemporary beauty-spot, whose natural attractions have been taken out of the context of the ordinary life of its inhabitants. And it was not only artists and writers who flocked there in growing numbers, but also the more affluent bourgeois families from Copenhagen, seeking the pleasures of a seaside resort. As Drachmann summed up in *The Creation of Skagen* (1887): 'There are people of all nations, yet it is the Danish contingent which is largest. One "does" this beach, these fishermen. ... Of course one doesn't limit oneself to this. One eats together in company with or without some friction, taking meals at the splendid inn, which just now has achieved European renown like those inns on the coast of Brittany or in the area about Fontainebleau.'[24] For all the disenchantment evident in these words, Drachmann still remained attached to Skagen and in *Raabjerg Mile* we still see proof of his melancholy attachment, which lasted until the end of his life. It was here, by the shores of the sea, that Drachmann chose to be buried.

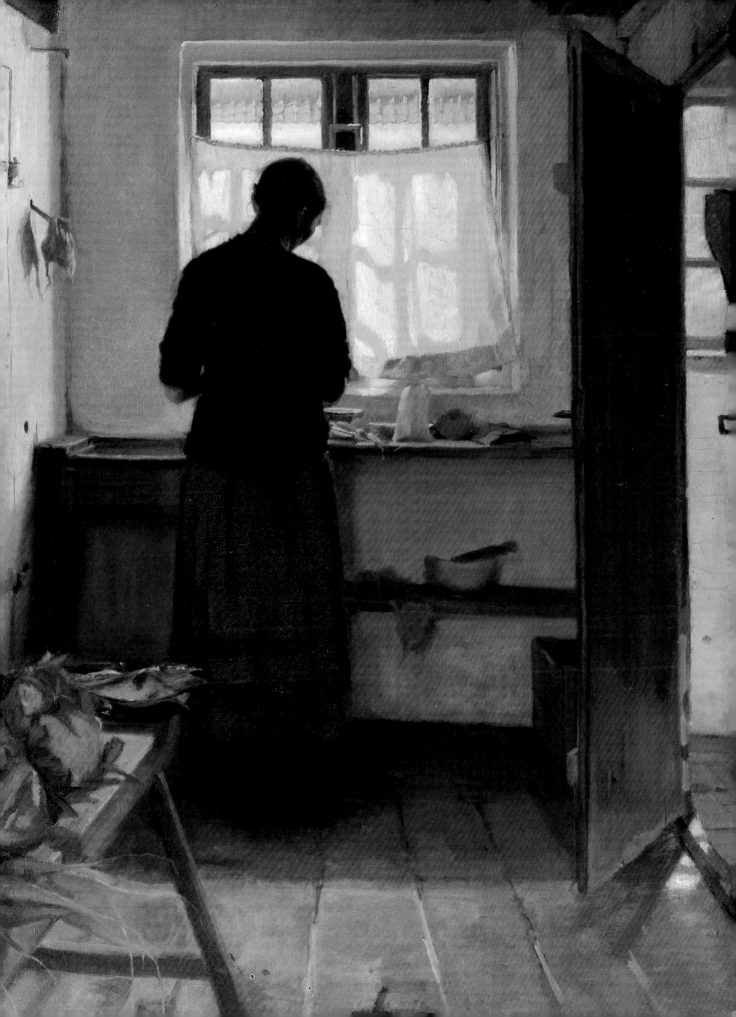

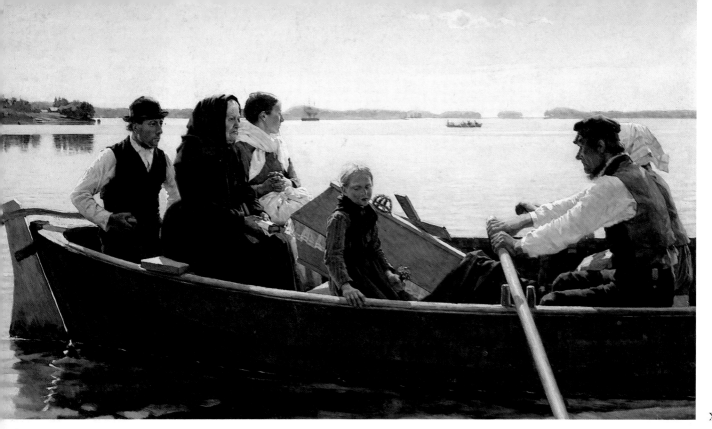

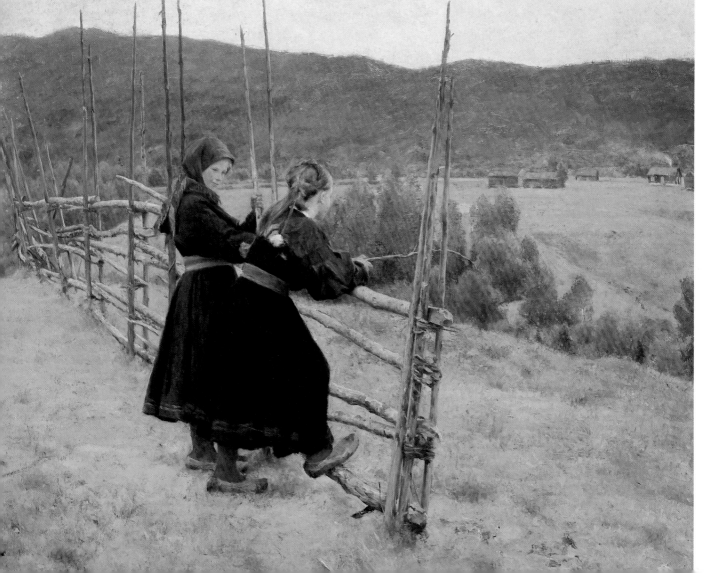

XVII

The weather at Skagen can be blustery and dull or still and dazzling, sometimes even tranquil and intimate, moods which the light of the area also reflected. Two of the artists who painted these moods with great sensitivity were Viggo Johansen (1851–1935) and Anna Ancher. Johansen, with Krøyer and other artists, had spent his summers, while a student at the Kunstakadamiet in Copenhagen, painting genre scenes at the picturesque fishing village of Hornbaek on Zealand. He moved to Skagen in 1875 but as he was used to the lush woods of his native Zealand, he was not, at first, taken by Skagen. He wrote: 'It was difficult for me to accustom myself to the spartan and bleak nature and the very primitive and far less attractive inhabitants. Despite this, the conditions were good to work under, no people from Copenhagen [and] easily accessible models. However, I missed enormously the trees and the marvels of summer in Zealand.'[25]

Nevertheless, he stayed on with his wife in the old post office in Vesterby, far removed from the activity in Østerby, the hub of Skagen, and in isolation from most of the other artists. This seclusion allowed him to devote himself entirely to his family and the painting of domestic scenes. Johansen had married in 1880 Martha Møller, Anna Ancher's cousin, and it was his wife who is the model in what is perhaps his best work, *Kitchen Interior with the Artist's Wife* (1884). It portrays her in their house, which he later described as 'three furnished rooms with a delightful kitchen, everything charming, old-fashioned, perhaps a little run down, but we are both delighted over it.'[26] There is a sad, quiet air about the work, in which Martha Johansen is shown arranging flowers and plants on a rough wooden table, the copper utensils above providing the only bright note. Many years later, towards the end of her life, she described her psychological circumstances at that time: 'I wasn't happy any longer in Skagen. Not that I was melancholic, I was so young, only twenty-three years old, but I didn't feel happy and wasn't happy. Henriette [her sister] was dead, mother was dead, I had three small children, Harry [Henriette's child] was in Copenhagen and I was about to have Gerda.'[27] Johansen's *Kitchen Interior* seems to hint at the inner sorrows and personal difficulties which his wife was experiencing in Skagen.

Anna Ancher had similar perceptions and feelings that became the subjects of her own painting. She occupies a special position in Skagen's artists' colony. Her work has earned her a unique reputation in Danish art: she achieved a standard of painting unrivalled by any other Danish female artist and on a par with few other Nordic artists of any period. As the Swedish painter Oscar Björck (1860–1929), who frequented Skagen, wrote: 'she was like a ray of sunlight, and there was something in her painting, which none of the rest of us possessed to the same degree – a quiet devotion to her work and a use of colour which was so full and juicy, that one enjoyed it like a ripe fruit.'[28] One of her best paintings is *Lars Gaihede Carving Wood* (1880) in which the old fisherman is depicted ruddy as an apple. This portrait's psychological characterization has an intensity that far surpasses the works her husband produced with the same model. Perhaps her best painting is *The Maid in the Kitchen* (1883–86), a meditation on domesticity. The theme is the same as in Johansen's later *Kitchen Interior*. The girl performs her work in reverence and silence, light streaming in from the window before her; the open door gives the scene a religious-like aura. The colours are intense and vibrant, and there is a poignant intimacy in the work which owes a debt to Jan Vermeer and Pieter de Hooch. The strong contrast between light and shade derives from the lessons she had at Vilhelm Kyhn's drawing school for ladies in Copenhagen. In 1888, Anna Ancher accompanied her husband to Paris where she came under the influence of Puvis de Chavannes, with whom she studied for six months. Subsequently, her work began to show a greater emphasis on mood, with Symbolist overtones.

78

81

XIV

78 **Oscar Björck** *In the Village School* 1884

SKAGEN

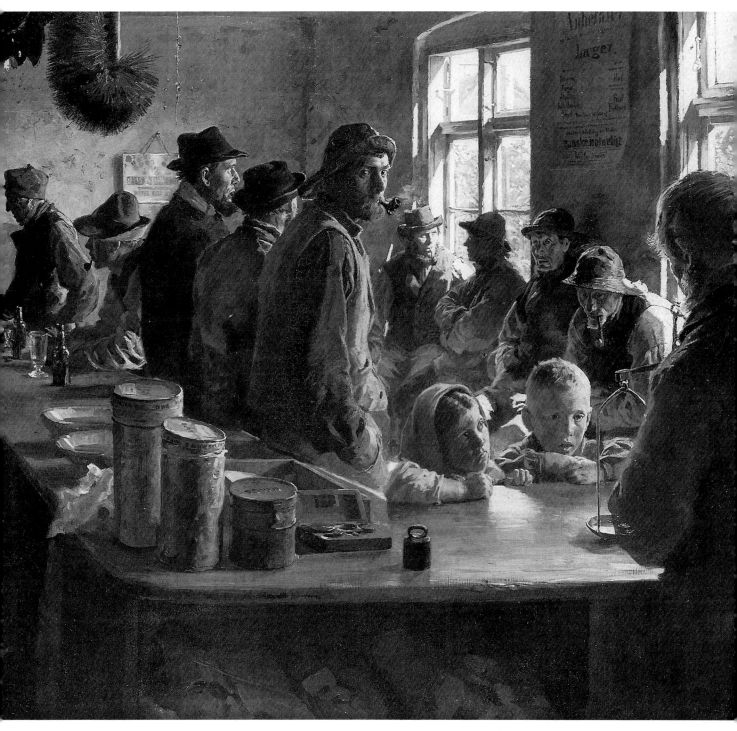

79 **Peder Severin Krøyer** *At the Grocer's When There Is No Fishing* 1882

80 **Harald Slott-Møller** *Georg Brandes at the University of Copenhagen* 1889

81 **Anna Ancher** *Lars Gaihede
Carving Wood* 1880

The increasing importance of mood and symbolism was not restricted to the works of
Anna Ancher; it was part of a general trend that, at the end of the nineteenth century,
became common throughout European art and literature. Realism had come to seem as
subjective a concept and style as any other, and faith in the notions of progress and 'the
good' as embodied in common life was waning. Drachmann had gradually rejected his
communistic ideology and finally became a conservative and a royalist. Even the radical
Georg Brandes came to espouse an elitist view of mankind, based largely on his
interpretation of the philosophical writings of Friedrich Nietzsche (1844–1900), in which
a loathing of Judaeo-Christian and middle-class values became coupled with a belief in
the superiority of the human will.

117

82 **Christian Krohg** *Portrait of Lucy Parr Egeberg* 1876

Brandes' views, which purported to espouse Nietzschean ideas, were formulated in a book entitled *Aristocratic Radicalism* (1889). In it, Brandes turned against many of his own previous beliefs and the so-called *Tendens* (a Danish word which means an inclination or tendency, in this context, for the purpose of agitating) approach to art and literature which aimed to produce works that provoked indignation in the viewer or reader, thereby compelling him to act and change society. By 1890 he was exclaiming, 'What one here has condemned as Tendens, is nothing else than the century's spirit, its ideas. ... That which one calls progress is a sick snail.'[29]

Despite *Tendens*'s success in the literature of the period – Ibsen's portrayal of crushed female identity in *The Doll's House* (1879) and Christian Krohg's novel *Albertine* (1886) about the problems of prostitution – in painting it seems contrived and sentimental. Its most memorable examples are to be found in Krohg's paintings. *Albertine in the Police Doctor's Waiting Room* (1886–87) and *Struggle for Existence* (1885–87). In the former, a young girl entering the life of prostitution finds herself for the first time awaiting a medical examination for venereal disease, while in the latter impoverished children in Christiania grasp hungrily for food given out by a charity kitchen. These works are painted with generous Impressionistic brushstrokes, yet in their theatricality they are stylistically more related to Realist painting of the mid-nineteenth century than Impressionism.

83

* * *

118

83 **Christian Krohg** *Albertine in the Police Doctor's Waiting Room* 1886–87

84 **Christian Krohg** *Tired* 1885

85 **Edvard Munch** *Ibsen in the Grand Café* 1902

85 Henrik Ibsen (1828–1906) devoted much time and effort to painting in his early life. He produced a considerable number of works which cover a wide range of subjects, from views of Norwegian fjords to designs for costumes and caricatures, many of them, in provincial Norwegian museums, now hardly ever seen. He spent one year at the Tegneskolen (Drawing School) in Skien, in the south of the country, after which he became a student of the painter Mikkel Mandt (1822–82) from Telemarken, who is most noted for his portraits. Ibsen then moved to Bergen. There he experimented with watercolours, with the help of a little-known artist, Lasting, whose œuvre ranged from altar pieces to medical illustrations. More important for Ibsen, however, was his training in Christiania under Magnus Bagge (1825–94). This Düsseldorf-trained painter was important to Ibsen not only as a teacher, but also as a model for characters in Ibsen's writing.

At the age of fourteen, Ibsen had painted a watercolour for his great-uncle Nicolay Plesner, *Store Follestad near Skien* (1842), which depicts Plesner's prosperous estate. A naïve painting, its broad planes of colour and linear emphasis give it an appealing simplicity. Though his success as a writer led him to spend less time painting than writing, he was always torn between the two. But his son Sigurd wrote, 'It makes one shake one's head to think that at one time in his life he wanted to give up writing to devote himself to painting. The world can thank my mother that it had one less bad painter and a great poet instead.'[30] This, at least in retrospect, seems unfair to Ibsen. His landscapes from Møre and Romsdal of 1862 confirm that he had no mean artistic ability and that he was still interested in painting at that late date, even though it contradicts his own statement that he gave up painting in 1860 to write *Love's Comedy* and *The Pretenders*. However one may judge his paintings today, there is no doubt that a painterly vision permeates his plays. As Edvard Munch wrote, 'There is no point in painting winter after Ibsen has done that in *John Gabriel Borkman*.'[31]

120

Light and nature, and their relationship to art, have signified different things at different times. In the last quarter of the nineteenth century, a great number of artists in the Nordic countries used these words specifically. Light was that of the Nordic sky: it could be the gentle haze given off by the sun in summer as it dipped below the horizon just before midnight, only to rise against shortly after; or it might be the blue-white light of the moon in winter, reflected off the glistening snow. Nature was that of the forests, moors and coasts of these countries, wilder, more sparsely populated and of greater expanse than anywhere else in Europe. These powerful characteristics of light and nature inspired native artists in the 1870s to produce specifically Nordic art.

Nature, Light and Mood
1870-1910

Political issues also greatly influenced the art of the Nordic countries in the 1870s. The Prussian-Danish War of 1864 had left Denmark shorn of Schleswig and economically drained. The failure of any unified Nordic military force to defend Denmark and Sweden's political neutrality brought home to their artists the limitations of the ideal of pan-Scandinavianism, which envisioned a great brotherhood of all the Nordic nations (and partly consisted of nostalgia for the Kalmar Union of 1387 to 1483, when these countries had been joined together under one crown). Secessionist sentiments in Norway, united since 1814 with Sweden, were growing, and in Finland an increasingly brutal Russian oppression was causing widespread strife. Even in Iceland, resentment against its union with Denmark was beginning, despite Iceland's almost total dependence on Copenhagen. Furthermore, industrialization and massive emigration were fracturing the rural society of these countries, so that many people, and in particular artists, looked back longingly to a mythical, Arcadian past. Some artists felt that one way of escaping from the social and political pressures was to concentrate in their work on the mood of a particular landscape in their native countries.

One of the earliest works which illustrates this tendency was painted by one of Norway's most talented artists, Kitty Kielland (1843–1914). *Peat Bog* (1880) was painted in Paris the year after Kielland, a sister of the author Alexander Kielland (1849–1906), arrived there with her life-long friend the artist Harriet Backer (1845–1932). Kielland had become a student of Gude's in Karlsruhe in 1873, but two years later she had moved to Munich where she and Backer entered the art school for women which Eilif Peterssen had established there. Although *Peat Bog* has colour and tonal affinities with those often found in Gude's works, it owes a greater debt to the inspiration of the landscape and atmosphere of Jaeren, in south Norway, which Kielland experienced in the summer of 1878. In 1879 she had done a drawing in ink of this landscape, *Abroad and at Home*, which her brother used as the background for his short story of the same name. For all the concentration on a melancholy and sombre mood of landscape, in which the atmospheric unity is more important than particular details of the moorland, Kielland generally eschewed overt symbolism, and strove instead to produce an objective depiction of landscape, following the tenets of Realism, popular in the 1880s in Scandinavia (see Chapter 5). These works were often based on *plein air* sketches or photographs.

Kielland's Nordic landscapes were received warmly by the public and by the Kunstforeningen (The Art Society, which had been founded by Johan Christian Dahl in 1836). As the principal purchaser and exhibitor of art during most of the nineteenth century in Norway, where private patrons were few in number and of limited resources, the Kunstforeningen usually purchased works by means of a lottery. This method benefited the Norwegian artists considered worthy and allocated ownership of the works to the lottery winner. Often, the income which thus accrued to these artists was of secondary importance because many of them lived abroad, where they earned their

86 **Ernst Josephson** *Portrait of Ludwig Josephson* 1893

livelihood through patrons in their host countries. The Kunstforeningen exerted an enormous influence on the arts at home, especially on those artists who were obliged to cater to the taste of the society's members, few of whom were artists themselves.

More revolutionary than the painting of Kitty Kielland was the work of the Swedish artist Ernst Josephson (1851–1906), born in a Jewish family which has been active in the cultural life of Sweden for over 150 years, first in theatre and then in painting. Josephson had gone to Eggedal in Norway in 1872, while a student at the Konstakademien in Stockholm, to find a more rural environment to inspire his painting than his life in Stockholm afforded him, and his work demonstrates the benefits of this stay. In a letter of 1872 to his mother, Josephson wrote: 'I have only experienced something like this in Beethoven's music. How powerful!…the sunlight plays on the valleys in the most charming of tones, while the shadows of the clouds, melancholy and enormous, fall gently on the mountains.'[32] To capture this musical and mystical quality of the Norwegian landscape, Josephson, in his painting *Näcken* (1882), has portrayed the water-sprite in a way which suggests the Greek sylvan god Pan, a recurring figure in Scandinavian art and literature of this time. Josephson employed a local boy to model for him in the woods, and he drew a variety of strikingly realistic sketches. These assisted him to create an allegorical figure who embodies the spirit and intense energy of Nordic nature. *Näcken* shows the influence of Titian and Velasquez in the use of colour, which is applied in broad and free brushstrokes. This style of painting proved difficult for some critics to accept, while the rude and naked figure of the youth disturbed the public, whose antagonism heightened Josephson's sense of alienation and aggravated his schizophrenic behaviour, a symptom of the syphilis he had contracted as a young man.

Josephson had first shown his volatile temperament in 1871 when he participated in a demonstration against the authorities at the Konstakademien. By the 1880s, his outspoken rebelliousness had earned him the reputation of an avantgardist and, when he showed his two versions of *Spanish Smiths* (first 1881, second 1882), many critics and members of the art establishment were outraged. It was not only that Josephson had portrayed a subject deemed unworthy. After all, Per Hilleström had depicted working men in the late eighteenth century. Viewers were shocked by what appeared to them as the ugliness of the figures, the crude, loosely painted, smug expression on their faces: these were not subservient workers, they were revolutionaries!

Other Swedish artists were also opposed to the Konstakademien's authority and tradition. This opposition was shared in particular by six artists who were to become the country's leading painters by the end of the century. They were Richard Bergh (1858–1919), Nils Kreuger (1858–1930), Karl Nordström (1855–1923) and Anders Zorn (1860–1920), actively committed for many years to reforms at the Konstakademien, and also Carl Larsson (1853–1919) and Georg Pauli (1855–1935) who were more briefly involved. When in 1885 Josephson assisted in the formulation of a demand to the Academy for thoroughgoing reform, including the right to choose instructors, greater freedom in the courses of study available and the abolition of medals and titles of honour, these artists provided the necessary support. They strove to create a new artists' society, which would provide an umbrella organization for their various reforms. (In this they were following the art students in Paris and the leading German cites, who had preceded them in the struggle for greater independence and self-determination.) In 1886 they established the Konstnärsförbundet (Artists' Association) which survived, though with diminishing importance by the end of the century, until after the First World War.

The Konstakademien against which they rebelled was a very conservative body. Two of its directors, Count Georg von Rosen (1843–1923) and August Malmström (1829–1901),

87 **Ernst Josephson** *Spanish Smiths* 1881

were widely acclaimed artists of historical and mythological subjects in the Neo-classical tradition. They were content with the principles on which the Academy had functioned since the early nineteenth century. They imposed on their students the tradition of drawing for several years from plaster models of antique sculpture before being permitted to advance to drawing models from life. Drawing, rather than painting, was the basis of the training. Von Rosen's *Erik XIV* (1871) illustrates this sort of painting. The picture shows the moment in the life of Sweden's sixteenth-century monarch when he hesitates to sign a death warrant for the rebellious Sture brothers. The virtuous queen Karin Månsdotter urges the king to abstain and the evil, false adviser Göran Persson urges him to sign; all is shown within the confines of a room depicted, by means of small, tight brushstrokes, with a dead, photographic realism.

Another academic painter at this time was Gustaf Cederström (1845–1933), an aristocrat from the estate of Krusenberg, not far from the university town of Uppsala, and a professor and director at the Academy. He also painted Erik XIV, using a later episode, *The Murder of Nils Sture* (1880). Whereas Von Rosen had taken stylistic inspiration from the Belgian history painter Hendrik Leys, with his ability to create a *tableau vivant* of important historical moments, Cederström's work reflects his studies in Düsseldorf in the late 1860s and his lessons under Léon Bonnat in Paris at the end of that decade. His **88** best work, *Karl XII's Funeral Procession* (1878), combines an intense realism of detail with a passionate interest in dramatic, historical moments. The seventeenth-century Swedish warrior-king is being borne by his mourning troops, but, for all the realism of the details of the costumes, it is a staged and stilted theatrical scene.

Josephson, too, had worked in the tradition of history painting and on a related theme. *Sten Sture the Elder Liberates the Danish Queen Kristina from the Convent of Vadstena*

88 Gustaf Cederström *Karl XII's Funeral Procession* 1878

89 **Carl Frederick Hill** *Landscape with Pines and Waterfall c.* 1880

(1876) was painted as a competition work. This theatrical tableau shows the queen (after her relinquishment of Swedish sovereignty and a year's imprisonment in Sweden) being freed to return to Denmark.

Such subjects were anathema to the rebellious young Swedish artists. Released from the constraints of the Academy, the *Pariserpoikarna* (The Paris lads, as the members of the new association who had studied in Paris were known) took the lead, at least in subject-matter, from Kitty Kielland and another Swede, Carl Frederick Hill. Hill (1849–1911), who had been a student at the Academy in Stockholm in the early 1870s, had come under the influence of Corot and the Barbizon painters. In his later life, before going insane in 1878, he achieved a poetic lyricism in his landscapes of dazzling luminosity. His work at its best can be seen in *Landscape. Motif from the Seine* (1877), a subtle painting of the atmosphere of the northern French landscape. When many of the Swedish artists who were studying in Paris returned to Sweden, they sought to capture, as Hill had done in France, the mood of their own countryside.

This reorientation in painting the Nordic landscape can be seen in the work of Nils Kreuger, the gifted descendant of an old merchant family, and in that of the two friends he made while attending the Konstakadamien's School in the mid-1870s, Richard Bergh and Karl Nordström. Kreuger's attendance at the school had been interrupted in 1877 by an attack of malaria and a lengthy convalescence. When he recovered the following year, he entered Edvard Perseus's Free Painting School in Stockholm where Nordström also studied. Then Kreuger moved to Paris, with Richard Bergh, in 1881. There, like many other Nordic artists, he learnt *plein air* painting as taught by Jules Bastien-Lepage. In particular, his sojourn in Grez-sur-Loing, a village south of Barbizon, in the summer of 1882 considerably developed his art. This can be seen in one of Kreuger's finest works, *Old Country House* (1887). In contrast to Josephson, who wished to express a vision of Nordic light and nature by using the Greek god Pan, Kreuger employs the play of light to do this. The luminous sky is reflected in the window panes of the wooden house while nature, in spring, seems to engulf the walls of the house itself, as though repossessing it.

90

94

125

THE FRENCH INFLUENCE

91–93 (RIGHT) **Nils Kreuger** *Spring in Halland* 1894

90 (BELOW) **Carl Frederick Hill** *Landscape. Motif from the Seine* 1877

94 **Nils Kreuger** *Old Country House* 1887

The influence of Bastien-Lepage consisted not only in the use of tonality, but also in sharpening the awareness of the setting, in which the artist should be immersed. Thus, as Bastien-Lepage had established himself at the artists' colony of Damvilliers, where the inhabitants and landscape inspired him, many artists in the Nordic countries, at one time or another, attached themselves to artistic colonies scattered over their native lands. Skagen in Denmark (see Chapter 5) was one such; Varberg, on the south-western coast of Sweden, was another. Its life-span, from 1893 until the early years of the new century, was briefer than that of Skagen, which had been flourishing since the 1870s; but many productive artists, especially Kreuger, Bergh and Nordström, found considerable inspiration in Varberg and its surroundings. *Autumn, Varberg* (1888), by Kreuger, is one of the best-known paintings produced there: with its spectrum of blue and grey tones, it expresses the ephemeral nature of the particularly short Nordic autumn. Furthermore, it demonstrates the high degree in which Kreuger found he was able to employ, in very different Swedish conditions of light, what he had learnt from Impressionism in France.

104

Some Swedish and Finnish artists established another colony at Önningeby on Lemland, the largest of the Åland Islands (1886–1914), because of its unspoilt rural charm and picturesque inhabitants. The artists included the Swedes Johan Axel Gustaf Acke (1859–1924), Georg Nordensvan (1855–1932), and Anna Wengberg (1865–1936), and the Finns Hanna Rönnberg, who wrote a book about the colony's history, and Victor Westerholm (1860–1919), 'Finland's Cuyp', who is known for his many paintings of cattle grazing. His work, *Åland* (1899–1909), largely painted in *plein air*, was the most famous work produced there. It is an intense expression of the stony and wooded landscape of Finland's remote island group.

In Norway, a group of the more innovative artists established their own colony at Fleskum in the Baerum region, in the summer of 1886. They settled on the farm of Erik Werenskiold (1855–1938), one of the most radical of the young Norwegian artists. It had been Werenskiold, with the artist Fritz Thaulow (1847–1906), who had led the revolt against the Kunstforeningen in Norway in the early 1880s, because of its refusal to purchase *The Carpenter's Workshop* (1881), by Gustav Wentzel (1859–1927), on the grounds that it was ugly. This resulted in a general boycott of the Kunstforeningen, which had also refused to include artists on its jury. It had led to the establishment of a new autumn exhibition (1884), at which Gauguin was a guest, and was thereafter known as the State's Yearly Exhibition of Art. Its foundation sounded the death-knell of the artistic domination of the Kunstforeningen.

Despite the political radicalism of Werenskiold and Thaulow and the disturbance they helped to cause, their painting was in no way shocking. On the contrary, their works proved very popular and were firmly linked to honoured traditions of painting in Norway. Werenskiold, who had gone to Munich in 1875, had been impressed by the realism which infused the works of such leading German painters as Wilhelm Leibl, but after he had seen an exhibition of contemporary French art in 1879, he turned towards Paris. He spent considerable periods of time in France during the years 1881 to 1885, but these stays were always dominated by lengthy visits to Norway, especially to Gudbrands-dal, with its lush green valleys in summer. Here he painted one of his most moving works, *Peasant Funeral* (1883–85). He has taken his subject from an event he witnessed in the village of Vågå and has shown the local burial customs and the mourning peasant family with great dignity and realism. Inspiration undoubtedly also came from Hans Gude's *Funeral Procession on Sognefjord* (1866) and the masterpiece of the Finnish artist Albert Edelfelt (1854–1905), *A Child's Funeral* (1879).

XXI

Though Werenskiold was not content with the work, the picture fulfils in pictorial terms Søren Kierkegaard's ethical demands, which were taken seriously by many Nordic artists and writers, which were that they should show truth and an objective reality. This was a prevalent theme in Nordic art and literature of the period and can be found, for instance, in Henrik Ibsen's *Fire*.

Similar themes are also prominent in the work of Thaulow, the brother-in-law of Gauguin (who disliked his work!). Thaulow was a student at the Kunstakadamiet in Copenhagen from 1870, under the Danish marine painter Carl Frederik Sørensen, from whom he acquired masterly skills in depicting water. He became well known for his seaside works. Gude in Karlsruhe, where Thaulow moved in 1873, was also influential on his development, but it was Daubigny and Bastien-Lepage, whom he met on his arrival in Paris in 1874, who were of crucial importance to his art. When Thaulow returned to Christiania in 1879, he brought with him a new emphasis on the nuances of light and atmosphere which can be seen in his painting *Winter at Simoa* (1883), based on pastel sketches which show subtle variations in tone. Moreover, *Winter at Simoa* demonstrates his predilection for river scenes and his passion for landscapes of snow and ice, which were unusual in earlier Norwegian art. Despite his attachment to Norway, Thaulow preferred the artistic climate of France and he settled there in 1892.

95 **Erik Werenskiold**
Kitty Kielland 1891

Two other Nordic artists were to continue the tradition of luminous paintings of wintry scenes: the Norwegian Harald Sohlberg (1869–1935) and the Swede Gustaf Fjaestad (1868–1948). Sohlberg, with another Norwegian Halfdan Egedius (1877–99) whose painting *Storm Approaching* (1896) is one of the most beautiful Nordic works on that subject, had trained under Werenskiold and Peterssen in Norway, and also under Zahrtmann in Copenhagen. Sohlberg used a new, symbolical style in a fairy-tale vision of wintry Nordic light on a country village: *After a Snowstorm* (1903) depicts the village of Røros, where Sohlberg lived from 1902 to 1904, in such a way that the houses seem like slumbering creatures, immobilized by the blasts of wind and snow. In Fjaestad's work *Winter Evening by a River* (1907), it is secretive, rippling water, rather than a village, which is the focus of the work, but once again it is the light and wind and their effects which are fundamental to the Symbolist mood of the painting. Here Fjaestad was inspired by the many winters he spent in Värmland, as well as by the works of Nils Kreuger. Generally, the paintings of Gustav Klimt and the Art Nouveau movement must have played a part in forming his style.

101

XXIII

Among other Norwegian artists who worked in Fleskum were Kielland, Backer, Peterssen, Gerhard Munthe (1849–1929) and Christian Skredsvig (1854–1924), all of whom had studied in Munich during the 1870s. Backer and Peterssen bear the closest resemblance, for both were greatly influenced by Puvis de Chavannes and James McNeil Whistler, especially in their use of blue and in allusions to musical nocturnes – in which the Norwegian composer Edvard Grieg (1843–1907), who was a visitor to Fleskum, may also have played a part. Backer wrote in her autobiography about this musical element in her painting: 'The flecks of colour should stand in a fixed constellation, just as, in pictures of the heavenly bodies, the stars are fixed in the firmament and wink at one another; as chords in music harmonize fully in a colourful unity.'[33] Such an approach can be fully appreciated in her work *Baptism in Tanum Church* (1892). The blue tones which unify the painting glisten like mother-of-pearl in the dark interior, while the deep diagonal perspective heightens the *chiaroscuro* effects of the light coming into the church. The light and its play on surfaces thereby become the real and symbolical themes of the work. This emphasis is also found in Eilif Peterssen's painting *Nocturne* (1887) and, in particular, in what is perhaps his best work, *Summer Night* (1886), where the deep,

XXVI

XXI

96 **Erik Werenskiold** *Peasant Funeral* 1883–85

brilliant colours he admired in Titian have been employed in depicting the effect of light on still water on a windless and bright Nordic summer night.

Mass, rather than planar surfaces, was used by Munthe to achieve a Nordic mood. He had studied in Düsseldorf until 1877, long after it had ceased to be a major artistic centre. His works tend to derive from Dutch landscape painting of the seventeenth century. Yet they also have affinities with the work of his Swedish colleagues and close friends Bergh, Pauli and Prince Eugen. In particular, Munthe's painting *At the Farm* (1889) possesses the monumentality and mystical mood of Eugen's *The Old Castle*, as well as its realistic qualities. It was the result of a lengthy visit to Ulvin, in Hedmark, and has the vibrant and harmonious atmosphere of a Norwegian summer night, when all forms of life seem integrated with nature.

This atmosphere is also found in a painting by Christian Skredsvig, *The Boy with the Willow Flute* (1889). The boy is a Pan figure, as much a part of the landscape as the hills and trees reflected in the glass-like surface of the lake, Daehlivannet near Fleskum (where a drawing on which this work is based was made in April 1886). The lustre of a windless spring evening is expressed by a symphony of blues, unifying the painting. Its use of colour to achieve mood links it to the works of the Swedes Nordström and Josephson who had influenced Skredsvig in Paris. Josephson, in particular, was of great importance to Skredsvig and they travelled together to Seville in Spain, in 1882, where the latter produced his charming work of a garden scene, *From Seville* (1882). It was Norwegian landscapes, however, which inspired him in his most evocative works, and Skredsvig shared with Josephson a keen love of Eggedal in Norway, whose countryside played a major role in the œuvre of both artists.

Perhaps one of the most memorable paintings made of the Norwegian landscape, and a very idiosyncratic one, was *Jotunheimen* (1892–93), by the Danish artist Jens Ferdinand Willumsen (1863–1958). It is a strongly Symbolist work, in which the frame is actually absorbed into the painting, thereby destroying the formal boundaries which until this time had separated the viewer from the pictorial illusion. Furthermore, the illusionistic three-dimensionality of the mountain depicted is strengthened by its sculptural form. Willumsen, indeed, had trained both as a painter and sculptor at the Kunstakadamiet in Copenhagen and at Krøyer's school, but the paintings of Gauguin, which he had seen in France (where he lived from 1890 to 1894), exerted the most important influence on his work, and it is to Gauguin that Willumsen's technique and style is most indebted in *Jotunheimen*.

119

97

102

97 **Christian Skredsvig**
*The Boy with the Willow
Flute* 1889

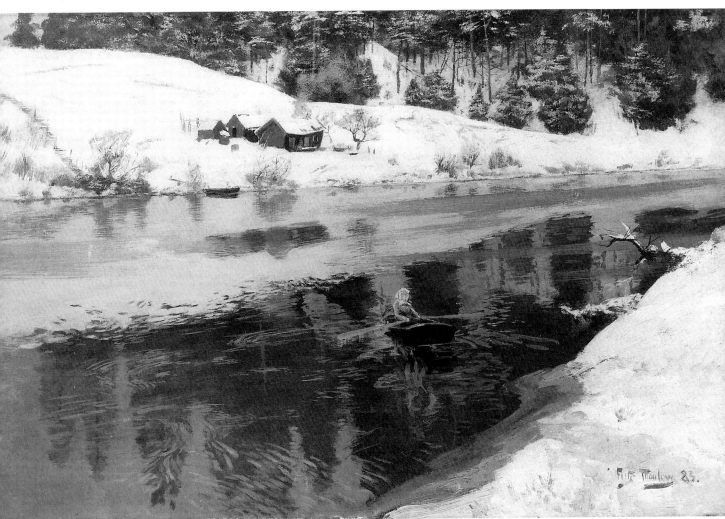

98 **Frits Thaulow** *Winter at Simoa* 1883

THE NORWEGIAN
LANDSCAPE

99 (RIGHT) **Harald Sohlberg** *Summer Night* 1899

100 (BELOW) **Halfdan Egedius** *Storm Approaching* 1896

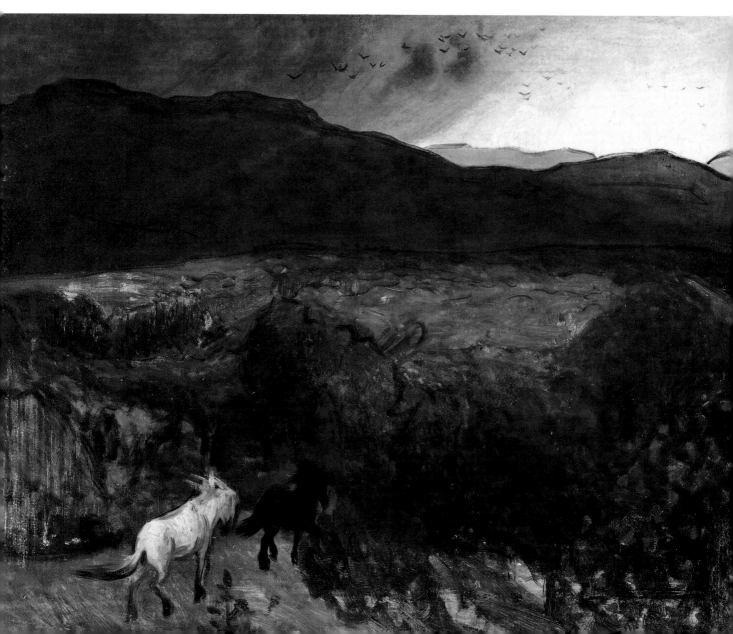

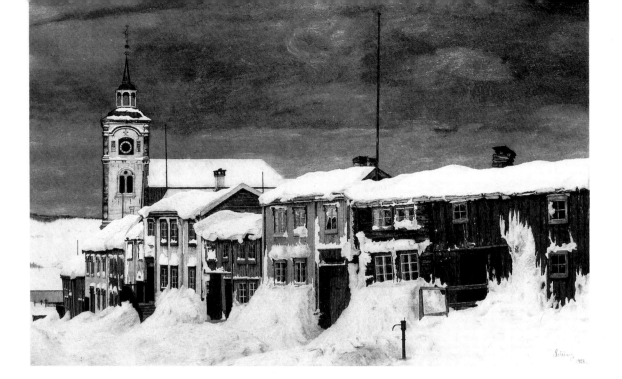

101 **Harald Sohlberg** *After a Snowstorm* 1903

102 **Jens Ferdinand Willumsen** *Jotunheimen* 1892–93

Developments in the art of Finland were not dissimilar to those in Norway or even in France and Germany: the Finska Konstföreningen (Finnish Art Society) provoked rebellion in 1882 when it selected paintings for the Russian State Exhibition in Moscow of that year without consulting any of the artists. This led to the creation, by a considerable number of young artists, of an alternative autumn exhibition, and the rift persisted until 1903 when Albert Edelfelt became director of the Finska Konstföreningen. This period of disunity, however, between the organizers of these two exhibitions, was one of extraordinary richness for the arts in Finland, as it was in the other Nordic countries.

Edelfelt had begun his training at the Konstföreningen under Sjöstrand, after which he had made extended visits to Belgium and France. In Paris he attended the Ecole des Beaux-Arts under J. L. Gérôme, studying history painting. However, it was Bastien-Lepage and the *plein air* school of painting that exerted a greater influence on him and which he applied after his return to Finland at the end of the 1870s.

By the mid-1880s Edelfelt used the *plein air* technique to paint the mood of a Finnish summer evening, in a work that combines the old and the new Finland. *Saturday Evening at Hammars* (1885) shows the local inhabitants on a dock by Haiko Fjord watching the arrival of a rowboat carrying workers from a steam-run saw mill, seen in the distance. Such an industrial feature makes its first appearance in paintings of the idyllic

103 **Hjalmar Munsterhjelm**
Wood in the Moonlight 1883

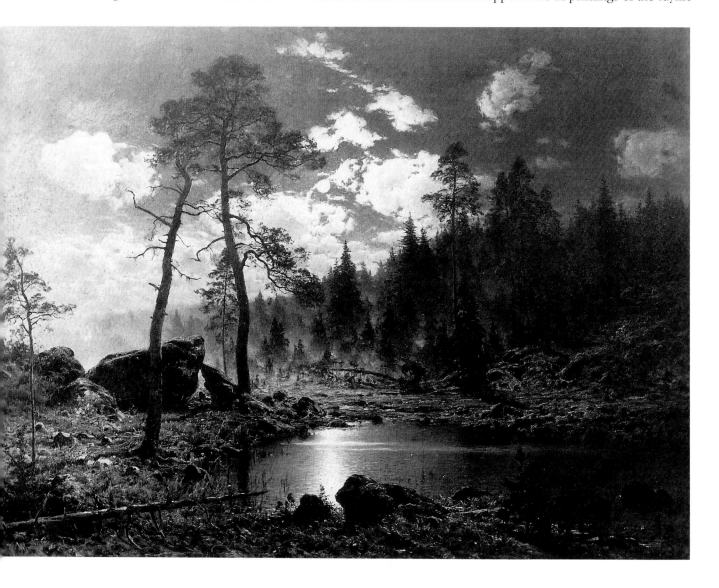

landscape of the country, though it is here unobtrusively remote on the far horizon.

Two years later he painted another work, *Women of Ruokolahti on the Church Hill* (1887), which adopts a photographic realism to focus on the peasant women. Stylistically, it has an affinity with Josephson's *Village Gossips* (1886), though the similarity in tone it shares with many of the works of Carl Wilhelmson is more striking. Wilhelmson (1866–1928), from Fiskebäckskil in Bohuslän, often depicted figures in a stern, sculptural manner that suits the rough dignity of the country people he portrayed. This is evident in *The Village Shop* (1896) and *Fisherwomen on the Way from Church* (1899), both of which eschew all sentimentality in favour of presenting an objective view of the reality of life for working people in the country. This was an aspect also taken up by the other great Finnish artist of the late nineteenth century, Akseli Gallen-Kallela (1865–1931).

Gallen-Kallela, who had changed his name from the Swedish Axel Gallen in order to assert his Finnish identity, had been a pupil of Edelfelt and attended Adolf von Becker's private art school in Helsinki in the early years of the 1880s, paying for his studies by illustrating temperance tracts. This illustration work was to be useful when later he became the first artist to introduce wood-cuts to Finland. He went to Paris in 1884 where at first he studied under Adolphe Bouguereau and Robert-Fleury at the Académie Julian, but shortly afterwards moved to Cormon's atelier. As was the case with Edelfelt, his mentor and friend in Paris, and many other Nordic artists, it was Bastien-Lepage and *plein*

105

106

104 **Victor Westerholm** *Åland*
1899–1909

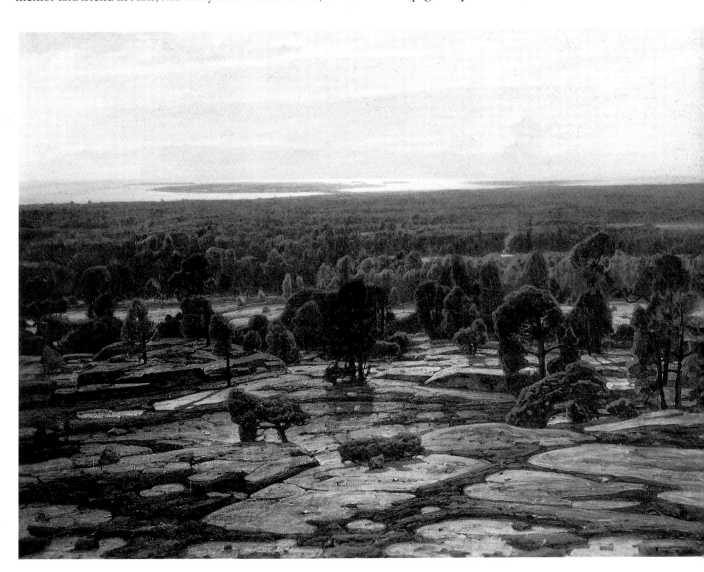

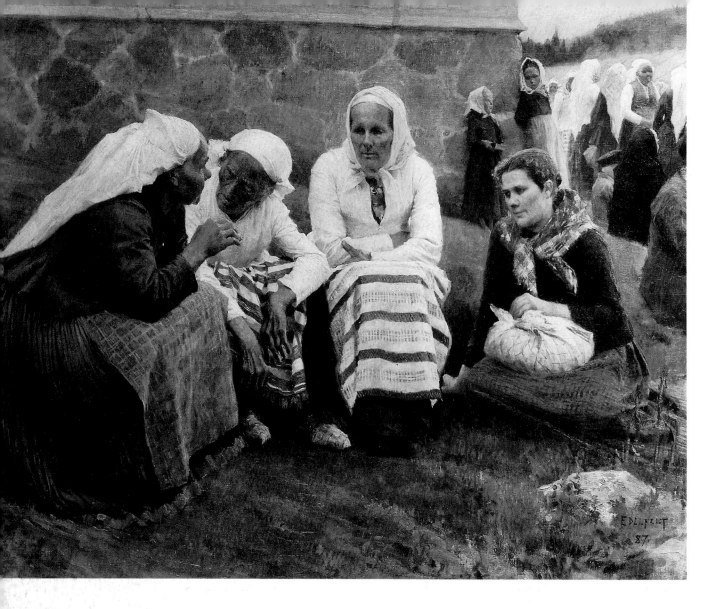

air painting which exerted most influence on him, though he professed a profound distaste for French Impressionism. His painting *Boy with a Crow* (1884) exemplifies his work of this period. The picture shows a peasant boy from Tyrvis in western Finland, as much a natural product of the Finnish soil as the crow he watches with such fascination. No attempt has been made to give the boy the classical physiognomy which previously often appeared in the countenances of such rustic figures. This uncompromisingly realistic approach to painting led some to label Gallen-Kallela the 'Apostle of Ugliness', a title which seems appropriate when one considers *Old Woman with a Cat* (1885). The coarse and ill-clad peasant woman, her face weather-beaten and her belly bloated, is indeed unattractive. Yet one senses in her character the powerful dignity and strength which gives this work its appeal. The old woman stares at the cat before her, gesturing towards it in a way which creates great psychological tension. Both she and the animal become a part of the landscape by means of a compositional arrangement which concentrates on the earth, showing little above the horizon level. Gallen-Kallela later wrote about his relationship to art and nature: 'He who lives and works much out in nature, can almost catch himself speaking to the trees of the wood. . . . Our folklore witnesses to the fact that a deep experience of nature is a characteristic of the Finns. It can be said, perhaps, that we tend to personify nature, which expresses itself in our art and literature.'[34]

140

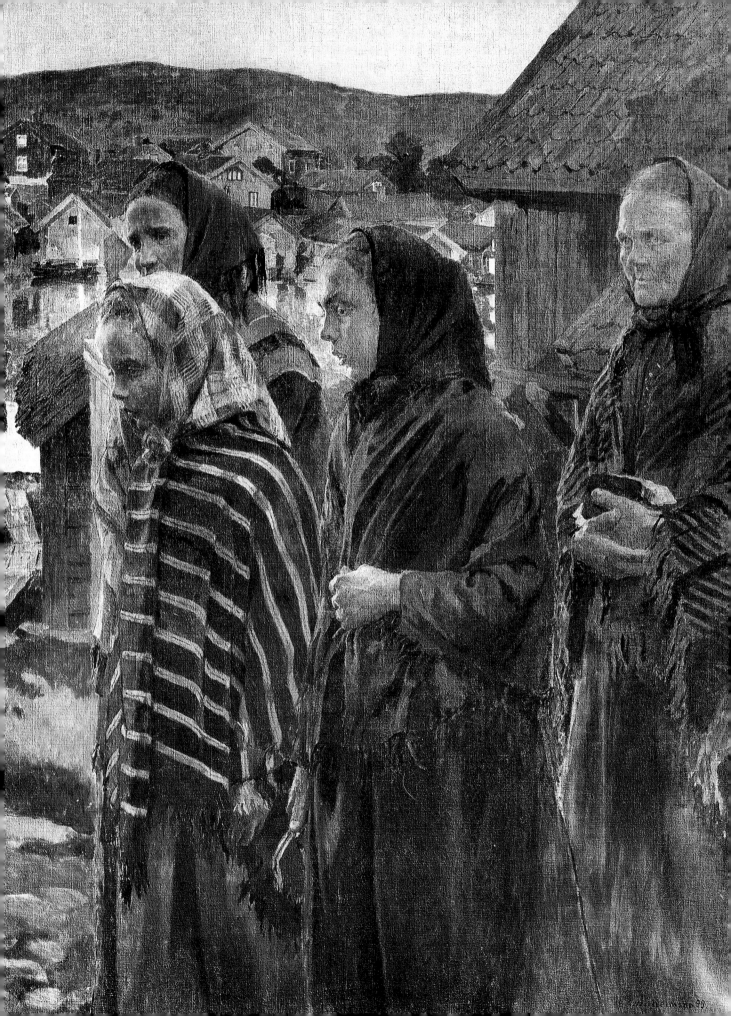

107 **Bruno Liljefors** *Blackgame in Springtime* 1907

This propensity is similarly to be found in one of Scandinavia's most well-known painters of wildlife in nature, Bruno Liljefors (1860–1939). He had begun to draw at the Cathedral School in Uppsala, continuing further studies first with the painter C. G. Holmgren and then at the Konstakadamien in Stockholm in 1879, where he remained until a rift developed between him and Georg von Rosen. Thereafter, Liljefors travelled considerably, first to Düsseldorf, where he received advice from the animal painter C. F. Deiker, and then to Italy and France, where in 1884 he stayed briefly in Grez, with his colleague from the Konstakadamien, Carl Larsson. He returned to Sweden that same year, settling down at Kvarnbo, not far from Uppsala.

By acute observation of the Uppland landscape, fauna and light, Liljefors created a Nordic mood. This is characteristically evident in *Sea Eagles* (1894), in which we seem to be witnessing an existential drama of life and death above the rolling seas. Here, as in Strindberg, 'the poet's dream fantasy and the scientific researcher's sober experiences meet.' [35] *Blackgame in Springtime* (1907) is a less dramatic but equally invigorating view of nature, which depicts, as if in a musical harmony, the oneness of the birds and their environment, at the same time accentuating their individual characteristics. As Prince Eugen commented on another work by Liljefors portraying seagulls, 'For him all the birds were individuals, for me they were all seagulls.' [36] But birds were to Liljefors what water-lilies were to Monet.

Gallen-Kallela's thematic and stylistic range was broader than that of Liljefors, in that he used Finnish folklore as well as flora and fauna. His still wider versatility can be seen in his richly-coloured portrayal of a French model in the nude, *Démasquée* (1888), an image of the Bohemian life of Paris at the time. This painting remains, however, as fully rooted in Finnish culture as the Finnish rug on which the French model reclines. For all the lushness of the flesh tones and the alluring face, there is a sombre note in the painting which contrasts with the nudes of, say, Anders Zorn, a friend of Gallen-Kallela's in Paris. The *eros-thanatos* motif is further accentuated by the skull resting on the table behind the vase of lilies.

As Zorn had felt a profound attachment to Dalecarlia, the province in Sweden which most seemed to embody the values and traditions of old Swedish culture, so Edelfelt and Gallen-Kallela became entranced with Finnish Karelia, the south-eastern province of

108 **Eero Järnefelt** *Lefrance, Wine
Merchant, Boulevard de Clichy, Paris*
1888

109 **Akseli Gallen-Kallela**
Démasquée 1888

Finland, where they both spent time in 1887. The two artists, however, were only visitors to the area and came from distant parts of Finland, so that Karelia was for them more a romantic state of mind than a geographical reality. This was not the case with another Finnish artist, Eero Järnefelt (1863–1937). He was from the port city of Viipuri, on the edge of Karelia, and so was better acquainted with the reality of life there. He too had studied at the drawing school of the Art Society, but he pursued his studies in St Petersburg, from 1883 to 1886, where he was taught by his uncle P. Clodt von Jürgensburg. This was followed by sojourns in Paris, during the years 1886 to 1891, at the Académie Julian where he too was influenced by Bastien-Lepage and the *plein air* movement. Their lessons he applied in Finland during the summer months. His *Long Boat* (1888) was painted in the Kuopio area of Savolax and depicts the landscape, villagers and luminous sky of the area with considerable skill. His most striking work, however, was *Lefrance, Wine Merchant, Boulevard de Clichy, Paris* (1888), which has a brilliance of colour, like that of Manet's work of the same period, heightened by glowing reds. Its counterpart in Nordic art can be found only in the work of the Norwegian Ludvig Karsten. The wine bar was a frequent watering-hole for Finnish artists in Paris at this time and it has been suggested that Gallen-Kallela was the model for the wine merchant.

In Sweden, Richard Bergh also mastered this use of different tones of a colour to achieve a visual unity and to suggest a mood, but he emphasised mass to a greater extent than many other Nordic artists, as his painting *The Dying Day* (1895) demonstrates. Its figures also show an affinity with those of Michelangelo, which Bergh greatly admired.

108

111

110 **Richard Bergh** *Vision* 1894

111 **Richard Bergh** *The Dying Day* 1895

This use of mass, in conjunction with the effects of light, attempts to reduce the composition to the essential qualities of the scene, thereby showing the brevity of the Nordic summer, as described in the novel *Pan* (1894), by the Norwegian Knut Hamsun (1859–1952). Such allusions to death could also be an expression of *fin-de-siècle* attitudes: Bergh, in common with many of the Nordic artists of this period, had certainly read Georges Rodenbach's novel *Bruges-la-morte* (1892), which inspired numerous literary and artistic works on the subjects of night and death. *Bruges-la-morte* was an important source of inspiration for Bergh on another account: it represented the city as corrupt and malevolent. The Swede Olof Sager-Nelson (1868–96) also painted works heavy with symbolism on this theme. *Old Ladies in Bruges* (1894) is the best example, melancholy and hopeless. For Bergh, however, the countryside was a place of refuge and revitalization from this bleak world. He thought the artist had an obligation to teach society to appreciate Nordic pastoral beauties. Bergh wrote: 'The artist should lead the old and the young, rich and poor, town-dweller and country-dweller into Swedish nature, our cultural mother and mentor.... He shall call us to meetings and festivities under the wintry night's starry sky and the summer night's flood of light.'[37]

Bergh, like many other artists of this time, was unable to commit himself completely to life in the country, just as the summer guest from Stockholm, in August Strindberg's *The People of Hemsö* (1887), could retreat into the country for a month, even a season, but then had to return to the city, with its cultural, intellectual, and economic resources. In this respect, the city stood for the nation as a whole, with its enormous cultural wealth, as in Bergh's painting *Vision* (1894): an armada of Viking ships are approaching Visby in Gotland, the walled 'New Jerusalem', which had been fabulously wealthy in the thirteenth and fourteenth centuries. With its historical background, Gotland was a symbol of vanished greatness for Sweden. *Vision* also alludes to paintings by other 110 Swedes on themes of nationalistic symbolism, but its most inspiring features are the intense and brilliant land, sea and light.

RURAL
AND
URBAN
VISIONS

112 **Carl Larsson** *A Home: Luncheon under the Big Birch* 1894

113 **Carl Larsson** *Autumn* 1884

114 (OPPOSITE) **August Strindberg** *The City c.* 1900

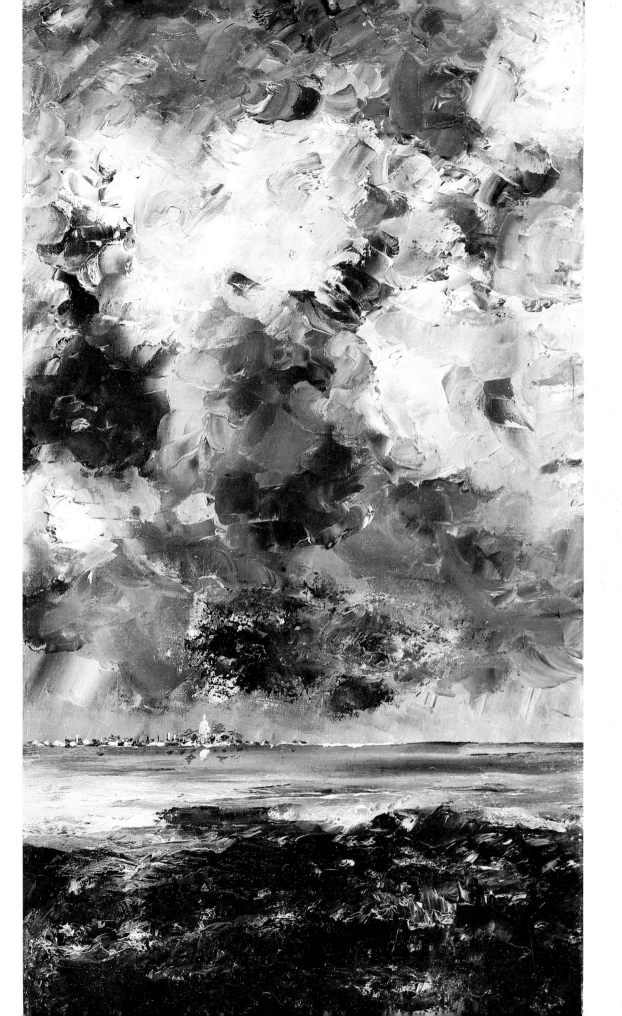

115 **Eugène Jansson** *Self-portrait* 1901 (detail)

112

XXVIII

A more troubled vision of the city and the life of its working people in Sweden preoccupied a considerable number of other artists and are in dramatic contrast to the more usual rural scenes painted at this time. This is especially true of the work of Anders Zorn (1860–1920), whose *Omnibus* (1891) highlights the vulnerability, the loneliness and the hum-drum quality in the working woman's life at the turn of the century. The heavy impasto of luminous paint enveloping the figures accentuates their isolated identities. Zorn's mother in her youth had been a worker in Stockholm, where she had experienced severe emotional and practical difficulties, and Zorn, aware of this, came to feel that a return to the old values of rural life provided the best remedy. His mother had been revived spiritually and physically by her native Dalecarlia; others too, he felt, could find a new and healthier life for themselves in the countryside.

Zorn's great rival for a position of primacy in late nineteenth-century Swedish art was Carl Larsson (1853–1919). Though he had actually been born in a working-class family in Stockholm, later attending the lower school of the Konstakadamien, his works came to embody, more than those of any other Nordic artist, the rural and domestic ideals of the Swedish people. Using skills he had learnt as an illustrator, Larsson had already, during his lengthy stay in France at the artistic colony of Grez, produced extremely delicate watercolours of atmospheric subtlety. His masterpiece *Old Man and New Planting* (1883) alludes to the life-cycle of living things, and the juxtapositions of young and old, light and shadow, mass and plane, heighten its spiritual dimension, for all its decorative appeal.

He had the greatest popular success with the paintings which formed the basis of his illustrations to the book *A Home* (1899): they are vignettes of middle-class rural bliss, taken from his own experience of family life at his newly built house in Sundborn in Dalecarlia. The actual events, however, did not always fulfil the idylls he portrayed and the old home-spun values he lauded.

Such a return to traditional rustic values was rejected by Eugène Jansson (1862–1915), a Stockholm artist of humble origins. Instead, he envisioned a socialistic utopia for Sweden. Jansson's works often shock us by their starkness. His painting *The Outskirts of the City* (1899) shows a row of tenements in the suburb of Nortull on the edge of Stockholm. Such buildings provided homes for the city's industrial workers and their families, newly arrived from the provinces. Vast in size and depicted with few details, they contrast strikingly with the furrowed acreage of the farmland onto which they abutt. The tenements embody a soulless and lifeless spiritual vacuum which is reflected in the chalky sky. Instead of the crowded city scenes shown in paintings of the 1880s, this is a mood painting created without the use of human figures.

The urban theme was also prominent in the paintings of August Strindberg (1849–1912), Sweden's most renowned author and playwright. Strindberg considered himself primarily an artist, though posterity has generally judged him on his literary merits, belittling his artistic work. None the less, a work such as *The City* (*c.* 1900) is inspiring. The paint, applied with a knife, is a thick impasto which creates dark tones and produces a stormy effect that mirrors not only turbulent city life but also Strindberg's anguished concern with the agonies of the working man, and with his own failed marriages. No attempt has been made to achieve a strictly realistic image of the city. Instead, the emphasis has been on suggestion through texture and colour. In these characteristics, Strindberg's paintings resemble and seem to anticipate in certain respects the Abstract Expressionism of the 1950s. As such, Strindberg's œuvre is unique in Nordic painting of this period.

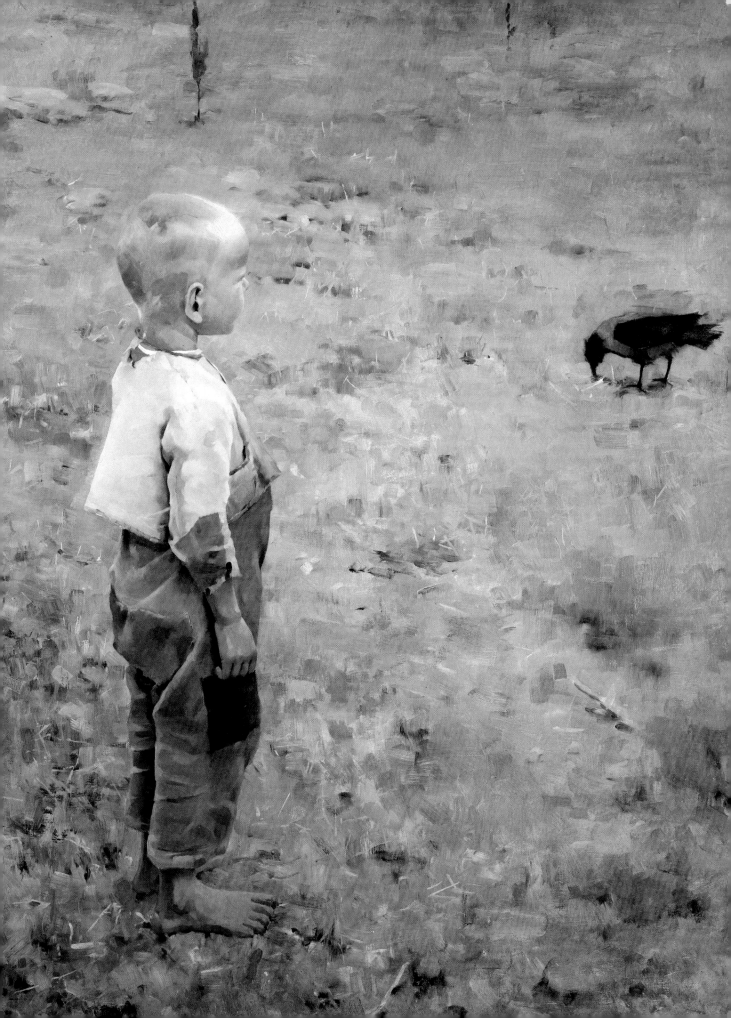

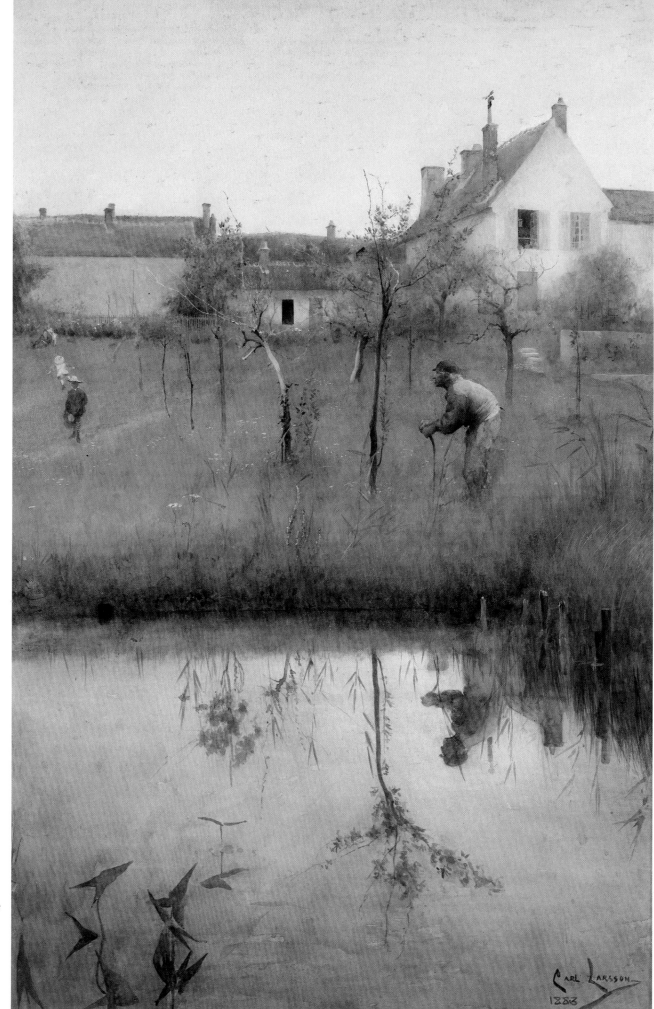

XXV

Carl Larsson
1888

More typical was some Nordic artists' use of light and nature to create what was called *stämning* (a combination of mood and atmosphere), as a means to express such abstract concepts as loneliness, isolation, the ephemeral and death. As seen in Chapter 3, an isolated tree bowed by the winds, painted by the Norwegian Johan Christian Dahl, could be intended to suggest a tragic mood and symbolize the artist's struggle in life. In the late nineteenth century, certain artists in Scandinavia became interested in suggesting similar moods, but more subtly, avoiding obvious symbolism. For example, Nordström, in *Neighbouring Farms* (1894), offers a fairly unspectacular scene: it is the house of his friend Kreuger and the neighbouring farmhouse, in Apelvik, during the summer. No man or animal is present and yet the vibrant, shimmering light and the flowering tree evoke the presence of life. Details are generalized and the farmhouses are structured as geometrical masses. They stand rigidly, like monolithic blocks, silently alluding to some other reality, perhaps a poetic reality of the kind that had led Bergh to declare, in a reference to Nordström, that 'in the North an artist must be a poet.'[38]

XXXII

While Nordström painted the gentle, quiet mood of a Swedish summer, Anders Zorn depicted an atmosphere seething with creative or erotic and other impulses in nature. His *Midsummer Dance* (1897) shows a celebration from his native Dalecarlia on the most joyous evening in the Nordic calendar. The swirls of the grass, the whirling of the dancers, the evanescent and luminous nocturnal sky are heightened by the form of the maypole with its surging force. Zorn uses the red and green colours he loved to represent the fertile qualities of the earth itself.

XXIX

In some instances, Nordic *stämning* painting, which predominated in the 1890s but spilt over into the early years of the next century, is pantheistic in spirit. Nils Kreuger's *Night Is Coming* (1904) is one example. As in the work of Karl Nordström, details are only sketched in. The heavy impasto of the foreground represents the rather barren soil of the heathland, but by using a pointillistic style of painting, a texture is produced which expresses the vitality and spirit of nature, despite the diminishing light. As Kjeill Boström, Kreuger's authoritative biographer, has commented, it is as if his work were possessed of a mystical pantheism in which the nature depicted 'lives in silence'.[39] In this sense Kreuger's painting is comparable to the poetry of Olle Hansson, a Swedish poet and writer, whose works are filled with painterly visions of the Swedish countryside, sometimes blanketed in light fog, sometimes bathed in a mellow light.

The sense of a pantheistic spirit achieves perhaps its fullest expression in the paintings of Prince Eugen (1865–1947), who worked from the early 1890s at Sundbyholm and Tyresö, both near Stockholm. A son of King Oscar II of Sweden, and great-grandson of Napolean's General Bernadotte, Eugen was undoubtedly the greatest royal artist of modern times. A master in the depiction of landscape and light, works such as *The Old Castle* (1893) are supreme examples of his painting. Here the land and the castle seem to have been invaded by a grim spirit and the mournful-looking edifice inspired Hjalmar Söderberg, one of the most lyrical of Sweden's turn-of-the-century novelists, to exclaim in a poem: 'God's peace, you wasted earth, God's peace, you dead house!'[40] Certainly, the intensity of tones, creating the effect of glowing light, and the swelling masses are extremely evocative of Nordic pantheistic *stämning*. Gustaf Lindgren, Prince Eugen's friend and biographer, remarked on this quality: 'Could not Prince Eugen's famous painting *The Old Castle* stand as an illustration to Heidenstam's *Karolinerna*? Sundbyholm, Carl Carlsson Gullenhielm's castle, stands there … powerful, sun-lit, proud and solid, while storm clouds seem to be homing in on its red brick roof. It is a Swedish *stämning*, conjuring up her imperial past, which hovers over this inspired work.'[41] Verner von Heidenstam did indeed acknowledge his debt to Eugen for his descriptive imagery.

119

ANDERS ZORN

116 **Anders Zorn** *Knitting Dalecarlian Girl* 1901

117 **Anders Zorn** *A Première* 1888

118 (OPPOSITE) **Anders Zorn** *Omnibus* 1891

119 **Prince Eugen** *The Old Castle* 1893

STÄMNING PAINTING

120 **Karl Nordström** *Varberg's Fortress* 1893

121 **Prince Eugen** *Still Water* 1901

122 **Theodor Kittelsen** *The Black Death* 1894–96: *The Soaring Eagle*

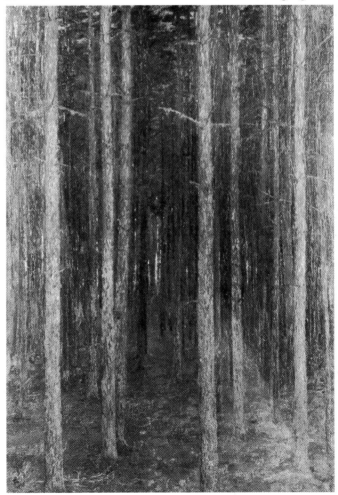

123 **Prince Eugen** *The Forest* 1892

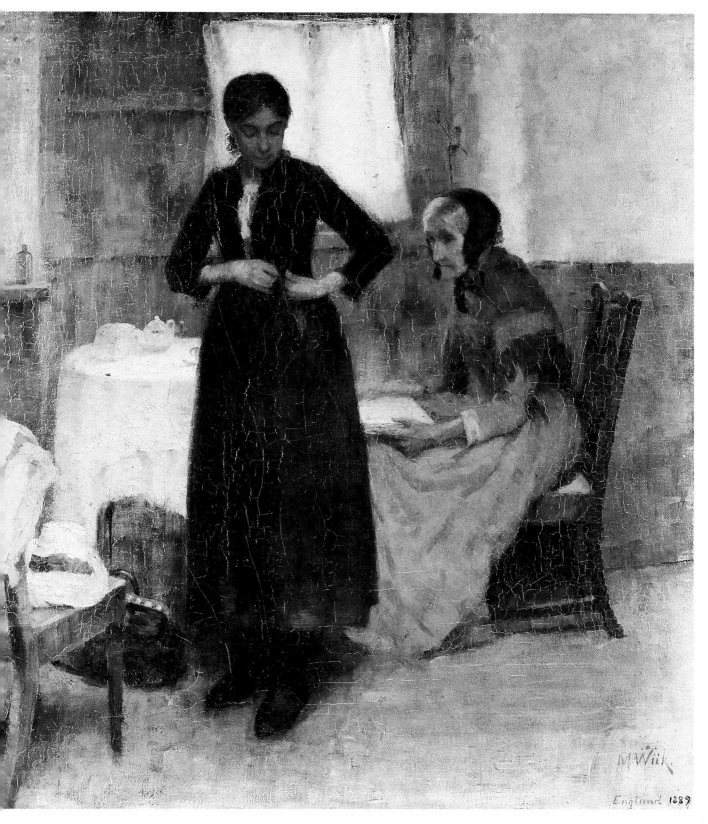

124 **Maria Wiik** *Out in the World* 1889

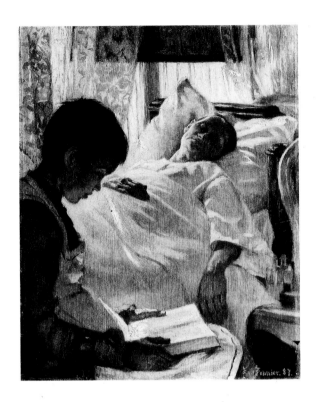

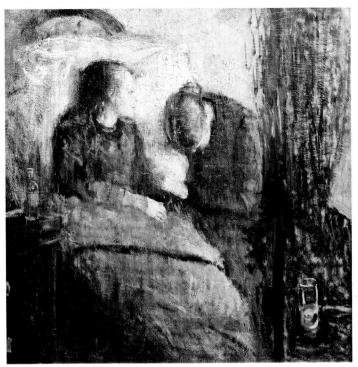

It has been shown that landscape paintings which express mood were extremely frequent in late nineteenth-century Scandinavia; this was equally true of portraits of people, in landscapes, in urban scenes or in the quiet of their homes. One of the first artists to accentuate light in an architectural setting in order to create mood was the Finn Maria Wiik (1853–1928). She had been a student of Severin Falkman from 1874 to 1875 at the drawing school of the Finska Konstföreningen before she too went to the Académie Julian, until 1880, in Paris. She subsequently divided her time between Finland and France, studying for a period under Puvis de Chavannes, in 1889. It was that same year, during a visit to St Ives in Cornwall, that she produced a tender and evocative work on youth and old age, *Out in the World* (1889). It is clearly inspired by Whistler and stylistically related to Anna Ancher's work, but its emotional intensity is stronger; the old lady clutching her Bible seems a part of another world from that of the young woman, who seems about to leave her home and its claustrophobic, withdrawn atmosphere.

Maria Wiik went to St Ives in the summer of 1889 in the company of another important Finnish artist, Helene Schjerfbeck (1862–1946). In England, Schjerfbeck was financially supported by the sculptor Walter Runeberg and she also met Anders Zorn, who was visiting at the time. She had also been a student at the drawing school of the Finska Konstföreningen, before moving to Adolf von Becker's private school. Like Wiik, with whom she shared an atelier, she too went to Paris where Realism greatly influenced her. In 1888 she had painted a work on a recurring theme in the paintings of many Nordic artists of this time, *The Convalescent*. It has been suggested that this work may in fact symbolize the artist's own recovery from a broken engagement with an Englishman. Whatever the truth of this suggestion, the theme of illness, and especially of sick children, was very popular at this time. Krohg had painted his famous *The Sick Child* in the early 1880s, an intensely penetrating work, due partly to its frontality. Edvard Munch (1863–1944) took up its theme.

125 **Eva Bonnier** *Reflex in Blue* 1887

126 **Edvard Munch** *The Sick Child* 1886

124

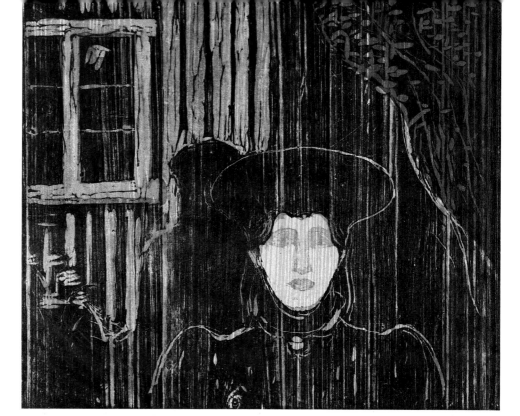

127 **Edvard Munch** *Moonlight* 1896

Munch had grown up surrounded by illness and had lived through the childhood trauma of his sister's decline and death from tuberculosis. This experience was used in what is one of the most evocative portrayals of death in European art, *Death in the Sickroom* (1893). Each character in the painting is isolated in their own world of anguish, unable to say or do anything which might alleviate the pain of the event. This fatalism is also found in a work by the Dane Ejnar Nielsen (1872–1956), *The Sick Child* (1886). The emaciated girl, imprisoned by illness in her iron-rimmed bed, stares before her, apparently resigned to her impending death. Stylistically, the broad surface planes look back to Puvis de Chavannes, whom Nielsen had admired while in Paris in 1900 and 1901.

Munch painted several other related works, including the death of his mother and that of others, and of a child struck down by inherited venereal disease, a subject made famous by Ibsen's *Ghosts* (1881). It was anxiety and anguish, rather than the actual loss of life, which preoccupied Munch in many of these paintings. The most renowned work on this subject by the artist, probably the most acclaimed painting by any Scandinavian XXXVIII painter, is *The Scream* (1893), which through a combination of line and colour encapsulates the full horror of the mind's landscape at its most anguished. It is not, however, so much a work which depresses the viewer, as one which is cathartic; it is, thus, not dissimilar to a psychoanalytical insight, both disturbing and yet providing relief. It was not coincidental that Sigmund Freud (1856–1939) was at this time developing his theory on the workings of the mind; his study on aphasia had appeared in 1891, two years before *The Scream*, and his major treatise, *Studies on Hysteria* (1895), was in the process of formulation. Both Munch and Freud had, in their own ways, attended to the problems of individuals in late nineteenth-century European industrialized society, who were unable to function successfully because of the conflict between inner and outer pressures.

Munch did not distance himself from tortuous psychological states and it was his own 127 fears that he expressed in many of his paintings and woodcuts. In *Moonlight* (1893),

Munch's vision is of woman as ominous and alluring, with threatening emotional power. The woman is his sister Inger and the painting is based on studies made in Asgaardstrand (1891–92). Munch has portrayed her as vicious and destructive but also seductive, a theme with literary correspondences to the work of Strindberg, among others. The moonlight creates a threatening mood, emphasising Inger's spectral aura, while the moon's reflection in a window-pane, in the background, mirrors the mood and alludes to the madness which plagued both Munch and his sister. Munch had spent part of 1892 in Berlin where he frequented the bohemian tavern Zum Schwarzen Ferkel (At the Black Pig). There he met not only Strindberg, whose friend he became, but also Stanislav Przybyszewski and Dagny Juell (later Przybyszewski's wife), with whom he became involved in a romantic triangle. This experience may also be reflected in *Moonlight*, one of the early works painted at the time when Munch began to plan his *Frieze of Life* series.

By contrast, the last work he produced for this series, *The Dance of Life* (1899–1900), concentrates on the erotic. The subject of the three ages of man is here transformed to the three ages of woman in triptych form: hopeful young innocence, self-aware maturity and frustrating middle age. This perception of life's progress makes the dance by the sea a vision of frenzied despair rather than of the joys and vitality of Midsummer Eve.

130

128 **Edvard Munch** *Rose and Amelie* 1893

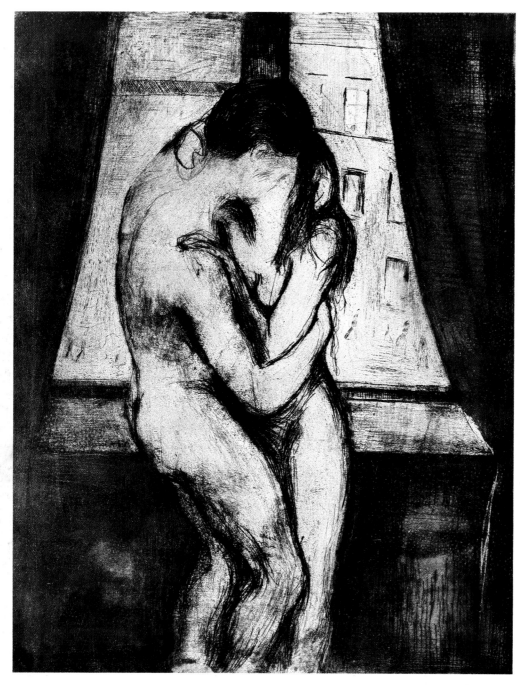

129 **Edvard Munch** *The Kiss* 1895

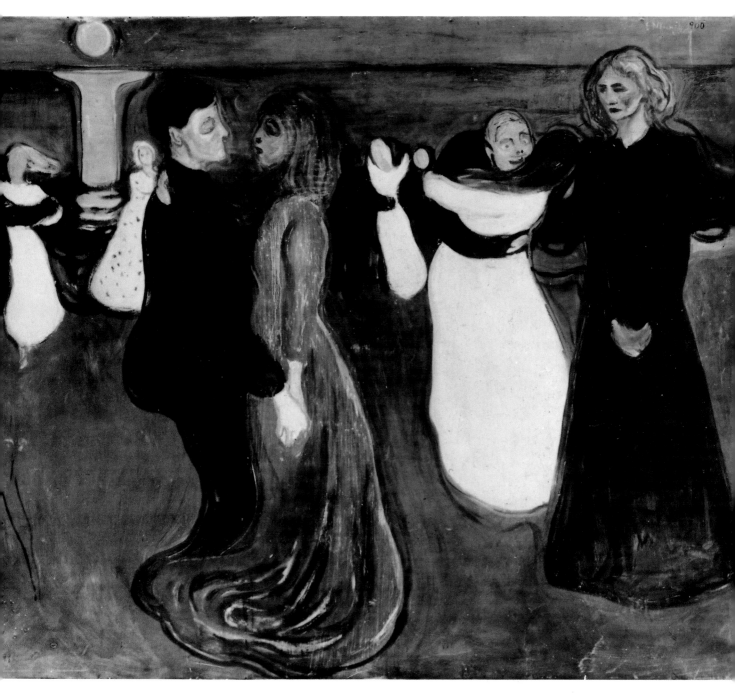

130 **Edvard Munch** *The Dance of Life* 1899–1900

131 **Akseli Gallen-Kallela** *The Aino Triptych* 1891

In Finland, Akseli Gallen-Kallela also painted themes which expressed psychological states of turmoil but, unlike Munch's works, Gallen-Kallela's also have a specifically patriotic dimension. One of his most celebrated paintings, *Symposium (The Problem)* (1894), portrays himself with the Finnish composers Robert Kajanus, Oskar Merikanto and Jean Sibelius (1865–1957) who, with others from the world of art, music and literature, had formed themselves into Young Finland (1892), a society with Finnish, nationalistic overtones. This meeting is typical of the sort that took place at Zum Schwarzen Ferkel, which Gallen-Kallela frequented. He had painted works such as *The Aino Triptych* (1891), whose subject-matter was taken directly from Finland's epic the *Kalevala*. In *Symposium*, however, the true subject is the minds of these leading men of Finnish culture. They are looking at the great wings of an otherwise invisible beast, possibly symbolizing the spirit of artistic creation, while the strange, unnatural light fosters a mystical mood.

By no means all Scandinavian artists at this time devoted themselves to such inward subjects. Hanna Pauli (1864–1940), wife of the Swedish painter Georg Pauli, from a prosperous Jewish background, painted some joyful works which are intimate and full of warmth. Perhaps her most charming painting is *Friends* (1900–07), in that it captures the atmosphere at a soirée centred round the Swedish literary figure Ellen Key. It bears comparison with the work of one of Hanna Pauli's closest friends, who had also studied at the Konstakadamien in Stockholm, Eva Bonnier (1857–1909). She too was from a prosperous Jewish background. Such paintings as *Reflex in Blue* (1887) have close affinities with the work of Wiik and Anna Ancher.

The works of the Danish artist Vilhelm Hammershøi (1864–1916) deserve a special place in Nordic art, for in both his landscapes and his domestic interiors, he achieved images embodying spiritual states of strength, patience, quietude and endurance which are virtually unequalled by any other European artist of the period. *A Baker's Shop* (1888), an early work by Hammershøi, is typical of many of his paintings: a young woman has her back towards us, but in a rigid, formal compositional arrangement. Less common in his œuvre are landscapes. One such work, *Landscape from Lejre* (1905), may owe much to his teachers Kyhn and Rohde, but the combination of monumentality in form and intimacy in handling are his own. In this work, Hammershøi gives the gently rolling topography of his native Zealand a spiritual dimension. This aspect is even more obvious in his masterpiece *Five Portraits* (1901), in which five of his friends are depicted: the architect Thorvald Bindesbøll (1846–1908), the art historian Karl Madsen, and three artists: his brother Sven (1873–1948), Jens Ferdinand Willumsen and Carl Holsøe (1863–1935). The central figure, that of Willumsen, whose paintings are stylistically antithetical to those of Hammershøi, seems a Christ-like figure. As such it is the focus of the work. It is also innovative in that, as the English art historian John House has pointed out, its pictorial space appears to be expanding, pushing out the boundaries of the painting, an effect heightened by Madsen's over-size feet on the right.[42] Furthermore, the subtle play of light on the features of the men and the room in which they are sitting, in combination with its symphonic range of greys, heightens the mood, which belies anecdotal explanation. The art historian Poul Vad has also stated that the absence of shadows on the table increases the sense of mystery.[43] Sometimes, as in those of Hammershøi's domestic interiors devoid of people, even the furniture in the rooms seems to have a soul of its own.

135

131

133

125

132

136

134

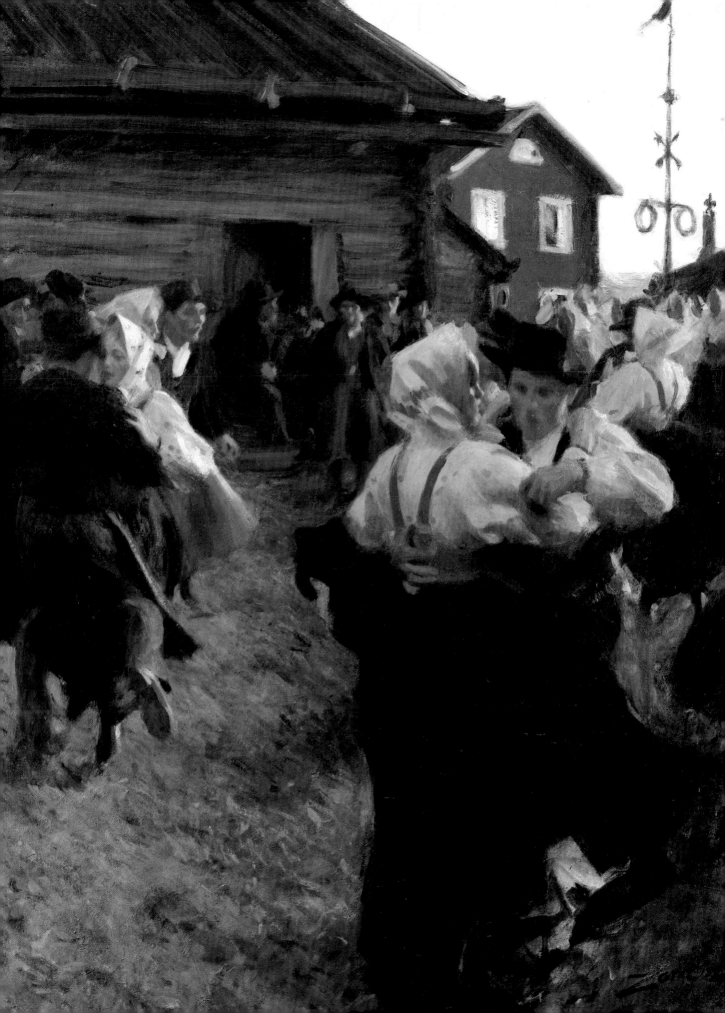

XXX

XXXI

XXXII

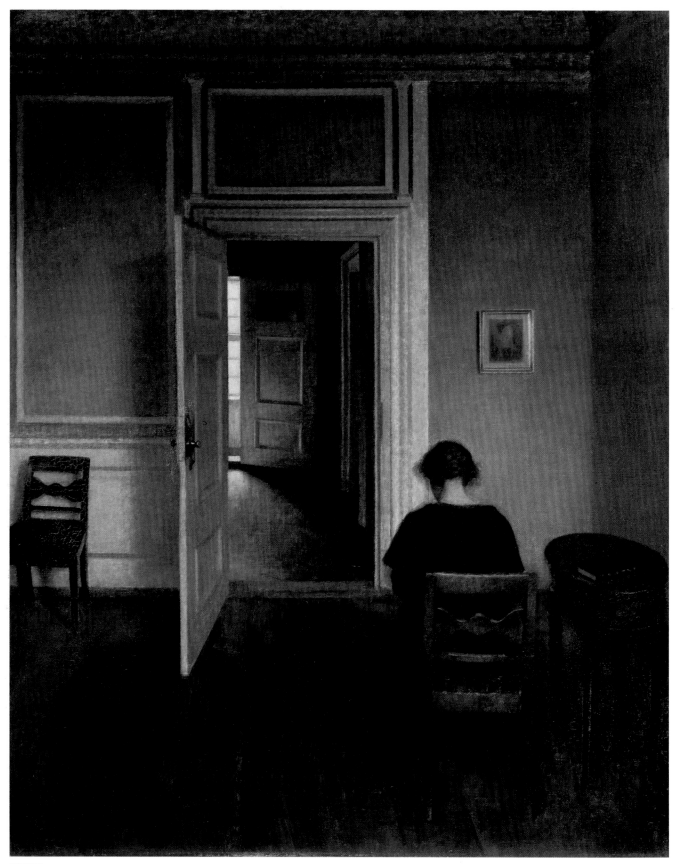

XXXIII

132 **Vilhelm Hammershøi** *A Baker's Shop* 1888

ARTISTS' GATHERINGS

136 Vilhelm Hammershøi
· *Landscape from Lejre* 1905

XXXIV

138

139

Holsøe's work, like Hammershøi's, looks back to Vermeer and the Dutch masters, but his paintings never show the spiritual dimension of Hammershøi's. Only his brother-in-law Peter Ilsted (1861–1933) can be said, on occasion, to approach Hammershøi in his ability to use light to express mood, as his painting *Interior with a Lady Knitting by the Window* (1902) demonstrates. There, the light falling from a mysterious source on the bowed figure casts an aura of sanctity on the woman and her domestic occupation.

Many Nordic artists in the late nineteenth century explored man's escape into Scandinavian nature and his flight within his own mental world. More rarely, but equally poignantly, some Nordic artists painted their countrymen who had sought a new life abroad, usually in America, but sometimes in Australia, New Zealand and other parts of the world far from their homeland. In particular, Edvard Petersen (1841–1911) clearly depicted the fears and hopes of emigrants of all classes on the way to the New World. His *Emigrants at Larsens Plads* (1890) shows the loss which 'abandonment' of the homeland entailed. Other works, such as Harriet Backer's *Departure* (1878), concentrated more on the private suffering or parting, but they also usually displayed a profound love and commitment to Scandinavia, its culture and its people.

In the Garden Door, The Artist's Wife (1897), by Laurits Andersen Ring (1854–1933), is an ode to the peasant life left behind in his beloved South Zealand. Ring's experiences at the Kunstakadamiet in Copenhagen under Vermehren during the mid-1870s, as well as the influence of Bastien-Lepage in France, resulted in colourful works, full of the details of country life. His *Foggy Winter Day in Vinderød* (1901) is perhaps the finest work in Scandinavian art on the atmospheric effects of a wintry fog; a gentle melancholy pervades the scene and one is reminded that Ring, like Hammershøi, was attracted by moods of sadness and wistfulness. This is equally apparent in his painting of domestic scenes, which *Dusk. The Artist's Wife by the Stove* (1898) demonstrates. In this aspect his painting can be compared with the work of a Swedish artist, Björn Ahlgrensson (1872–1918). In *Glowing Embers at Dusk* (1903), a similar mood prevails which expressively depicts the beautiful but sad period of twilight on a Nordic winter's evening.

176

137 **Laurits Andersen Ring** *Young Girl looking out of an Attic Window* 1885

138 **Edvard Petersen** *Emigrants at Larsens Plads* 1890

139 (OPPOSITE) **Laurits Andersen Ring** *In the Garden Door, The Artist's Wife* 1897

140 **Laurits Andersen Ring** *Plasterer. The Old House Is Cleaned Up* 1908

Tradition and the Birth of Modernism

1900-1940

Unlike the radical transformation which occurred in the arts of continental Europe within the first decade of the twentieth century, developments in the Nordic countries at this time were slow and ambivalent. The stirrings of modernism were not felt, except in a few cases, although there was a gradual erosion of naturalism, as well as of traditional conventions of space and depiction. A conventional use of colour which aimed to approximate visual reality did not quickly give way to one which strived to be more expressive and emotionally responsive. Although by the early 1910s many artists in Scandinavia had succeeded in finding a new pictorial language contrasting with that employed in the works of most Nordic artists in the late 1890s, the transition, none the less, was tentative.

The Gothenburg artist Ivar Arosenius (1878–1909) helped to effect this change. In some ways his painting exemplifies the art of this intermediate period, eschewing naturalism for something approaching expression. Arosenius had begun his studies at the conservative Konstakademien in Stockholm in 1898. However, the following year, he left to join the radical Konstnärsförbundet's School (Artists' Association School), directed by the principal leader of opposition to the Konstakademien, Richard Bergh. After this training, Arosenius returned to Gothenburg in 1901, working with, among others, the Dane Ole Kruse, who inspired in him a keen interest in decorative folk art. But it was the new art of the Fauves, which he encountered in Paris in 1904 and 1905, that opened his eyes: strong colour and line, and their use outside the conventional representation context. Colour thus achieved, in Arosenius's work, a new decorative identity and independence which allowed it to convey emotions in a novel way. Gauguin and Munch to a large extent pioneered the use of colour as an independent element. The most important, immediate predecessor, however, was Henri Matisse, especially in his Fauvist work. It is he who most inspired the new generation of Nordic artists. Quite apart from his Fauvist sense of colour, he had engendered a new experimentalism, an approach which constantly sought stylistic innovation, but which at the same time did not set out to shock, but rather to find ready acceptance among the new patrons who provided the resources for its sustenance.

Arosenius's *Apotheosis* (1906) is not only about the bacchanalian revels accompanying the rising of a rustic Aphrodite into the heavens, but is also an orgiastic display of colours and forms which become the real subject of this work. Arosenius was a haemophiliac and the emphasis in this painting on the pleasures of life may relate to his awareness of the precariousness of his own life. Not long before he died, Arosenius painted *Noah's Ark* (1908, not completed): it is an expression of his hope that a divine miracle might occur to save him from early death.

Other artists, though, were now progressing into the areas he had explored. The Danish painter and illustrator Robert Storm Petersen (1882–1949) was Arosenius's principal stylistic successor. His paintings combine elements of caricature, as well as an expressionistic use of colour and form derived from Munch. These devices he used to encourage social change through *Tendens* painting (see Chapter 6). To do this, Storm Petersen also drew on the paintings of Toulouse-Lautrec for subject-matter, which he had seen during his first visit to Paris in 1908. These influences can be seen in his painting *The Girl with the Cigarette* (1909), which depicts a prostitute self-confidently awaiting her next client. In *Scene from Nyboder* (1912–14) his debt to Arosenius is even clearer, for the subject has been taken from the Swedish artist's *Temptation* (1907). In *Scene from Nyboder*, Petersen produced a comic painting of the carefree wives of absent seamen, hanging about in the doorways and windows of their little houses in the eastern district of Østerbro in Copenhagen, gazing invitingly at potential admirers.

142

141

141 **Robert Storm Petersen** *Scene from Nyboder* 1912–14

142 **Ivar Arosenius** *Noah's Ark* 1908

In many ways, the work of the Finnish artist Hugo Simberg (1873–1917) can be said to have an affinity with that of Arosenius and Storm Petersen. *The Farmer and Death* (1896) and *Poor Devil with Twins*, an etching of 1898, share compositional elements with the works of Arosenius and Storm Petersen, but there is a pervading sense of gloom and pathos in Simberg absent in the others. This is especially so in *Devil with Twins*, where the devil and his children seem to be suffering victims, rather than malicious culprits of evil. This theme of innocent suffering is even more evident in Simberg's masterpiece, *The Wounded Angel* (1903), in which a blinded angel is borne on a stretcher by two realistically portrayed Finnish boys, forerunners of those he later used for his magnificent frieze in Tampere Cathedral (1904–06), in which a huge wreath is carried by nude Finnish youths.

In the autumn of 1907 a group of painters was formed in Sweden who came from a variety of schools: the Konstnärsförbundet's School, Zahrtmann's school in Copenhagen and the Académie Colarossi in Paris. This Swedish group called themselves De Unga (The Young Ones) and were led by Leander Engström (1886–1927) and Isaac Grünewald (1889–1946). When they migrated to Paris in 1908, most of the students of the Konstnärsförbundet's School accompanied them, forcing it to close after twenty-two years of teaching.

Despite the group's condemnation by the painter Carl Larsson, who was now the grand old man of art (characteristically self-portrayed in 1900 in this role, *In Front of the Mirror. Self-portrait*), and who had come to stand for traditional Swedish family life, De Unga embraced the Post-Impressionist tenets and imported them to the Nordic countries. The new paintings were well received by the Scandinavian public.

143 Hugo Simberg *Wounded Angel* 1903

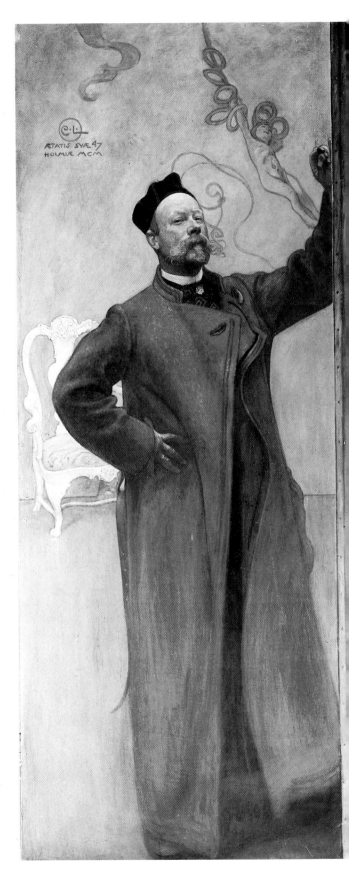

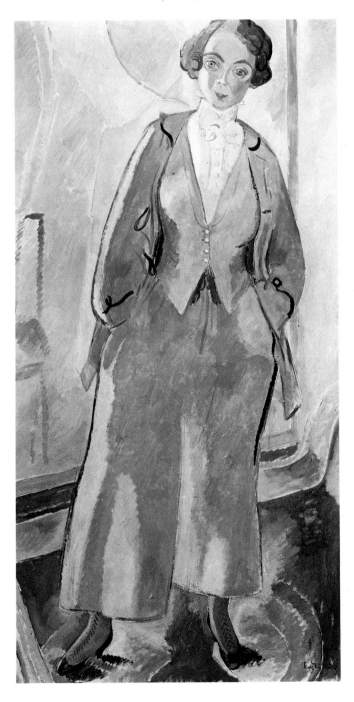

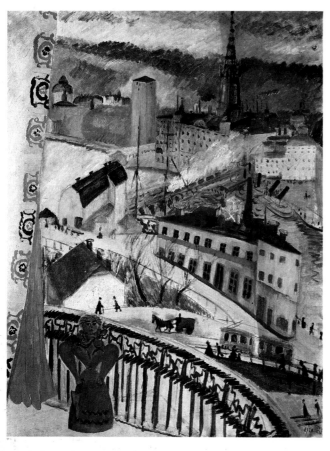

THE TORMENTED VISION

146 **Sigrid Hjertén Grünewald** *View over the Sluice* 1919

147 **Bror Hjorth** *Kappsläden* 1922

148 (OPPOSITE) **Nils von Dardel** *Visit at the Home of an Eccentric Lady* 1921

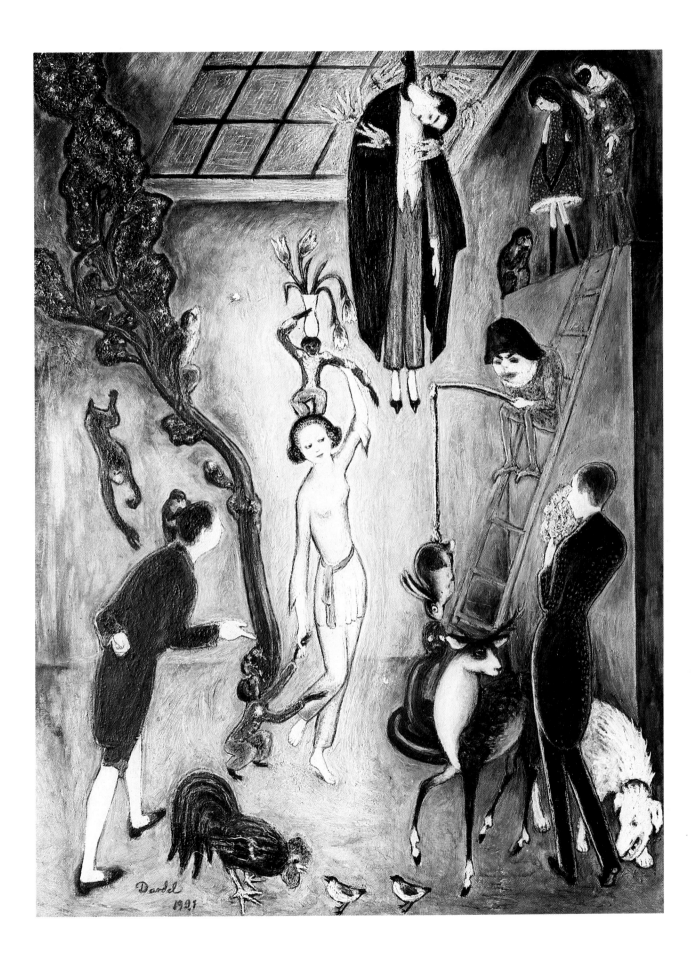

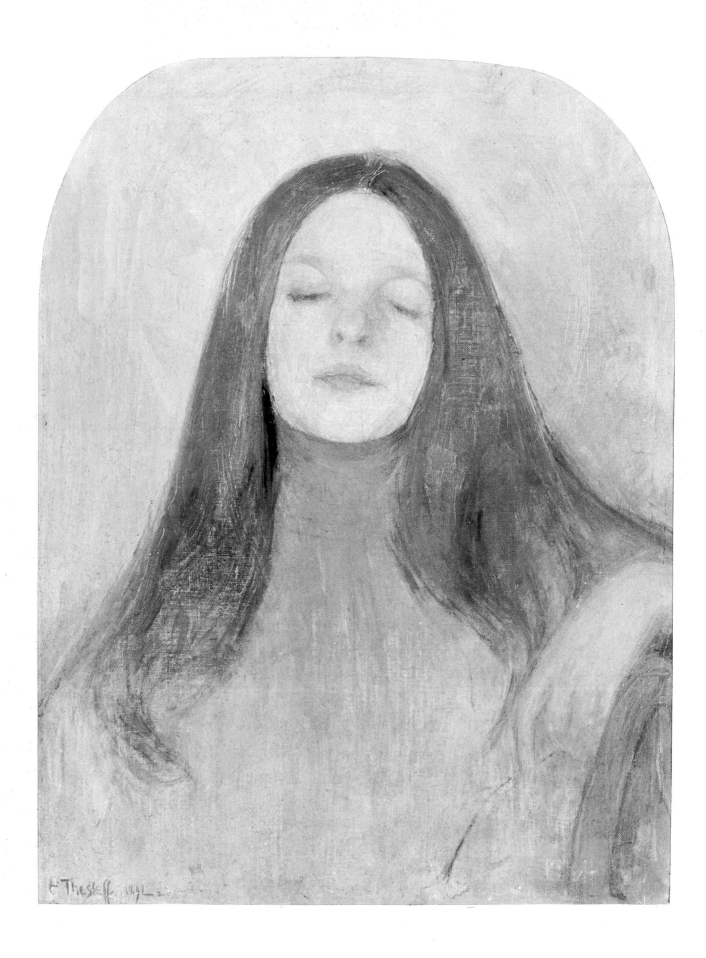

THE 'SEVEN'

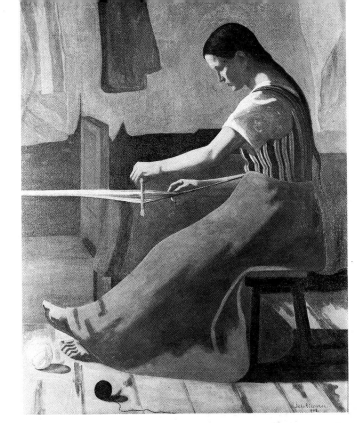

150 **Juho Rissanen** *A Woman
Weaving* 1908

151 **Pekka Halonen** *Homeward
Journey from Work* 1907

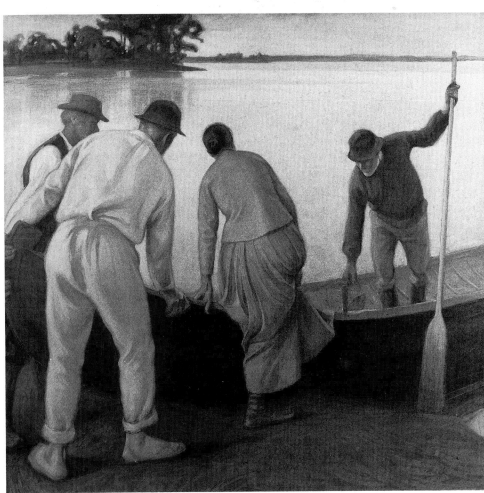

149 (OPPOSITE) **Ellen Thesleff** *Thyra
Elisabeth* 1892

In Paris De Unga absorbed not only the examples of Gauguin and Matisse, but also those of Cézanne who, although of the previous generation, was now seen as the precursor of the new art. For example, Leander Engström, in *Inger and Sara* (1910), makes use of a brilliant colour because of its decorative and expressionistic power – just as Munch did – thereby rejecting both realistic and impressionistic depiction. Engström also here abandons conventional composition and perspective which, except in peasant art, had remained unquestioned in the Nordic countries since the Renaissance.

In 1911 De Unga was dissolved as a group, but one of its members, Isaac Grünewald, a Stockholm Jew of German background, joined Sigrid Hjertén (1885–1948), who later became his wife, Nils von Dardel (1888–1943) and Einar Jolin (1890–1976), among others, to form a new society, De Åtta (The Eight). Profoundly impressed by the Cubist exhibitions in Paris in 1911, they began to experiment with the new concepts about space

144

and representation. Grünewald's *Portrait of Ulla Bjerne* (1916) shows the noted Swedish authoress in a style greatly influenced by Cézanne. Classical perspective is absent and the forms are condensed into a restricted, flattened space. Moreover, there is no conventional concern with psychological insight. The picture focuses on the formal aspects of Ulla Bjerne's baggy culottes, shimmering in a light that has no source.

146

Sigrid Hjertén Grünewald's *View over the Sluice* (1919), painted at the height of her career, shows evidence of Cubist influence. In this work, one-point perspective has been fragmented; the effect is to produce a kaleidoscope of Stockholm life. The viewer is drawn into the work by a statuesque figure, borrowed from Picasso, to share the view from her balcony.

148

In *Visit at the Home of an Eccentric Lady* (1921) by Nils von Dardel, the grandson of the history painter Fritz von Dardel (1817–1901), the intimacy of the scene is jarring because the viewer seems to be an intruder, forced on the bizarre events depicted; the perspective twists three-dimensional reality, heightening the macabre effects of this modern Bosch-like vision. There is also a naïve quality to the work, and indeed some of the animal figures, such as the monkey perched on the dancing lady's head, are taken from Henri Rousseau. Other motifs are derived from the Oriental animal painting which von Dardel saw on his extensive travels round the world, from Mexico to Japan, in the company of the impresario Rolf de Maré, the rich and brilliant founder of the Swedish Royal Ballet.

Von Dardel was not the only aristocratic figure active in Swedish art. A young English noblewoman, Margaret (1882–1920), daughter of the Duke and Duchess of Connaught and granddaughter of Queen Victoria, arrived in Sweden in 1905 to assume her position as Crown Princess of Sweden and wife of the future king Gustaf VI Adolf. She had a passionate love of painting, having trained under Monet in Paris from 1903 to 1904. Monet's wintry paintings made in Norway, in the company of Christian Krohg, had impressed her greatly and gave her the stylistic devices for her own work. One of her most painterly evocations of the Swedish landscape, which she learned to love in the company of her uncle by marriage, Prince Eugen, was *Winterday* (1914). It was painted in Stockholm in March and exhibited at the Baltic Exhibition in Malmö of that year, organized by the Crown Princess's friend and leading Swedish architect, Ferdinand Boberg. This exhibition was of great significance because it allowed modern Scandinavian and European artists to exhibit new work to a public largely isolated from current continental movements in art, and it was the catalyst of further artistic developments throughout the Nordic countries.

XXXIV

XXXV

XXXVI.

XXXVII

XXXVIII >

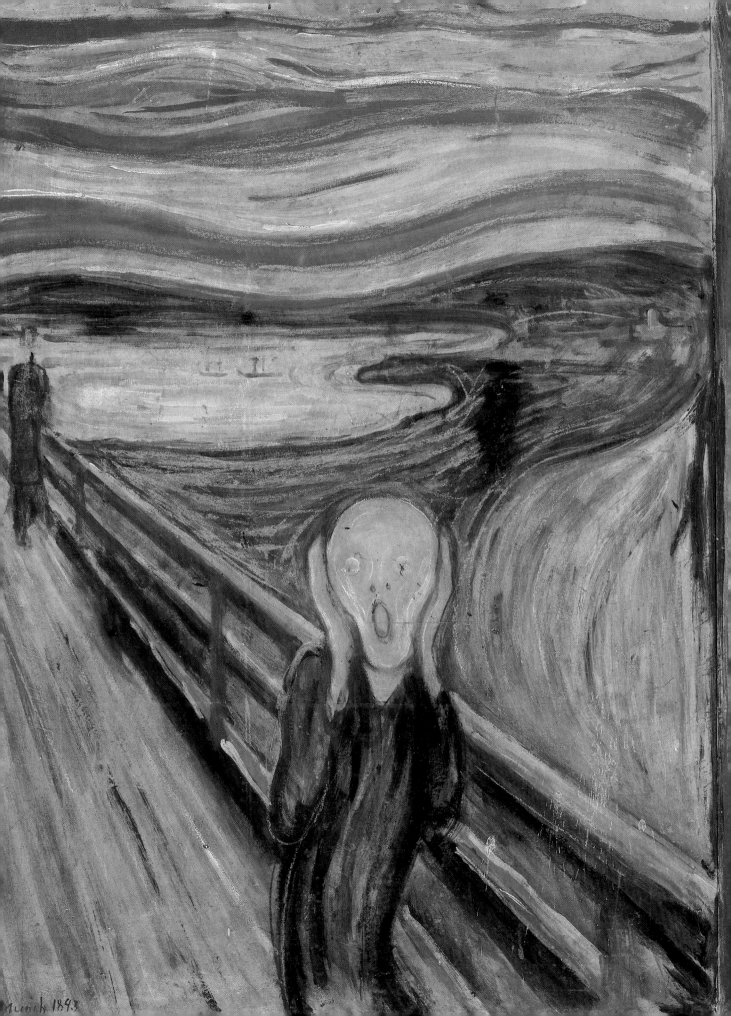

Munch 1893

XXXIX

In Finland, despite political repression by the Russians and the assassination of the hated Russian Governor N. I. Bobrikov, art had taken a fresh impetus and, as in other parts of Scandinavia, various societies were formed. In 1912, for example, seven artists established themselves as the Group of Seven, inspired by continental artistic trends, and in particular, the Fauves, in their stress on the decorative importance of colours. Magnus Enckell (1870–1925) was its leading figure (after the death of Edelfelt in 1905), together with Gallen-Kallela. Enckell was also Finland's best-known portraitist. His *Portrait of Mrs Emmy Frosterus* (c. 1907), is painted in bright colours somewhat reminiscent of Matisse, and is permeated by a gentle, lyrical mood.

Two other important artists in the Group of Seven were Ellen Thesleff (1869–1954) and Juho Rissanen (1873–1950). Thesleff had attracted attention in the 1890s with her Symbolist portrait *Thyra Elisabeth* (1892), which bears some resemblance to a saint in 149
ecstasy. Rissanen's best-known work, *A Woman Weaving* (1908), with its broad planes of 150
colour inspired by Puvis de Chavannes, and monumental figures, depicts the sombre life of ordinary Finns. Rissanen went to Paris for the first time in 1908. He travelled extensively throughout his life, and his painting came gradually to lose much of its native charm. He finally emigrated to the United States and died in Florida. The influence of Symbolism is also apparent in the work of Pekka Halonen (1865–1933), who was admired for his wintry paintings of trees blanketed by snow. He went to Paris in 1890, becoming a pupil of Gauguin with the Finn Vaino Blomstedt (1871–1947), who was famous for his Symbolist painting *Church at Bourg-la-Reine* (1894). It is Puvis de Chavannes, however, who appears to have exerted the greater influence on Halonen's *Homeward Journey from Work* (1907), with is firm contours and expanses of colour. 151

The artist of the Group of Seven who became perhaps the most popular at the beginning of the twentieth century was Verner Thomé (1878–1953). His *Bathing Boys* 153
(1904) highlights the dynamism and joy of young boys on a beach at play, a subject also taken up with considerable zeal by Munch, in *Playing Boys* (1907–10), and by the Dane Peder Krøyer and the Swede Johan Acke. Thomé's work looks back to early paintings of the 1890s, such as Magnus Enckell's *Two Boys* (1892) and *The Awakening* (1893). 152

In opposition, to some extent, to the Group of Seven stood another artists' society, the November Group; whereas the former has generally been considered to be preoccupied with a new romantic style, the latter has been seen as representing a more idealistic direction, though their actual differences today seem more to be based on the cultural and personal characteristics of the artists forming each society. The November Group's leading proponent was Tyko Konstantin Sallinen (1879–1955), who took his predominant stylistic inspiration, for his use of colour, from the Dutch artist Kees van Dongen. Sallinen's *Washerwomen* (1911) caused considerable scandal because of its rough 154
handling, loose contours and the opposition it met in Gallen-Kallela, who was at that time chairman of the Artists' Guild. Sallinen's *Alder Trees in Spring* (1911) uses this vigorous technique to express the vibrant freshness of the Finnish countryside, the trees positioned like sentinels, as though heralding the arrival of summer. Its compositional arrangement looks back to landscapes by the Finnish artist Fanny Churberg (1845–92), 156
whose broadly painted works seem to anticipate Expressionism.

Alvar Cawén (1886–1935) was another member of the November Group. His paintings show a predilection for the bright colours of Matisse and the Fauves, as in *Still-life with Red Cyclamen* (1915). This work also demonstrates his awareness of Cubist paintings which he saw in Spain and France, where he lived from 1908 to 1914. The picture's blue and red harmonies have an affinity with to the work of the Norwegian painter Ludwig Karsten (1876–1926). Marcus Collin (1882–1966) was also a member of the November

152 **Magnus Enckell** *The Awakening* 1893

153 **Verner Thomé** *Bathing Boys* 1904

Group who was influenced by Cubist ideas. His *Russian Float in Helsinki Harbour* (1918) shows a scene from the turbulent period of Finland's independence from Russia and its bloody civil war in 1918. The Cubist-like composition reveals the mechanical inhumanity of destruction.

In Sweden, the influence of Cubism is apparent in the work of two artists, the one long resident in Denmark, the other in France and in Arab countries, Karl Isakson (1878–1922) and Ivan Aguéli (1869–1917). Isakson, who had attended the Konstakadamien in Stockholm, went to Italy in 1902. Apart from Florence and Rome, he visited Christian Zahrtmann, the Danish painter, at his little artistic court at Civita d'Antino. He then returned with Zahrtmann to Copenhagen. Copenhagen became Isakson's home during and after attending the latter's progressive school there. Isakson's work had at first been influenced by Böcklin, but after going to Paris in 1905 some traces of Picasso's and Robert Delaunay's styles are evident in his painting. He was one of the artists who helped introduce Cubist and Orphist notions in Denmark. His paintings have a joyous air, especially apparent in those he produced during the many summers he spent after 1911 on the little island of Christiansø, near Bornholm. *Landscape with Bastions* (1921), painted there, illustrates the importance to his style of Cézanne and Gauguin.

158

Aguéli's early artistic career had been fraught with difficulties, not least because of his father's stubborn refusal to accept his aspirations. None the less, Aguéli had persisted, painting at first on Gotland, and in Paris in the 1890s, where he was impressed by modern French art. While in Paris he became involved in anarchism, which led to his imprisonment for a number of months. His friendship with the Swede Olof Sager-Nelson (see Chapter 6) inspired his interest in North Africa, where Sager-Nelson had retired in the hope of curing his tuberculosis. Aguéli visited Egypt for the first time in the early autumn of 1894 and discovered there a culture and light which inspired him. Aguéli's conversion to the Islamic faith gave his work a blend of European and Arab elements and he made frequent use of Arabic motifs and scenes in his intimate and subtly coloured pictures. *African City* (1914) is a good example, which also illustrates the influence of Cubism – 'the great simplicity', as he called it.[44]

157

194

154 **Tyko Konstantin Sallinen** *Washerwomen* 1911

TOWARDS THE MODERN LANDSCAPE

155 (LEFT) **Princess Margaret** *Winterday* 1914

156 (BELOW) **Fanny Churberg** *Landscape from Nyland* 1872

157 (OPPOSITE, ABOVE) **Ivan Aguéli** *African City* 1914

158 (OPPOSITE, BELOW) **Karl Isakson** *Landscape with Bastions* 1921

159 **Poul S. Christiansen** *The Painter Niels Larsen Stevns* 1911

160 **Edvard Weie** *Victoria Weie, the Artist's Mother* 1908

In Denmark, some artists used a style one might call decorative Cubism, not unlike that of Isakson and Aguéli. In the case of Fritz Syberg (1862–1939) it was used in paintings of the Danish landscape. Syberg had briefly attended the Kunstakadamiet in Copenhagen in 1884 but, like Isakson, he had come under the influence of Zahrtmann and had attended his school from 1885 to 1891 where he learned to make use of lush colours, though in his case expressionistically. *Overkaerby Hill, Winter* (1917) is, in this respect, his most successful work, pictorially half-way between Nordic *stämning* painting of the 1890s and such works by Oluf Høst as *Bognemark* (1944), which depicts the artist's farmhouse at Gudhjem on Bornholm in expressive contrasting light and dark harmonies.

Syberg settled in Fåborg on Fünen not only only because of his deep attachment to the area and because his mother had died there, but also because of local patronage. In 1910 the Fåborg Museum was established and some of the best paintings of Fünish artists were assembled with the financial assistance of the industrialist Mads Rasmussen. A group of these artists, known as the Fynboerne (Fünen Residents), included, besides Syberg, Peter Hansen (1868–1928) and Poul S. Christiansen (1855–1933).

Hansen was a brother of Anna Syberg, a painter and wife of Fritz. Like Syberg and his fellow Fynboerne, Hansen had been a pupil of Zahrtmann, not only in Copenhagen but also in Italy, and his work shares Zahrtmann's rich colours. The painting *The Plowman Turning* (1900–02) is a whirlpool of blues and browns which expresses not only the texture but the pace of life in the Fünish countryside. In this sense it is similar to works by Theodor Philipsen (1840–1920), such as *Evening. From Svendstrup Field near Borup* (1908). The general public now considers that Philipsen's landscapes best embody the spirit of Denmark. By contrast, Christiansen's *The Painter Niels Larsen Stevns* (1911) is static and muted. Its soft and psychologically penetrating style, however, is almost exactly opposite that of another Danish portraitist of the period, Edvard Weie. *Victoria Weie, the Artist's Mother* (1908) looks back to the Golden Age of Danish painting and to works by Eckersberg and Købke. She is depicted in a statuesque pose before a stone balustrade, behind which Christianshavn's canal in Copenhagen is shown in the evening twilight. After 1911 Weie, like Isakson, also spent many summers painting on the island of Christiansø and, despite violent rows, he established a fruitful relationship with Isakson, each inspiring the other.

198

161 **Kai Nielsen** *Mads Rasmussen* 1912–14
162 **Jens Søndergaard** *Landscape, Jutland* 1929

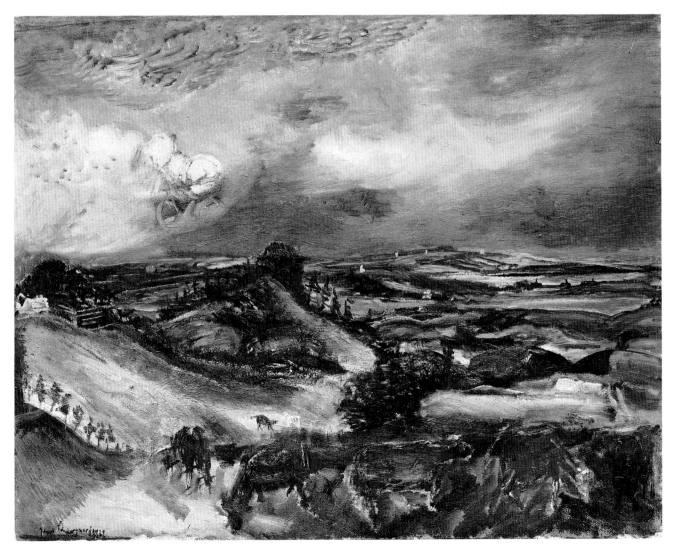

THE DANISH LANDSCAPE

163 **Theodor Philipsen** *Evening. From Svendstrup Field near Borup* 1908

164 Johannes Larsen
*April Shower, Taarby
Shore* 1901–07

165 Fritz Syberg
Overkaerby Hill, Winter
1917

166 Peter Hansen *The
Plowman Turning*
1900–02

167 **Henrik Sørensen**
Svartbekken 1909

168 **Axel Revold** *Italian Girl* 1913

XXXVII

XXVI

169

168

169 (OPPOSITE) **Jean Heiberg**
Nude 1912

The dominating function of colour, particularly blues and browns, can be seen in the work of another artist active in Denmark, the Norwegian Ludvig Karsten. Karsten, perhaps more than any other Norwegian artist, was fascinated by Munch's expressive use of colour (he had come to know Munch at Asgaardstrand during the summer months), though the technical training he had received from Christian Krohg and Harriet Backer at the Tegneskolen in Christiania was also of great value to him. One of his most intensely luminous works, *Blue Kitchen* (1913), painted in Vasser, is thus heir to Backer's *Baptism in Tanum Church*. It also owes much to Gauguin's emphasis on colour for its own sake, and the anti-classical compositions of Cézanne, free from conventional perspective, both of whose works he had seen in Paris in 1900. Furthermore, his attendance at Matisse's school in 1910 strengthened his devotion to deep colours.

More obviously in debt to Matisse, at least compositionally, is the work of another Norwegian, Jean Heiberg (1884–1976), the first of his countrymen to attend the master's newly opened school in 1908, after he had studied at the Académie Colarossi in Paris, where many other Nordic artists attended. His *Nude* (1912) contrasts form and colour and, at the same time, aims to produce an overall harmony. This work inspired many Norwegian artists, in particular Axel Revold (1887–1962), whose painting *Italian Girl* (1913) shows this stylistic connection. But it also owes its emphasis on planes to Cézanne and Kees van Dongen. In Heiberg's zeal to propagate the lessons of the Fauves, he was assisted by his fellow-student in Paris and life-long friend Henrik Sørensen (1882–1962). In his work *Svartbekken* (1909), Sørensen portrays the man in the landscape in a way that transforms figure and setting so that they are made incidental to the intensity of the colour, which is the true subject of the work.

202

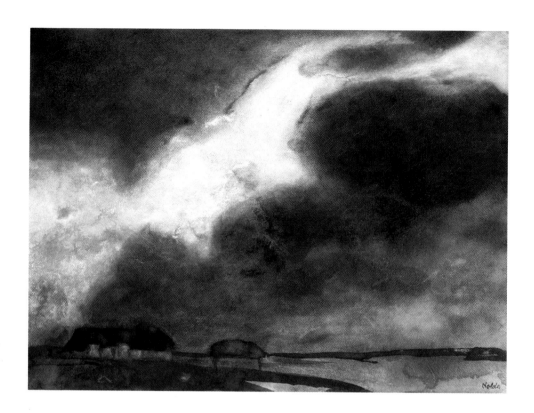

170 Emil Nolde *Friesland Farm under Red Clouds* 1930

171

For all the stylistic innovations in the paintings of these artists, however, Gösta Adrian-Nilson (1884–1965) or GAN, as he was known, from Lund like his predecessor Carl Frederick Hill, became the first Scandinavian to apply more rigorously in his work Futurist and Cubist principles. From 1912, GAN was often in Berlin where he came in contact with Futurist painting. His *City at the Seaside* (1919) uses Cubo-Futurist perspective to portray various angles of life in the city of Halmstad, on the south-western coast of Sweden. A domestic scene, depicting his friend Egon Østlund's sitting-room, and even an attempted burglary, are contained within this microcosmic view of modern urban life, while the train racing through the centre of the picture gives it a sense of accelerating movement.

Emil Hansen, better known as Nolde (1867–1956), assumed his name from his native village, not far from Tønder in Denmark. He came from a farming family who lived in an area which is today on the border between Germany and Denmark but which at the time of Nolde's birth had been newly wrested from Danish sovereignty in a bloody war, immortalized by the Danish novelist Herman Bang in his novel *Tine* (1889). Eventually, half the land which had been seized was returned to Denmark, but Seebüll, Nolde's home, remained under German rule. Nevertheless, Denmark and Danish culture were of enormous importance in Nolde's development and he acquired Danish nationality. After a brief period working in furniture factories in such diverse cities as Flensborg, Monaco, Karlsruhe and Berlin, Nolde went to Switzerland to attend a technical design course at St Gallen, after which he went to study in Paris. Finally, in the autumn of 1900, he moved to Copenhagen, where he hired an atelier, and there he met Hammershøi, Johansen, Skovgaard and Willumsen. He made numerous forays into the countryside of North Zealand where, in the company of the polar explorer Knud Rasmussen, he met the Danish actress Ada Vilstrup, who became his wife in 1902.

Four years later Nolde joined the German group of artists Die Brücke, when he was already one of Europe's leading Expressionist painters. Nolde's use of colour has affinities with contrasting musical tonalities, and he wrote: 'The colours are my notes with which I compose the harmonies and contrasting tones and chords.' [45] *Friesland Farm under Red Clouds* (1930), which, as well as depicting the intense beauty of the land and sky of the area, evokes a metaphysical mood of enormous power and depth, may serve to illustrate his notions about colour and music.

For all his attachment to Denmark and his acquaintance with the artists on Fünen, Nolde was closer to German artists than to his fellow Danes, not least for reasons of patronage.

170

*　*　*

Nordic art in the early twentieth century was characterized by a great and varied preoccupation with artistic trends from the heartland of Europe, which Nordic artists tried to assimilate while retaining a native identity. Their aim was to create an art which would be distinct from that part of Europe. This period also saw the first blossoming of art in Iceland, a country which had hitherto possessed few economic resources and was, as a result, hardly promising for the sustenance of the visual arts. However, by 1900, the Icelandic economy had begun to prosper and this, in combination with closer links to the rest of Europe, meant that it was then possible for a number of Icelanders to receive financial support for artistic training. During the previous 120 years, Iceland's artistic

171 **Gösta Adrian-Nilson** *City at the Seaside* 1919

172 **Vilhelm Lundstrøm** *Still-Life* c. 1930

production had been meagre. It is true that in 1783 and 1784 an Icelander, Saemundur Holm, working in Copenhagen, had won from the Kunstakadamiet the silver and gold medals, and that the father of the great sculptor Thorvaldsen had also emigrated to Denmark from Iceland, but that was not much on which to build the future of the fine arts in the developing nation.

Political circumstances in the early 1800s were difficult in Iceland, for the Danish king had provoked considerable antagonism in the country by abolishing Iceland's cherished ancient national assembly, the Alting (which was not re-instated until 1874). Gradually, however, the cultural climate began to become more European, and Icelanders started to appreciate their landscape's awesome beauty. They no longer resented its harsh conditions or feared its brutal appearance as many had done before. However, it was two Danish artists, both pupils of Eckersberg, who became the first painters of views of the coast of Iceland. Frederik Theodor Kloss (1802–76) had journeyed to Iceland in 1834 and produced two works of geysers in eruption. Through his influence, the artist Emanuel Larsen (1823–59) also visited Iceland's coast, producing his own *Geyser in Eruption* (1847), which was purchased by the Danish king Christian VIII.

It was in the early 1860s, however, that some of the first landscapes were painted in Iceland by local artists, in the first instances as backcloths for the Icelandic theatre production, Matthias Jochumson's *Skugga-Sveinn* (1862), a play about outlaws in the wilds of the country. Soon after, artistic and literary tastes current in Denmark reached Iceland and, by 1884, Bjørn Bjarnarson, an Icelander resident in Copenhagen, had taken the initiative in the foundation of the National Gallery of Iceland, which collected works by a number of leading Scandinavian artists. Georg Brandes's influence was particularly great at this time in Iceland's small cultural circle, and the Icelander Gestur Palsson (1852–91) was his apostle. Palsson wrote short stories which are taken from his experiences as a student in Copenhagen and its cultural milieu. In his efforts to create a fertile soil for the growth of the arts in Iceland, which at the time had only about 70,000 inhabitants, he was assisted by another young Icelander, Einar H. Kvaran (1859–1938), who had been a fellow-student in Copenhagen. Kvaran became the first modern, full-time Icelandic writer, and his writings as a journalist were of considerable importance in generating a cultural debate.

In the autumn of 1900 the first exhibition devoted to a single Icelandic artist was held at Reykjavik, the capital, dedicated to the painting of Thórarinn B. Thorláksson (1867–1924). Thorláksson had moved to Reykjavik from the north in 1885. He had worked as a bookbinder until 1895, when he moved to Copenhagen. There he studied first at the Kunstakadamiet and then at the private school of the Danish landscape painter Harald Foss (1843–1922). Though he painted portraits and intimate domestic interiors, his greatest skill was with moody landscapes that express visually the poetry of such contemporary Icelandic writers as Steingrimur Thorsteinsson. One of Thorláksson's best

works, *Thingvellir,* was painted in the same year as his 1900 exhibition, not long after his return to Reykjavik from Denmark. The volcanic plain of Thingvellir was an image the artist often returned to and one which was rich in resonance from Icelandic history, for it was here, since the year 930, that the Icelandic 'Thing' (Assembly of local chieftains) regularly gathered to build their national assembly and carry out their administrative and judicial responsibilities. Thingvellir also stood as a symbol of Iceland's fight for independence from Denmark, a struggle which led to home rule in 1918 and finally to independence in 1944. The National Assembly, which had been re-established in 1874, also sponsored Ásgrímur Jónsson (1876–1958), a rival of Thorláksson, to study art in Germany and Italy.

Jónsson had begun his training in Copenhagen in 1897 and within six years he too had his first exhibition in Iceland. He had been taught drawing by Gustav Vermehren before entering the Kunstakadamiet under August Jerndorff (1846–1906) and Frederik Vermehren. *Tindafjøll* (1903–04), the glacier Jónsson had sketched on his return to Iceland from Copenhagen in the summer of 1902, shares the emphasis on light and nature to create mood which was peculiar to Nordic art in the preceding decade, though later paintings were to show the growing influence which the Impressionists and Post-Impressionists, Van Gogh especially, had on him.

175

Three young artists strengthened the footing of painters in Iceland which Thorláksson and Jónsson had established. They were Jón Stefánsson (1881–1963), Jóhannes Kjarval (1885–1972) and Gudmundur Thorsteinsson (1891–1924). Stefánsson had studied in Copenhagen, but it was his period of training with Matisse in Paris, as well as the profound influence of Cézanne, which was of greatest importance to him when he returned to Iceland in 1924. His painting *Summer Night* (1929), for all its formal composition which hints at Mondrian, is still concerned with the Nordic tradition of depicting light and nature exuding a mystical mood, pointing perhaps towards some other higher reality, and it is certainly closer to Caspar David Friedrich than to Mondrian.

173

Kjarval's landscape *Thingvellir* (1930) rejects the tradition of Thorláksson and that of Stefánsson. In Kjarval's painting, natural forms are diffused in flecks of colour which surprisingly emphasise the hard and rocky geological make-up of the plain, which endured all onslaughts of nature and man. Kjarval's work owes its greatest debt not to modernism but to Turner, whose works he had seen in London, and where he had stayed after working on a fishing schooner, endeavouring to enter the Royal Academy. He was rejected and eventually joined the Kunstakadamiet in Copenhagen.

174

Gudmundur Thorsteinsson gives landscape a secondary role in his triptych *Christ Healing the Sick* (1921), made for the chapel at the presidential residence Bessastadir. He has chosen, instead, to emphasise the religious theme.

Though all these artists drew inspiration from a basically continental painterly tradition, one woman artist at this time in Iceland turned her attention to the volcanic island of Vestmannaeyjar, where her childhood had been spent, and sought inspiration in the Icelandic tradition of tapestry-making. Júliana Sveinsdóttir (1889–1960) spent most of her life in Denmark, but the colourful scenes she painted of the rugged Icelandic landscape of Vestmannaeyjar reflect her interest in Icelandic tapestries. Sveinsdóttir was herself an extremely accomplished weaver, using traditional Icelandic techniques of weaving and dyeing and this craft influenced the colours she used in her paintings and their compositional arrangement. Ingibjoerg H. Bjarnason, however, who was born in Reykjavik, studied and painted in Paris in the 1920s, where she absorbed a modernist style. Her *Composition Abstraite* was one of the more innovative works produced by an Icelandic artist of this time, employing a composition and style of painting related to Mondrian, and was exhibited at the Salon des Indépendents in Paris, 1929 and 1930.

* * *

Sculpture, too, in Iceland showed signs of a new impetus, but without great stylistic innovation. The first Icelandic sculptor was Einar Jónsson (1874–1954) who worked on themes with symbolic and mythological content, looking back to the great Icelandic Sagas of the early Middle Ages. He was also influenced by Thorvaldsen and, to a lesser degree, by the Norwegian sculptor Stephan Sinding, by whom he had been taught.

THE ICELANDIC LANDSCAPE

173 (LEFT) **Jón Stefánsson** *Summer Night* 1929

174 (BELOW) **Jóhannes Kjarval** *Thingvellir* 1930

175 (TOP) **Ásgrímur Jónsson** *Tindafjøll* 1903–04

176 (ABOVE) **Thórarinn B. Thorláksson** *Sunset by the Lake* 1905

The renewed interest in sculpture by a native Icelander reflected a general revival of interest in this art form in the rest of Scandinavia, where sculpture since the middle years of the nineteenth century had fallen into a decline. One of the main subjects of sculpture in the Nordic countries at the beginning of the twentieth century was the male nude, executed in a newly defined classicism which expressed energy, motion, strength and power. They reflect the increasing attention given to gymnastics and physical education at this time. The preoccupation with male physical prowess mirrored, perhaps, a nationalistic attitude associated with this kind of imagery, appropriate at the time because of the First World War (the full brunt of which Scandinavia succeeded in averting, though volunteers fought on both sides).

In Sweden, Carl Eldh (1873–1954) was the leading sculptor of this muscular ideal. Eldh, who as a child had carved in wood, had been an apprentice to an ornamental sculptor in Uppsala, before moving to Stockholm where he joined the atelier of the ornamental sculptor Lars Mellin (1841–1905), and attended evening courses at the Techniska Skolen (Technical School). In 1896 Eldh went to Paris where he stayed for the next eight years, studying at, among other schools, the Académie Colarossi (1898–99). He received an honourable mention at the World Exhibition of 1900 for a sculpture of a young girl entitled *Innocence*.

After Eldh returned to Stockholm in 1903 he was able to draw inspiration not only from his close friends among the *Pariserpoikarna* (see Chapter 6), Bergh, Jansson, Kreuger and Nordström, but also from J. A. Injalbert, a salon sculptor in the traditional style. More importantly, he was inspired by Auguste Rodin whose influence is evident in Eldh's work *The Runners* (1937), one of the most powerful sculptures in Nordic art of this period, erected in bronze at the Stockholm stadium (a model is reproduced here). The ability to express physical power was one of Eldh's greatest gifts, but he also succeeded in evoking spiritual energy, as his bronze bust of Strindberg (1905) demonstrates. He had met Strindberg through Bergh and they had become close friends. As an influential Swedish art critic of the time, August Brunius, wrote: 'He [Strindberg] is listening to the storms within and pressing the blackened nails into his breast – that image is just one side of Strindberg, for he is also a visionary, and one who remembered what he saw. But is not this introversion, the egocentric and dialectic, the most characteristic of Strindberg?'[46]

In the work of a Norwegian sculptor of this period, Gustav Vigeland (1869–1943), there is a similar preoccupation with the nude form at its most powerful and energetic, often in the grips of strong emotions. Vigeland's father was a woodcarver and carpenter; a deeply religious man, his piety could overflow into fanaticism, as on Good Fridays, when he used to beat the young Vigeland to make him share in Christ's sufferings on that day. Gustav followed his father's footsteps as a woodcarver, then trained as a sculptor when he moved to Copenhagen in 1891 to study with Christian Gottlieb Bissen (1836–1913), son of the famous sculptor of the first half of the nineteenth century, and Georg Christian Freund (1821–1900), nephew of the sculptor Herman Freund (see Chapter 3). This was followed by a period in Paris from 1892 to 1893, after which, in 1895, he went to Berlin, associating with Munch, as well as Przybyszewski and Strindberg. After further visits to Paris and London he was given a major commission to carry out sculptural work on Trondheim Cathedral (1897), which helped him to make his name. Thereafter, he was patronized by the Swedish-Jewish bank director Ernst Thiel, who had assisted many other Nordic artists and whose collection of works of art in Stockholm is today one of the greatest of this period in Scandinavia.

179 **Ville Vallgren** *The Widow* 1892

The Commune of Oslo (Oslo city council) eventually agreed to provide Vigeland's financial needs and this led to the creation of his most memorable and imposing group of work, the sculptures at Frøgner Park in Oslo (the fountain was commissioned in 1907, but the park was not opened to the public until 1947). Here figures play, fight, caress and cavort in massive and energetic poses, full of sensuality, in what he intended to be a sculptural equation of Einstein's theory, especially in the fountain! His ability to express energy and physical intensity is also evident in busts, including his *Self-portrait* (1922). The sheer number of the sculptures on view in this park and their muscular poses seem to exude health, boundless energy and a strident militancy. As such, it is perhaps the most monumental display of socially realistic sculpture ever made in Scandinavia. It was an appropriate symbol of Norway as a vigorous young nation building its new identity.

183, 184

In Finland, similarly socially realistic sculpture, of muscular and active nudes, is also to be found, as in the work of Yrjo Liipola (1881–1971), Waïnö Aaltonen (1894–1966) and Felix Nylund (1878–1940). Liipola had studied in Turku from 1899 to 1901, and travelled to Italy before settling in Hungary (whose language is related to Finnish), where he remained until 1934. His bronze statue, *Son of the Forest,* portrays the spirit of Finland striding through its forests. Liipola's distant cousin Aaltonen sculpted in bronze a contemporary personality, Paavo Nurmi (1924–25). It expresses, in a Neo-classical form, the dynamism of this triumphal runner at the Paris 1924 Olympics, and seems to embody the power of a resurgent Finland newly recovered from civil war. The nudity of the statue precluded its acceptance as a large, out-door work in the puritanical climate which prevailed in Finland at this time, and it was not until 1952 that a copy was made for the Olympic Stadium in Helsinki, and another two copies were made for Turku, Aaltonen's native city, and Nurmis. *Paavo Nurmi* was one of the several public commissions for Aaltonen. It was Nylund who portrayed the construction of the new Finland, which was now the people's principal task after the cessation of civil hostilities in 1919. His *Three Smiths* (1932), which includes Nylund's self-portrait, was erected in the Studenthusplats in Helsinki. The three figures seem to be toiling for the new, ideal society which many hoped would arise in Finland. A sketch from 1919 for this work exists and Nylund had considered a sculpture on this theme even before the First World War. Greater economic resources than had been available previously and a newly established period of stability after the civil war provided the means for aspiring artists to work and created the need for sculptural monuments which could symbolize the new social order in Finland in the 1930s.

181

180

As well as dynamically expressed nude figures, another common subject of Nordic sculpture in the early part of the twentieth century was derived from classical and Nordic myths. In Sweden Carl Milles (1875–1955) acquired a reputation for such works. Milles was largely self-taught, excluding three years of training at the Techniska Skolen (Technical School), but his artistic ability was recognized early and when the Sljöidföreningen (Crafts Union) gave him a stipend he used it to stay in Paris. There he studied briefly at the Académie Colarossi, but it was Rodin whose work most profoundly influenced him. Another influence was his elder countryman Per Hasselberg (1849–94), best known for his sculpture *The Frog* (1889). In 1902 Milles achieved his breakthrough when he won a competition to produce a monument to the sixteenth-century Swedish political leader Sten Sture, which he carried out the following year. Travels to Italy heightened his appreciation of the classical, in particular the integration of sculpture in gardens. In 1908 he began to lay out his own garden, Millesgården (now open to the public), at Lidingö near Stockholm, which he filled with a vast collection of his own sculptures.

SOCIAL REALISM

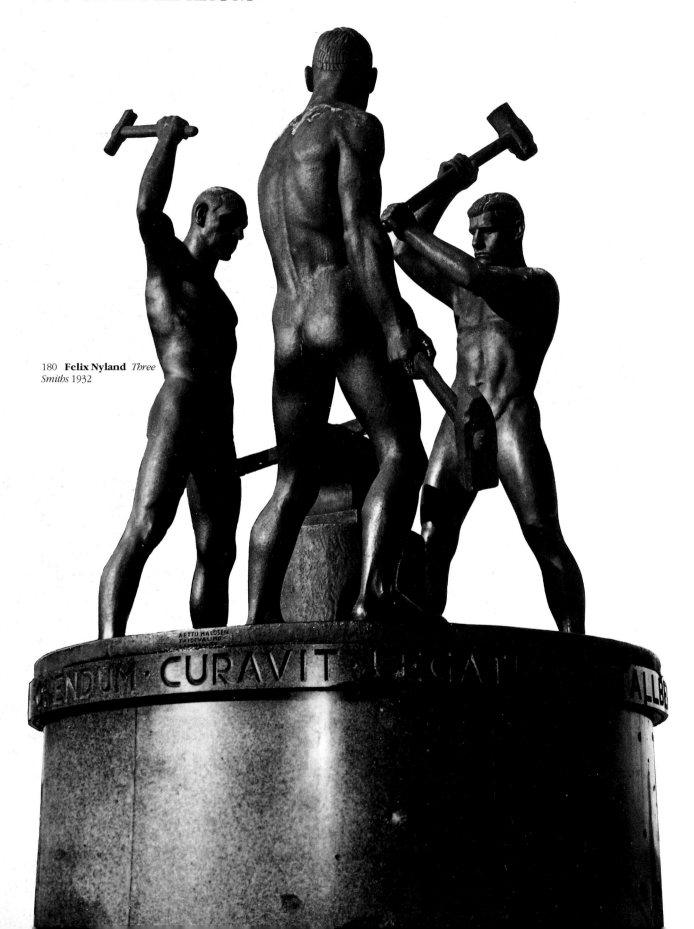

180 **Felix Nyland** *Three Smiths* 1932

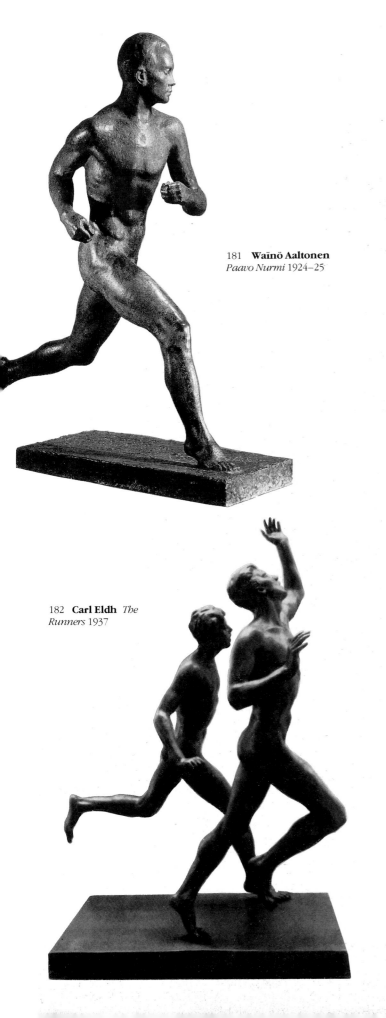

181 **Wäinö Aaltonen**
Paavo Nurmi 1924–25

183, 184 **Gustav Vigeland** *Monolith* 1929–42 (details)

182 **Carl Eldh** *The Runners* 1937

185 **Carl Milles** *Nymph Riding a Dolphin, The Sun Shining* 1918

185 It was the archaic period of classical sculpture which most appealed to Milles and its traces are to be found in *Nymph Riding a Dolphin, The Sun Shining* (1918) and *Folke Filbyter*. Though the former is on a classical theme and the latter is purely Nordic, both are direct descendants of the archaic sculpture he so much admired. Milles has, however, added to these traditional subjects his own energetic and fluid rhythm, a unique combination which emphasises the unmistakable individuality of the work. Millesgården is on an intimate scale, in spite of the great quantity of sculpture it contains.

Two other sculptors also worked with mythological subjects, the Dane Kai Nielsen (1882–1924) and the Swede Gerhard Henning (1880–1967). Both had travelled extensively in France and Italy and both were deeply impressed by the works of Rodin and Maillol. They looked towards a new classical approach to sculpture, which ignored and rejected modernism, especially Cubism. Nielsen's work on the saga of a giant, *Ymerbrønden* (1912), and Henning's *Dansai* (1927) were of considerable importance for the development of sculptural styles in Denmark at the time. All these sculptors' works bear witness to the continued preoccupation in the Nordic countries with a classical tradition of art which they tried to use in ways most suited to interpret their visions and aspirations in early twentieth-century Scandinavia, at a time when modernism was taking over the sculpture of continental Europe.

The Second World War was a watershed in the development of Nordic art. During the War, Scandinavia was plunged into greater cultural isolation than had been the case since the Napoleonic Wars, but after 1945 Nordic artists produced works more closely integrated with continental and especially American styles, and they completely adopted modernist conventions. Contemporary Nordic art thus contrasts sharply with that of the previous two centuries. Even though the art of that period generally adhered to European artistic traditions, it had a unique Scandinavian identity because of its preoccupation with nature, light, mood and Nordic culture.

216

NOTES ON THE TEXT
BIOGRAPHIES
SELECT BIBLIOGRAPHY
LIST OF ILLUSTRATIONS
INDEX

Notes on the Text

1 Gösta Lilja, Bror Olsson and S. Artur Svensson (eds), *Svensk Konstnärslexikon* (5 vols, Allhems Förlag, Malmö 1967) vol. 1, p. 237

2 Erik Lassen (ed.), *Dansk Kunsthistorie* (4 vols, Politikens Forlag, Copenhagen 1972) vol. 3, p. 388

3 Kasper Monrad, 'Dankvart Dreyer', *Danish Painting: The Golden Age* (The National Gallery, London 1984) p. 249

4 Bo Lindwall, *Konsten i Sverige: Det tidliga 1800-talen* Sven Sandström (ed.) (8 vols, Almqvist & Wiksell Förlag, Stockholm 1981) vol. 5, p. 74

5 *Svensk Konstnärslexikon*, vol. 5, p. 33

6 E. N. Tigerstedt (ed.), 'Tegnér', *Ny Illustrerad Svensk Litteratur Historia* (Natur och Kultur, Stockholm 1967) vol. 3, p. 251

7 *Dansk Kunsthistorie,* vol. 3, p. 311

8 Hans Edvard Nørregård-Nielsen, *Dansk Kunst* (2 vols, Gyldendal, Copenhagen 1983) vol. 1, p. 243

9 *Norsk Kunstnerleksikon* (4 vols, Universitetforlaget, Oslo 1982–86) vol. 4, p. 144

10 *Norsk Kunstnerleksikon,* vol. 4, p. 158

11 Jan Askeland, *Norsk Malerkunst* (J. W. Cappelens Forlag AS, Oslo 1981) p. 43

12 Helmut Börsch-Supan, *Caspar David Friedrich* (Prestel Verlag, Munich 1980) p. 8

13 Jan Askeland, *Norsk Malerkunst,* p. 57

14 Jan Askeland, *Norsk Malerkunst,* p. 73

15 Jan Askeland, *Norsk Malerkunst,* p. 69

16 Jan Askeland, *Norsk Malerkunst,* p. 121

17 Sixten Strömbom, *Konstnärsförbundets Historia* (Albert Bonniers Förlag, Stockholm 1945) p. 27

18 *Norsk Kunstnerleksikon,* vol. 4, p. 275

19 Frederik Dessau, *Skagen og Digterne* (Hamlet 1980) p. 68

20 Knud Voss, *Skagensmalerne* (2 vols, Hamlet 1980, 1981) vol. 1, p. 64

21 Georg Brandes, 'Inledning', *Hovedstrømninger i det Nittendeaarhundredes Litteratur* (1871) p. 3

22 Dessau, *Skagen og Digterne,* p. 21

23 Dessau, *Skagen og Digterne,* p. 20

24 Dessau, *Skagen og Digterne,* p. 12

25 Voss, *Skagensmalerne,* vol. 2, p. 7

26 Voss, *Skagensmalerne,* vol. 2, p. 9

27 Voss, *Skagensmalerne,* vol. 2, p. 9

28 Voss, *Skagensmalerne,* vol. 1, p. 92

29 Hakon Stangerup and F. J. Billeskov Jansen, *Dansk Litteratur Historie* (4 vols, Politikens Forlag, Copenhagen 1967) vol. 3, p. 33

30 Otto Lous Mohr, *Henrik Ibsen som Maler* (Gyldendal Norsk Forlag, Oslo 1953) p. 44

31 Mohr, *Henrik Ibsen,* p. 52

32 Per-Olov Zenström, *Ernst Josephson* (Bo Caverfors, Malmö 1978) p. 28

33 *Norsk Kunstnerleksikon,* vol. 5, p. 167

34 Akseli Gallen-Kallela, *Boken om Gallen-Kallela* (Wallström & Widstrand, Stockholm 1947) pp. 93–94

35 Allan Ellenius, *Bruno Liljefors* (Carmina, Uppsala 1981) p. 99

36 Prins Eugen, *Breven Berätta* (P. A. Norstedt & Söners Förlag, Stockholm 1942) p. 244

37 Brigitta Rapp, *Richard Bergh: Konstnär och Kulturpolitiker 1890–1915* (Stockholm 1978) p. 46

38 Richard Bergh, *Om Konst och Annat* (Albert Bonniers Förlag, Stockholm 1908) p. 118

39 Kjell Boström, *Nils Kreuger* (Albert Bonniers Förlag, Stockholm 1948) p. 42

40 Axel Gauffin, *Prins Eugen* (P. A. Norstedt & Söners Förlag, Stockholm 1915) p. 41

41 Gustaf Lindgren, *Prins Eugen* (Bokkonst, Göteborg 1944) p. 8

42 John House at the Courtauld Institute Symposium on Nordic Art, 3 October 1986

43 Poul Vad at the Courtauld Institute Symposium on Nordic Art, 3 October 1986

44 *Svensk Konstnärslexikon,* vol. 1, p. 32

45 Martin Urban, 'Emil Nolde: Einführung in die Austellung', *Emil Nolde* (National Museum for Western Art, Tokyo 1981) p. 1

46 *Svensk Konstnärslexikon,* vol. 2, p. 117

Biographies

AADNES, Peder (1739–92). Itinerant Norwegian painter and student of Eggert Munch. He painted landscapes and portraits in a Rococo style.

AALTONEN, Wäinö (1894–1966). Leading twentieth-century Finnish sculptor. He was inspired by Rodin. Such a work as *Paavo Nurmi* is an excellent example of the classically inspired, socially realistic style in Scandinavia at this time. *See* E. Hakkila *Wäinö Aaltonen: Elämä ja taidetta* 1953

ABILDGAARD, Nikolai Abraham (1743–1809). Danish painter and also architect. He trained at the Kunstakadamiet in Copenhagen, winning the gold medal (1767) which enabled him to study in Italy. His early interest was in literary and historical subjects (the Oldenborg's dynastic history at Christiansborg Palace). Later, he concentrated on themes taken from classical mythology. He was Thorvaldsen's tutor and, with Jens Juel, the most important late eighteenth-century Danish artist. *See* Bente Skovgaard *Maleren Abildgaard* 1961, Copenhagen

ACKE, Johan Axel Gustaf (1859–1924). Swedish artist best known for paintings such as *Morning Air* (1911). He was also active in the artists' colony of Åland. *See* W. Berg 'J. A. G. Acke' in *Ord och Bild* 1925

ADRIAN-NILSON, Gösta (1884–1965). Swedish artist deeply influenced by Cubism and Futurism. Many of his paintings of city-scapes and sailors possess an energy and harmony of composition unequalled in Nordic art. *See* Jan Torsten Ahlstrand *GAN: Gösta Adrian-Nilson* 1985, Stockholm

AGUÉLI, Ivan (1869–1917). Swedish artist who studied in Paris, where Cézanne and Gauguin inspired him. He converted to Islam and moved to North Africa where he acquired subjects for his paintings. *See* Axel Gauffin *Ivan Aguéli: Människan, mystikern, måleren* 1948–49, Stockholm

AHLGRENSSON, Björn (1872–1918). Swedish artist who was in the artists' colony at Racken in Värmland. He is known for his domestic interiors expressive of Nordic *stämning*.

ANCHER, Anna (1859–1935). Leading Danish late nineteenth-century painter. She studied in Paris under Puvis de Chavannes and was influenced by the Impressionists. The only native Skagen artist, she produced powerful works of domestic interiors. She was married to Michael Ancher. *See* Knud Voss *Anna Ancher* 1974, Copenhagen

ANCHER, Michael (1849–1927). Danish painter noted for his scenes from the artists' colony of Skagen. A student of the Kunstakadamiet, he is best known for his portrayals of local fishermen. *See* Karl Madsen 'Michael Ancher' in *Tilskueren* 1886, Copenhagen

ANDERSEN, Hans Christian (1805–75). The Danish author was also a gifted artist who produced charming paper cut-outs, and collages which seem to anticipate those of the 1930s. He 'discovered' Skagen in Denmark. *See* Kjeld Heltoft *Hans Christian Andersen* 1977, Copenhagen

ARBO, Peter Nicolai (1831–92). Norwegian artist who studied in Copenhagen, Düsseldorf and Paris. He was most interested in themes from Viking history and mythology. *See* L. Dietrichson *Dagen af P. N. Arbo* 1878, Stockholm

AROSENIUS, Ivar (1878–1909). Swedish artist who studied at the Konstakadamien. His caricatures in tempera show how important the Fauves were to his artistic development. *See* K. Asplund *Ivar Arosenius* 1928, Stockholm

BACKER, Harriet (1845–1932). Late nineteenth- and early twentieth-century Norwegian artist, renowned for her lustrous palette. The art school which she opened in Christiania on her return from Düsseldorf and Paris was of considerable importance for the young Norwegian artists. *See* Marit Lange *Harriet Backer og Kitty L. Kielland* 1893, Åmot

BALKE, Peder (1804–87). Norwegian landscape painter. He studied in Christiania, Stockholm and Dresden, and visited Paris and London. Many of his works show the awesome beauty of the north of Norway and won considerable acclaim abroad.

BENDZ, Wilhelm (1804–32). Danish painter. After training at the Kunstakadamiet under Eckersberg, he travelled to Germany and Italy. He is most famous for his domestic interiors and portraits. *See* A. Røder *Maleren W. Bendz* 1905

BERGH, Richard (1858–1919). Swedish painter and student at the Konstakadamien. Many of his works are of the Swedish landscape, often depicted with a Symbolist dimension. With Kreuger and Nordström, he developed a national Romantic art. *See* Axel Gauffin 'Richard Bergh' in *Tidskrift för konstvetenskap* 1919

BERGSLIEN, Brynjulf (1830–98). Norwegian sculptor who studied at the Copenhagen Kunstakadamiet under Bissen and Jerichau. His work shows the influence of both classical and Baroque Roman sculpture. *See* M. Dragestad *Dei tre Bergslikunstnarane* 1945, Voss

BISSEN, Herman Vilhelm (1798–1868). Danish sculptor who trained at the Kunstakadamiet. He spent ten years in Rome as a pupil and assistant of Thorvaldsen and faithfully continued his Neo-classical style. He was made a professor of the Kunstakadamiet in 1840. *See* Haavard Rostrup *H. W. Bissen* 1945

BLOMMÉR, Nils Jakob (1816–53). Swedish artist who studied extensively in Germany and France. He painted themes from Nordic mythology. *See* G. Thomaeus *Nils Jakob Blommér* 1922

BLOMSTEDT, Vaino (1871–1947). Finnish artist who was a pupil of Gauguin in Paris. He is best known for his Symbolist works.

BLUMENTAL, Mathias (*c.* 1719–63). Danish artist who emigrated to Norway. He worked in a Rococo style, painting murals for the interiors of rich burghers' houses. *See* A. M. G. Gandrup *Mathias Blumental* 1950, Oslo

BREDA, Carl Fredric von (1759–1818). Swedish portrait painter and pupil of Joshua Reynolds in London. He became Professor at the Stockholm Kunstakadamien, exerting a conservative influence. *See* E. Hultmark *Carl Fredric von Breda* 1915

BYSTRÖM, Johan Niklas (1783–1848). Swedish sculptor who studied under Martin and Sergel at the Konstakadamien. In 1810 he won a stipend to study in Rome, where the Greek and Roman antiquities he saw strengthened his Neo-classical style. *See* T. Nyman *Johan Niklas Byström* 1939

CAINBERG, Eric (1771–1816). Finnish sculptor who studied under Sergel at the Stockholm Konstakadamien before going to Rome. He worked in a Neo-classical style, sometimes choosing Finnish mythological themes as subjects.

CAPPELEN, August (1827–52). Norwegian landscape painter who studied under Gude in Düsseldorf. He painted melancholy scenes from his native Telemark. *See* O. Thue *August Cappelen* 1957, Oslo

CAWÉN, Alvar (1886–1935). Finnish artist and member of the November Group. He lived for six years in Spain and France where Cubism and Fauvism influenced his work. *See* Onni Okkonen *Alvar Cawén* 1958

CEDERSTRÖM, Gustaf (1845–1933). Swedish artist, from an aristocratic family, and a director of the Konstakadamien. He devoted much of his œuvre to history painting. *See* A. Romdahl *Gustaf Cederström* 1948

CHRISTIANSEN, Poul S. (1855–1933). Danish painter and member of the artists' colony at Fåborg on Fünen. He is best known for his portraits. *See* Carl V. Petersen 'Poul S. Christiansen: Barndom og Ungdom' in *Tilskueren* 1914, Copenhagen

CHURBERG, Fanny (1845–92). Finnish landscape painter whose works possess an expressionistic intensity unusual for their period. She was also active in fostering the decorative Finnish craft tradition, especially embroidery. *See* A. Lindström *Fanny Churberg: Elämä ja teokset* 1938

COLLIN, Marcus (1882–1966). Finnish artist and a member of the November Group. He was profoundly influenced by Cubist concepts. His best-known works are scenes from Finland's civil war. *See* L. Wennervirta *Marcus Collin* 1925

DAHL, Johan Christian (1788–1857). Greatest Norwegian landscape painter of the first half of the nineteenth century. He studied at the Kunstakadamiet in Copenhagen, and afterwards spent most of his life in Dresden, where he taught a number of the leading Norwegian artists of the next generation. He was influenced by the Netherlandish Masters of the seventeenth century and depicted the sublimity and wild grandeur of the Norwegian landscape. *See* A. Aubert *Johan Christian Dahl* 1920

DALSGAARD, Christen (1824–1907). Danish artist who studied at the Kunstakadamiet. He painted genre themes, often showing dramatic moments in the lives of ordinary people. *See* Knud Søeborg *Christen Dalsgaard og hans kunst* 1902, Copenhagen

DARDEL, Nils von (1888–1943). Swedish artist, from an aristocratic family, and member of the artists' society De Åtta. His grandfather was the history painter Fritz von Dardel (1817–1901). *See* Ingemar Lindahl *Visit Hos Excentrisk Herre: En bok om Nils Dardel* 1980, Stockholm

DRACHMANN, Holger (1846–1908). Danish poet and artist. A student of Sørensen, he devoted much of his poetry and painting to Skagen.

ECKERSBERG, Christoffer Wilhelm (1783–1853). Called the father of Danish painting because of the enormous influence he exerted on Danish nineteenth-century art and artists. He studied at the Kunstakadamiet and in Paris under David, before moving to Rome. He was later made professor at the Kunstakadamiet. He is famous for his portraits of Danish middle-class patrons, and for his marine paintings. *See* Emil Hannover *C. W. Eckersberg* 1898, Copenhagen

ECKERSBERG, Johan Fredrik (1822–70). Norwegian landscape painter who studied in the Low Countries and Düsseldorf. His paintings evince a more classical and linear style than those of other Norwegian artists.

EDELFELT, Albert (1854–1905). One of the leading Finnish painters of the late nineteenth and early twentieth century. He studied in Paris where Bastien-Lepage greatly influenced him. His landscapes are rich in Nordic *stämning*, while his portraits are some of the best painted in Finland. *See* B. Hintze *Albert Edelfelt* 1945, Stockholm

EGEDIUS, Halfdan (1877–99). Norwegian artist whose works are especially evocative of Nordic *stämning*. In depicting his native countryside or a local dance, the portrayal of light is central to the work. *See* Øistein Parmann *Halfdan Egedius: Liv og verk* 1979, Oslo

EKMAN, Robert Wilhelm (1808–73). Known as the father of Finnish painting because of his devotion to themes from

Finland's history. He was also an accomplished genre painter and travelled extensively in Italy and France. *See* B. Hintze *Robert Wilhelm Ekman* 1926

ELDH, Carl (1873–1954). Leading Swedish sculptor of social realism. He trained in Paris at the Académie Colarossi and was extremely influenced by Rodin. His best work, *The Runners* (1937), exemplifies its type in Scandinavia. *See* K. Asplund *Carl Eldh* 1943, Stockholm

ENCKELL, Magnus (1870–1925). Finnish painter and one of the leaders of the Group of Seven. He is most noted for his portraits, both of members of Finnish society and young men confronted with the problems of adolescence and existence itself. *See* J. Puokka *Magnus Enckell: Ihminen ja taiteilija* 1949

FAGERLIN, Ferdinand Julius (1825–1907). Swedish artist, best known for his colourful genre painting. He studied at Uppsala University before going to Düsseldorf and Paris. *See* Axel Gauffin *Ferdinand Fagerlin* 1910

FEARNLEY, Thomas (1802–42). Norwegian landscape painter who studied in Copenhagen, Stockholm and Dresden, and travelled extensively in Italy. He worked in a naturalistic style which emphasised the energy and force in nature. *See* S. Willoch *Maleren Thomas Fearnley* 1932, Oslo

FINNBERG, Wilhelm (1784–1833). Finnish artist who studied at the Konstakadamien in Stockholm. He is most noted for his portraits and paintings on classical themes. *See* S. Sarajas-Korte *Gustaf Wilhelm Finnberg: Täydennystä Finnbergtutkimukseen* 1959

FJAESTAD, Gustaf (1868–1948). Swedish landscape painter who trained under Liljefors and Larsson. He is most famed for his paintings of the surfaces of lakes and rivers in winter and spring. He was assisted by his wife Maja, who translated many of his compositions into tapestries. *See* A. Fjaestad *Gustaf och Maja Fjaestad: Ett konstnärspar* 1981, Karlstad

FLINTOE, Johannes (1787–1870). Norwegian landscape painter who studied at the Kunstakadamiet in Copenhagen. He brought the wild beauties of his native land to the attention of Norwegian artists, who until then had seldom considered them worth depiction. *See* H. Alsvik *Johannes Flintoe* 1940

FOGELBERG, Bengt Erland (1786–1854). Swedish sculptor. He was a pupil of Sergel's at the Konstakadamien and worked in his mentor's Neo-classical style, reinforced by a lengthy stay in Rome. Later in life, Nordic subjects preoccupied him. *See* J. Böttiger *Bengt Erland Fogelberg* 1880

FREUND, Hermann Ernst (1786–1840). German-born sculptor who emigrated to Denmark. He studied at the Kunstakadamiet and in Rome, where he became a pupil and assistant of Thorvaldsen, working in his master's Neo-classical style, but infusing it with Gothic and Nordic elements. In 1829 he became a professor of the Kunstakadamiet. *See* Thomas Oppermann *H. E. Freund* 1916

FRIEDRICH, Caspar David (1774–1840). The leading German Romantic painter of the nineteenth century. A native of Swedish Pomerania, he studied at the Copenhagen Kunstakadamiet. His northern landscapes and domestic interiors are full of metaphysical allusions and symbolic associations. *See* Helmut Börsch-Supan *Caspar David Friedrich* 1980, Munich

HALL, Peter Adolph (1739–93). Swedish portrait painter, and former student in Uppsala of the botanist Carl Linnaeus. He spent much of his life in Paris and is particularly noted for his miniatures. *See* F. Villot *Hall: célèbre miniaturiste du XVIII siècle, sa vie, ses œuvres, sa correspondance* 1867, Paris

GALLEN-KALLELA, Akseli (1865–1931). Wide-ranging artist who became Finland's most noted Symbolist painter, inspired by the Finnish landscape and mythology. He also introduced woodcuts and monumental frescos and was a champion of Art Nouveau in Finland. He travelled extensively, visiting East Africa and the United States of America, whose primitive arts provided new inspiration in the latter part of his life. *See* Onni Okkonen *A. Gallen-Kallela: Elämä ja taide* 1961; Timo Martin and Douglas Sivén *Axeli Gallen-Kallela* 1985

GRÜNEWALD, Isaac (1889–1946). Swedish-Jewish artist who was one of the group known as De Unga which later regrouped as De Åtta. His work was strongly influenced by Matisse and Cézanne. He was married to the artist Sigrid Hjertén. *See* J. P. Hodin *Isaac Grünewald* 1949

GUDE, Hans (1825–1903). Norwegian landscape painter who studied under Flintoe in Christiania. He was the first Norwegian to move to Düsseldorf, where he studied under the German landscape and genre artists attached to the academy. He became a professor there and was instrumental in attracting many Scandinavians to study in Düsseldorf. *See* S. Willoch *Hans Gude* 1925

HALONEN, Pekka (1865–1933). Finnish painter, from a peasant family, who studied at the Konstföreningen's Drawing School. He went to France where he was greatly influenced by the Barbizon painters, studied under Gauguin, and was strongly impressed by Puvis de Chavannes. He painted scenes from peasant life and the beauties of Finland's lakes and forests. *See* A. Lindström *Pekka Halonen: Elämä ja teokset* 1957

HAMMERSHØI, Vilhelm (1864–1916). One of Denmark's leading late nineteenth- and early twentieth-century artists. He succeeded in expressing mood in domestic interiors to a greater degree than any other contemporary European artist, but was also a master of architectural and landscape paintings. *See* Sophus Michaëlis and Alfred Bramsen *Vilhelm Hammershøi* 1918, Copenhagen; Poul Vad *Vilhelm Hammershøi* 1957, Copenhagen

HANSEN, Constantin (1804–80). Danish painter and student of Eckersberg at the Kunstakadamiet. He lived in Rome in his thirties and later won the much-prized Thorvaldsen Medal

(1852). He is most noted for his portraits and history paintings. *See* Emil Hannover *Maleren Constantin Hansen* 1907

HANSEN, Peter (1868–1928). Danish painter and member of the artists' colony at Fåborg on Fünen. He produced its most notable landscape paintings, rich in texture and movement. *See* Karl Schou *Maleren Peter Hansen* 1938, Copenhagen

HANSSON, Ola (1754–1820). Norwegian artist who painted decorations for provincial domestic interiors in a rustic style, full of vivid colours.

HASSELBERG, Per (1849–94). Swedish sculptor who studied at the Ecole des Beaux-Arts in Paris. Carpeaux exerted a considerable influence on his style. *See* G. Nordensvan 'Tvänne konstnärsporträtt. Per Hasselberg – Carl Larsson' in *Nornan* 1883

HEIBERG, Jean (1884–1976). Norwegian artist who studied under Matisse in Paris. He worked to achieve a unified effect in his paintings by contrasting different forms and colours.

HENNING, Gerhard (1880–1967). Swedish artist whose works were greatly influenced by Rodin and Maillol. His sculptures were often of mythological subjects. *See* P. Hertz *Billedhuggeren Gerhard Henning* 1931, Copenhagen

HERTERVIG, Lars (1830–1902). Norwegian landscape painter who was a student of Flintoe and Eckersberg in Christiania and later under Gude in Düsseldorf. Although insane for most of his life, he none the less produced some of the most evocative landscape paintings by any Nordic artist. *See* Holger Kofoed *Lars Hertervig* 1984, Oslo

HILL, Carl Frederick (1849–1911). Swedish landscape painter. He studied at the Konstakademien and in France where Corot and the Barbizon painters exerted an enormous influence on him. In the late 1870s and particularly after insanity set in, he developed a very individual style. *See* Adolf Anderberg *Carl Hill* 1951, Malmö.

HILLESTRÖM the Elder, Pehr (1732–1816). Swedish genre painter, whose works are full of anecdote. He was strongly influenced by the seventeenth-century Dutch Old Masters. *See* Rönnow *Pehr Hilleström: och hans bruks- och bergverksmålningar* 1929

HJERTÉN GRÜNEWALD, Sigrid (1885–1948). Swedish painter and wife of Isaac Grünewald, she also was a member of the De Åtta group. She was profoundly influenced by Cubism.

HJORTH, Bror (1894–1968). Swedish painter and sculptor who studied at the Kunstakademiet in Copenhagen. His works have a naïve and humorous charm, inspired by traditional wood-carving and painterly decoration. *See* E. Blomberg *Bror Hjorth* 1942

HÖCKERT, Johan Fredrik (1826–66). Sometimes called the 'Swedish Delacroix' because of his evocative use of colour. His paintings of Lapland and its local inhabitants were highly popular in France. *See* A. J. T. Borelius *Johan Fredrik Höckert* 1927, Stockholm

HOLMBERG, Werner (1820–60). Finnish landscape painter. He worked with Ekman in Turku, before studying in Düsseldorf. His paintings are naturalistic, and often sublime in character. *See* E. Aspelin *Werner Holmberg: Hans lefnad och verk* 1890

HOLSØE, Carl (1863–1935). Danish artist whose works are deeply influenced by Vermeer and other Dutch masters. He mainly painted domestic interiors.

HÖRBERG, Pehr (1746–1816). Swedish painter of humble background who trained as a *bonadsmålerer*, following his father Abraham Clemetsson (1729–95). He produced works on biblical themes for country houses and churches. He also painted portraits of great emotional power.

HOSENFELDER, Heinrich Christian Friedrich (*c.* 1719–1805). German artist who emigrated to Norway. He was attached to the Herrebøe Fajance Factory and also produced able portraits and murals.

HØST, Oluf (1884–1966). Danish painter from the island of Bornholm. He trained at Vermehren's painting school, then attended the Kunstakademiet, and finally studied under Rohde and Giersing. He travelled to Italy, France and most of the Nordic countries, winning the Eckersberg Medal in 1933 and the Thorvaldsen Medal in 1943. His works include coastal scenes and vividly coloured pictures of simple farmhouses and stables, particularly from his village of Gudhjem on Bornholm. *See* Jørgen Sandvad and Otto Gelsted *Oluf Høst* 1960, Copenhagen

IBSEN, Henrik (1828–1906). The most famous Norwegian playwright who was also a keen artist in his early years. *See* Otto Lous Mohr *Henrik Ibsen som Maler* 1953, Oslo

ILSTED, Peter (1861–1933). Danish painter and brother-in-law of Hammershøi. He often depicted quiet domestic interiors with women at work.

ISAACHSEN, Olaf (1835–93). Norwegian artist who studied in Düsseldorf. He is best known for his paintings of interiors from his native Setesdal.

ISAKSON, Karl (1878–1922). Swedish painter who trained at the Konstakademien, and under Zahrtmann in Italy. He then settled in Copenhagen. He was important in introducing the concepts of Cubism and Orphism to Denmark. *See* G. Engwall *Karl Isakson* 1944, Copenhagen

JANSSON, Eugène (1862–1915). Swedish 'blue painter' from Stockholm, who was influenced by Munch. His early works were frequently of urban architecture, bathed in a deep blue light. Later paintings show a remarkable awareness of the human anatomy, in particular those of nude male figures in bathhouses and gymnasiums. *See* N. G. Wollin *Eugène Janssons målerie* 1920, Stockholm

JANSSON, Karl Emanuel (1846–74). Artist from the Swedish-speaking islands of Åland, in Finland. He studied in Düsseldorf and is best known for his genre paintings. *See* A. Reitala *Karl Emanel Janssonin taide* 1976

JÄRNEFELT, Eero (1863–1937). Finnish landscape and portrait painter who studied in St Petersburg and Paris and was particularly influenced by the Barbizon painters. His works embody *stämning* through the use of light and nature. *See* L. Wennervirta *Eero Järnefelt* 1950, Helsinki

JENSEN, Christian Albrecht (1792–1870). Danish portrait painter. He trained at the Kunstakadamiet, after which he went to Dresden, Rome and St Petersburg, and achieved considerable acclaim for his realistic works, which were inspired by the Dutch masters of the seventeenth century. *See* Sigurd Schultz *C. A. Jensen* 1932, Copenhagen

JENSEN, Frits (1818–70). Norwegian artist and theatre director. He was most interested in themes from Nordic mythology.

JERICHAU, Jens Adolf (1816–83). Danish sculptor who studied under Freund. He was a leading proponent of naturalism in sculpture.

JERNBERG, August (1826–96). Swedish artist who trained in Stockholm and Düsseldorf. He spent most of his life near Düsseldorf, painting landscape and genre works. *See* E. Blomberg 'August Jernbergs minnesutställning i Konstnärshuset' in *Stockholms Dagblad* 22 February 1927

JOHANSEN, Viggo (1851–1935). Danish artist who studied at the Kunstakadamiet and was interested in seventeenth-century Dutch art. He painted deeply evocative interiors from Skagen, and dreamlike landscapes. *See* Annette Stabell *Viggo Johansen: Kontrafej og Komposition* 1985, Copenhagen

JÓNSSON, Ásgrímur (1876–1958). Icelandic artist who trained in Copenhagen at the Kunstakadamiet. He is best known for landscapes of his native country. *See* Hrasnhildur Schran and Hjörleifur Sigurdsson *Ásgrímur Jónsson* 1986, Reykjavik

JÓNSSON, Einar (1874–1954). The first Icelandic sculptor of modern times. His works were often of subjects from the Icelandic Sagas. *See* G. Finnbogason *Einar Jónsson* 1925, Copenhagen

JOSEPHSON, Ernst (1851–1906). One of the most distinguished Swedish artists of the late nineteenth century. He trained at the Konstakademien in Stockholm and then in Paris and became a leading member of the radical Artists' Association in the 1880s. His works include historical paintings, mythological subjects, portraits and illustrations, many of the most striking works done after he became insane in 1888. *See* E. Blomberg *Ernst Josephsons konst* 1956, Stockholm

JUEL, Jens (1745–1802). Danish painter who studied in Hamburg with J. M. Gehrmann and then attended the Kunstakadamiet. He lived in Rome for two years and also visited Paris and Geneva. He was made Court Painter in 1780 and six years later Professor. One of the Nordic countries' most gifted portraitists and a skilled landscape painter, he was considerably inspired by English painting. (His two daughters each in turn married C. W. Eckersberg.) *See* Ellen Poulsen *Jens Juel* 1961

KARSTEN, Ludvig (1876–1926). Norwegian artist who was strongly influenced by Munch and Backer. His works display an expressionistic use of intense colours. *See* Pola Gauguin *Ludvig Karsten* 1949, Copenhagen

KIELLAND, Kitty (1843–1914). Norwegian painter, sister of the novelist Alexander Kielland, and one of the Nordic countries' best known artists. She studied under Gude in Karlsruhe. She painted primarily Norwegian landscape scenes, emphasising mood, atmosphere and the lyrical qualities of Nordic summer nights. *See* Marit Lange *Harriet Backer og Kitty Kielland* 1983, Åmot

KIEMPE, Thomas (*c*. 1752–*c*. 1808). Swedish painter who emigrated to Finland. He produced works for churches. *See* A. -B. Ehrnrooth *Måleren Thomas Kiempe* 1973

KITTELSEN, Theodor (1857–1914). Norwegian artist who studied in Munich and Paris. He is best known for his illustrations of children's books. *See* Leif Østby *Theodor Kittelsen* 1975, Oslo

KJARVAL, Jóhannes (1885–1972). Icelandic painter who studied at the Kunstakadamiet in Copenhagen. His Icelandic landscapes were considerably inspired by Turner, whose works he had seen in London. *See* Jóhannes S. Kjarval 1985, Reykjavik

KLOSS, Frederik Theodor (1802–76). Danish artist who studied under Eckersberg at the Kunstakadamiet. His most famous work is *The Great Geyser on Iceland in Eruption in the year 1834* (1835)

KØBKE, Christen (1810–48). One of the finest painters of the Danish Golden Age, he trained at the Kunstakadamiet under Eckersberg and Lorentzen. His gentle landscapes and urban views are unequalled in their depiction of Copenhagen and other parts of Zealand, while his drawings, particularly of Frederiksborg Palace, are perhaps the finest in Scandinavia of that period. *See* Emil Hannover *Maleren Christen Købke* 1893; Henrik Bramsen *Christen Købke* 1942

KROHG, Christian (1852–1925). Norwegian artist and writer, and leading exponent of *Tendens* painting. He often painted provocative subjects and sought to inspire an awareness in the viewer of moral and social issues. *See* O. Thue *Christian Krohgs portretter* 1971, Oslo

KREUGER, Nils (1858–1930). Swedish artist and student at the Konstakademien. He painted lyrical landscapes of his native country, sometimes in a style derived from pointillism but mainly influenced by Bastien-Lepage and the Barbizon painters. *See* K. Boström *Nils Kreuger* 1948, Stockholm

KRØYER, Peder Severin (1851–1909). Norwegian-born artist who settled with his family in Denmark. He is the most famous of the Skagen painters. He studied at the Kunstakadamiet, where he won the gold medal, and later in Paris under Léon Bonnat. His best-known works depict women at work on the beach at Skagen in the blue light of summer twilight evenings. He suffered from mental illness later in life. *See* Ernst Mentze *P. S. Krøyer* 1980, Copenhagen

LAFRENSEN the Younger, Niclas (1737–1807). Swedish Rococo painter, long active in Paris, whose works are in the style of Boucher and Fragonard. He was forced to leave France during the French Revolution. *See* B. G. Wennberg *Niclas Lafrensen den yngre* 1947

LARSEN, Emanuel (1823–59). Danish artist who trained at the Kunstakadamiet. His travels in pursuit of artistic inspiration took him to the Faroe Islands and Iceland.

LARSEN, Johannes (1867–1961). Danish artist who studied under Zahrtmann. He was a member of the Fynboerne and is best known for his landscapes. *See* J. V. Jensen *Johannes Larsen og hans Billeder* 1920, Copenhagen

LARSON, Marcus (1825–64). Swedish painter who trained with the Dane Melbye in Copenhagen, and later in Düsseldorf. An extremely productive artist, he concentrated on sublime marine and landscape subjects, painted in vivid colours. *See* Axel Gauffin *Simon Marcus Larson: Ett svenskt könstnärsöde* 1907–08, Stockholm

LARSSON, Carl (1853–1919). Swedish artist who attended the Konstakadamien before studying in France, where his water-colours were supreme among those by Nordic artists. His later works in Sweden were sometimes historical, and he is especially noted for his paintings and illustrations evoking idyllic Swedish middle-class family life. *See* G. Nordensvan *Carl Larsson* 1920–21, Stockholm

LAURÉUS, Alexander (1783–1823). Finnish painter who studied under Hilleström in Stockholm. Best known for his portraits and works on genre subjects. *See* A. Reitala *Alexander Lauréus redivivus* 1974

LIIPOLA, Yrjo (1881–1971). Finnish sculptor who studied in Italy and then settled in Hungary. His works were often of specifically Finnish subjects.

LILJEFORS, Bruno (1860–1939). Swedish landscape painter from Uppsala who trained at the Konstakadamien, and lived in France for three years, where he was influenced by Impressionism and Japanese art. He painted mainly wildlife in his native province of Uppland. *See* Allan Ellenius *Bruno Liljefors* 1981, Uppsala

LÖFGREN, Erik Johan (1825–84). Finnish painter who studied in Paris. He is most noted for works which depict events from Finland's history.

LUNDBERG, Gustaf (1695–1786). Swedish portrait painter who studied under David von Krafft before moving to Paris, where he was elected to the French Royal Academy and patronized by the royal family and many aristocrats. He returned to Sweden in 1745. *See* O. Levertin *Gustaf Lundberg* 1902

LUNDBYE, Johan Thomas (1818–48). Danish painter who trained at the Kunstakadamiet, as well as in Rome. He was a gifted landscape and portrait painter. *See* Karl Madsen *Johan Thomas Lundbye* 1949, Copenhagen

LUNDSTRØM, Vilhelm (1893–1950). Danish artist who studied at the Kunstakadamiet. Picasso and Braque's Cubism exerted considerable influence on his style, though in the 1920s his work became more expressionist, particularly evident in his mosaic decorations of the 1930s. His portrait of Storm Petersen (1922) is one of his best-known works. *See* P. Uttenreitter 'Vilhelm Lundstrøm' in *Vor tids Kunst* 13, 1933

MALMSTRÖM, August (1829–1901). Swedish painter and member of the Gothic Society. He worked mainly on Nordic mythological themes. *See* H. Wieselgren *Johan August Malmström: Lefnadsteckning* 1904, Stockholm

MARSTRAND, Wilhelm (1810–73). Danish painter who trained at the Kunstakadamiet under Eckersberg, after which he travelled to Rome and other continental cultural centres before returning home. He is best known for his portraits of rich middle-class patrons. *See* Karl Madsen *Wilhelm Marstrand* 1905

MARTIN, Elias (1739–1818). Swedish landscape painter who lived for twelve years in England where he became an Associate of the Royal Academy. He used an Italianate style to portray Nordic landscapes. *See* Ragnar Hoppe *Elias Martin* 1933, Stockholm

MELBYE, Vilhelm (1824–82). Danish marine painter who went to Skagen and Iceland in search of subject-matter. His brothers Anton (1818–75) and Fritz (1826–69) were also painters.

MICHELSEN, Hans (1789–1859). Norwegian sculptor who studied at the Konstakadamien in Stockholm. He worked in a Neo-classical style in Sweden, and was one of the few artists in the straitened economic circumstances of early nineteenth-century Norway. *See* O. Thue *Hans Michelsen: Tegninger og skulptur* 1974, Oslo

MIDDELTHUN, Julius (1820–86). Norwegian sculptor who studied under Bissen in Copenhagen. His style was Neo-classical. *See* H. Gran *Billedhuggeren Julius Middelthun og hans samtid* 1946, Oslo

MILLES, Carl (1875–1955). Swedish sculptor who studied in Paris where Rodin greatly influenced him. His sculptures are of classical or Nordic mythological subjects. *See* Henrik Cornell *Carl Milles: Hans Verk* 1963, Stockholm

MUNCH, Edvard (1863–1944). Norwegian artist who achieved a greater renown than any other Scandinavian painter. His works explore more than any other artist man's existential anxieties and mental turmoil and helplessness. His time in Paris and Berlin was vital for his artistic development, as well as for financial support. His genius expressed itself not only in his deeply expressionistic paintings, but also in his woodcuts. *See* Arne Eggum *Edvard Munch: Malerier-Skisser og Studier* 1983, Oslo; Ragnar Stang *Edvard Munch: The Man and the artist* 1979, London

MUNCH, Jacob (1776–1839). Norwegian portrait painter and military officer. He trained at the Kunstakadamiet in Copenhagen, followed by studies in Paris and Rome. He received the patronage of both the Norwegian middle-classes and the Swedish-Norwegian royal family.

MUNTHE, Gerhard (1849–1929). Norwegian landscape painter who studied in Munich and Düsseldorf. He was a frequent visitor to the artists' colony at Fleskum. *See* H. Bakken *Gerhard Munthe: En biographisk studie* 1952, Oslo

NIELSEN, Amaldus Clarin (1838–1932). Norwegian landscape painter who studied in Copenhagen, Düsseldorf and Karlsruhe. He was one of the most popular artists of his time in Norway. *See* M. Wangensten Wiik *Amaldus Nielsen og bildene hans* 1952, Oslo

NIELSEN, Kai (1882–1924). Danish sculptor profoundly influenced by Rodin and Maillol. His works were often of mythological subjects. *See* A. Naur *Kai Nielsen* 1937, Copenhagen

NOLDE, Emil (1867–1956). Considered the greatest German Expressionist painter, Emil Hansen, as he was christened, was born in the former Danish territory of Schleswig. He assumed Danish nationality and painted in Copenhagen. Many of his works depict the northern landscape with a highly metaphysical dimension. *See* Martin Urban *Emil Nolde: Aquarelle unde Handzeichnungen* 1975, Seebüll

NORDENBERG, Bengt (1822–1902). Swedish painter who studied at the Konstakadamien and then in Paris, Düsseldorf and Rome. His brilliantly coloured genre works are highly theatrical in composition. *See* Axel Gauffin *Ur Nationalmusei arkiv: Utdrag ur Bengt Nordenbergs självbiografi* 1926, Stockholm

NORDSTRÖM, Karl (1855–1923). Swedish artist, best known for his lyrical paintings of the Swedish landscape, using historical and Symbolist imagery. He had been a student at the Konstakadamien before joining the Artists' Association. *See* A. L. Romdahl 'Karl Nordström' in *Paletten* 1943

NYLUND, Felix (1878–1940). Finnish sculptor who worked in a socially realistic style. His sculptures sought to embody the ideals of a resurgent Finland after its civil war (1918–19). *See* O. Jauhiainen 'Felix Nylund. Muistikuvia' in *Taide* 4/1962

PAULI, Hanna (1864–1940). Swedish-Jewish artist and wife of the painter Georg Pauli. Her works are on a warm and intimate scale. *See* K. Fåhreus 'Hanna Pauli' in *Ord och Bild* 1924

PETERSEN, Edvard (1841–1911). Danish artist who studied at the Kunstakadamiet. He is best known for his works exploring the emotional problems facing Danish emigrants embarking for the New World.

PETERSSEN, Eilif (1852–1928). Norwegian painter who studied in Copenhagen, Karlsruhe and Munich. His landscapes express the pantheism artists then saw in the Norwegian countryside. He also visited Skagen. *See* E. Werenskiold 'Eilif Peterssen og Gerhard Munthe' in *Samtiden* 1929, pp. 81–86

PHILIPSEN, Theodor (1840–1920). Danish landscape painter who studied at the Kunstakadamiet. His landscapes of the countryside are still extremely popular and loved for their essentially Danish spirit. *See* Karl Madsen *Maleren Theodor Philipsen* 1912, Copenhagen

PILO, Carl Gustaf (1711–93). Swedish painter who trained under Olof Arenius in Stockholm. He lived for many years in Copenhagen and was noted for his grand portrait paintings of the Danish royal family. He was appointed Court Painter and Director of the Kunstakadamiet there. He returned to Sweden in 1772 where the Swedish king Gustaf III became his foremost patron. *See* O. Sirén *Carl Gustaf Pilo och hans förhållande till den samtida portraittkonsten i Sverige och Danmark* 1902, Stockholm

PRINCE EUGEN (1865–1947). Swedish landscape painter and brother of King Gustaf V. His early landscape paintings particularly express the *stämning* of the Nordic landscape. He was influenced by the Symbolists. *See* Axel Gauffin *Prins Eugen* 1915, Stockholm

PRINCESS MARGARET (1882–1920). English-born wife of the Swedish King Gustaf VI Adolph. Her landscape paintings demonstrate Monet's influence on her work. Prince Eugen, her uncle by marriage, taught her to love the Swedish countryside. *See* Charlotte Christensen (ed.) *Kronprinsesse Margareta* 1984, Copenhagen

REVOLD, Axel (1887–1962). Norwegian painter who studied under Sørensen in Christiania and Matisse in Paris. His most famous works, painted in Provence during 1913 and 1914, evince his profound attachment to Fauvism. *See* J. H. Langaard *Axel Revold* 1933, Oslo

RIBBING, Sophie (1835–94). Swedish painter who studied in Düsseldorf, Paris and Brussels. She is most noted for her genre works and portraits.

RING, Laurits Andersen (1854–1933). Danish painter. At first a house painter's apprentice, he studied at the Kunstakadamiet and briefly trained with Krøyer. He travelled extensively in Europe, winning the Eckersberg Medal twice (1896, 1901) and the Thorvaldsen Medal (1906). Many of his works, influenced

by Bruegel, demonstrate his concern for the rural way of life. *See* Peter Hertz *Maleren L. A. Ring* 1934, Copenhagen

RISSANEN, Juho (1873–1950). Finnish artist and member of the Group of Seven. His main subject-matter was the ordinary Finn at his labours. *See* Onni Okkonen *Juho Rissanen: Elämäkertaa ja taidetta* 1927, Porvoo

ROED, Jørgen (1808–88). Danish artist who trained under Eckersberg at the Kunstakademiet. The majority of his paintings were of architectural subjects taken from his many travels in Europe or in Denmark. *See* Helene Nyblom *Maleren Jørgen Roed* 1904, Copenhagen

RØRBYE, Martinus (1803–48). Danish painter who attended the Kunstakademiet and then went to France, Italy, Greece and Turkey. In 1833, he became the first artist to paint at Skagen. He won the Thorvaldsen Medal (1838) and was made professor in 1844. He was noted for his 'reportage' painting, which captured the narrative potential and local colour of the exotic scenes he frequently depicted. *See* J. B. Hartmann *Fra maleren Martinus Rørbyes Rejesdagbog 1830* 1930

ROSEN, Georg von (1843–1923). Swedish history painter, from an aristocratic family. He was a conservative director of the Konstakadamien. *See* E. Wettergren *Georg von Rosens konst* 1919, Stockholm

ROSLIN, Alexander (1718–93). The greatest Swedish portrait painter of the eighteenth century. He moved to Paris as a young man and was acclaimed by both French and foreign royalty and aristocrats for his elegant and charming works. He died there in the early part of the Revolution, unwilling to flee abroad. *See* Gunnar W. Lundberg *Roslin* 1957, Malmö

RUNEBERG, Walter (1838–1920). Finnish sculptor and son of the poet Johan Ludvig Runeberg. He studied under Ekman in Turku and worked in a strictly Neo-classical style. *See* P. Nordmann *Walter Runeberg 1838–1918: Bidrag till en könstnärsbiografi* 1918

SALLINEN, Tyko Konstantin (1879–1955). Finnish artist and leading member of the November Group. His expressionist style owes much to Kees van Dongen. *See* T. Colliander *Sallinen* 1948

SANDBERG, Johan Gustaf (1782–1863). Leading Swedish history painter of the early nineteenth century who trained at the Konstakadamien, where he won the Gold Medal (1809). Best known for his murals from the life of Gustaf Vasa in Uppsala Cathedral, he was also a gifted portrait painter. *See* M. Beijerstein *Johan Gustaf Sandberg* 1928

SCHILLMARK, Nils (1745–1804). Most notable Finnish artist of the late eighteenth century. He painted many portraits of the Finnish aristocracy and gentry in a subdued, Neo-classical style.

SCHJERFBECK, Helene (1862–1946). Finnish artist who studied in Paris and painted at Pont-Aven. She also worked in St Ives, with Maria Wiik. Many of her paintings show the strong influence of Japanese art and the works of Whistler. *See* H. Ahtela *Helena Schjerfbeck* 1953, Stockholm

SERGEL, Johan Tobias (1740–1814). Greatest Nordic sculptor of the late eighteenth century. He was long resident in Rome where antique sculpture influenced him, and he produced Neo-classical works for both the French and Swedish courts. *See* Georg Göthe *Johan Tobias Sergel* 1898, Stockholm

SIMBERG, Hugo (1873–1917). Finnish Symbolist painter and etcher. His highly individual works were inspired by medieval European miniatures, though the faces of the people he portrayed are undeniably Finnish in form. *See* S. Saarikivi *Hugo Simberg: Hans liv och verk* 1951, Helsinki

SJÖSTRAND, Carl Eneas (1828–1906). Swedish-born sculptor who settled in Finland. He is called the father of Finnish sculpture because of the many students he taught. Trained in Stockholm, Copenhagen, and Rome, he was most indebted to the Neo-classical style of Bissen. *See* J. Tolvanen *Carl Eneas Sjöstrand: Suomen uudemman kuvanveistotaiteen uranuurtaja* 1952

SKOVGAARD, Peter Christian (1817–75). Danish painter who trained at the Kunstakademiet. He is famed for his lyrical summer landscapes. He was the father of Joachim Skovgaard (1856–1933), generally known for his mural decorations in Viborg Cathedral, and of Niels Skovgaard (1858–1938), also a painter and sculptor. *See* Henrik Bramsen *Malerier af P. C. Skovgaard* 1938, Copenhagen

SKREDSVIG, Christian (1854–1924). Norwegian artist. He studied in Munich and then travelled with his friend the Swedish artist Josephson in Spain. He is particularly noted for his Norwegian summer landscapes. *See* T. Kronen *Christian Skredsvig: Liv og diktning* 1939, Oslo

SÖDERMARK, Olof Johan (1790–1848). Swedish painter who during his military training learnt to draw and engrave maps. He gave up his commission to concentrate on art, especially portrait painting. *See* L. Looström *Olof Johan Södermark: Hans lif och verk* 1879

SOHLBERG, Harald (1869–1935). Norwegian landscape painter who studied at Zahrtmann's school in Copenhagen. Many of his works depict the countryside and mountains in the vicinity of the mining town of Røros, in central Norway, which he infused with a mystical and rich Symbolism. *See* Arne Stenseng *Harald Sohlberg: En kunstner utenfor allfarvei* 1963, Oslo

SØNDERGAARD, Jens (1895–1957). Leading Danish Expressionist painter of the twentieth century and a student at the Kunstakademiet. He is best known for landscapes of his native Jutland, particularly near Limfjord. *See* Flemming Madsen and Jørgen Sandvad *Jens Søndergaard* 1957, Copenhagen

SØRENSEN, Henrik (1882–1962). Norwegian Expressionist

artist born in Värmland in Sweden. He lived mainly in Norway, after studies at Zahrtmann's school in Copenhagen and at the Académie Colarossi in Paris. Matisse also taught him. *See* F. Nielssen *Henrik Sørensen* 1950, Oslo

STEFÁNSSON, Jón (1881–1963). Icelandic painter who trained under Matisse in Paris. His landscapes depict the Icelandic countryside in a style derived from Caspar David Friedrich.

STOLTENBERG, Matthias (1799–1871). Norwegian portrait painter who began his training as a woodcarver's apprentice in Copenhagen and then studied under Lorentzen. His *Portrait of Margrethe Bredahl Plahte* is one of the finest produced in early nineteenth-century Norway. *See* P. M. Tvengsberg (ed.) *Matthias Stoltenberg* 1975, Stockholm

STORM PETERSEN, Robert (1882–1949). Danish painter and illustrator. Munch's influence on his style can be seen in his brilliantly coloured caricatures. *See* Jens Bing *Maleren Storm P.* 1985, Copenhagen

STRINDBERG, August (1849–1912). The renowned Swedish author was also an impassioned painter, though in separate, short bouts. His work as an art critic influenced the next generation of Swedish artists. *See* Göran Söderström *Strindbergs Måleri* 1972, Malmö

SVEINSDÓTTIR, Júliana (1889–1960). Icelandic artist who lived mainly in Denmark. She was inspired for most of her paintings by her native Vestmannaeyjar area.

SYBERG, Fritz (1862–1939). Danish artist who studied at the Kunstakadamiet and Zahrtmann's school. His landscape paintings evoke *stämning* through an expressionistic use of colour. He was one of the leading artists at Fåborg on Fünen. *See* H. Madsen *Fritz Syberg* 1937, Copenhagen

THAULOW, Frits (1847–1906). Norwegian landscape painter who studied in Karlsruhe and Paris. He frequently painted the icy rivers of Norway and their snowy banks. *See* E. Østvedt *Frits Thaulow: Mannen og verket* 1951, Oslo

THESLEFF, Ellen (1869–1954). Finnish artist best known for her Symbolist portraits. She was influenced by early Renaissance art in Italy and became a member of the Group of Seven. *See* L. Bäcksbacka *Ellen Thesleff* 1955, Helsinki

THOMÉ, Verner (1878–1953). Finnish artist and member of the Group of Seven. His paintings of boys at play on the beach pick out their vitality.

THORLÁKSSON, Thórarinn B. (1867–1924). The most noted Icelandic artist of his time. He trained first as a bookbinder and then entered the Kunstakadamiet in Copenhagen. He is best known for his landscapes full of Icelandic *stämning*, but also for his able portraits. *See* Gudrún Thorarinsdottír and Váltyr Petúrsson *Thórarinn B. Thorláksson* 1982, Reykjavik

THORSTEINSSON, Gudmundur (1891–1924). Icelandic painter. He produced religious works, one of which is his famous triptych *Christ Healing the Sick* (1921) for the presidential chapel at Bessastadir. *See* Björn T. Björnsson *Gudmundur Thorsteinsson* 1984, Reykjavik

THORVALSDEN, Bertel (*c.* 1768–1844). The most famous Scandinavian sculptor. Though a native of Denmark, he spent most of his life in Rome where he became the first Protestant commissioned to work in St Peter's Cathedral. He sculpted exclusively in Neo-classical style, producing portraits of European aristocrats and cultural figures. *See* Christian Elling *Thorvaldsen* 1944, Copenhagen

TIDEMAND, August (1814–76). Norwegian painter who concentrated on landscape and genre subjects. He studied at the Kunstakadamiet in Copenhagen and then at the academy in Düsseldorf. He achieved his greatest fame for his works at the Norwegian royal residence of Oscarshall. *See* S. Willoch *August Tidemand* 1969, Oslo

TOPPELIUS, Mikael (1734–1821). Finnish painter and student in Stockholm of Johan Pasch the Elder. He painted a considerable number of works on religious themes. *See* R. Mähönen *Kirkkomaalari Mikael Toppelius* 1975

VERMEHREN, Johan Frederik (1823–1910). Danish landscape painter who studied in Düsseldorf. He captured the peculiar beauty of the heaths of Jutland in his work.

VALLGREN, Ville (1855–1940). Finnish sculptor who studied under Sjöstrand and at the Ecole des Beaux-Arts in Paris. He is best known for his Symbolist works with their sensuous rhythm. *See* O. Valkonen *Ville Vallgren pienoisveistäjänä* 1955–56

VIGELAND, Gustav (1869–1943). Norwegian sculptor who began as a wood carver, later studying in Copenhagen under Bissen and Freund. He went to Paris, Berlin, Italy and England and had a lengthy stay at Trondhjem in Norway. Generally working in stone, he emphasised the naked muscular form of men and women in energetic activities or in the throes of deep emotions. *See* Hans P. Lødrup *Gustav Vigeland* 1944, Oslo

WACKLIN, Isak (1720–58). The best-known Finnish portrait painter of the mid-eighteenth century. He was a student of Pilo in Copenhagen and spent some time in England. *See* A. Lindström *Isak Wacklin* 1959

WAHLBOM, Carl (1810–58). Swedish history painter, sometimes called the Swedish Géricault, because of the attention he gave to horses in violent movement in his works. His studies took him to Paris and Rome, where Fogelberg influenced his style. *See* V. Loos *Carl Wahlbom* 1949

WEIE, Edvard (1879–1943). Leading Danish portrait painter of the artists established at Fåborg. He was a student at Zahrtmann's school in Copenhagen. The painters of the Danish Golden Age were the most important influence on his work. *See* Leo Swane 'Edvard Weie' in *Vor Tids Kunst* 11, 1932

WERENSKIOLD, Erik (1855–1938). Norwegian artist whose farm at Fleskum became an artists' colony. He is best known for his landscape works expressing the summer mood of the Norwegian countryside. *See* L. Østby *Erik Werenskiold: Eventyrtegninger* 1971, Oslo

WERTMÜLLER, Adolph Ulric (1751–1811). Swedish portrait painter who studied under L'Archevêque in Stockholm before moving to Paris. The French Revolution caused him to leave and he went to America where he painted George Washington. Later, he returned to Europe. *See* Axel Gauffin 'A. U. Wertmüller: Ett könstnärsliv' in *Ord och Bild* 1918

WESTERHOLM, Victor (1860–1919). Finnish landscape painter, active on Åland. He is sometimes called Finland's Cuyp because of his frequent paintings of grazing cattle. *See* A. Reitala *Victor Westerholm* 1967

WIIK, Maria (1853–1928). Finnish artist who studied at the Académie Julian in Paris where she was profoundly influenced by Puvis de Chavannes. Her most charming works, of domestic interiors, were painted while visiting St Ives in Cornwall. *See* P. Katerma *Maria Wiik* 1954

WILHELMSON, Carl (1866–1928). Swedish artist who studied in Paris at the Académie Julian. He mainly painted the daily life of local people in his native Bohuslän. *See* A. L. Romdahl *Carl Wilhelmson* 1938, Stockholm

WILLUMSEN, Jens Ferdinand (1863–1958). Danish painter and sculptor who studied at the Kunstakadamiet and under Krøyer and was deeply influenced by Gauguin. His profoundly Symbolist works are often both painterly and sculptural. *See* Ernst Mentze *Mine erindringer* 1953, Copenhagen

WRIGHT, Magnus von (1805–68). Finnish painter of Scottish descent who, with his two brothers Vilhelm (1810–87) and Ferdinand (1822–1906), produced exquisite renderings of birds, in particular, and the Finnish landscape. Largely self-taught, he and his brothers were little influenced by trends in European art, usually living in isolation at their country house Haminanlaks near Kuopio. *See* Leena Peltola *Von Wright* 1982, Helsinki

ZAHRTMANN, Kristian (1843–1917). Danish artist who lived at Civita d'Antino in Italy where he established a colony of young artists. His school in Copenhagen emphasised intense colours and was of great importance for the next generation of artists, such as Karl Isakson. *See* S. Danneskjold-Samsøe *Kristian Zahrtmann* 1942, Copenhagen

ZOLL, Kilian (1818–60). Swedish painter who studied in Düsseldorf. He mainly painted richly coloured genre themes from Sweden. *See* P. Humbla *Kilian Zoll* 1932

ZORN, Anders (1860–1920). Most renowned Swedish portrait painter of the late nineteenth and early twentieth century. He is especially noted for his nudes, often set in a typically Nordic landscape of lakes and rivers. *See* Gerda Boëthius *Anders Zorn* 1954, Stockholm

Select Bibliography

ASKELAND, Jan *Norsk Malerkunst* J. W. Cappelens Forlag AS, Oslo 1981

BJÖRNSSON, Björn T. *Nordisk Malerkunst* Tiden Norsk Forlag, Oslo 1951

—— *Íslenzk Myndlist á 19. og 20. Öld, 1–2,* Helgafell, Reykjavik 1964

BOULTON SMITH, John *The Golden Age of Finnish Art, Art Nouveau and the National Spirit* Otava, Helsinki 1975, revised and enlarged 1985

DANSK KUNSTHISTORIE, 4 vols (ed. Erik Lassen) Politikens Forlag, Copenhagen 1972–5

DREAMS OF A SUMMER NIGHT (eds L. Ahtola-Moorhouse, C. T. Edam and B. Schreiber) The Arts Council of Great Britain, London 1986

1880–TAL I NORDISKT MÅLERI (eds Pontus Grate and Nils-Göran Hökby) Nationalmuseum, Uddevalla 1985

JACOBS, Michael *The Good and Simple Life: Artist Colonies in Europe and America* Phaidon, Oxford 1985

KONSTEN I FINLAND (ed. Sixten Ringbom) Holger Schildts Förlag, Helsinki 1978

KONSTEN I SVERIGE, 8 vols (ed. Sven Sandström) Almqvist & Wiksell Förlag ADB, Stockholm 1981

LINDE, Ulf *Thielska Galleriet* Stockholm 1979

MONRAD, Kasper *Danish Painting: The Golden Age* The National Gallery, London 1984

NORGES KUNSTHISTORIE, 7 vols (eds Knut Berg, Nils Messel and Marit I. Lange) Gyldendal Norsk Forlag, Oslo 1981

NØRREGÅRD-NIELSEN, Hans Edvard *Dansk Kunst,* 2 vols, Gyldendal, Copenhagen 1893

NORSK KUNSTNERLEKSIKON, 4 vols, Universitetsforlaget Oslo, 1982–6

NORTHERN LIGHT: Realism and Symbolism in Scandinavian Painting 1880–1910 (ed. Kirk Varnedoe) The Brooklyn Museum, New York 1982

OKKONEN, Onni *Finsk Konst* Werner Söderström Förlag, Helsinki 1946

SVENSKT KONSTNÄRSLEXIKON, 5 vols (eds Gösta Lilja, Bror Olsson and S. Artur Svensson) Allhems Förlag, Malmö 1952–67

VOSS, Knud *Skagensmalerne,* 2 vols, Tønder, Hamlet 1980–1

List of Illustrations

Measurements are given in inches and centimetres, height before width

27 Martinus Rørbye *The Prison at the Town Hall and Palace of Justice* 1831.
Oil on canvas. 18¾ × 24¾ (47.5 × 63) Statens Museum for Kunst, Copenhagen
28 Johan Gustaf Sandberg *Midsummer Dance at Säfstaholm* 1825.
Oil on canvas. Present whereabouts unknown. Photo Statens Konstmuseer, Stockholm
29 Johan Gustaf Sandberg *Portrait of Erik Gustaf Geijer* 1828.
Oil on canvas. 9 × 7 (23 × 18) Gripsholms Slott, Mariefred. Photo Svenska Porträttarkivet, Nationalmuseum, Stockholm
30 Per Krafft the Younger *The Misses Laurent* 1815.
Oil on canvas. 58¼ × 46 (148 × 117) Nationalmuseum, Stockholm
31 Wilhelm Bendz *The Blue Room or Interior in the Amaliegade* 1825.
Oil on canvas. 12¾ × 19¼ (32.3 × 49) Den Hirschsprungske Samling, Copenhagen
32 Christoffer Wilhelm Eckersberg *Bertel Thorvaldsen* 1814.
Oil on canvas. 35¾ × 29¼ (90.7 × 74.3) The Royal Danish Academy of Fine Arts, Copenhagen
33 Bertel Thorvaldsen *The Three Graces* 1817–19.
Marble. 68 (172.7) Thorvaldsens Museum, Copenhagen
34 Bertel Thorvaldsen *Maria Barjatinskaya* 1818.
Marble. 71¼ (181) Thorvaldsens Museum, Copenhagen
35 Jens Adolf Jerichau *Panther Hunter* 1845–46.
Plaster. 72⅞ (185), with spear 88⅝ (225) Ny Carlsberg Glyptotek, Copenhagen
36 Matthias Stoltenberg *Portrait of Margrethe Bredahl Plahte* 1831.
Oil on canvas. 18⅞ × 15⅜ (48 × 39) Erik M. Plahte Collection
37 Johannes Flintoe *Duel at Skiringsal* mid-1830s.
Oil on canvas. 21¼ × 25⅝ (54 × 65) Nasjonalgalleriet, Oslo
38 Caspar David Friedrich *The Arctic Sea* (formerly *Wreck of the Hope*) c. 1823–24.
Oil on canvas. 38½ × 51⅛ (29.6 × 21.9) Kunsthalle, Hamburg
39 Johan Christian Dahl *Winter at Sognefjord* 1827.
Oil on canvas. 24 × 29½ (61 × 75) Nasjonalgalleriet, Oslo
40 Johan Christian Dahl *Shipwreck on the Coast of Norway* 1832.
Oil on canvas. 28⅜ × 43¼ (72 × 110) Nasjonalgalleriet, Oslo
41 Thomas Fearnley *From Sorrento* 1834.
Oil on panel. 9 × 10¼ (23 × 26) Bergen Billedgalleri, Bergen
42 Peder Balke *Landscape Study from Nordland* 1860.
Oil on paper. 13⅝ × 10¼ (34.5 × 26) Göteborgs Konstmuseum, Gothenburg
43 Peder Balke *Vardøhus Fortress* c. 1860.
Oil on canvas. 36¼ × 48¾ (92 × 124) Bergen Billedgalleri, Bergen
44 Hans Gude *Funeral Procession on Sognefjord* 1866.
Oil on canvas. 38¾ × 55⅞ (98.5 × 142) Göteborgs Konstmuseum, Gothenburg
45 Werner Holmberg *Kyrö Falls* 1854.
Oil on canvas. 43¼ × 40⅜ (110 × 102.5) Ateneumin taidemuseo, Helsinki

46 Hans Gude *A Mill Dam* 1850.
Oil on paper. 13⅜ × 18½ (34 × 47) Nasjonalgalleriet, Oslo
47 August Cappelen *Falls in Lower Telemark* 1852.
Oil on canvas. 30⅜ × 40⅜ (77 × 102.5) Nasjonalgalleriet, Oslo
48 Wilhelm Finnberg *Portrait of Carl Edwin Lundgren* 1828.
Oil on canvas. 28¾ × 24⅜ (73 × 62) Ateneumin taidemuseo, Helsinki
49 Alexander Lauréus *Peasant Dance at Christmas in Finland* 1815 (detail).
Oil on canvas. 17½ × 20⅞ (44.5 × 53) Private Collection
50 Alexander Lauréus *Self-portrait* c. 1805.
Oil on canvas. 23¼ × 20⅛ (59 × 51) Ateneumin taidemuseo, Helsinki
51 Ferdinand von Wright *Doves* 1867.
Oil on canvas. 18⅞ × 26 (48 × 66) Nationalmuseum, Stockholm
52 Magnus von Wright *Hazelgrouse in the Wood* 1866.
Oil on canvas. 16½ × 21¼ (42 × 54) Ateneumin taidemuseo, Helsinki
53 Wilhelm von Wright *Hanging Wild Ducks, Still-Life* 1851.
Oil on canvas. 29¾ × 25¼ (75.5 × 64) Ateneumin taidemuseo, Helsinki
54 Constantin Hansen *The Constitutional Assembly of 1848* 1860–64.
Oil on canvas. 136⅝ × 197⅝ (347 × 502) The Museum of National History at Frederiksborg Castle, Denmark
55 Carl Wahlbom *Death of Gustaf II Adolph in the Battle of Lützen* 1855.
Oil on canvas. 39¾ × 59½ (101 × 151) Nationalmuseum, Stockholm
56 Nils Jakob Blommér *Freja Seeking her Husband* 1852.
Oil on canvas. 53⅛ × 78¾ (135 × 200) Nationalmuseum, Stockholm
57 Frits Jensen *Viking Raping a Southern Woman* 1845.
Oil on canvas. 52¾ × 46 (134 × 117) Bergen Billedgalleri, Bergen
58 August Malmström *King Helmer and Aslög* 1856.
Oil on canvas. 46⅞ × 40⅛ (119 × 102) Nationalmuseum, Stockholm
59 Vilhelm Kyhn *Winter Evening in a Forest* 1853.
Oil on canvas. 51⅜ × 77⅜ (130.5 × 196.5) Statens Museum for Kunst, Copenhagen
60 Ferdinand Julius Fagerlin *Young Fishermen Smoking* 1862.
Oil on canvas. 15¾ × 19 (40 × 48) Nationalmuseum, Stockholm
61 Bengt Nordenberg *A Tithe Meeting in Scania* 1865.
Oil on canvas. 35¾ × 48½ (91 × 123) Nationalmuseum, Stockholm
62 Olaf Isaachsen *Bedroom from Kveste in Setesdal* 1866.
Oil on canvas. 18¼ × 26¾ (46.5 × 68) Nasjonalgalleriet, Oslo
63 Christen Dalsgaard *Country Carpenter Bringing a Coffin for the Dead Child* 1857.
Oil on canvas. 28⅞ × 41⅛ (73.5 × 104.5) Statens Museum for Kunst, Copenhagen

64 Karl Emanuel Jansson *Sailor Boy* 1866. Charcoal drawing. 16 × 12 (40.5 × 30.5) Art Museum of Åland, Mariehamn

65 Sophie Ribbing *Boys Drawing* 1864. Oil on canvas. 36 × 31⅛ (91.5 × 79) Göteborgs Konstmuseum, Gothenburg

66 Kilian Zoll *Midsummer Dance at Rättvik* 1852. Oil on canvas. 12¼ × 16⅛ (31 × 41) Nationalmuseum, Stockholm

67 August Tidemand *Fanatics* 1866. Oil on canvas. 53½ × 70 (136 × 178) Nationalmuseum, Stockholm

68 Johan Frederik Vermehren *Study of the Heathland* 1854. Oil on canvas. 16½ × 25⅝ (42 × 65) Statens Museum for Kunst, Copenhagen

69 Amaldus Clarin Nielsen *Morning at Ny-Hellesund* 1885. Oil on canvas. 39¾ × 68⅛ (101 × 173) Nasjonalgalleriet, Oslo

70 August Jernberg *View Over Düsseldorf c.* 1865. Oil on paper. 12¼ × 15¾ (31 × 40) Nationalmuseum, Stockholm

71 Carl Eneas Sjöstrand *Henrik Gabriel Porthan* 1864. Bronze. Over life-size. Porthanskvär, Åbo/Turku. Photo Åbo Akademis Bildsamlingar, Åbo/Turku

72 Walter Runeberg *Johan Ludvig Runeberg* 1878–83. Bronze. Over life-size. Esplandipuisto Park, Helsinki. Photo Helsingin kaupunginmuseo, Helsinki

73 Julius Middlethun *J. S. Welhaven* 1863. Marble 21⅝ (55) Student Society, Oslo. Photo Nasjonalgalleriet, Oslo

74 Walter Runeberg *Apollo and Marsyas* 1874. Marble. 78¾ (200) Ateneumin taidemuseo, Helsinki

75 Hans Christian Andersen *Collage with Clippings Related to the Danish Playwright Ludwig Holberg and Weber's Opera 'Der Freischutz'* 1865. 16¼ × 24⅝ (153 × 62.5) Hans Christian Andersen Hus, Odense

76 Michael Ancher *Young Woman Ill in Bed* 1883. Oil on canvas. 31⅞ × 35⅜ (81 × 90) Den Hirschsprungske Samling, Copenhagen

77 Anna Ancher *Interior with a Young Girl Plaiting her Hair* 1901. Oil on canvas. 27⅛ × 22¼ (69 × 56.5) Statens Museum for Kunst, Copenhagen

78 Oscar Björck *In the Village School* 1884. Oil on canvas. 29¾ × 23⅝ (76 × 60) Nationalmuseum, Stockholm

79 Peder Severin Krøyer *At the Grocer's When There Is No Fishing* 1882. Oil on canvas. 31¼ × 43¼ (79.5 × 109.8) Den Hirschsprungske Samling, Copenhagen

80 Harald Slott-Møller *Georg Brandes at the University of Copenhagen* 1889. Oil on canvas. 37¼ × 32¼ (94.5 × 82) Det kongelige Bibliotek, Copenhagen

81 Anna Ancher *Lars Gaihede Carving Wood* 1880. Oil on canvas. 15⅜ × 11⅜ (39 × 29) Skagens Museum, Skagen

82 Christian Krohg *Portrait of Lucy Parr Egeberg* 1876. Oil on canvas. 43¾ × 32⅝ (111 × 83) Nasjonalgalleriet, Oslo

83 Christian Krohg *Albertine in the Police Doctor's Waiting Room* 1886–87. Oil on canvas. 83⅛ × 128⅜ (211 × 326) Nasjonalgalleriet, Oslo

84 Christian Krohg *Tired* 1885. Oil on canvas. 31¼ × 24 (79.5 × 61) Nasjonalgalleriet, Oslo

85 Edvard Munch *Ibsen in the Grand Café* 1902. Lithograph. 16½ × 22⅞ (42 × 58)

86 Ernst Josephson *Portrait of Ludwig Josephson* 1893. Oil on canvas. 53⅞ × 42⅞ (137 × 109) Nationalmuseum, Stockholm

87 Ernst Josephson *Spanish Smiths* 1881. Oil on canvas. 48¾ × 40½ (124 × 103) Nationalmuseum, Stockholm

88 Gustaf Cederström *Karl XII's Funeral Procession* 1878. Oil on canvas. 100¾ × 145⅝ (256 × 370) Göteborgs Konstmuseum, Gothenburg

89 Carl Frederick Hill *Landscape with Pines and Waterfall c.* 1880. Black chalk. 6⅞ × 8½ (17.5 × 21.5) Malmö Museum, Malmö

90 Carl Frederick Hill *Landscape. Motif from the Seine* 1877. Oil on canvas. 19⅝ × 23⅝ (50 × 60) Nationalmuseum, Stockholm

91 Nils Kreuger *Spring in Halland* 1894. Painted on wood. 17¾ × 14½ (45 × 37) Nationalmuseum, Stockholm

92 Nils Kreuger *Spring in Halland* 1894. Painted on wood. 19⅝ × 23⅝ (50 × 60) Nationalmuseum, Stockholm

93 Nils Kreuger *Spring in Halland* 1894. Painted on wood. 17¾ × 14½ (45 × 37) Nationalmuseum, Stockholm

94 Nils Kreuger *Old Country House* 1887. Oil on canvas. 17⅞ × 24⅜ (45.5 × 62) Nationalmuseum, Stockholm

95 Erik Werenskiold *Kitty Kielland* 1891. Oil on canvas. 39⅜ × 26⅝ (100 × 67.5) Nasjonalgalleriet, Oslo

96 Erik Werenskiold *Peasant Funeral* 1883–85. Oil on canvas. 40⅜ × 59¼ (102.5 × 150.5) Nasjonalgalleriet, Oslo

97 Christian Skredsvig *The Boy with the Willow Flute* 1889. Oil on canvas. 31⅛ × 47¼ (79 × 120) Nasjonalgalleriet, Oslo

98 Frits Thaulow *Winter at Simoa* 1883. Oil on canvas. 19½ × 30⅞ (49.5 × 78.5) Nasjonalgalleriet, Oslo

99 Harald Sohlberg *Summer Night* 1899. Oil on canvas. 44⅞ × 53⅜ (114 × 135.5) Nasjonalgalleriet, Oslo

100 Halfdan Egedius *Storm Approaching* 1896. Oil on canvas. 24¾ × 31⅛ (63 × 79) Nasjonalgalleriet, Oslo

101 Harald Sohlberg *After a Snowstorm* 1903. Oil on canvas. 23¾ × 35⅝ (60.5 × 90.5) Nasjonalgalleriet, Oslo

102 Jens Ferdinand Willumsen *Jotunheimen* 1892–93. Oil, painted zinc and enamelled copper. 59 × 106¼ (150 × 270) The J. F. Willumsens Museum, Frederikssund

103 Hjalmar Munsterhjelm *Wood in the Moonlight* 1883. Oil on canvas. 41½ × 57¼ (105.5 × 145.5) Turun taidemuseo, Turku

104 Victor Westerholm *Åland* 1899–1909. Oil on canvas. 78¾ × 103½ (200 × 263) Turun taidemuseo, Turku

105 Albert Edelfelt *Women of Ruokolahti on the Church Hill* 1887. Oil on canvas. 51⅝ × 62⅝ (131 × 159) Ateneumin taidemuseo, Helsinki

106 Carl Wilhelmson *Fisherwomen on the Way from Church* 1899. Oil on canvas. 53⅞ × 41⅞ (137 × 104) Nationalmuseum, Stockholm

107 Bruno Liljefors *Blackgame in Springtime* 1907. Oil on canvas. 26⅜ × 39¾ (67 × 101) Nationalmuseum, Stockholm. Copyright Uppsala advokatbyrå, Uppsala. Photo Statens Konstmuseer, Stockholm

108 Eero Järnefelt *Lefrance, Wine Merchant, Boulevard de Clichy, Paris* 1888. Oil on canvas. 23¾ × 27¾ (60.5 × 70.5) Ateneumin taidemuseo, Helsinki

109 Akseli Gallen-Kallela *Démasquée* 1888. Oil on canvas. 26 × 21⅝ (65 × 55) Ateneumin taidemuseo, Helsinki

110 Richard Bergh *Vision* 1894. Oil on canvas. 48 × 82¼ (122 × 209) Nationalmuseum, Stockholm

111 Richard Bergh *The Dying Day* 1895. Charcoal with oil on canvas. 14½ × 32⅝ (37 × 83) Nationalmuseum, Stockholm

112 Carl Larsson *A Home: Luncheon under the Big Birch* 1894. Watercolour. 13 × 18⅛ (32 × 46) Nationalmuseum, Stockholm

113 Carl Larsson *Autumn* 1884. Watercolour. 36¼ × 23⅝ (92 × 60) Nationalmuseum, Stockholm

114 August Strindberg *The City c.* 1900. Oil on canvas. 37¼ × 20⅞ (94.5 × 53) Nationalmuseum, Stockholm

115 Eugène Jansson *Self-portrait* 1901 (detail). Oil on canvas. 39¾ × 56⅝ (101 × 144) Thielska Galleriet, Stockholm. Photo Statens Konstmuseer, Stockholm

116 Anders Zorn *Knitting Dalecarlian Girl* 1901. Oil on canvas. 28⅜ × 22½ (72 × 57) Nationalmuseum, Stockholm

117 Anders Zorn *A Première* 1888. Gouache. 29⅞ × 22 (76 × 56) Nationalmuseum, Stockholm

118 Anders Zorn *Omnibus* 1891. Oil on canvas. 39⅜ × 26 (100 × 66) Nationalmuseum, Stockholm

119 Prince Eugen *The Old Castle* 1893. Oil on canvas. 39¾ × 38¼ (101 × 97) Prins Eugens Waldemarsudde, Stockholm

120 Karl Nordström *Varberg's Fortress* 1893. Oil on canvas. 24⅜ × 34⅞ (62 × 88.5) Prins Eugens Waldemarsudde, Stockholm

121 Prince Eugen *Still Water* 1901. Oil on canvas. 55⅞ × 70⅛ (142 × 178) Nationalmuseum, Stockholm

122 Theodor Kittelsen *The Black Death* 1894–96: *The Soaring Eagle*. Wash, pen, pencil and black chalk. 10⅝ × 8⅞ (27.1 × 22.6) Nasjonalgalleriet, Oslo

123 Prince Eugen *The Forest* 1892. Oil on canvas. 59 × 39⅝ (150 × 100.5) Göteborgs Konstmuseum, Gothenburg

124 Maria Wiik *Out in the World* 1889. Oil on canvas. 27⅛ × 24 (69 × 61) Ateneumin taidemuseo, Helsinki

125 Eva Bonnier *Reflex in Blue* 1887. Oil on canvas. 31½ × 25¼ (80 × 64) Nationalmuseum, Stockholm

126 Edvard Munch *The Sick Child* 1886 version. Oil on canvas. 47⅝ × 46½ (121 × 118) Nasjonalgalleriet, Oslo

127 Edvard Munch *Moonlight* 1896. Woodcut. 16¼ × 18⅜ (41.2 × 73.5) Oslo Kommunes Kunstsamlinger, Munch-museet, Oslo

128 Edvard Munch *Rose and Amelie* 1893. Oil on canvas. 30¾ × 42⅞ (78 × 190.5) Oslo Kommunes Kunstsamlinger, Munch-museet, Oslo

129 Edvard Munch *The Kiss* 1895. Drypoint and aquatint. 13 × 10½ (32.9 × 26.3) Oslo Kommunes Kunstsamlinger, Munch-museet, Oslo

130 Edvard Munch *The Dance of Life* 1899–1900. Oil on canvas. 49⅜ × 75 (125.5 × 190.5) Nasjonalgalleriet, Oslo

131 Akseli Gallen-Kallela *The Aino Triptych* 1891. Oil on canvas. Side panels: 60¼ × 30¼ (153 × 77), centre panel: 60¼ × 60¼ (153 × 153) Ateneumin taidemuseo, Helsinki

132 Vilhelm Hammershøi *A Baker's Shop* 1888. Oil on canvas. 44⅝ × 35½ (113.5 × 90) Vejen Kunstmuseum, Vejen

133 Hanna Pauli *Friends* 1900–07. Oil on canvas. 82¼ × 102⅜ (209 × 260) Nationalmuseum, Stockholm

134 Vilhelm Hammershøi *Five Portraits* 1901. Oil on canvas. 74¾ × 133⅞ (190 × 340) Thielska Galleriet, Stockholm

135 Akseli Gallen-Kallela *Symposium (The Problem)* 1894. Oil on canvas. 29⅛ × 39 (74 × 99) Jorma Gallen-Kallela's Family Collection

136 Vilhelm Hammershøi *Landscape from Lejre* 1905.
Oil on canvas. 16⅛ × 26¾ (41 × 68) Nationalmuseum, Stockholm

137 Laurits Andersen Ring *Young Girl looking out of an Attic Window* 1885.
Oil on canvas. 13 × 11⅜ (33 × 29) Nasjonalgalleriet, Oslo

138 Edvard Petersen *Emigrants at Larsens Plads* 1890.
Oil on canvas. 53⅜ × 85 (135.6 × 216) Aarhus Kunstmuseum, Aarhus

139 Laurits Andersen Ring *In the Garden Door, The Artist's Wife* 1897.
Oil on canvas. 75¼ × 56⅝ (191 × 144) Statens Museum for Kunst, Copenhagen

140 Laurits Andersen Ring *Plasterer. The Old House Is Cleaned Up* 1908.
Oil on canvas. 48 × 37¾ (122 × 96) Statens Museum for Kunst, Copenhagen

141 Robert Storm Petersen *Scene from Nyboder* 1912–14.
Watercolour. 10⅛ × 12⅛ (25.8 × 30.7) Collection Bent Lysberg, Espergaerde

142 Ivar Arosenius *Noah's Ark* 1908.
Tempera. 35⅜ × 57¼ (90 × 145.5) Nationalmuseum, Stockholm

143 Hugo Simberg *Wounded Angel* 1903.
Oil on canvas. 50 × 60⅝ (127 × 154) Ateneumin taidemuseo, Helsinki

144 Isaac Grünewald *Portrait of Ulla Bjerne* 1916.
Oil on canvas. 78¾ × 39⅜ (200 × 100) Moderna Museet, Stockholm

145 Carl Larsson *In Front of the Mirror. Self-portrait* 1900.
Oil on canvas. 94⅞ × 39⅜ (241 × 100) Göteborgs Konstmuseum, Gothenburg

146 Sigrid Hjertén Grünewald *View over the Sluice* 1919.
Oil on canvas. 42½ × 35⅜ (108 × 90) Moderna Museet, Stockholm

147 Bror Hjorth *Kappsläden* 1922.
Oil on canvas. 32¼ × 26 (82 × 66) Moderna Museet, Stockholm

148 Nils von Dardel *Visit at the Home of an Eccentric Lady* 1921.
Oil on canvas. 51⅜ × 38⅜ (130.5 × 97.5) Moderna Museet, Stockholm

149 Ellen Thesleff *Thyra Elisabeth* 1892.
Oil on canvas. 16½ × 9½ (42 × 24) Collection Bäcksbacka, Helsingin kaupungin taidemuseo, Helsinki

150 Juho Rissanen *A Woman Weaving* 1908.
Oil on canvas. 57½ × 47¼ (146 × 120) The Hedman Collection, Ostrobothnia Museum, Vaasa

151 Pekka Halonen *Homeward Journey from Work* 1907.
Oil on canvas. 65 × 68⅞ (165 × 175) The Hedman Collection, Ostrobothnia Museum, Vaasa

152 Magnus Enckell *The Awakening* 1893.
Oil on canvas. 44½ × 37⅞ (113 × 86) Ateneumin taidemuseo, Helsinki

153 Verner Thomé *Bathing Boys* 1904.
Oil on canvas. 44⅛ × 57⅞ (112 × 142) Ateneumin taidemuseo, Helsinki

154 Tyko Konstantin Sallinen *Washerwomen* 1911.
Oil on canvas. 60⅝ × 53½ (154 × 136) Ateneumin taidemuseo, Helsinki

155 Crown Princess Margareta of Sweden *Winterday* 1914.
Oil on canvas. 22½ × 24¼ (57 × 61.5) Collection of Her Majesty Queen Ingrid of Denmark

156 Fanny Churberg *Landscape from Nyland* 1872.
Oil on canvas. 21¼ × 33⅝ (54 × 85.5) Ateneumin taidemuseo, Helsinki

157 Ivan Aguéli *African City* 1914.
Oil on (unprepared) canvas. 7⅞ × 11¾ (20 × 30) Moderna Museet, Stockholm

158 Karl Isakson *Landscape with Bastions* 1921.
Oil on canvas. 27½ × 37¾ (70 × 96) Statens Museum for Kunst, Copenhagen

159 Poul S. Christiansen *The Painter Niels Larsen Stevns* 1911.
Oil on canvas. 50⅜ × 34⅝ (128 × 88) Statens Museum for Kunst, Copenhagen

160 Edvard Weie *Victoria Weie, the Artist's Mother* 1908.
Oil on canvas. 51¾ × 41½ (131.5 × 105.5) Statens Museum for Kunst, Copenhagen

161 Kai Nielsen *Mads Rasmussen* 1912–14.
Black granite. 95⅝ (243). Faaborg Museum, Faaborg

162 Jens Søndergaard *Landscape, Jutland* 1929.
Oil on canvas. 33½ × 43⅛ (85 × 109.5) Statens Museum for Kunst, Copenhagen

163 Theodor Philipsen *Evening. From Svendstrup Field near Borup* 1908.
Oil on canvas. 21⅝ × 28⅜ (55 × 72) Statens Museum for Kunst, Copenhagen

164 Johannes Larsen *April Shower, Taarby Shore* 1901–07.
Oil on canvas. 51⅝ × 77½ (131 × 197) Faaborg Museum, Faaborg

165 Fritz Syberg *Overkaerby Hill, Winter* 1917.
Oil on canvas. 35⅞ × 51⅝ (91 × 131) Statens Museum for Kunst, Copenhagen

166 Peter Hansen *The Plowman Turning* 1900–02.
Oil on board. 36¼ × 48¾ (92 × 124) Faaborg Museum, Faaborg

167 Henrik Sørensen *Svartbekken* 1909.
Oil on canvas. 47¼ × 43½ (120 × 115.2) Rasmus Meyers Samlinger, Bergen

168 Axel Revold *Italian Girl* 1913.
Oil on canvas. 36¼ × 28⅞ (92 × 73.5) Nasjonalgalleriet, Oslo

169 Jean Heiberg *Nude* 1912.
Oil on canvas. 51¼ × 38⅜ (130 × 97.5) Rasmus Meyers Samlinger, Bergen

170 Emil Nolde *Friesland Farm under Red Clouds* 1930.
Watercolour. 12¾ × 18⅜ (32.4 × 46.7) Victoria and Albert Museum, London

171 Gösta Adrian-Nilson *City at the Seaside* 1919.
Oil on canvas. 12¼ × 13 (31 × 33) Moderna Museet, Stockholm

172 Vilhelm Lundstrøm *Still-Life c.* 1930.
Oil on canvas. 51 × 38¼ (129.7 × 97) Århus Kunstmuseum, Århus
173 Jón Stefánsson *Summer Night* 1929.
Oil on canvas. 39⅜ × 51¼ (100 × 130) Listasafn Íslands, Reykjavík
174 Jóhannes Kjarval *Thingvellir* 1930.
Oil on canvas. 37¾ × 54¾ (96 × 139) Private Collection
175 Ásgrímur Jónsson *Tindafjöll* 1903–04.
Oil on canvas. 31½ × 49⅜ (80 × 125.5) Listasafn Íslands, Reykjavík
176 Thórarinn B. Thorláksson *Sunset by the Lake* 1905.
Oil on canvas. 31⅛ × 49¼ (79 × 125) Sverrir Thórdarson, Reykjavík
177 Carl Eldh *Strindberg* 1923.
Marble. 96½ (245), base 23⅝ × 24⅜ (60 × 62) City Hall garden, Stockholm. Photo The Eldh Studio Museum, Stockholm
178 Carl Eldh *The Young Strindberg (in the Archipelago)* 1909.

Statuette, plaster. 15¾ (40), base 8⅝ × 8⅝ (22 × 22) The Eldh Studio Museum, Stockholm
179 Ville Vallgren *The Widow* 1892.
Bronze. 6½ (16.5) Ateneumin taidemuseo, Helsinki
180 Felix Nyland *Three Smiths* 1932.
Bronze. 127⅞ (335), with base 261¾ (665) The Studenthusplatsen, Helsinki. Photo Helsingin kaupunginmuseo, Helsinki
181 Waïnö Aaltonen *Paavo Nurmi* 1924–25.
Bronze. 84½ (214.5) Ateneumin taidemuseo, Helsinki
182 Carl Eldh *The Runners* 1937.
Statuette, plaster. 27 (68.5), base 18⅛ × 9 (46 × 23) The Eldh Studio Museum, Stockholm
183, 184 Gustav Vigeland *Monolith* modelled 1924–25 (details), carved 1929–42.
Granite. 669¼ (1700) Vigeland Park, Oslo
185 Carl Milles *Nymph Riding a Dolphin, The Sun Shining* 1918.
Bronze. 31⅛ × 26⅜ (79 × 67) Millesgården, Stockholm

COLOUR PLATES

I Carl Gustaf Pilo *Frederick V in Coronation Robes c.* 1751.
Oil on canvas. 91⅛ × 54⅞ (231.5 × 139.5) Statens Museum for Kunst, Copenhagen
II Jens Juel *The Ryberg Family Portrait* 1796–97.
Oil on canvas. 99⅝ × 132½ (253 × 336.5) Statens Museum for Kunst, Copenhagen
III Christoffer Wilhelm Eckersberg *The Nathanson Family Portrait* 1818.
Oil on canvas. 49⅝ × 67⅞ (126 × 172.5) Statens Museum for Kunst, Copenhagen
IV Christen Købke *The Landscape Painter Frederik Sødring* 1832.
Oil on canvas. 16⅝ × 14⅞ (42.2 × 37.9) Den Hirschsprungske Samling, Copenhagen
V Magnus von Wright *Annegatan 15, a Cold Winter Morning* 1868.
Oil on canvas. 14⅛ × 21¼ (36 × 54) Ateneumin taidemuseo, Helsinki
VI Christen Købke *View in Front of the North Castle Gate* 1834.
Oil on canvas. 31⅛ × 36⅝ (79 × 93) Ny Carlsberg Glyptotek, Copenhagen
VII Johan Christian Dahl *Birch Tree in a Storm* 1849.
Oil on canvas. 36¼ × 28⅜ (92 × 72) Bergen Billedgalleri, Bergen
VIII Thomas Fearnley *Labro Falls* 1837.
Oil on canvas. 59¼ × 88⅝ (150.5 × 225) Nasjonalgalleriet, Oslo
IX E. J. Löfgren *Erik XIV and Karin Månsdotter* 1864.
Oil on canvas. 88⅝ × 65 (225 × 165) Ateneumin taidemuseo, Helsinki. Photo Martti Puhakka, 1986, Turku Provincial Museum, Turku

X Lars Hertervig *Forest Lake* 1865.
Oil on canvas. 18½ × 25 (47 × 63.5) Nasjonalgalleriet, Oslo
XI Marcus Larson *Waterfall in Småland* 1856.
Oil on canvas. 74¾ × 91¾ (190 × 233) Nationalmuseum, Stockholm
XII Peder Severin Krøyer *Summer Evening at the Beach at Skagen* 1899.
Oil on canvas. 53⅛ × 73⅝ (135 × 187) Den Hirschsprungske Samling, Copenhagen
XIII Michael Ancher *Portrait of Anna Ancher* 1884.
Oil on canvas. 72⅛ × 47⅛ (183.3 × 119.8) Den Hirschsprungske Samling, Copenhagen
XIV Anna Ancher *The Maid in the Kitchen* 1883–86.
Oil on canvas. 34½ × 27 (87.7 × 68.5) Den Hirschsprungske Samling, Copenhagen
XV Albert Edelfelt *A Child's Funeral* 1879.
Oil on canvas. 47¼ × 80¾ (120 × 205) Ateneumin taidemuseo, Helsinki
XVI Erik Werenskiold *On the Plain* 1883.
Oil on canvas. 31⅞ × 39¾ (81 × 101) Nasjonalgalleriet, Oslo
XVII Kitty Kielland *After Sunset* 1886.
Oil on canvas. 31½ × 45½ (80 × 115.5) Stavanger Faste Galleri, Stavanger
XVIII Nils Kreuger *Autumn, Varberg* 1888.
Oil on wood. 12⅝ × 16⅛ (32 × 41) Nationalmuseum, Stockholm
XIX Ernst Josephson *Näcken* 1882.
Tempera on canvas. 56⅝ × 44⅞ (144 × 114) Nationalmuseum, Stockholm
XX Akseli Gallen-Kallela *Waterfall at Mäntykoski* 1892–94.
Oil on canvas. 106¼ × 61⅜ (270 × 156) Jorma Gallen-Kallela's Family Collection

XXI Eilif Peterssen *Summer Night* 1886. Oil on canvas. 52⅜ × 59½ (133 × 151) Nasjonalgalleriet, Oslo

XXII Bruno Liljefors *Wild Duck in Horse-tail* 1901. Oil on canvas. 37 × 52¾ (94 × 134) Thielska Galleriet, Stockholm

XXIII Gustaf Fjaestad *Winter Evening by a River* 1907. Oil on canvas. 59 × 72⅞ (150 × 185) Nationalmuseum, Stockholm

XXIV Akseli Gallen-Kallela *Boy with a Crow* 1884. Oil on canvas. 34 × 28½ (86.5 × 72.5) Ateneumin taidemuseo, Helsinki

XXV Carl Larsson *Old Man and New Planting* 1883. Watercolour. 36⅝ × 24 (93 × 61) Nationalmuseum, Stockholm

XXVI Harriet Backer *Baptism in Tanum Church* 1892. Oil on canvas. 42⅞ × 55⅞ (109 × 142) Nasjonalgalleriet, Oslo

XXVII Richard Bergh *Nordic Summer Evening* 1899–1900. Oil on canvas. 66⅞ × 88 (170 × 223.5) Göteborgs Konstmuseum, Gothenburg

XXVIII Eugène Jansson *The Outskirts of the City* 1899. Oil on canvas. 59⅞ × 53½ (152 × 136) Nationalmuseum, Stockholm

XXIX Anders Zorn *Midsummer Dance* 1897. Oil on canvas. 55⅛ × 38⅝ (140 × 98) Nationalmuseum, Stockholm

XXX Prince Eugen *The Cloud* 1896. Oil on canvas. 44⅛ × 40½ (112 × 103) Prins Eugens Waldemarsudde, Stockholm

XXXI Thórarinn B. Thorláksson *Thingvellir* 1900. Oil on canvas. 22⅝ × 32⅛ (57.5 × 81.5) Listasafn Íslands, Reykjavík

XXXII Karl Nordström *Neighbouring Farms* 1894. Oil on canvas. 37¾ × 77⅛ (96 × 196) Nationalmuseum, Stockholm

XXXIII Vilhelm Hammershøi *Interior with a Seated Woman* 1908. Oil on canvas. 27⅞ × 22⅝ (71 × 57.5) Århus Kunstmuseum, Århus

XXXIV Peter Ilsted *Interior with a Lady Knitting by the Window* 1902. Oil on panel. 23¼ × 26 (59 × 66) Private Collection

XXXV Vilhelm Hammershøi *Interior with a Lady* 1901. Oil on canvas. 21⅝ × 20⅞ (55 × 53) Private Collection

XXXVI Oluf Høst *Winter Sunset* 1931. Oil on canvas. 32¼ × 45⅞ (82 × 116.5) Statens Museum for Kunst, Copenhagen

XXXVII Ludvig Karsten *Blue Kitchen* 1913. Oil on canvas. 20⅞ × 26¾ (53 × 68) Nasjonalgalleriet, Oslo

XXXVIII Edvard Munch *The Scream* 1893. Oil on cardboard. 35⅞ × 29 (91 × 73.5) Nasjonalgalleriet, Oslo

XXXIX Nils von Dardel *Passionate Crime* 1921. Oil on canvas. 51¼ × 38⅝ (130 × 98) Moderna Museet, Stockholm

Index